The American Century

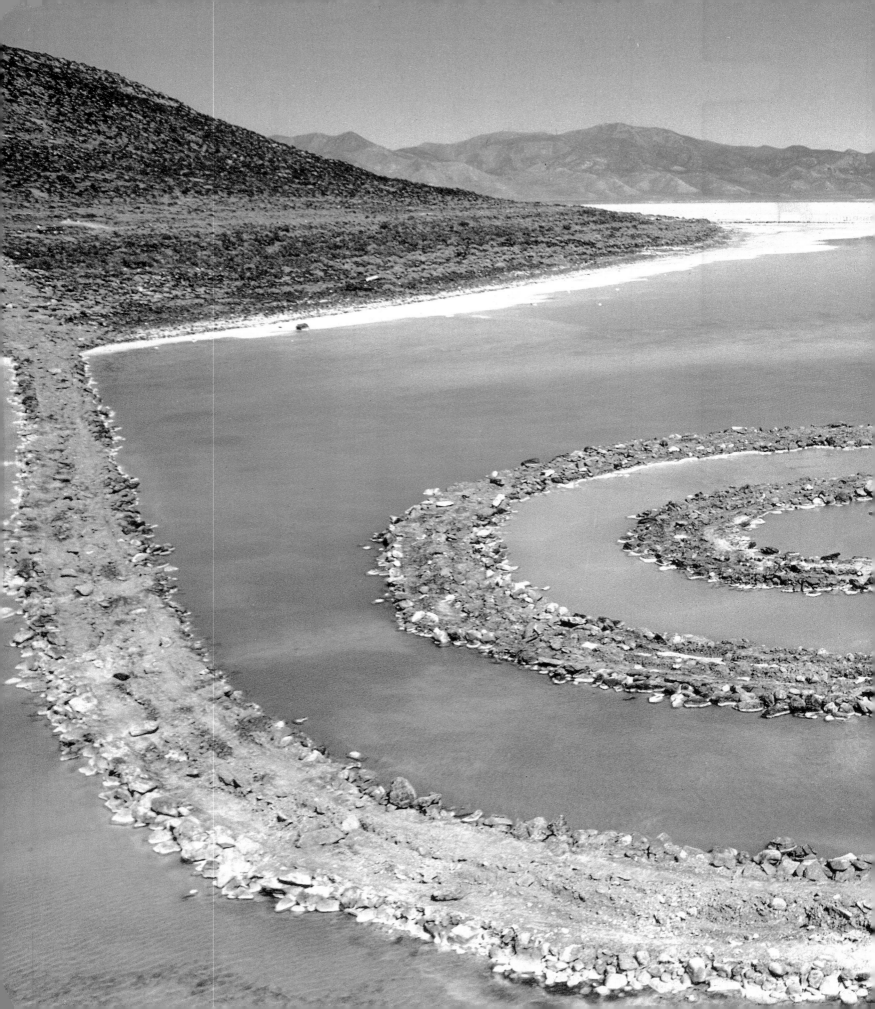

THE
AMERICAN CENTURY

ART & CULTURE
1950–2000

Lisa Phillips

Whitney Museum of American Art, New York

in association with

W. W. Norton & Company New York London

**The American Century
Art & Culture 1900–2000**
Organized by the
Whitney Museum
of American Art
Presented by
Intel Corporation

Additional support for this exhibition
is provided by
the National Endowment for the Arts,
the National Committee of the
Whitney Museum,
Booth Ferris Foundation, and
The Lauder Foundation, Evelyn and
Leonard Lauder Fund.
Educational and Public Programs are
funded by a generous grant from
The Brown Foundation, Inc., Houston.

This publication is made possible by a gift
from Susan and Edwin Malloy.

Research for Museum publications is
supported by an endowment established
by The Andrew W. Mellon Foundation
and other generous donors.

This book was published on the occasion of the exhibition
The American Century: Art & Culture 1900–2000
at the Whitney Museum of American Art.
Part I, 1900–1950
April 23 to August 22, 1999, and
Part II, 1950–2000
September 26, 1999, to February 13, 2000.

A complete list of works in the exhibition is available at www.whitney.org.

Library of Congress Cataloging-in-Publication Data
Phillips, Lisa.
 The American century : art & culture, 1950-2000 / Lisa Phillips.
 p. cm.
 Completes the history begun with: The American century : art & culture,
1900-1950 / Barbara Haskell.
 Includes bibliographical references and index.
 ISBN 0-393-04815-2 (Norton)
 1. Art, American. 2. Art, Modern—20th century—United States.
3. Arts, American. 4. Arts, Modern—20th century—United States.
I. Haskell, Barbara. American century. II. Whitney Museum of American Art.
III. Title.
N6512H355 1999 Suppl.
709' .73'0747471—dc21 99-24969
 CIP

ISBN 0-393-04815-2 (Norton cloth)
ISBN 0-87427-123-1 (Whitney paper)

W. W. Norton & Company, Inc.
500 Fifth Avenue, New York, NY 10110
www.wwnorton.com

W. W. Norton & Company Ltd.
10 Coptic Street, London WC1A 1PU

1 2 3 4 5 6 7 8 9 0

Cover: **Jasper Johns**, *Three Flags*, 1958. Encaustic on canvas, 30 7/8 x 45 1/2 x 5 in. (78.4 x 115.6 x 12.7 cm).
Whitney Museum of American Art, New York; 50th Anniversary Gift of the Gilman Foundation, Inc., The Lauder
Foundation, A. Alfred Taubman, an anonymous donor, and purchase 80.32
© Jasper Johns/Licensed by VAGA, New York, NY

Frontispiece: **Robert Smithson**, *Spiral Jetty*, 1970 (fig. 338).

Statement of Collaboration

Organized by the Whitney Museum of American Art
Presented by Intel Corporation

Intel Corporation is honored to collaborate with the Whitney Museum of American Art in presenting *The American Century: Art & Culture 1900–2000*, a sweeping exhibition that explores the forces of immigration and technology in the context of America's social and cultural landscape during the past one hundred years. Within this landscape, it is the spirit of inventiveness, the openness to new ideas and technologies, and the intellectual rigor found in the work of American artists which speak to us. These are the same dynamics that gave birth to and continue to propel the American high-technology industry.

The American Century is also a record of the evolution and growth of our modern visual culture, from silent film to television to the visual computer. Modern American artists have a tradition of standing in the vanguard—of tackling tough issues and creating new visual languages that force us to look at how new technology impacts our society.

As visual computers, connected to the Internet, change the way we learn and communicate, Intel looks to artists to help our industry develop a new visual and interactive literacy in order to make PCs even more useful to more people. In that spirit, Intel and the Whitney Museum will be working together over the course of *The American Century* to design a range of new interactive and educational tools that will enrich the museum experience and extend the exhibition into homes and classrooms around the world.

We commend the Whitney Museum of American Art for undertaking this ambitious and important exhibition and are pleased to help bring it to the American public.

Andrew S. Grove
Chairman, Intel Corporation

Contents

Sidebar Texts

Foreword

Maxwell L. Anderson
Director
Whitney Museum of American Art

Jackson Pollock
Number 17, 1950, 1950
Enamel and aluminum
paint on board, 22¼ x
22¼ in. (56.5 x 56.5 cm)
Whitney Museum of
American Art, New York;
Gift of Mildred and
Herbert C. Lee 99.59

The second half of the twentieth century in America has been a time of change so rapid as to defy the imagination. Cycles of creativity are now so accelerated that barely has an art movement been charted by the critical, museological, and academic establishments than its energy seems spent. Demographic changes also differentiate the art of the past fifty years. According to the Internal Revenue Service, hundreds of thousands of Americans today describe themselves as artists—an exponential increase in the population of artists that greeted American museums at the time of the Whitney's charter in 1930. It should not be surprising to find that artistic life in these last five decades has been a contradictory and kaleidoscopic affair, one characterized by concurrent but diverse impulses that cannot be chronicled in a straightforward, linear progression. Reading an account of this period therefore requires patient agility on the part of the reader.

In keeping with the dizzying pace of these decades, this second part of *The American Century: Art & Culture 1900–2000* represents a history of the avant-garde. This focus is warranted not only by the complexity of the task facing the museum world at the end of the century, but as well by the leading role American art has played on the international scene since 1950. The vanguard concentration of this volume and of the exhibition it accompanies also reflects the Whitney's own history in these years as a leader in identifying and championing the avant-garde—despite the indignant stance of some critics, for whom the Museum is too connected to contemporary artistic milieus rather than to the more mainstream creative landscape. Many of the works included in Part II are by artists who received their first or early-career exhibitions at the Whitney, and who subsequently achieved renown. The selection of artists will no doubt irritate some and win favor with others, but such dissension in the critical ranks is also part of the Whitney tradition—as attested by the controversies that attend every one of our Biennial exhibitions. Ultimately, however, the aim of this project is not to create a definitive "A-list" of vanguard artists during the past fifty years, but rather to peg their work to the society and culture in which they flourished.

The story begins with Abstract Expressionism and the New York School, whose proponents set a new course for American art. This sustained burst of individual creativity launched an art that affirmed America's emergence from the shadow of the Old World. The second generation of New York School artists are then given their due, even as the text charts their ineluctable descent into the last phase of a revolutionary artistic cycle: the perceived ossification of what was once seen as daring and innovative. The need to overthrow the hegemony of Abstract Expressionism spawned a series of responses, including the resurgence of figurative art and the broader acceptance of women artists.

The decade of the 1950s was also defined by the Beat generation and the introduction of assemblage and junk sculpture as well as environments and Happenings—all representing an openness to nontraditional media and an interdisciplinary enterprise that marked a decisive break from the norms of European art. These works, in a time-honored *épater le bourgeois* sensibility, offered pastiches of contemporary life that challenged the complacency of establishment America during the Eisenhower years. Photographers weaned on photojournalism exposed the surreality of Main Street and the urban jungle and made America see itself in ways that undermined the pristine Technicolor picture promoted by mainstream media. By the 1960s, the hip, ironic language of Pop culture coexisted with this impassioned resentment of the stern moral and political center.

In the fertile collision of Pop art and Minimalism, the disconnection of art-making from social concerns and from the Abstract Expressionist model of the heroic artist was complete, and a new vanguard of activist, anti-modernist artists took the stage. In the later 1960s and into the 1970s, Minimalism was followed by Eccentric Abstraction,

Postminimalism, Earthworks, and Conceptual art. A section on the influence of feminism sheds light on the use of pattern and decoration as well as craft, while the discussions of performance, body art, video, and the founding of alternative spaces reinforce the complex picture of this period. Painting and sculpture were also reconceived—in expressionist and superrealist modes, among others—which allowed these traditional media to continue alongside the myriad assaults on conventional art.

In the 1980s, the emergence of street culture, graffiti art, and other forms that rejected the art establishment as the arbiter of quality kindled a younger generation of artists. Meanwhile, Ronald Reagan's election in 1980 gave rise to a conservative culture—small but vocal—that declared war on the avant-garde, even as the art market boomed in an explosion of record-breaking auction prices. The prosperous economy of the eighties produced a materialist sensibility that made art collectible once again, and it is surely no coincidence that the appropriation-rich styles of postmodernism held sway during the decade.

In the closing decade of this century, the manifestations of high culture that demand our attention are more difficult to identify than ever. Although challenging the authority of a solipsistic art world has always been a prerogative of the avant-garde, in the 1990s the number and diverse character of the artists tilting their lances almost defy analysis in the short view. Artistic responses in a media-saturated world and a largely affluent and self-congratulatory America are extraordinarily multifaceted, which makes the mining of today's art as formidable and potentially rewarding a task as ever.

We are grateful to the scores of lenders from the United States and around the globe who parted with their treasures to make this exhibition possible. The staff of the Whitney was exemplary at every turn in bringing this highly ambitious enterprise to fruition. Everyone worked tirelessly to plan and implement the project, from the Museum's senior managers to the Publications and New Media Department to the art handlers. I single out here only Lisa Phillips, curator of the exhibition and author of this catalog, and Susan Harris and Karl Willers, associate curators for Part II of *The American Century* project.

We have been fortunate in attracting major support from the National Endowment for the Arts, the National Committee of the Whitney Museum, Booth Ferris Foundation, and The Lauder Foundation, Evelyn and Leonard Lauder Fund. The Brown Foundation, Inc., of Houston funded the educational and public programs in conjunction with the exhibition. The book itself was made possible by a gift from Susan and Edwin Malloy.

On behalf of the Whitney's Board of Trustees and its president, Joel S. Ehrenkranz, I thank Andrew S. Grove, chairman of Intel Corporation. Intel and the Whitney have embarked on an unprecedented collaboration which marries the latest advances in high technology with the finest examples of American art. Our association allows the masterworks and related educational resources from *The American Century* to reach a broad, global audience. I would like to add my personal thanks to Leonard A. Lauder, chairman of the Whitney Museum, and to my predecessor, David A. Ross, now director of the San Francisco Museum of Modern Art, who played key roles in securing Intel's support for the exhibition. This collaboration testifies to the Whitney's rightful place as a primary arbiter of American culture and to Intel's as a visionary company dedicated to the support of the technological and artistic vanguard.

The story of American art in the twenty-first century will begin in the aftermath of *The American Century* with the Whitney's 2000 *Biennial*. We look forward to welcoming back readers and visitors who want to participate in the "research and development" phase of art history, in which we are justifiably proud of our contribution.

America Takes
Command
1950–1960

The chronological halfway mark of the twentieth century may be 1950, but a more decisive turning point is the end of World War II in 1945. The war was a watershed in American life and culture. Though there were heavy death tolls, America emerged politically and economically victorious and physically intact.

This was exactly the outcome Henry Luce had envisioned when he penned his historic February 1941 editorial for *Time* magazine, "The American Century," from which this book takes its title. Lamenting American isolationist tendencies, Luce exhorted his readers to throw aside their moral and intellectual confusion and to support American involvement in the war then raging in Europe. He wanted Americans to accept responsibility for the "world-environment" and to embrace a "vision of America as a world power which...will guide us to the authentic creation of the 20th Century—our Century."

The immediate postwar years met Luce's expectations. While most of Europe and part of Asia suffered extensive physical damage during the war, the United States was untouched. It thus emerged in 1945 with its manufacturing capacity intact and a strong economy generated by years of war production. Going into the war, America had been one of the world's great powers; by 1945, it was militarily, politically, and economically without equal. By 1947, for instance, America was producing half the world's manufactured goods: 57 percent of its steel; 43 percent of its electricity; 62 percent of its oil; and 80 percent of its automobiles. In addition, America had a monopoly on the atomic bomb, the most dangerous weapon the world had ever seen.

But the postwar period was politically and socially complex. These years of victory and supremacy also brought a perceived threat to the safety and indeed the existence of the United States from the Soviet Union, which acquired atomic weapons in 1949 and soon controlled the governments of most nations in Eastern and Central Europe. The once vocal left in American politics was nearly silenced as the nation became committed to an ideology of anti-Communism.

The postwar years also saw the rise of new social conditions. Vast numbers of poor blacks and whites from the South migrated to urban centers in the North— a population movement comparable in numbers to the immigration from Europe to the United States between the Civil War and World War I.[1]

In 1940, ten out of thirteen million African Americans still lived in the South, where they were segregated, denied access to justice and the political process, and deliberately kept in a state of social and economic inferiority. But with the economic boom of the war years, rural blacks flocked to cities in search of jobs in burgeoning industries. This radical change in the nation's demographics inflamed racial issues that had been smoldering for almost a century.

There were other important demographic shifts. The postwar baby boom produced a million more Americans each year, a birthrate that vastly exceeded that of the Depression and the war years. Increased postwar employment opportunities led to rising incomes and a growth in the middle class. Higher education became cheaper and more available through the GI Bill of Rights, which helped veterans with loans for college tuition, as well as for home construction and business initiatives. A flourishing economy also enabled other Americans to afford tuition costs, and a college education thus became a possibility for many, instead of the privilege of a few.

The dramatic changes following the war are crucial to understanding the art of the last fifty years. America's ascendance on the geopolitical stage and the new social order irrevocably altered art and culture no less than daily life. In examining these five decades, however, we should remember that neither history nor art progresses in a straight line—at any point, multiple, shifting, and often contradictory tendencies coexist.

This book therefore provides an array of perspectives that reflect the complexity of this period, the heterogeneity that is America. As a new century dawns, it is essential to take both a retrospective and a prospective view—to look back at the past with an eye to the future. Today we are inclined to question Luce's ideal of American hegemony—a monolithic entity at the dynamic center of an ever-widening sphere of influence. Instead, it seems more relevant to challenge each word of "The American Century." Is there only one story, one uniform identity, one center, as implied by the definitive "the"? How has the meaning of "American" changed over the past fifty years? And is the notion of a "century" the best way to delineate history?

The Postwar American Art Community

"If [Picasso] drips, *I* drip," said the Armenian-born American painter Arshile Gorky in the 1930s.[2] His statement epitomizes the condition of American art before World War II as essentially a province of European art. While Americans customarily looked to Paris for the latest developments in art, Europeans did not look at American art at all. It was the prevailing critical view that until the late 1940s America "had not yet made a single contribution to the mainstream of painting or sculpture."[3] Even American modernists were considered too parochial to provide a model for the international mainstream.

As America became a world leader after the war, however, American artists wanted to take the initiative and create something new—something that would express aspiration, risk, freedom, and, in keeping with the new anti-isolationist spirit, "cultural values on a global scale."[4] Though these general goals for art coincided with America's larger political agenda, the artists did not see their work as ideological. Freedom, to them, was best communicated through unconstrained individual expression; their break with tradition represented risk, and their epic scale spoke of ambition. Their form of abstraction, they believed, could transcend national boundaries and the specificity of particular cultures.

With Europe still rebuilding after the devastation of war, New York replaced Paris as the capital of the art world and would dominate the American and international art scene for the next two decades. A few hundred artists, a half dozen dealers devoted to contemporary art, and a couple of supportive museums formed the basis of what became by 1950 an explosive vanguard—the "New York School," an umbrella term that encompassed a variety of styles, primarily, but not exclusively, Abstract Expressionism.

Many New York School artists had come to the city from elsewhere. Several had immigrated from abroad—Mark Rothko (in 1913), Willem de Kooning (in 1926), Hans Hofmann (in 1930), and Arshile Gorky (in 1920)—while Jackson

1. **Hans Hofmann**
Equipoise, 1958
Oil on canvas, 60 x 52 in.
(152.4 x 132.1 cm)
Los Angeles County
Museum of Art; Gift of
Marcia Weisman
©Estate of Hans
Hofmann/Licensed by
VAGA, New York, NY

Pollock, Clyfford Still, and Philip Guston had come from other parts of the country. Though they had different cultural backgrounds and styles of working, they did share alliances, friendships, and certain goals for art. They bonded together in a vital community in Greenwich Village, and the dynamic, cosmopolitan environment of New York fueled their desires and ambitions.

Three factors helped solidify the New York School. The first was sociological: during the Depression, many of the artists had worked together on federally supported relief programs such as the Federal Art Project, an officially sanctioned form of employment that lent legitimacy to the art profession. The second factor was the German-immigrant artist Hans Hofmann (fig. 1) who in the 1930s had founded the Hans Hofmann School of Fine Arts in Greenwich Village. Hofmann's

CORPORATE HEGEMONY: THE PUBLIC TRIUMPH OF MODERNITY

By the early 1950s, American corporate culture had seized upon and thoroughly transformed the architectural interest in transparency that had been developing since Joseph Paxton built the Crystal Palace for London's 1851 World Exposition. Glass was, and remains, a kind of architectural talisman and projection screen: all the conflicting desires and contradictory thoughts that constitute the modern tradition can be read in its reflective, translucent, and opaque surfaces. In 1950, Ludwig Mies van der Rohe broke ground on 860 Lake Shore Drive (fig. 2) in Chicago for an apartment building that used the repetitive and modular schema of the curtain wall—in which the exterior wall of a building serves no structural purpose—not only to realize his dream of a glass tower, first sketched in 1919, but to establish a universalizing logic of architectural expression and production. As the vitreous structure absorbed reflected images of the surrounding area into its surface, the distinction between the object and its context broke down, producing instead a conceptually infinite terrain. This ever-proliferating and expanding field was further stretched by the fact that Mies' Lake Shore Drive project comprises two buildings. This doubling initiated an almost endlessly repeating series of curtain-wall structures throughout the world.

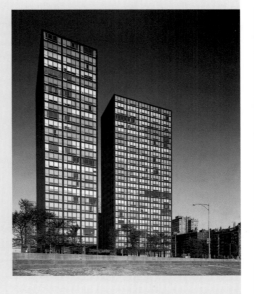

The effects of the glass tower were created by machine modes of manufacture, which produced an infinitely applicable and universalizing logic of production and anonymous exchange. This logic was that of the postwar, increasingly international, corporation—Skidmore, Owings & Merrill's Lever House of 1950–52 (fig. 3), designed by Gordon Bunshaft, typifies the elegant, relentless form of the curtain-wall building that dismantled barriers not only between solid and void, object and context, but between public and private, one nation and another, making the world the potential site of a new American hegemony. —S. L.

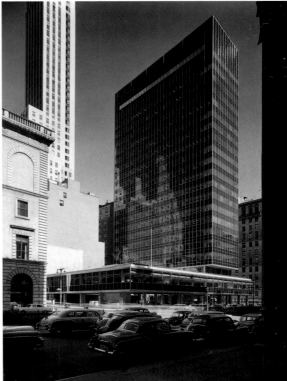

2. **Ludwig Mies van der Rohe**
Lake Shore Drive Apartments, Chicago, 1952, photograph by Ezra Stoller
© Esto. All Rights Reserved

3. **Gordon Bunshaft (Skidmore, Owings & Merrill)**
Lever House, New York, 1950–52, photograph by Ezra Stoller
© Esto. All Rights Reserved

teachings, which combined Cubist structure and space with German Expressionist and Fauvist feeling and color, influenced a generation of artists who emerged in the 1950s, including his former students Larry Rivers, Lee Krasner, and Ray Eames. But most important to the momentum of the New York School was the influx of European vanguard artists to New York during the war—from Fernand Léger, Piet Mondrian, Marc Chagall, and Walter Gropius to the Surrealists (Matta, Yves Tanguy, Salvador Dalí, André Breton, Max Ernst, André Masson), who arrived practically en masse in 1939. This firsthand contact with the European avant-garde during the war is widely considered to be one of the most significant developments in the history of American art.[5]

In the 1940s, the burgeoning community of young American artists in New York had frequent contact with the Surrealists through Peggy Guggenheim's Art of This Century gallery, among other professional and social venues. They absorbed the Surrealists' emphasis on mythic content and on the unconscious, including their use of automatic writing and other techniques that gave precedence to intuitive process over rational conception. Toward the end of the decade, however, New York artists began to move away from Surrealist-inspired biomorphism and mythic references to forge their own independent styles. By 1948, after many of the Surrealists had left New York or returned to Europe, most American artists had abandoned even the allusive imagery of the Surrealists in favor of the radical abstract styles that would become famous under the banner of Abstract Expressionism.

Abstract Expressionism: The New York Vanguard

The aesthetic breakthrough of the New York School rested on two concepts: spontaneous process and a dramatic increase in scale. The very method of painting was direct and confrontational, reflecting America's new, emboldened identity as the most powerful country in the world. Despite Willem de Kooning's warning that "it is disastrous to name ourselves," this radical new aesthetic was called Abstract Expressionism[6]—the first American art movement to win international acclaim as central to the development of contemporary art. De Kooning was not alone in his resistance to constricting labels, for Abstract Expressionism championed the primacy of individual expression. In this pursuit, a collective style was as abhorrent as a single name. By 1950, most of the original Abstract Expressionists had arrived at their individual signature styles. And the bold images that would become trademarks of the new American painting were visibly different from one another: Jackson Pollock's drip paintings (1947); Mark Rothko's floating, rectangular expanses of color (1950); Clyfford Still's excoriated dark fields (1947); Franz Kline's architectonic black-and-white gestures (1949).

The critical penchant for categorization, however, has left us not only with the term "Abstract Expressionism," but with subdivisions. The work of the first generation of Abstract Expressionists is generally divided into two strains: the gestural and energetic Action Painters (Jackson Pollock, Willem de Kooning, Franz Kline) and the Chromatic Abstractionists (Barnett Newman, Mark Rothko, Adolph Gottlieb, Clyfford Still, Ad Reinhardt), with Robert Motherwell, Philip Guston, and Bradley Walker Tomlin in between. Whatever the nomenclature—and no matter how idiosyncratic their individual styles—all these artists shared a desire to do away with the conventions of easel painting and eliminate representation or the use of forms borrowed from Cubism, Surrealism, and other sources. They often adopted generic or numbered titles to help purge allusions to imagery and subject matter from the real world.

Newman said that he wanted to be free from "the impediments of memory,

association, nostalgia, legend, myth."[7] Rothko rejected the obstacles of "memory, history, or geometry," and Still wanted no "outworn myths or contemporary alibis."[8] This collective will to abandon subject matter was a final attempt to break free from the weight of European culture—to seek something indigenous to the American experience. Even if, as in the case of de Kooning and, by 1951, Pollock, a personal aesthetic impulse led some artists to retain or reintroduce figurative references, large-scale abstraction became a fresh new language of individual expression and invention—one in which iconoclasm could be linked to innovation. The scale of these works, unprecedented in American art, may have been an outgrowth of the public mural painting in which many artists engaged while working on government projects during the 1930s. Translated to private canvases a decade later, such scale reflected the ambitiousness of the American self-image. But it also bespoke the experience of America's dramatic landscape, which had led nineteenth-century artists and philosophers to pantheism and transcendentalism. To American artists at the mid-twentieth century, this indigenous history could be transmitted through epic scale and rhythmic processes—"I *am* nature" was Pollock's famous declaration.[9] To the critic Clement Greenberg, writing in 1950, the monumental size of Abstract Expressionist painting was one of its defining characteristics.[10] One Pollock work of that year, *Number 27* (fig. 4), was 106 inches wide; another, *Autumn Rhythm: Number 30* (fig. 5), stretched to 207 inches—more than 17 feet long.

Rothko, Newman, and Still were also making wall-scale pictures at that time. In fact, Still was the first to expand his paintings to gargantuan scale, which he did in 1944, even before Pollock. The large scale subsumed viewer and artist alike, and it allowed the artist to "be" in the picture, to be inside the work. As Rothko described it:

> I paint very large pictures. I realize that historically the function of painting large pictures is painting something very grandiose and pompous. The reason I paint them, however—I think it applies to other painters I know—is precisely because I want to be very intimate and human. To paint a small picture is to place yourself outside your experience, to look upon an experience as a stereopticon view with a reducing glass. However you paint the larger pictures, you are in it. It isn't something you command.[11]

Abstract Expressionists relished the drama of the encounter. The large-scale canvas enabled them to have a more direct connection with their work—as Pollock

4. Jackson Pollock
Number 27, 1950
Oil on canvas, 49 x 106 in.
(124.5 x 269.2 cm)
Whitney Museum of
American Art, New York;
Purchase 53.12

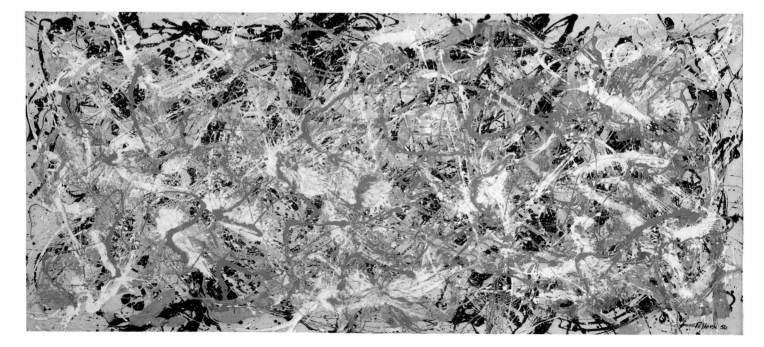

said, "When I am *in* my painting, I'm not aware of what I'm doing . . . because the painting has a life of its own."[12] The artists' physical immersion allowed for emotional immersion, which was further assisted by spontaneous processes.

Abstract Expressionists, particularly the gestural painters, who used their whole arm or body, not just the wrist, prized immediacy. They worked spontaneously—dripping, pouring, slashing, the artist's hand serving as conduit for unconscious, unpremeditated feelings. The picture's "life of its own" was, in fact, the unconscious revealed.

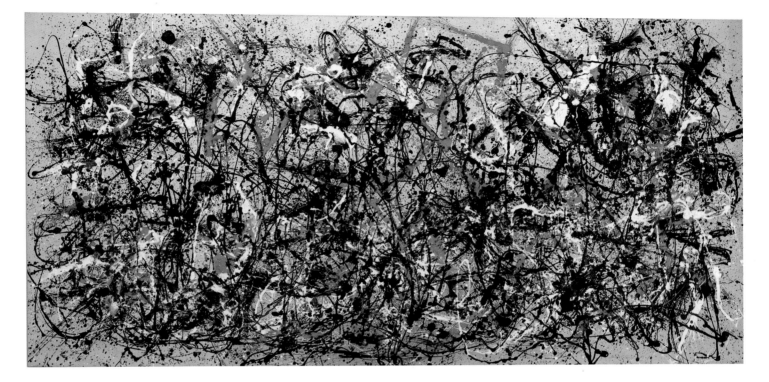

5. **Jackson Pollock**
Autumn Rhythm:
Number 30, 1950
Oil on canvas, 105 x 207 in.
(266.7 x 525.8 cm)
The Metropolitan Museum
of Art, New York; George A.
Hearn Fund, 1957

ACTION PAINTING

With the introduction of his "drip" paintings of 1947–52, Jackson Pollock made a radical break with pictorial conventions of the past. He painted his canvases on the floor, standing over them, dripping and splashing turpentine-thinned enamel paint in rhythmic formations, using sticks, dried-out brushes, and basting syringes (fig. 6). He was not painting in the conventional sense: his brush never touched the canvas. Instead, he used the movements of his body and the density of the paint to create intricate webs of lines that filled the field (fig. 5). The painting was a trace of a process, a performance, a dance. It was explosive and direct.

As if to suggest the action of a bullfight, Pollock called his floor-bound canvas "the arena." In his defining essay of 1952, "The American Action Painters," the critic Harold Rosenberg went on to describe all the large canvases of the Abstract Expressionists as "an arena in which to act." Painting was not a "space in which to reproduce, redesign, analyze or 'express' an object, actual or imagined. What was to go on the canvas was not a picture but an event. . . . Form, color, composition, drawing, are auxiliaries any one of which . . . can be dispensed with. What matters always is the revelation contained in the act. . . . The act-painting is of the same metaphysical substance as the artist's existence. The new painting has broken down every distinction between art and life."[13]

In compositional terms, there was no hierarchy in these "all-over" paintings, which dispensed with the conventional figure-ground relationship, illusionistic

space, and central focus. Instead, there was an atmosphere that Pollock's critical champion, Clement Greenberg, described as "pulverized value contrasts in a vaporous dust of interfused lights and darks."[14] There were implications of cosmic space in these optical paintings, but the unprimed canvas also asserted itself as literal, raw material, with hair, fingerprints, sand, broken glass, string, and cigarette butts embedded in the paint, bringing the viewer back to the material "here and now." Some important precedents for this all-over painting include Joan Miró's "constellation" paintings, where the field was filled with a network of delicate connecting spheres and lines, and Claude Monet's *Water Lilies*, where the entire surface was covered with brushstrokes that represented not only flowers but light and atmosphere—the effect approached total abstraction. Pollock's painting was also quickly compared to the abstractions of the Dutch Neoplasticist Piet Mondrian and to Cubist collage in terms of their nonhierarchical compositions. The legacy of Cubism was strong, and the most influential critics of the time sought to connect Cubism and Abstract Expressionism, declaring that the latter had realized the revolutions implied by Synthetic Cubism.[15] But no one before Pollock had ever reoriented the picture plane horizontally, from the vertical easel to the floor. Even when the final painting was hung on the wall, it bore evidence of its horizontal vector in the pooling and scabbing of paint congealed into tarry pockets or flowing in bleeding rivulets. This reorientation, Pollock himself suggested, may have been inspired by the paint-spattered floor of his studio or by the ceremonial sand paintings of the Navajo Indians he admired.[16]

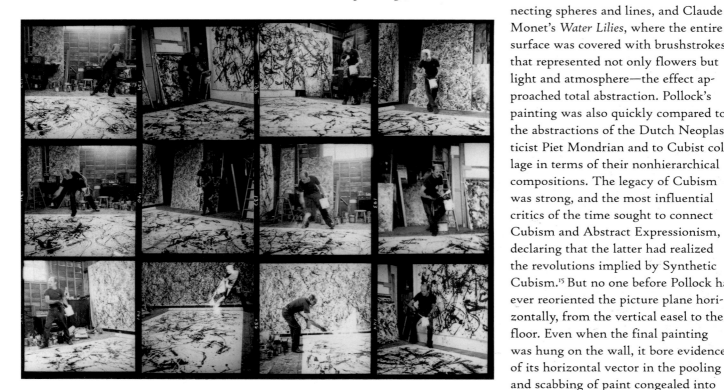

6. *Jackson Pollock Painting in His Studio*, 1950, photograph by Hans Namuth

Pollock also liberated line from any descriptive function of contour and form, instead creating a calligraphy of fluid, undulating rhythms. An artist of great formal intelligence, he merged drawing and painting, line and color. The rhythmic layering of great skeins of color, plane over plane, represented a new way of depicting pictorial space.

Pollock and his Abstract Expressionist colleagues contributed more than art to American culture in the 1950s. The premium they placed on originality, autonomy, and individual actions led to one of the most enduring myths of the decade—the idea of the artist as the romantic, alienated genius. Photographs of Pollock, particularly those by Hans Namuth, have abetted this myth. In a remarkable sequence of still and filmed images, we see Pollock alone in his studio, confronting the canvas and, through his rhythmic actions, creating a painting (fig. 6). Though Pollock had pioneered a new kind of space and process, his background, painting style, and personal manner contributed to his ascendance as an "American hero"—as did his premature death in an automobile accident at the age of forty-four in 1956.

Pollock was the virile and rugged man of the American West. Born in Cody, Wyoming, and raised in California and Arizona, he was hard-drinking and physical and, like the cinematic persona of John Wayne, an anti-intellectual man of action.

The idea of frontier America, where heroic acts and individual freedom prevailed, continued to ignite the American imagination. The Western—consoling stories about independence, individualism, open spaces, self-reliance, discovery, and man against nature—enjoyed enormous popularity in the 1950s. The frontier myth was part of the larger Cold War "us and them" spirit, and Abstract Expressionism both originated from and contributed to this mythology.

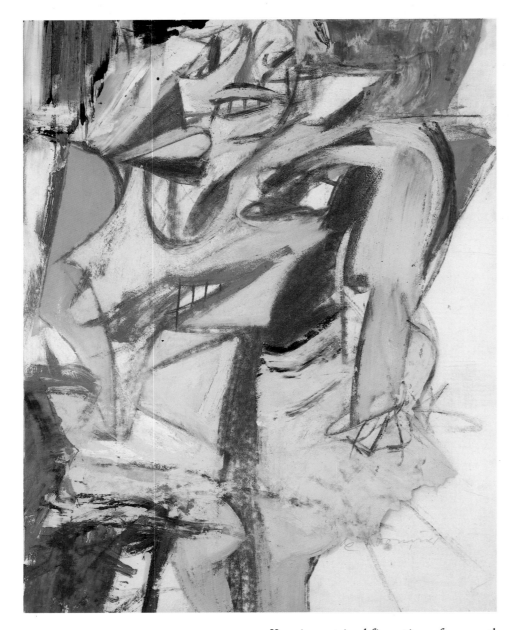

7. **Willem de Kooning**
Woman, 1953
Oil and charcoal on paper mounted on canvas, 25⅝ x 19⅝ in. (65.1 x 49.8 cm) Hirshhorn Museum and Sculpture Garden, Smithsonian Institution, Washington, D.C.; Gift of Joseph H. Hirshhorn, 1966

The Abstract Expressionist credo of free individual expression through direct action was epitomized by Willem de Kooning, who achieved a sense of power through brash and raw virtuoso brushwork. De Kooning began his career in the Netherlands, where his academic training gave him prodigious drafting skills that enabled him to continually synthesize tradition and modernism. He arrived in the United States at the age of twenty-three in 1926, and during the 1930s worked on Works Progress Administration (WPA) murals with Arshile Gorky and Pollock. After an early figurative period, his work became increasingly abstract, and by 1950 the brushwork had loosened considerably as the scale of the paintings increased. Like Pollock's, his paintings had an all-over quality, but there was more compositional planning to his interwoven biomorphic forms. The brushwork was robust and muscular and soon took on a powerful life of its own.

In de Kooning's renowned Woman series, begun in 1950, high-intensity color mixed with aggressive brushstrokes produced charged works that were as startling when first shown in 1953 at the Sidney Janis Gallery in New York as Pollock's drip paintings had been (figs. 7, 8). These large, confrontational canvases, dominated by fragmented human figures, are fierce. De Kooning retained figurative references throughout his work (and Pollock eventually returned to figuration), demonstrating that abstraction and figuration need not be polarized. In de Kooning's paintings, the fluidity of the space, the unpremeditated brush slashing, and the disjunctive syntax result in an ever-shifting quality that brilliantly communicates the flux and velocity of modern life (fig. 9).

Franz Kline took another approach to gestural abstraction in his grand-scale architectonic black-and-white paintings. His conversion to abstraction came in 1949, when de Kooning suggested that he put one of his small ink drawings in a Bell-Opticon opaque projector that de Kooning had been using to enlarge his own

8. **Willem de Kooning**
Woman and Bicycle,
1952–53
Oil on canvas, 76½ x 49 in.
(194.3 x 124.5 cm)
Whitney Museum of
American Art, New York;
Purchase 55.35

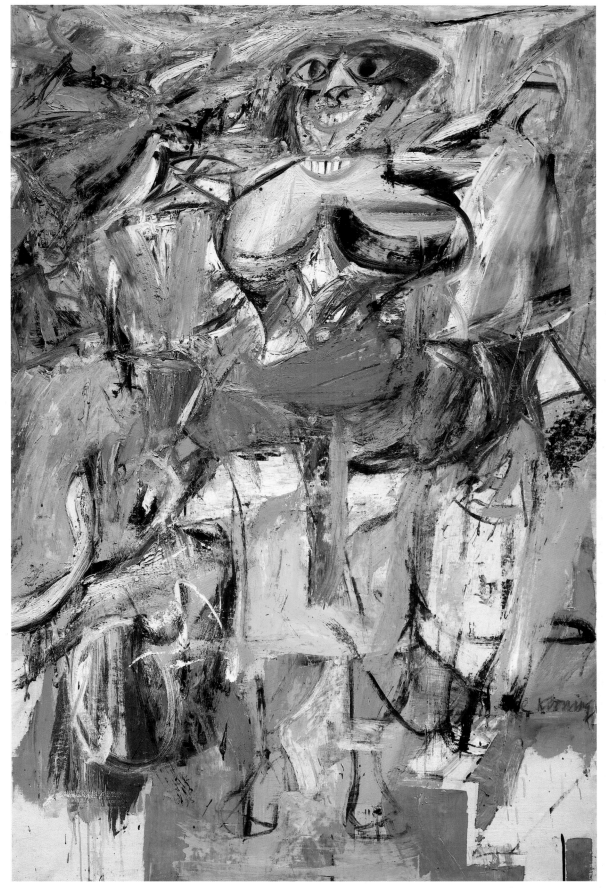

sketches onto big canvases. Suddenly, Kline's little ink drawing of a rocking chair "loomed in gigantic black strokes," obliterating the image.[17] The strokes became entities in themselves, monolithic forms divorced from any external reality. Kline went on to create dynamic, enveloping paintings, such as *Mahoning*, that began their lives as intimate gestures on paper (fig. 10). Still, the directness and vigor of the paint handling conveyed immediacy—these works were not merely reproductions of originals in another scale.

9. **Willem de Kooning**
Door to the River, 1960
Oil on canvas, 80 x 70 in.
(203.2 x 177.8 cm)
Whitney Museum of
American Art, New York;
Purchase, with funds from
the Friends of the Whitney
Museum of American Art
60.63

The primacy of the act, epitomized in Abstract Expressionist painting, was also one of the central tenets of existentialism—the most influential philosophical movement to emerge in the postwar period. In an uncertain world, where the A-bomb and the H-bomb made the future seem tenuous, one could reaffirm one's existence only by acting in the here and now. The distinct possibility that there would be no tomorrow demanded an existential view. Thus artists who had been political activists in the 1930s turned to personal acts of free will as a means of self-liberation and as an expression of anxiety.

SCULPTURE OF THE NEW YORK SCHOOL

Even sculptors of this period developed working methods that allowed for greater spontaneity and relied on unconscious and aleatory effects. The direct metal process, for instance, was a three-dimensional analogue to Action Painting. Thanks to the improvement of welding technology during the war and the introduction of the portable oxyacetylene torch, sculptors could weld, braze, and model durable metals to create textured effects that paralleled expressionist painting surfaces. Using a combination of Constructivist and expressionist approaches, sculptors freed themselves at last from the relatively static, monolithic tradition of carving and modeling. Artists like Theodore Roszak, Herbert Ferber, Seymour Lipton, Ibram Lassaw, and David Smith forged raw, open, penetrating forms that were often more about line and surface than about volume and mass (figs. 12–17).

In describing the connection between materials and intentions, David Smith observed that "metal possesses little art history, what associations it does possess are those of this century: power, structure, movement, progress, suspension, brutality."[18] Also implicit, though unacknowledged, were associations of male conquest and domination. Theodore Roszak recognized the brutal, violent content of direct metal and used it to explain his abrupt shift of imagery following the war. Having abandoned his earlier Constructivist ideals as innocent illusions, he was now turning to highly expressionist, mythic images in welded and brazed steel because "the

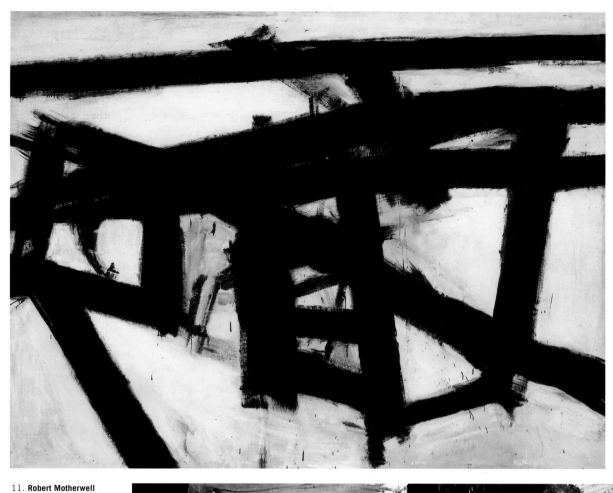

10. **Franz Kline**
Mahoning, 1956
Oil and paper collage on canvas, 80 x 100 in. (203.2 x 254 cm)
Whitney Museum of American Art, New York; Purchase, with funds from the Friends of the Whitney Museum of American Art 57.10

11. **Robert Motherwell**
Elegy to the Spanish Republic, 54, 1957–61
Oil on canvas, 70 x 90¼ in. (178 x 229 cm)
The Museum of Modern Art, New York; Anonymous gift
©Dedalus Foundation/ Licensed by VAGA, New York, NY

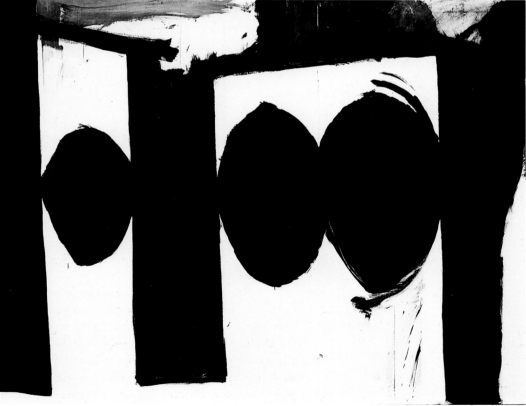

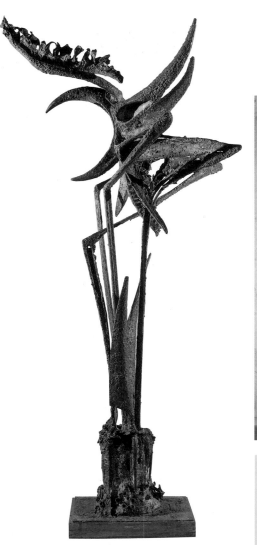

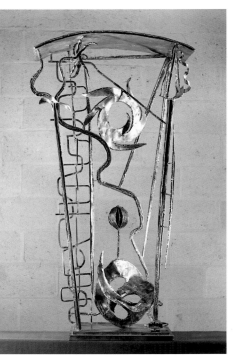

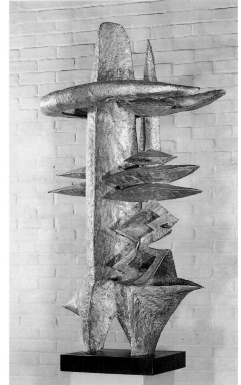

12. **Theodore Roszak**
Sea Sentinel, 1956
Steel brazed with bronze,
105 in. (266.7 cm) height
Whitney Museum of
American Art, New York;
Purchase 56.28
©Estate of Theodore
Roszak/Licensed by VAGA,
New York, NY

13. **Herbert Ferber**
Sun Wheel, 1956
Brass, copper, and
stainless steel, 56¼ x
29 x 19 in. (142.9 x
73.7 x 48.3 cm)
Whitney Museum of
American Art, New York;
Purchase 56.18

14. **Seymour Lipton**
Sorcerer, 1957
Nickel silver on metal,
60¾ in. (154.3 cm) height
Whitney Museum of
American Art, New York;
Purchase, with funds from
the Friends of the Whitney
Museum of American Art
58.25

15. **Ibram Lassaw**
Procession, 1955–56
Bronze and silver, 32 x
40 in. (81.3 x 101.6 cm)
Whitney Museum of
American Art, New York;
Purchase and exchange
56.19

16. **David Smith**
Hudson River Landscape,
1951
Welded painted steel and
stainless steel, 49¹⁵⁄₁₆ x
73¾ x 16⅝ in. (126.8 x
187.3 x 42.1 cm)
Whitney Museum of
American Art, New York;
Purchase 54.14
©Estate of David
Smith/Licensed by VAGA,
New York, NY

17. **David Smith**
Running Daughter, 1956
Painted steel, 100⅜ x
34 x 20 in. (255 x 86.4 x
50.8 cm)
Whitney Museum of
American Art, New York;
50th Anniversary Gift of
Mr. and Mrs. Oscar Kolin
81.42
©Estate of David
Smith/Licensed by VAGA,
New York, NY

forms [he found] necessary to assert are meant to be blunt reminders of primeval strife and struggle, reminiscent of those brute forces that not only produced life, but in turn threaten to destroy it" (fig. 12).[19]

Sculptures of this era often had repellent surfaces that suggested scorched and excoriated skin and alluded to the devastation of war—particularly atomic devastation. The drama of the possible extinction of the human race is as much in evidence in sculpture of the fifties as in the popular science fiction novels and films of the time. Like many monsters of science fiction, new sculptural images were imaginative crossbreeds of dinosaurs, predatory plants, pods, and blobs—nature gone berserk, grotesque mutations that represent an attempt to exorcise unbearable terrors by invoking and then subduing them. Resonant as these images were of death, however, they also suggested a natural cycle moving from birth, death, and decay to rebirth—the process of natural growth was visualized as a momentous, primordial event.

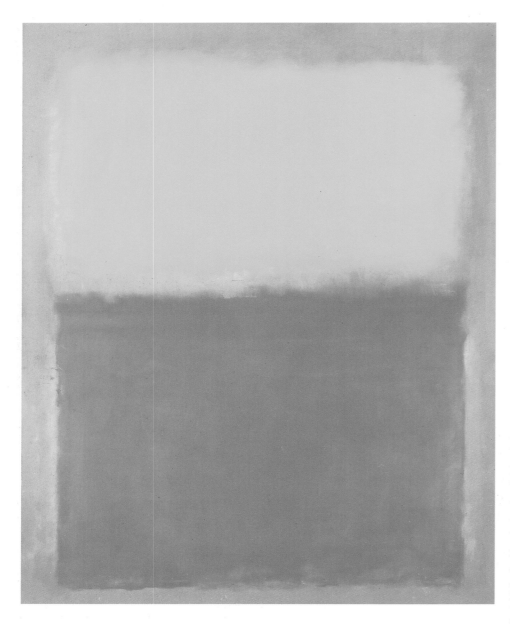

18. **Mark Rothko**
Orange and Yellow, 1957
Oil on canvas, 91 x 71 in.
(231.1 x 180.3 cm)
Albright-Knox Art Gallery,
Buffalo; Gift of Seymour
H. Knox, 1956

CHROMATIC ABSTRACTION

The second group of Abstract Expressionist painters who achieved prominence in the early 1950s was the Chromatic Abstractionists, foremost among them Mark Rothko, Barnett Newman, Ad Reinhardt, and Clyfford Still. Their work was as nonrelational as Pollock's all-over paintings, but they concentrated on the physical sensations generated by large color fields, producing what have been called "single image" paintings. Enveloping and atmospheric, their large canvases yielded luminous, optical effects. But the Abstract Expressionist label never really fit, because the Chromatic Abstractionists were not gesturally expressive and their enormous surfaces were usually thinly painted. Unlike those of the Action Painters, their canvases showed little evidence of brushwork.

The empty expanses of the Chromatic Abstractionists suggested to some the vastness of the American landscape: Rothko's exalted light emanating from ethereal fields of color (figs. 18, 19); Newman's simple, vast spaces (fig. 67); the sense of solitude and emptiness in Reinhardt's painting (fig. 68). All these works allude to the awe that generations of Americans had experienced before the seemingly boundless expanse of nature. An enveloping, operatic statement about nature is given in Clyfford Still's jagged, flamelike vertical contours that suggest crags and fissures (fig. 20) or in Philip Guston's shimmering clusters of brushstrokes (fig. 21).

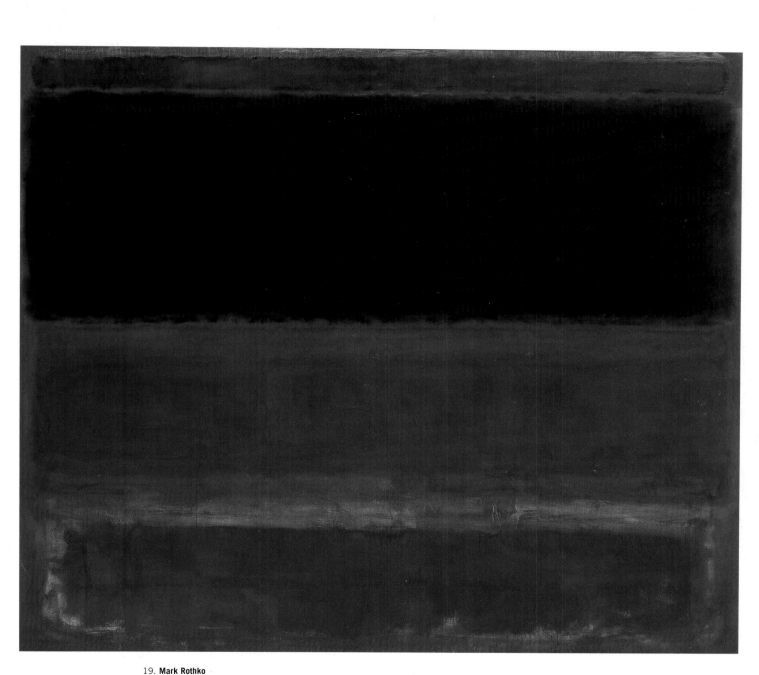

19. **Mark Rothko**
Four Darks in Red, 1958
Oil on canvas, 102 x 116 in.
(259.1 x 294.6 cm)
Whitney Museum of American
Art, New York; Purchase, with
funds from the Friends of the
Whitney Museum of American
Art, Mr. and Mrs. Eugene M.
Schwartz, Mrs. Samuel A.
Seaver, and Charles Simon
68.9

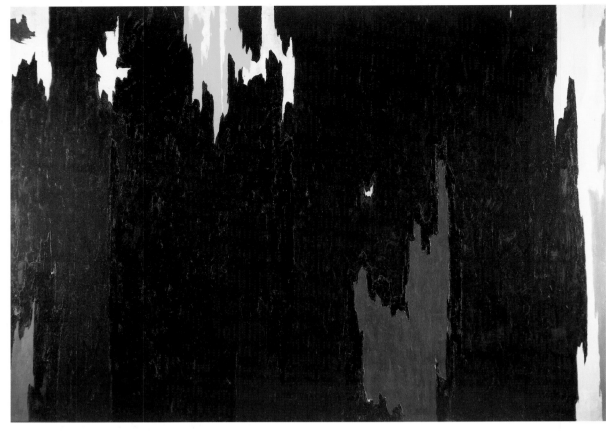

20. **Clyfford Still**
Untitled, 1957
Oil on canvas, 112 x
154 in. (284.5 x 391.2 cm)
Whitney Museum of
American Art, New York;
Purchase, with funds from
the Friends of the Whitney
Museum of American Art
69.31

21. **Philip Guston**
Dial, 1956
Oil on canvas, 72 x 76 in.
(182.9 x 193 cm)
Whitney Museum of
American Art, New York;
Purchase 56.44

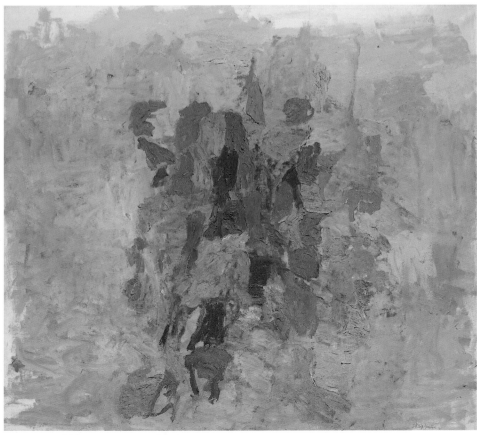

In their search for an American identity, artists found themselves drawn to the dramatic sensations of the American landscape, as they were attracted by its huge scale. It was this scale as well as the emotion-laden imagery of the Abstract Expressionists that suggested to some the eighteenth-century European concept of the sublime—the intermingling of beauty and terror before the majesty of natural phenomena.[20]

The detonation of the atomic bomb at the end of World War II and subsequent nuclear tests conducted throughout the 1950s (fig. 28) may have contributed another, more contemporary dimension to the "sublime." We have already seen how the threat of nuclear extinction produced an existential climate and how sculptors in particular created works with apocalyptic themes. Yet artists were also affected by the beauty of these cataclysmic explosions. The light-emanating works of Rothko, for instance, may refer not only to the magnificence of the natural world but to the threat that science posed to the world's very existence. As technology seemed to be returning humankind to a primal state of mythic awe and vulnerability before the universe,[21] it is no accident that we find this primal condition expressed not just in the overwrought, rough-hewn manner of Action Painting but also in the titles of such Chromatic Abstractions as *Day One* and *The Beginning* (both by Newman), and *Primeval Landscape* (Rothko).

Born of growing confidence, yet tempered by the anxieties of the age, Abstract Expressionism was an art of paradoxical extremes—one that could evoke anger, aggression, fragmentation, and angst—as well as joy, liberation, and lyricism.

Vanguard Art and Cold War Politics

If Abstract Expressionism conveyed both confidence and anxiety, it perfectly mirrored the contradictions and conflicted longings that defined America in the 1950s.

On the positive side, as the economy surged, upward mobility seemed attainable to most Americans. The private home and automobile were the most conspicuous symbols of the new affluence. Suburbs like Levittown, New York (fig. 24) proliferated, and a vast new interstate highway system knit together far-flung forms and cities into one national community. Television also unified the nation, and by the end of the 1950s people would spend more time watching it than they would spend at work (fig. 26). In 1950, only 9 percent of American families owned television sets; by 1960, over 50 million homes (or 87 percent) were receiving images of the good life and American "family values" into their homes.[22] There was another revolution in the home as increasingly affordable modern appliances cut housework in half. The postwar house embodied a golden age of domesticity. A rising standard of living produced more money, more leisure time, and a richer cultural life. The "American dream" seemed to be a tangible reality.

President Dwight D. Eisenhower, who was elected in 1952 and served two terms, watched over this growing economy. His campaign motto was "peace and prosperity," and the public responded with "I like Ike," voting in the first Republican president in twenty years (fig. 27). Under Eisenhower's paternalistic leadership, stability and complacency reigned. His moderation had a powerful appeal to a nation ready for peace and tranquillity. Under his tenure, Americans came to believe that the U.S. economic system was sound and that the capitalist free-enterprise system would provide social harmony and prosperity at home and prestige abroad.

Materialism prevailed and, with it, fantasies of modernization and progress. This was the period of Disneyland Park, drive-in movies, McDonald's, and flamboyant car tail fins (fig. 25). The decade's abundance also produced a more supportive

NEW LANDSCAPES OF DOMESTICITY: THE PRIVATE TRIUMPH OF MODERNITY

American residential architecture and domestic furnishings of the 1950s are, at this turn of the century, the object of an extraordinary revival and nostalgia. The covers of lifestyle magazines have moved from the flounces and fusses of chintz and Wedgwood to the simple lines and once new materials of Florence Knoll's lounge (1954) and Russell Wright's plastic dinnerware. Suburban patterns of life established after World War II are now being redeployed by late twentieth-century city planners; domestic situation comedies of the 1950s can be viewed at any time of day or night on revival television; even Martha Stewart now lives in an important modernist building completed by Gordon Bunshaft in 1962.

This revival can be best understood as a longing for domesticity itself, for it was in 1950s America that the idealized standards of family life that still prevail were established. Indeed, the American postwar house not only encapsulated for many the golden age of domesticity (which never was) but realized European fantasies of modern living that had been developing since the turn of the preceding century. An important exemplar of this private triumph of modernity was the Case Study House Program, initiated by John Entenza, editor of *Arts & Architecture*. Between 1945 and 1966, the journal sponsored the construction of thirty-six middle-class houses intended to serve as prototypes not only for future mass production but for a new mode of domestic life. The houses had open plans which, the architects felt, would promote happier family lives with less reliance on domestic servants; the slick materials used and contemporary "look" of the design were meant to gain a place for these homes in an emerging suburban utopia. Although initially thought of as a regional development local to Southern California and its architects, including Richard Neutra, Charles and Ray Eames, Pierre Koenig, and Craig Ellwood, the program caused a tidal wave in domestic architecture that was felt from Sarasota, Florida, to Sydney, Australia.

The Case Study houses might be profitably seen as wish fulfillments: actualizing the dismantling of barriers between inside and outside, developing new forms of transparency, eliminating Victorian domestic formality, and mobilizing machine production that had been only dreamed of by the "masters" of European modernism. Yet the very success of this program introduced a significant change in the cultural reception of modernity: with the widespread popularity of an architect such as Richard Neutra (fig. 22), who in the postwar period built an enormous number of houses for a broad range of clients and appeared on the cover of *Time* magazine in 1949, this postwar American modernism gave to the avant-garde the character of victor rather than renegade.

An important aspect of this change in cultural status was the way in which the Case Study program—and indeed much of the American domestic apparatus of the period—

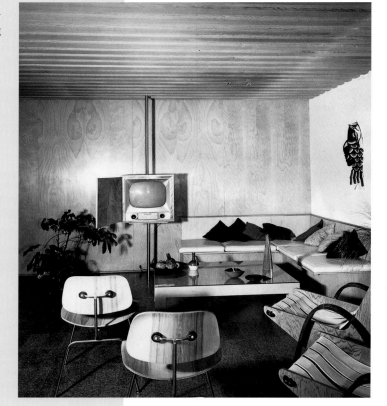

22. **Richard Neutra**
Goodman Residence,
1952, photograph by
Julius Shulman

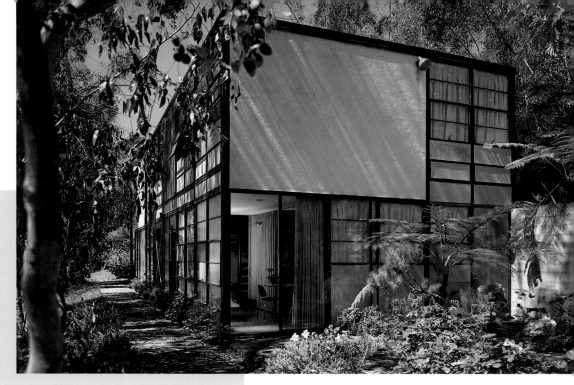

23. **Charles Eames**
*Exterior of Charles Eames
House, Pacific Palisades,
California,* 1949

entered the new and burgeoning logic
of consumer culture. Not only did high
modernist houses incorporate advanced
technologies, as in Raphael Soriano's
steel frame houses or in the increasingly
common use of mullionless, insulated,
large-expanse glass, but they came replete
with an entire menagerie of domestic
technologies, such as televisions, washers,
dryers, refrigerators, and central heating.
This equipment, which perhaps trans-
formed the American house into more of a machine for living than Le Corbusier ever
imagined, was produced by retooling the massive production facilities developed during
the war for civilian use. Military command-and-control techniques were quickly trans-
formed into consumer operations of supply and demand.

While such proliferating creature comforts were readily absorbed into this new eco-
nomic and domestic logic—and are a primary reason for today's nostalgia for the good
life, when TV was free and vacuum cleaners exciting—they propelled architecture into a
new relationship with the marketplace. Instead of being conceived of as permanent and
monumental, houses of the 1950s were expected to last only as long as the mortgage
amortization period; instead of containing attics in which to store family treasures, flat-
roofed and often basementless postwar houses encouraged the acquisition of increas-
ingly disposable goods; and through the invasion of picture windows, television, and
other media, the privacy of the postwar house entered a new and more public arena.

One of the most interesting features of these combined developments is the way in
which they eroded conventional distinctions between high and low culture. The Case
Study Program generated buildings that can be easily assimilated to the category of pro-
gressive modernism; the Eames House of 1949 (fig. 23), for example, was built in a
matter of weeks, was constructed out of prefabricated elements, and rigorously avoided
formal stylization and organization. The same can be said of the millions of ranch-style
houses, of suburban developments based on the model of Levittown, and of trailer
houses—all of which suddenly covered the United States with a promise of happiness.
Most of these structures were in significant part factory-made, incorporated innovative
construction methods, and contained countless domestic machines. The sudden and
seemingly infinite proliferation of these modern houses created a new suburban land-
scape, which in turn generated the possibility of its own critique and hyperextension. In
1955, Walt Disney opened his first theme park, which, like much of the new American
domestic scene, deployed the most advanced devices of modernity, such as mass tran-
sit systems developed for large cities, yet packaged them in rural nostalgia to suggest
that one could simply opt out of the processes of modernization. In this totally para-
doxical environment, apparently private but plugged into the media and markets of the
public realm, the tools of modernism triumphed while being domesticated in new and
still strangely unsettling ways. —S. L.

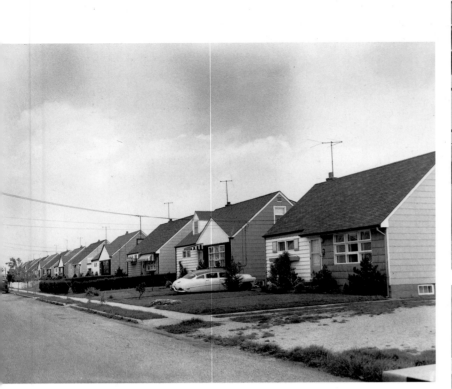

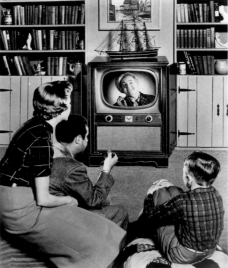

26. *Family Watching TV,*
1950s

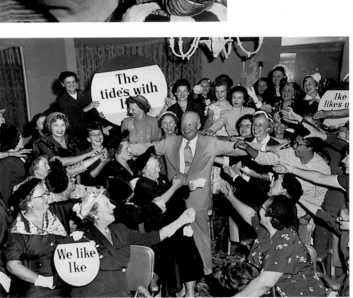

24. *Levittown Houses,*
Long Island, New York,
1954
UPI/Corbis-Bettmann

27. *Gen. Dwight D.*
Eisenhower with Women
from the Republican
National Committee, 1952
UPI/Corbis-Bettmann

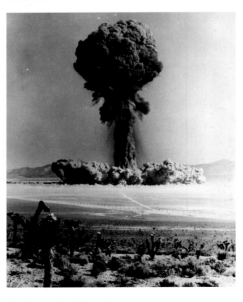

25. *Sleeping Beauty*
Castle, Disneyland Park,
Anaheim, California

28. *Atomic Bomb Explosion*
in Nevada, 1951

environment for art. Framed reproductions of Impressionist works or replicas of Old Master paintings were popular additions in the home. Though the vast majority of Americans remained mistrustful of advanced art and preferred the anecdotal realism of Norman Rockwell or Andrew Wyeth (fig. 59), prosperity and greater disposable income still translated into greater sales for the emerging vanguard.

29. *Cedar Tavern*, New York, 1959 Photograph © Fred W. McDarrah

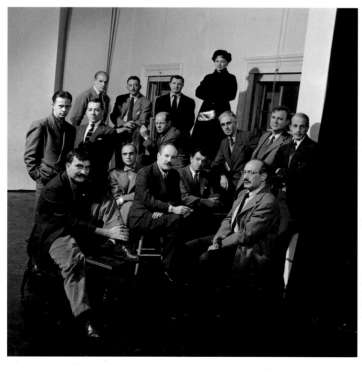

30. "The Irascibles," from *Life*, January 15, 1951, photograph by Nina Leen From left to right, top row: Willem de Kooning, Adolph Gottlieb, Ad Reinhardt, Hedda Sterne; middle row: Richard Pousette-Dart, William Baziotes, Jackson Pollock, Clyfford Still, Robert Motherwell, Bradley Walker Tomlin; bottom row: Theodoros Stamos, Jimmy Ernst, Barnett Newman, James Brooks, Mark Rothko

In response to this growing interest in art, a number of new dealers opened their doors. In New York alone, the handful of thirty respectable galleries at the start of the decade had mushroomed to three hundred by 1960. Visionary dealers such as Sam Kootz, Betty Parsons, and Charles Egan, who had been supporting vanguard artists throughout the forties, were joined by many more, among them Sidney Janis (1948), Tibor de Nagy (1950), Martha Jackson (1952), Eleanor Ward (1953), and Leo Castelli (1957).

The exhibition opportunities brought by the new galleries were further increased by the artists themselves, who met in active groups to discuss mutual concerns. This dialogue peaked in the early 1950s around meetings at the Artists' Club. The Club, located in Greenwich Village, was a forum for lectures and discussions for artists throughout the decade. It had grown out of earlier meetings at Subjects of the Artists, a school founded by Clyfford Still, Mark Rothko, Robert Motherwell, William Baziotes, and David Hare in 1948, where weekly discussions under Motherwell's leadership helped define the New York School. After the meetings, they would go over to the Cedar Tavern, the social epicenter of downtown culture (fig. 29). Protests against the exclusionary practices of The Metropolitan Museum of Art toward contemporary vanguard American art were organized by a group of eighteen painters and ten sculptors (from Studio 35, another short-lived group, formed in 1949). Dubbed "The Irascibles," they garnered attention from the press and credibility as serious contenders (fig. 30).[23]

The growing public interest in art also engendered expanding forums for arts coverage, both in specialized journals and in the mainstream press. Several critics emerged as articulate and powerful spokesmen for this new American vanguard:

Clement Greenberg and Harold Rosenberg, as we have seen, both wrote important defenses of Abstract Expressionism. For the first time, writers with literary credentials were publishing essays about advanced American art for an enlightened public: Greenberg wrote for the *Partisan Review* (mid-1940s) and then *The Nation* (late 1940s); Robert Goldwater became editor of the *Magazine of Art* in 1948; Manny Farber started writing on art for *The New Republic* in 1945; Thomas Hess took over as managing editor of *Art News* in 1948. The arrival of eloquent advocates and serious critical voices championing the new American art was inestimable in widening its sphere of influence. Even the popular press was taking notice of vanguard developments. Often cited examples include *Life* magazine's 1949 article on Jackson Pollock—headlined "Is He the Greatest Living Painter in the United States?"—and a *Vogue* magazine spread photographed by Cecil Beaton where models were posed in front of a drip painting (figs. 31, 32).[24]

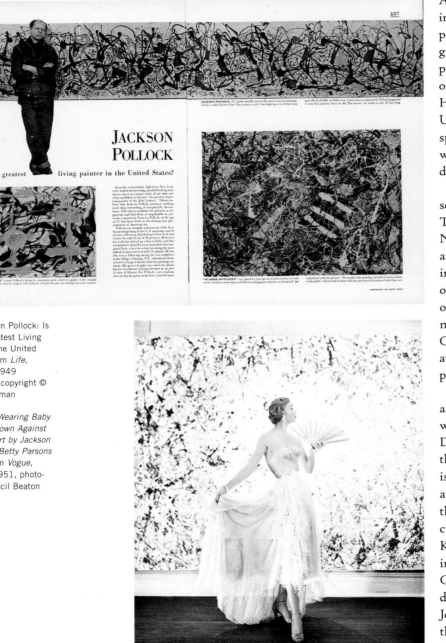

31. "Jackson Pollock: Is He the Greatest Living Painter in the United States?" from *Life*, August 8, 1949 Photograph copyright © Arnold Newman

32. *Model Wearing Baby Blue Ball Gown Against Backdrop Art by Jackson Pollock, at Betty Parsons Gallery,* from *Vogue*, March 1, 1951, photograph by Cecil Beaton

But expansive as the climate for art seemed, it was simultaneously stifling. The vanguard painters and sculptors in New York had banded together partly as a refuge from the prevalent anti-intellectual and chauvinist sentiments of the public at large. The idyllic picture of the 1950s as a time of abundance masks the underlying tensions of the Cold War, which created the stagnant atmosphere of timid conformity that permeated American life.

Conformity was born of fear that all might be lost. Many Americans were still haunted by memories of the Depression, but for most the threats of the postwar era came from Communism and the bomb. Both Communism and nuclear radiation were invisible threats that fomented tensions and insecurities. Mao Tse-tung ousted Chiang Kai-shek's Nationalists in 1949, and installed a Communist government in China; that same year, the Soviet Union detonated an atomic bomb. Senator Joseph McCarthy, who, as a member of the House Committee to Investigate Un-American Activities (HUAC), had conducted a Communist witch-hunt in Hollywood and in the State Department, was at the peak of his popularity in 1950; the Hollywood Ten, who refused to testify before his committee about alleged Communist affiliations or denounce colleagues in the film industry, began serving prison sentences in 1950; and Julius and Ethel Rosenberg, accused of passing nuclear secrets to the Russians, were sentenced to

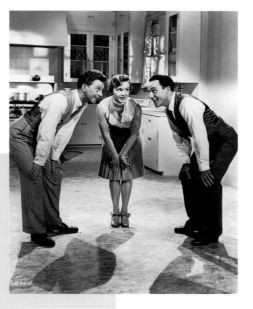

HOLLYWOOD AT TWILIGHT

It was the best of times for America, the worst of times for Hollywood—and a great time for movies. As the nation marched from World War II into unprecedented economic prosperity, fortress Hollywood endured continual assault and barely survived.

No sooner did the House Committee to Investigate Un-American Activities (HUAC) begin to purge suspected Communists from Hollywood in 1947 than the Supreme Court ordered studios to divest themselves of their movie theaters, an antitrust action that dammed up a revenue stream. In 1948, moreover, moviegoers began defecting to television. An unintended result of the GI Bill was that veterans used loans to buy homes in the suburbs, where there were no movie theaters. Yet like many civilizations at twilight, Hollywood's colors shone their most brilliant—literally and figuratively.

To compete with the black-and-white box, movies increasingly were made in color. And to distinguish themselves from that squarish TV frame, movies expanded from portrait to panorama, thanks to new wide-screen processes—all the better to accommodate biblical spectacles such as *Ben-Hur* (1959, William Wyler), musicals such as *Funny Face* (1957, Stanley Donen), and Westerns such as *Rio Bravo* (1959, Howard Hawks).

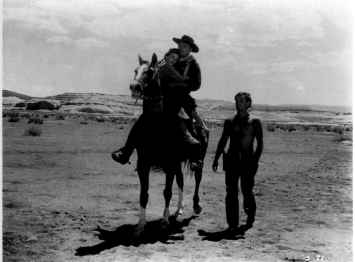

Many of the period's memorable films analogized the end of an epoch. *Sunset Boulevard* (1950, Billy Wilder), *Singin' in the Rain* (fig. 33), and *Splendor in the Grass* (1961, Elia Kazan) each eulogized the twenties. Wilder's Hollywood gothic profiled a silent star (Gloria Swanson) projecting her grand delusions on the walls of her decaying mansion. Kelly's bouncy musical focused on Hollywood's transition from silents to sound. Kazan's drama with Natalie Wood and Warren Beatty showed teens on the cusp of sexuality in a country on the cusp of the Depression. *The Man Who Shot Liberty Valance* (1962, John Ford) and *Cleopatra* (1963, Joseph Mankiewicz) are the ultimate twilight films, one set in the frontier West and the other in the Roman Empire, and mark the last gleaming of great directors. Both star legends (John Wayne and James Stewart in *Valance*, Elizabeth Taylor in *Cleopatra*) and explore the paradox of our need to create legends—and to destroy them.

While worrying about its own extinction, Hollywood produced compelling dramas about human dinosaurs—among them, the aging Broadway diva (Bette Davis in *All About Eve*, 1950, Joseph Mankiewicz), the washed-up Hollywood hoofer (Fred Astaire in *The Band Wagon*, 1953, Vincente Minnelli), and the remorseless bigot (John Wayne in *The Searchers*, fig. 34).

Prewar Hollywood leading men such as Humphrey Bogart, Gary Cooper, and James Stewart continued to play leading roles in the fifties, but Katharine Hepburn was virtually alone among the female icons to make the transition (*The African Queen*, 1951,

33. Gene Kelly, Debbie Reynolds, and Donald O'Connor in *Singin' in the Rain*, directed by Gene Kelly and Stanley Donen, 1952
Courtesy Metro-Goldwyn-Mayer

34. John Wayne, Natalie Wood, and Jeffrey Hunter in *The Searchers*, directed by John Ford, 1956
Courtesy Warner Brothers

death in 1951 (fig. 36). Confidence in the perfectability of American society and paranoia about a Communist threat were two faces of America in the early 1950s.

As the decade progressed, there developed a bipartisan consensus that the Soviet Union remained the chief threat to American security and leadership of the free world. Though fear abated somewhat when Stalin died (1953), the Korean War ended (1953), and McCarthy was censured (fig. 37), doubts rose again when in 1957 the Soviets launched Sputnik, the first satellite to orbit the earth (fig. 38), the Soviets shot down an American U-2 reconnaisance plane, capturing its pilot (1960), and the Berlin Wall was erected (1961). As a pathological fear of Communist infiltration persisted through the Eisenhower years, a pall of intimidation, repression, and conformity descended on America. The complacency and caution that ruled the era compelled writer Norman Mailer to call the fifties "one of the worst decades in the history of man."[25]

During the early years of the Cold War, government patronage of art was revived in an effort to demonstrate to the world that America was not (as the Soviet Union claimed) just a nation of uncultured materialists. Exchange pro-

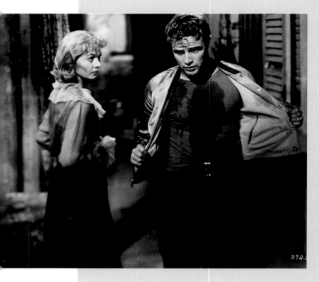

35. Marlon Brando and Vivian Leigh in *A Streetcar Named Desire*, directed by Elia Kazan, 1951
Courtesy Warner Brothers

John Huston; *Pat and Mike*, 1952, George Cukor). Audrey Hepburn and Grace Kelly led the youthquake of actresses enlisted to give sex appeal to the mature actors (*Sabrina*, 1954, Billy Wilder; *Rear Window*, 1954, Alfred Hitchcock). In a nation that had demobilized women from war work to housework, the new movie heroines were aggressively marriage-minded—even the courtesan *Gigi* (1958, Vincente Minnelli).

Compare this essentially conformist, emerging actress type with that of the rebel actor. Marlon Brando, Montgomery Clift, James Dean, and Paul Newman redefined American masculinity in movies where characters defied taboos and authority. Stage-trained, they employed Method acting—triggering personal memories in order to meld emotionally with their characters. These vanguard actors were exploring psychological realism at a time when American vanguard artists were exploring abstraction. This is perhaps coincidental, yet it might be said of Brando in *A Streetcar Named Desire* (fig. 35), of Clift in *A Place in the Sun* (1951, George Stevens), of Dean in *Rebel Without a Cause* (1955, Nicholas Ray), and of Newman in *The Left-Handed Gun* (1958, Arthur Penn) that their performances were actorly Action Paintings, with anxiety splattered instead of pigment. In more directly visual terms, the non-naturalistic color, comic strip composition, and exaggerated sexuality found in Pop Art was also introduced in Hollywood films—in such melodramas as *Written on the Wind* (1956, Douglas Sirk) and *Some Came Running* (1959, Vincente Minnelli) and comedies such as *Gentlemen Prefer Blondes* (1953, Howard Hawks) and *The Ladies' Man* (1961, Jerry Lewis).

Political anxiety about Communism and the bomb erupted in Hollywood films, crossing genre lines to define Westerns, paranoid thrillers, and science fiction. *High Noon* (1952, Fred Zinnemann), an allegory of the HUAC witch-hunt, starred Gary Cooper as a sheriff abandoned by his townspeople when he stands alone against bandits. *Pickup on South Street* (1953, Samuel Fuller) and *Kiss Me Deadly* (1955, Robert Aldrich) feature con men out to profit on smuggled microfilm and a smuggled atomic bomb before each realizes that his self-interest is not in the country's best interests. An earnest film like *The Day the Earth Stood Still* (1951, Robert Wise) preached pacifism, while the paranoid *The Manchurian Candidate* (1962, John Frankenheimer) projected the nightmare of Korean War soldiers brainwashed by Communists to subvert U.S. electoral politics.

Sexual anxiety was a favorite theme of the era's most popular directors, Alfred Hitchcock and Billy Wilder. Hitchcock explored it in psychological thrillers such as *Rear*

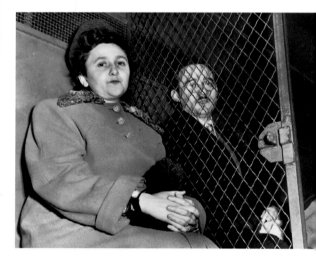

36. *Ethel and Julius Rosenberg Being Transported to Jail After Being Found Guilty of Espionage and Conspiracy, March 29, 1951*, photograph by Sam Schulman
UPI/Corbis-Bettmann

grams were established by the United States Information Agency (USIA), a branch of the State Department, to send American art and artists abroad—what a group of senators called "a worldwide Marshall plan in the field of ideas."[26] However, the atmosphere of anxiety and paranoia that pervaded American culture in the 1940s and the early 1950s made many people suspicious of advanced American art. Modernism in any form was something they could not understand, and ignorance bred fear. One congressional critic considered modern art and all its "isms"— Cubism, Futurism, Surrealism—dangerous enemies that threatened to destroy by "designed disorder," "depravity," and "decadence."[27]

Window and *Vertigo* (1958), haunting studies of impotence and fixation in which lovers lie to each other and bad things happen. Wilder exploded it in comedies such as *Some Like It Hot* (1959) and *The Apartment* (1960), bittersweet bonbons about cross-dressing and attempted suicide in which lovers lie to each other and good things happen.

As the civil rights movement gained momentum during the 1950s and 1960s, Hollywood films addressed race and racism, usually with Sidney Poitier traversing the arc from discrimination to vindication in movies such as *No Way Out* (1950, Joseph Mankiewicz) and *Lilies of the Field* (1963, Ralph Nelson). Desegregation may have been in the headlines, but in thirties-era movies like *To Kill a Mockingbird* (1962, Robert Mulligan), where a lawyer (Gregory Peck) defends a black man (Brock Peters) against rape charges, the courtroom was segregated.

The contemporary concerns of these films, their consistent reflection of the world beyond celluloid, were inadequate weapons in the war against television. In 1963, *Cleopatra* was such a colossal disaster that it nearly sank 20th Century-Fox. The year it was released, only 121 feature films were made in the United States—an all-time low. —C. R.

Waging an assault on modern art, conservative politicians and anti-Communist crusaders joined with aesthetically conservative, representational artists (from such organizations as the National Sculpture Society, the American Artists Professional League, and the National Academy of Design), whose monopoly on official art was being threatened by the growing ascendancy of Abstract Expressionism.[28] Their protests forced the cancellation of several exhibitions abroad planned under the auspices of the USIA: "Advancing American Art" in 1947, which included works by established older modernists such as Stuart Davis and Marsden Hartley, and the later "Sport in Art," intended for the Olympics in Australia in 1956.[29] Right-wing critics objected to any form of social commentary they deemed subversive and to any artists with alleged Communist affiliations. Modern art, in their eyes, was a tool of Communism. The anti-modernist campaign was undertaken by a small but vocal minority who successfully argued that modern art was a deviation from the standard of "Americanism." Ironically, they failed to see that the realism they supported was in fact exactly the style propagated by totalitarian regimes, whether that of the Soviet Union or Hitler's Third Reich, which vehemently rejected all forms of abstraction as degenerate. As Alfred H. Barr, Jr., director of The Museum of Modern Art, pointed out in a 1952 article entitled "Is Modern Art Communistic?," most people were expressing a common dislike by means of a common prejudice: "Those who equate modern art with totalitarianism are ignorant of the facts."[30]

George Dondero, a Republican congressman from Michigan and an outspoken

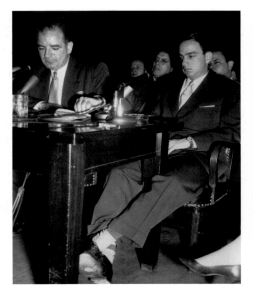

37. *Roy Cohn and Senator Joseph McCarthy During Session of McCarthy-Army Hearing in Washington, D.C.,* 1954

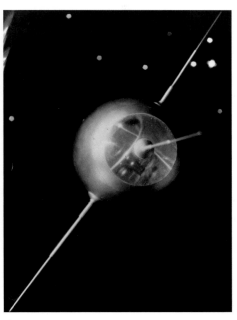

38. *Model of Sputnik,* 1957
UPI/Corbis-Bettmann

foe of Communism, was the most vehement denouncer of modern art.[31] For him, its "distortion, grotesqueness and meaninglessness" failed to glorify our beautiful country; modern art's rejection of traditional ways of seeing form and space was irrational, ugly, and "un-American." Calling such art a subversive instrument of the Kremlin, he demanded that it be banned from publicly supported arts institutions and from federally sponsored cultural exchanges, that exhibitions be suppressed, and that large-scale murals be censored. In an extreme example of paranoia, some people even claimed that abstract paintings were secret maps of strategic U.S. fortifications.[32]

The general public, especially outside of New York, did not oppose the anti-modernist campaign. Traditional-minded Middle America wanted recognizable subject matter—art that reflected reality. Moreover, they suspected that abstract art was too easy to make and thus violated the nation's proud work ethic. At the heart of the objections to modernism, however, was a fear of intellectuals and cosmopolitans, and a desire to eliminate foreign influence and revive traditional values in a period of societal stress. Objections also often

ARTISTIC CENSORSHIP IN COLD WAR AMERICA

Throughout the 1950s and early 1960s, Cold War America was fraught with paranoia: fear of Communist aggression, fear of protest and public unrest, fear of racial and sexual difference. In the world of everyday politics and popular culture, this paranoia focused on the threat of Communism, subjecting celebrities and ordinary citizens alike to congressional witch-hunts, loyalty oaths, and blacklists.

The radical edge of the American avant-garde, a world of iconoclasts and Beatniks committed to pushing the envelope of artistic acceptability and decorum, was particularly vulnerable to the censorious, fear-baiting campaigns of the period. The artistic landscape was teaming with self-appointed cultural watchdogs—members of church committees and parent-teacher associations, Daughters of the American Revolution and American Legionnaires, district attorneys and city councilmen—in search of the abnormal, the nonconformist, and the depraved.

The transgressive, often sexually explicit avant-garde art of the period supplied these crusaders with ample material with which to manipulate the apprehensions of the American public. The most notorious and publicized acts of censorship were often of literary works with overt sexual or homoerotic content: Vladimir Nabokov's *Lolita* (1955), Allen Ginsberg's *Howl and Other Poems* (1956), William Burroughs' *Naked Lunch* (1959), and Henry Miller's *Tropic of Cancer* and *Tropic of Capricorn* (both first published in the United States in 1961). These books, among others, were attacked by political, cultural, and religious leaders as lurid and immoral and were vigorously prosecuted under state and local anti-obscenity and anti-pornography statutes.

Other artistic disciplines were also targeted by censors. The cast and playwright of *The Beard* (1967)—Michael McClure's sexually explicit and passionate fantasy about a meeting between two icons of American culture, Billy the Kid and Jean Harlow—were arrested on pornography charges on nineteen consecutive nights during the show's Los Angeles engagement. Kenneth Anger's film *Scorpio Rising* (1963) was deemed obscene by a court in Los Angeles, while Jonas Mekas was prosecuted in New York for publicly screening Jack Smith's *Flaming Creatures* (1963). The artist Wallace Berman was arrested and convicted in 1957 for exhibiting "pornographic" work at the Ferus Gallery in Los Angeles (fig. 39). And the comedian and monologist Lenny Bruce was arrested nearly twenty

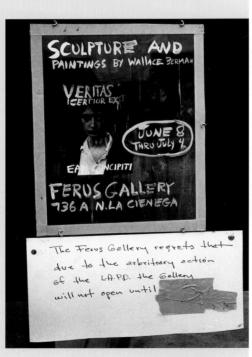

39. *Ferus Gallery Notice*, 1957, photograph by Charles Brittin

40. *Lenny Bruce Being Arrested on Narcotics Charge*, February 23, 1963

masked homophobia, anti-Semitism, and resentment toward "newly made Americans"—"polyglot rabble" and "effeminate elite" from Harvard sent out to run our cultural institutions were typical "slurs" of the day.[33]

By mid-decade, such strident views had become less fashionable. Senator McCarthy had been censured by Congress in 1954, and anti-Communism, while never far below the surface, became less hysterical. President Eisenhower's calm, middle-of-the-road demeanor also contributed to a spirit of moderation. In this spirit, the public grew more tolerant of modern art and came to believe that the flourishing of avant-garde art and culture was the mark of a liberal, democratic society. Indeed, at decade's end, the same art once lambasted by conservative forces as anti-American was being held up as a symbol of capitalist liberty, freedom, and the American way of life. By the late 1950s and early 1960s, Abstract Expressionism was celebrated as a quintessentially American form, the embodiment of the kind of personal freedom of expression denied artists behind the Iron Curtain.[34] For the first time, modernism and America were linked, the one nurtured by the free society of the other.

In both America and Europe, the pace of exhibitions devoted to advanced American art quickened, and advocates—dealers, critics, curators, and museum directors—successfully promoted the iconoclasm of the new art as innovation. Europeans had increasing opportunities to view Abstract Expressionism as the fifties progressed: Abstract Expressionist works were exhibited at Venice Biennales; and several American exponents of New York School aesthetics were living in Paris on the GI Bill—Al Held, Ellsworth Kelly, and Sam Francis, among others (figs. 42, 43, 54). But the most influential encounters that Europeans had with Abstract Expressionism took place through The Museum of Modern Art's traveling exhibitions.[35] By 1958, the museum had become America's unofficial cultural ambassador, exporting

times on obscenity charges, arrests that resulted in devastating publicity and canceled performances, ultimately ending his career (fig. 40).

The outlook for defendants in these censorship prosecutions was not always grim, however. While some obscenity cases of the period ended in conviction, others—like the infamous San Francisco obscenity trial of *Howl*'s publisher, Lawrence Ferlinghetti, and bookstore clerk Shigeyoshi Murao in the summer of 1957 (fig. 41)—found a sympathetic judge or juries who chose to affirm the right of free expression under the First Amendment rather than banish art that some people found offensive or blasphemous.

The badgering, shrill rhetoric of Cold War crusaders was reminiscent in both tone and content of the Nazi campaigns against avant-garde and progressive art—or degenerate art, as they called it. The Cold Warriors similarly held up offending culture as a model of social depravity and pathology. But of all the "crimes" against nature and God monitored by the censors of the period, homosexuality was perhaps the most egregious. The widespread homophobia of the day often served as a convenient tool for discrediting cultural enemies. Many errant artists, such as Ginsberg, Anger, Smith, and Burroughs, were attacked for the gay content of their work. Even heterosexual artists

were transformed by censors into handmaidens of a gay conspiracy. McClure and Bruce, for example, were prosecuted for violating laws specifically designed to criminalize gay sexuality even though the work in question had no homosexual content. It was not just the fear of gays, however, but the fear of difference in general that fueled the forces of reaction: the presence of interracial couples, libidinous women, extramarital sex, or explicit sexuality of any kind in a work of art could render it suspect or unhealthy in the repressive atmosphere of Cold War America. —M. B.

41. *Lawrence Ferlinghetti and Shigeyoshi Murao at the Obscenity Trial for Allen Ginsberg's* Howl and Other Poems, 1957

exhibitions of works from its collection around the world through its International Program, initiated with a grant from the Rockefeller Brothers Fund in 1952.[36]

The European response to Abstract Expressionism was at first mixed. It was a shock for Europe to be on the receiving end of an aesthetic—especially one being

42. Al Held
Taxi Cab I, 1959
Acrylic on paper mounted on canvas, 107½ x 146¼ in. (273 x 371.5 cm)
Robert Miller Gallery, New York
©Al Held/Licensed by VAGA, New York, NY

43. Ellsworth Kelly
La Combe I, 1950
Oil on canvas, 38¼ x 63¾ in. (97.2 x 162 cm)
Private collection

THE NEW MONUMENTALITY IN ARCHITECTURE

Although today we have come to see the dynamic surfaces of the modernist "glass box" in its various forms as a profoundly expressive medium, in the 1940s the international architectural community was debating the capacity of such surfaces to reflect cultural specificity and establish civic identity. In 1943, this anxiety produced an influential essay by José Louis Sert, Fernand Léger, and Siegfried Giedion entitled "Nine Points on Monumentality." This polemical text declared that "people want the buildings that represent their social and community life to give more than functional fulfillment."

The effects of this essay, composed while the three European authors were living in New York during World War II, were most strongly felt in the resurgence of the monumental forms and expressive materials of public buildings of the late 1950s and early 1960s. A work such as Louis Kahn's Salk Institute (1959–65), although still wedded to traditional modernist interests in new technologies and in the rejection of explicit historical references (which would come to define monumentality in the 1980s), took on the task of giving communal life a symbolic center and distinctive icon. At the Salk Institute, Kahn used symmetry, hierarchical massing and solid materials to reconnect architecture to an apparently eternal ideal. Moving away from the gridded abstractions of the International Style, Kahn sought to infuse architecture with the psychic richness of Jungian archetypes.

Architects were not all equally convinced by Kahn's mystical thinking: Eero Saarinen's TWA Terminal of 1956–62 at Idlewild (now John F. Kennedy) Airport in New York (fig. 44) is as monumental and as concerned with symbolic value as Kahn's Jewish Community Center in Trenton, New Jersey (1954–59), but Saarinen pursued a less hierarchically determined formalism. Nevertheless, many architects shared an interest in obscuring corporate modernism's fantasies of weightless transparency with the heavy roughness and plasticity of concrete. Frederick Kiesler's second project for the Endless House (fig. 140), Paul Rudolph's Yale Art and Architecture Building (fig. 45), Frank Lloyd Wright's Guggenheim Museum (1956–59), and Paolo Soleri's Earth House (1959) all explore the poetic potential of this dense yet malleable material.

Despite the sentimental rhetoric of sensitivity to place and community that often inflected the critical literature, the neomonumental work of this period also reflected the needs and structures of the developing Cold War. These massive structures, particularly popular with American embassies such as Edward Durell Stone's U.S. Embassy in New Delhi, India (1954), were politically defensive and culturally aggressive. Indeed, the new monumentality would make architecture into a primary weapon in the Cold War, which, especially under President Kennedy, was largely fought on the cultural battlefield as America sought to add discriminating respectability to economic dominance. —S. L.

44. **Eero Saarinen and Associates**
TWA Terminal at Idlewild Airport (now JFK Airport), Queens, New York, 1962, photograph by Ezra Stoller © Esto. All Rights Reserved

45. **Paul Rudolph**
Yale Art and Architecture Building, New Haven, Connecticut, 1957–63

sent by a prosperous America at a time when the economies of most European countries had not yet recovered from World War II. In Paris, some decried American "gigantism," brash conceit, and emptiness; others tried to diminish Abstract Expressionism by calling it derivative of French mainstream art, from Surrealism to Art Informel.[37]

Arshile Gorky was derided as "Miró without flavor" and Pollock as a producer of "endpapers." *The London Observer* attributed to Pollock and de Kooning "an air of impermanence" and noted that American works suggested "a prevailing uneasiness." "More often inquisitive than truly creative, exploiting the bizarre, the eerie, or novel, most of these artists seem to reflect the character of a continent at once inquiring, energetic, assertive, and ill at ease"—the critic here pinpointing the conflicting sense of confidence and anxiety of America in the 1950s.[38]

46. **Alfred Leslie**
Big Green, 1957
Oil on canvas, 146 x 139⅝ in. (370.8 x 354.6 cm)
Whitney Museum of American Art, New York; Gift of the artist 95.259a-d

The most important of The Museum of Modern Art's exhibitions was "The New American Painting," which toured Europe in 1958–59, showcasing the leaders of Abstract Expressionism. A Pollock retrospective opened in Rome in March 1958 and then traveled throughout Europe; Abstract Expressionist canvases were seen at the Brussels World's Fair in 1958 and at Documenta II (1959), the second of the internationally organized exhibitions still held every four years in Kassel, Germany. Documenta II focused on art made after 1945 and had a strong representation of American art. Moreover, the semi-official nature of the show was instrumental in winning acceptance for Abstract Expressionism. By the end of the 1950s, the tide of European critical reaction began to turn.

No longer able to deny that cultural supremacy had shifted to New York, Europeans reluctantly admired the American commitment to freedom and uncompromising individualism. In addition, a small but influential group of European museum directors, collectors, and critics began championing the new American painting—directors like Arnold Rüdlinger of the Kunsthalle Basel, the British critic Lawrence Alloway (who would soon move to New York), and the collectors E. J. Power, the German chocolate magnate Peter Ludwig, and Count Giuseppe Panza di Biumo, who began to make regular trips to galleries and studios in New York in 1956.

To its admirers in both America and Europe, Abstract Expressionism, with its improvisational gestures, epic scale, and intensely subjective emotion, symbolized the power of individual liberty in a democratic society. The artists themselves,

however, were uninterested in politics, preferring to embrace private or universal values. Clyfford Still wrote, "It has always been my hope to create a free place or area of life where an idea can transcend politics, ambition, and commerce."[39] This proved a utopian sentiment. The claim that they were free from ideology only made their art function more effectively as propaganda for various political agendas.

The Second-Generation New York School and Beyond

The supposed freedom of Abstract Expressionism from political and social values was one of the myths that grew up around the art. Another was the perception that the art created under the Abstract Expressionist rubric was a unified enterprise. We have already seen that it encompassed varied approaches to form and materials. The second generation of New York School artists, following in the footsteps of the pioneers, similarly fall into diverse groups: the gesture painters loyal to de Kooning and Kline (Joan Mitchell, fig. 53; Alfred Leslie, fig. 46); Richard Diebenkorn (fig. 62); the stainers (Helen Frankenthaler, fig. 69; Morris Louis, fig. 47; Sam Francis, fig. 54), who were inspired by Pollock's unprimed canvas permeated with paint; and a group of artists who used impressionist brushstrokes to capture the effects of natural light (among them Philip Guston, fig. 21). It should be noted that The Museum of Modern Art's 1955 acquisition and exhibition of Monet's *Water Lilies*, one of the masterpieces of French Impressionism, significantly contributed to this last trend. Until the light-filled monumental canvases went on display in New York, Monet's late work had been derided. Now artists such as Barnett Newman lauded it as revolutionary, giving rise to the term "Abstract Impressionism" to describe the works of Guston or Mitchell.[40]

This second generation of Abstract Expressionists comprised younger artists

47. **Morris Louis**
Iris, 1954
Acrylic on canvas, 80¾ x 106¾ in. (205.1 x 271.1 cm)
Collection of Barbara Schwartz

who were pouring into New York from around the country, often right out of art schools, which they had attended under the GI Bill. They felt they had to go to New York—now the recognized center of the art world—to fraternize with the masters, get a show downtown, and eventually be taken on by an uptown gallery.

48. *View of 10th Street Looking East from Fourth Avenue*, 1960
Photograph © Fred W. McDarrah

49. *View of Louise Bourgeois' studio*, 1953
©Louise Bourgeois/ Licensed by VAGA, New York, NY

Several of them formed their own co-op galleries, many on or near 10th Street (such as the Tanager and the Hansa), the geographic center of New York's downtown artists' neighborhood (fig. 48).[41]

But Abstract Expressionism was often diluted in the hands of its successors. Even by the time of Pollock's death, in 1956, it was clear that much of Abstract Expressionism had become stale and academic and was spawning hordes of imitators. Complaints about mannerism and a "new academy" were the subject of a controversial session at the Artists' Club in the spring of 1959. And in the early sixties, after the original Cedar Tavern closed, the Club was dissolved. The first generation was uneasy, struggling with the contradictions inherent in its success, and its members retreated.

Arguments about quality aside, one of the most important contributions made by the second generation was a new tolerance for a variety of aesthetic approaches, from figuration to pure abstraction to collage—and no less an openness to artists of color, among them Norman Lewis, Beauford Delaney, Romare Bearden, and Bob Thompson (fig. 57), and to women. The first-generation Abstract Expressionists had been a boys' club; in photographs of their meetings, few women are ever present (fig. 30). Plenty of first-rank artists, such as Louise Bourgeois (fig. 49), suffered for years because of the male orientation of the vanguard art world. Bourgeois had been making abstract *personnages* since the forties—totemic figures carved in wood and sometimes painted, which she clustered together, creating sensual, mysterious environments. Lee Krasner, like Bourgeois, had been there from the beginning, but received only belated recognition—a problem exacerbated by

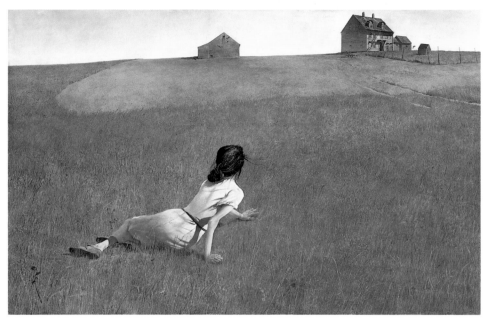

59. **Andrew Wyeth**
Christina's World, 1948
Tempera on panel,
32¼ x 47¾ in. (81.9 x
121.3 cm)
The Museum of Modern
Art, New York; Purchase

60. **Edward Hopper**
People in the Sun, 1960
Oil on canvas,
40⅜ x 60⅜ in. (102.6 x
153.4 cm)
National Museum of
American Art,
Smithsonian Institution,
Washington, D.C.;
Gift of S.C. Johnson &
Son, Inc.

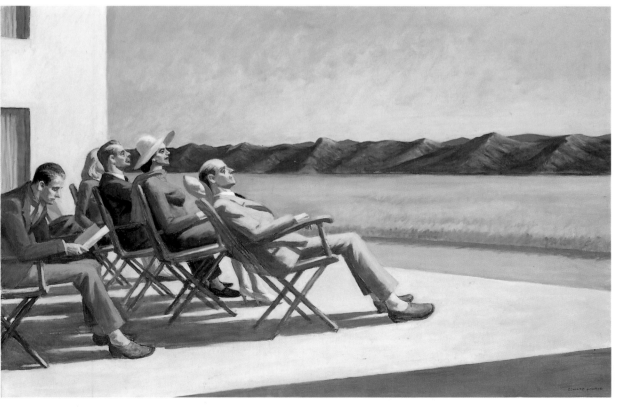

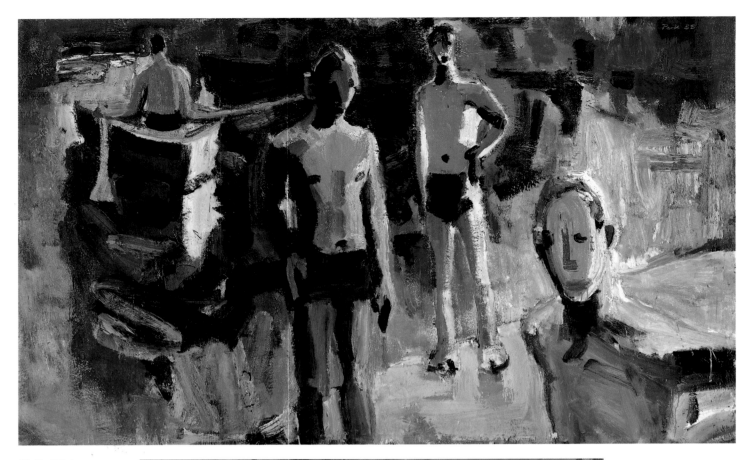

61. **David Park**
Four Men, 1958
Oil on canvas, 57 x 92 in.
(144.8 x 233.7 cm)
Whitney Museum of
American Art, New York;
Purchase, with funds from
an anonymous donor
59.27

62. **Richard Diebenkorn**
Girl Looking at Landscape,
1957
Oil on canvas, 59 x 60¼ in.
(149.9 x 205.7 cm)
Whitney Museum of
American Art, New York;
Gift of Mr. and Mrs. Alan H.
Temple 61.49

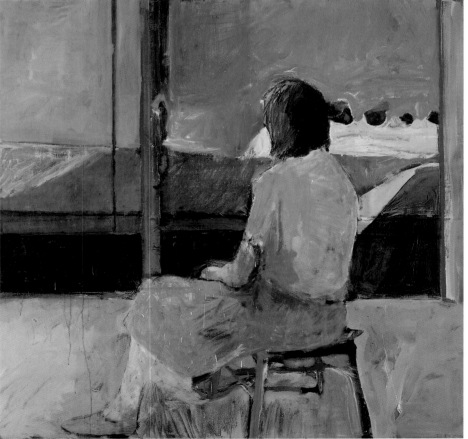

ensuing decades (fig. 63). Like other Chicago artists, he communicated the irrationality and baser instincts of human behavior through crusty surfaces and rendered the body as distorted or mutilated—a penchant for pictorial violence that earned the group the label Monster Roster.

By the mid-1950s, art communities in major urban centers such as Los Angeles, San Francisco, and Chicago had expanded to include a yeasty brew of jazz musicians, poets, independent filmmakers, performers, and photographers—a multidisciplinary mix that encouraged artists to cross boundaries and experiment with other media. As a new era of hybridity loomed, mainstream defenders of modernism clamped down to ensure that the traditional boundaries were preserved. Clement Greenberg, the critic who had championed Pollock early on and whose opinion had been ratified by Pollock's subsequent acclaim, had in 1940 given another verdict in support of his formalist credo: that every art form must be true to its particular properties. In the case of painting, this meant attention to the irreducible elements of surface, edge, color, and shape. Any reference to the outside world was prohibited.[44]

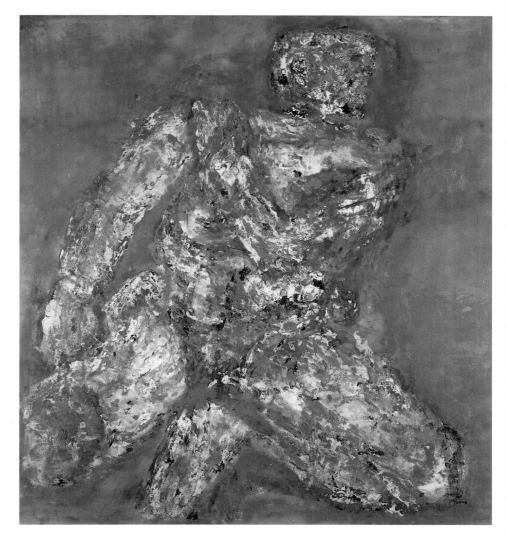

63. **Leon Golub**
Fallen Warrior (Burnt Man),
1960
Lacquer on canvas, 81 x
73 in. (205.7 x 185.4 cm)
Collection of Mr. and Mrs.
Ulrich Mayer

In the 1950s, the austere, nonreferential work of Clyfford Still, Mark Rothko, Ad Reinhardt, and particularly Barnett Newman proved useful to Greenberg's line of thinking. These artists, who had never really fit into the categories of Abstract Expressionism and Action Painting, became, at the end of the fifties, exemplars of an alternative to expressionist abstraction. They offered a way out of de Kooning-style imitations—while still adhering to the abstract mode. Their kind of painting had no self-revelatory brushstrokes, and the most ascetic work approached monochromes. It was said that "Newman had closed the door, Rothko had pulled down the shades, and Reinhardt had turned out the lights"—a statement that created a vivid image for their reductive process.[45]

Newman, who had his first show in 1950, at the Betty Parsons Gallery, was a well-known speaker and provocateur at the Artists' Club. He was more valued for his ideas than for his canvases of single, unmodulated colors punctuated by a few vertical lines of contrasting color—"zips," as he called them (fig. 67). His work had been somewhat neglected during the fifties, but was resurrected when Clement Greenberg arranged for a show in 1959 at French and Co. and praised Newman's painting for its formal simplicity, rigor, and transcendent capacity. His work prefigured much of the classic hard-edge and geometric abstraction that was developed

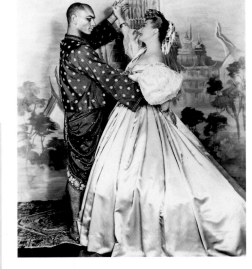

AMERICAN THEATER IN TRANSITION

The 1950s marked an important transitional period for the American theater. At the decade's start, Broadway was in the doldrums, both aesthetically and economically, and vital theatrical activity came more and more to be centered Off-Broadway, the home of the theatrical avant-garde of the period, and outside of New York City.

Broadway fare of the fifties, however, did include some significant new plays, such as the realist dramas by Arthur Miller and Tennessee Williams, who had established their reputations in the preceding decade. Their respective careers burgeoned in the 1950s. Miller's *A View from the Bridge* (1955) is a tragic family drama set in working-class Brooklyn, while *The Crucible* (1953) employs the Salem witch trials as a metaphor for the anti-Communist "witch-hunts" being conducted by the House Committee to Investigate Un-American Activities. *Cat on a Hot Tin Roof* (1955), a Southern gothic family drama, was Williams' most successful realist play, unlike the more experimental, expressionistic *Camino Real* (1953). The emphasis on realism, family themes, psychological complexes, and sexual tension found in Miller's and Williams' work was also apparent in the plays of William Inge, among them *Come Back, Little Sheba* (1950) and *Picnic* (1953), which dwell on the psychological destructiveness of repressed sexuality.

The majority of Broadway productions during the 1950s, however, tended toward escapism rather than realism: light comedies; historical dramas; prestige productions of classical, Shakespearean, or European plays featuring famous actors; and musicals. Indeed, the 1950s were great years for the American musical. The decade began with the Pulitzer Prize-winning *South Pacific* (1950) and saw the premieres of *Guys and Dolls* (1951), *The King and I* (fig. 64), *Damn Yankees* (1956), *My Fair Lady* (1957), *The Music Man* (1958), and *The Sound of Music* (fig. 65).

The dominant acting style at the beginning of the fifties was the "grand manner," which emphasized elocution over emotion. Later in the decade, a more realistic acting style known as the Method achieved a strong presence, largely through the influx of younger actors trained at universities and in the New York acting

studios by followers of the Russian acting theorist Konstantin Stanislavski, on whose teachings various versions of American Method acting were based. It was this form of acting, practiced in the realist dramas of Miller, Williams, and Inge, that led American theater of the 1950s to be stereotyped—however falsely—as the playground of self-indulgent, introspective, so-called Method actors, whose commitment to psychological truth over theatricalism supposedly led them to mumble their way through performances.

The emergence of Off-Broadway and regional theaters during this period had a lasting impact on the American theater. Traditionally, the American theater was centered in

New York City; other regions were served by road companies of Broadway productions. By the Depression, however, touring companies had lost their economic viability, and audiences outside of New York had little opportunity to see live theater. This gap was filled by the establishment of regional theaters in such cities as Houston, San Francisco, and Washington, D.C. In some instances, the adventurousness and quality of their productions far exceeded those of Broadway, and they attracted considerable critical attention.

Off-Broadway originated in the late 1940s when actors and directors in New York City began to create employment opportunities by starting their own theaters. During the 1950s, such theaters prospered to the point where far more productions were presented Off-Broadway than on. Yet Off-Broadway was more a complement to Broadway than an alternative, serving primarily as a training ground for young theater professionals and a showcase for plays without the commercial appeal to sustain a Broadway run. Joseph Papp's New York Shakespeare Festival, which would become one of the most important Off-Broadway institutions, mounted its first production in 1955. In a pattern that developed during the 1950s and persists to this day, successful productions frequently moved from regional or Off-Broadway theaters to more commercial Broadway venues.

The real theatrical avant-garde of the 1950s existed on the fringes of Off-Broadway. Reacting against the trend toward realism in the American theater, both the Living Theater (founded in 1951) and the Artists' Theater (founded in 1953) were initially devoted to the revival of poetic drama in a European style (although the Living Theater went on to become one of the most notorious radical theater troupes of the 1960s). The two theaters produced plays by established literary figures such as Gertrude Stein, Wallace Stevens, W. H. Auden, Jean Cocteau, and William Carlos Williams, among others, and invited younger American writers and poets to try their hand at playwriting. Julian Beck, who founded the Living Theater with Judith Malina, had been an Abstract Expressionist painter and wanted to produce theater that would emulate postwar innovations in the visual arts and music. The 1959 production of Jack Gelber's *The Connection* (fig. 66), which ran for three years, was one of the few theatrical manifestations of the Beat sensibility—it even included a live bebop jazz band in its cast.

The Artists' Theater was affiliated with an art gallery, the Tibor de Nagy Gallery. John Bernard Myers, director of the gallery, wanted to bring the literary and visual arts together in theatrical productions written by poets and designed by artists. Among the poets who contributed plays to the Artists' Theater were Frank O'Hara, James Schuyler, John Ashbery, Kenneth Koch, and James Merrill. Participating artists included Larry Rivers, Nell Blaine, Grace Hartigan, and Elaine de Kooning. The provocative work produced by these and other poets' theaters—and their almost underground cultural status—anticipated the Off-Off-Broadway theater of the 1960s. —P. A.

66. *The Connection*, by Jack Gelber, directed by Judith Malina, 1959
Living Theater Archives

67. **Barnett Newman**
Day One, 1951–52
Oil on canvas, 132 x
50¼ in. (335.3 x
127.6 cm)
Whitney Museum of
American Art, New York;
Purchase, with funds from
the Friends of the Whitney
Museum of American Art
67.18

in the late 1950s and 1960s by such artists as Ellsworth Kelly, Frank Stella, and Agnes Martin.

Similarly, the formal rigor of Ad Reinhardt's austere monochromatic paintings, begun in the fifties, was a source of inspiration to younger artists (fig. 68). These include his Black paintings—composed of square areas of different shades of black—which are impossible to perceive fully in reproduction and should be experienced directly (fig. 68). Reinhardt, like Newman, wrote extensively (and created wonderful cartoons and genealogical charts of the contemporary art world), penning such dictates as the "Six No's" of art or the "Twelve Technical Rules": no texture, no brushwork, no drawing, no forms, no design, no colors, no light, no space, no time, no size or scale, no movement, no subject. Reinhardt's philosophical starting point was "art begins with getting rid of nature."[46]

68. **Ad Reinhardt**
Abstract Painting, Blue, 1953
Oil on canvas, 50 x 28 in. (127 x 71.1 cm)
Whitney Museum of American Art, New York; Gift of Susan Morse Hilles 74.22

In the 1950s, Greenberg also started to support a group of artists who he felt were extending the possibilities Pollock had presented in his drip paintings by merging material and support.[47] These artists—Helen Frankenthaler, Morris Louis, and Kenneth Noland—were the leading practitioners of what is called Color Field painting, or stain painting, as it was also known. They poured and brushed thinned paint directly on unprimed canvas so that it would penetrate, creating a watercolor effect with normally opaque oil or acrylic paint.

Frankenthaler was the first to exploit this technique, and Greenberg responded enthusiastically to it during a studio visit in 1953. He brought Noland and Louis over to view the work, and after seeing her *Mountains and Sea* (fig. 69), they began their own stain paintings. Encouraged by their critic and mentor, these artists continued to stain increasingly large-scale canvases, using a variety of procedures. Noland employed the repeated images of targets, chevrons, and stripes to explore color and opticality (fig. 70). Louis poured layers of paint into vaporous "veils"; later, in his Unfurled series, he expanded the width of his canvases, stretching the pictorial expanse beyond the field of vision.

The Color Field painters were popular and well received. Their work was lyrical and decorative, which may explain why it soon found a comfortable home in

69. **Helen Frankenthaler**
Mountains and Sea, 1952
Oil on canvas,
86⅞ x 117¼ in.
(220.6 x 297.8 cm)
Collection of the artist;
On loan to the National
Gallery of Art, Washington,
D.C.

corporate headquarters and government buildings. This purportedly advanced abstract art was far less threatening in the early sixties than art with obvious content and subject matter.

Greenberg fiercely defended his purist position. He was less perceptive than he had been with Abstract Expressionism, however, and his pronouncements became increasingly formulaic, exclusionary, and dogmatic. His authoritative declarations nevertheless propelled a new generation of critics in the sixties, many of whom would rigorously and zealously defend their positions with an unparalleled moral fervor. Greenberg's hard line was provoked in part by what he saw as an impending crisis—the threat of popular art invading and polluting the domain of "high" or "pure" art.

70. **Kenneth Noland**
Song, 1958
Synthetic polymer on canvas, 65 x 65 in. (165.1 x 165.1 cm)
Whitney Museum of American Art, New York; Purchase, with funds from the Friends of the Whitney Museum of American Art 63.31
©Kenneth Noland/ Licensed by VAGA, New York, NY

Redefining the American Dream 1950–1960

Truth Tellers and Rebel Angels

The "impurities" that disturbed Clement Greenberg were already apparent in Pollock's work, as the young artist Allan Kaprow was quick to recognize: "Pollock . . . left us at the point where we must become preoccupied with and even dazzled by the space and objects of our everyday life, either our bodies, clothes, rooms, or if need be, the vastness of 42nd Street."[48]

Kaprow's advocacy of what can be called street-level realism reflects another take on America in the 1950s. If many Americans seemed to be realizing the American dream, others either could not grasp it or did not care to. Groups that fell outside of consensus culture had different values and a different vision that eventually redefined the American dream. This was the period in which civil rights protests set the groundwork for the cultural revolution of the 1960s: boycotts against racial segregation in Montgomery, Alabama (fig. 71); the emergence of Martin Luther King, Jr., as a civil rights leader; protests against school segregation in Little Rock, Arkansas (fig. 72).

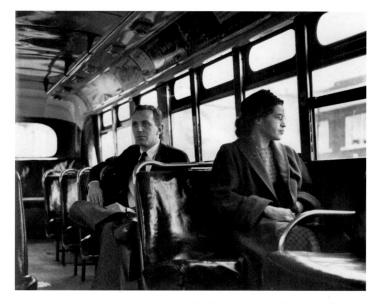

71. *Rosa Parks Sitting in the Front Seat of a Montgomery, Alabama, Bus After Supreme Court Ruling Banning Segregation on the City's Public Buses*, 1956
UPI/Corbis-Bettmann

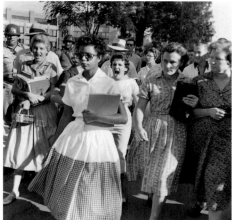

72. *Elizabeth Eckford, Age 15, One of Nine Black Students Whose Admission to Central High School in Little Rock, Arkansas, Was Ordered by a Federal Court, Following Legal Action by NAACP Legal Defense Fund Attorneys*, 1957
UPI/Corbis-Bettmann

As dissident voices gathered force, they were bolstered by an explosion of youth culture. By the end of the 1950s, the baby boomers born shortly after World War II were swelling the ranks of teenagers. Before the war, teens had often worked on the farm or in other family businesses. In the affluent fifties, they had more leisure time, education, and money to spend. Teenagers were becoming important consumers, enjoying jive, junk, and jazz music, and fast cars. They also began to investigate adult activities such as drinking and sex at an earlier age, the latter made more accessible through skin magazines like *Playboy*, which started publication in 1953. But teenagers also took part in important civil rights boycotts, and it was a group of African American teenagers who, in 1957, forced the issue of school integration by walking into segregated Central High School in Little Rock.

Teen role models were also polarized. While some teens bought into the clean-cut Ozzie and Harriet or Mouseketeer image broadcast on television, others were identifying with young literary protagonists such as Holden Caulfield in J. D. Salinger's *Catcher in the Rye* (1951), young rebels like Marlon Brando in *The Wild One* (fig. 73) and James Dean in *Rebel Without a Cause* (fig. 74), the gyrating rock 'n' roller Elvis Presley, who debuted on TV's *Ed Sullivan Show* in 1956, and Allen Ginsberg and Jack Kerouac, the cool nonconformist Beats. These youthful heroes—or anti-heroes—defined the restlessness and dissatisfaction that American youth felt toward the status quo.

In an age that brought us David Riesman's *The Lonely Crowd* (1950), an examination of suburban conformity that introduced new terms for social alienation,

73. Marlon Brando in
The Wild One, directed by
Stanley Kramer, 1954

74. *James Dean*, 1950s

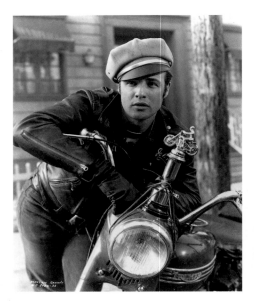

75. Cover of *Free Jazz*, by
the Ornette Coleman
Double Quartet, featuring
Jackson Pollock's *White
Light* (1954)
Atlantic Records, 1960

76. **Ray Johnson**
Elvis Presley #2, 1957
Collage, 15⅜ x 11½ in.
(39.1 x 29.2 cm)
Collection of William
Wilson

William H. Whyte's *The Organization Man* (1956), a commentary on the sacrifice of individuality for corporate norms, and Vance Packard's *The Hidden Persuaders* (1957), a critical dissection of advertising and consumerism, a large segment of a new generation was understandably "sickened on the inside and rebellious on the outside at having seen human existence being squeezed into organized molds of conformity."[49] Many artists, musicians, and writers gave strong voice to these concerns about timid conformity by creating art that offered another American reality—the radical experiments of free jazz (fig. 75), the emergent sounds of rock 'n' roll, and the openly gay lyrics of Beat poetry. In this revisionist spirit, the liberal Greenwich Village newspaper *The Village Voice* began publication.

ROCK 'N' ROLL: THE CRAFT BEHIND THE CRAZE

Bold, brash, and uncompromised music was the soundtrack to American life in the 1950s. Jazz musicians broke free from conventional forms to find a level of self-expression unheard-of in popular culture. The segregated genres of rhythm & blues and country & western fused to form rock 'n' roll. And the idea of the "teen" wreaked havoc in the social structure of the country. It was as if all the energy spent and lost in World War II had come home to roost with a vengeance—fueled by fast cars, cheap electricity, affordable middle-class housing, and the explosion of radio, television, and portable record players.

But there is also another story here, more obscure, but perhaps as significant. Using techniques intrinsic to the recording studio like multitracking and electronic manipulation of sound such as reverberation, popular music began to evolve from merely capturing low fidelity folk performances to sophisticated sonic compositions that manipulated, edited, and altered what was played. This was both a technological advance that permitted high-fidelity recordings for the first time and an artistic achievement in the hands of certain performers and producers who took advantage of recording methods unavailable before.

In 1954, Sam Phillips was a struggling music producer with a label in Memphis, Tennessee, called Sun Records. He had been recording local blues legends like B.B. King, Howling Wolf, and Junior Parker for a few years. According to legend, he boasted, "If I could find a white performer who could sing like [them] I'd make a million dollars." As fate would have it, a young man named Elvis Presley walked into the studio shortly thereafter to cut a record for his mother (fig. 78). Phillips' secretary overheard his voice and suggested that they record Presley. After a few weeks of tepid rehearsals, Phillips heard Elvis and his guitarist Scotty Moore cut loose with a crazy version of Arthur Crudup's "That's All Right Mama." Phillips recorded the sound on the big half-inch tape machine he bought from a local radio station, adding a dollop of reverb that would become the signature of the Sun Records sound for Elvis, Jerry Lee Lewis, Carl Perkins, Roy Orbison, Johnny Cash, and others. Together they changed not only music but the basic fabric of American society.

On the other end of the Mississippi River, two brothers in Chicago (Leonard and Phil Chess) owned another independent label, named Chess Records after themselves. During the early fifties they also made great recordings of blues artists, with the help of Willie Dixon, who supervised recordings, played bass, and wrote most of the best songs. Chess concentrated on musicians who had migrated north after World War II—Muddy Waters, Little Walter, and Howling Wolf. These artists had grown up in the Mississippi Delta and transformed the blues from acoustic guitar and voice to powerhouse electric bands that rocked the crowded bars on Chicago's South Side. In 1954, a young beautician named Chuck Berry walked into the Chess studio, hoping to record some of his tasteful blues songs in the more sophisticated style of Nat King Cole and Charles Brown. He did, but on the back of one of those releases, there was a different type of track named after his days in the beauty parlor. It was called "Maybellene" and, like "That's All Right Mama," it defined the driving beat and controlled abandon that came to be known as rock 'n' roll.

77. *Ray Charles*, 1960s

Interestingly enough, this story occurred many times and in many places in America between 1954 and 1957. Little Richard recorded "Tutti Frutti" in New Orleans for Specialty, while Clyde McPhatter and Ray Charles (fig. 77) invented soul music for Ahmet Ertegun and Jerry Wexler at Atlantic, Buddy Holly added his own unique spin for Coral, so-called girl groups, such as the Shirelles, reigned at Scepter, and Hank Ballard paved the way for James Brown on King. All over, America was exploding with regional artists bursting to encapsulate their energy in three-minute songs that were pressed on vinyl, played on AM radio, and bought by teens with more disposable income and leisure time than ever before.

By the late 1950s, rock music had not only captured the hearts, minds, and bodies of young Americans, it was beginning to grow into a remarkable medium for artistic expression. Rock did not just thrive on the libidinous charm of rising icons like Elvis. It galvanized the best creative talents of the age who filled the ranks of producers and songwriters. Two writers from New York's Brill Building, Leiber & Stoller, wrote many of Presley's best songs while transforming the disposable teen fluff of 1950s pop music into classic arias of romantic longing and social desperation. Meanwhile, producers like Phil Spector began to push the idea of the recording studio as a creative instrument through which they could craft little sonic symphonies. One of the ways that Spector did this was by making extensive use of multitracking, the practice of having a single instrument play the same part many times; these parts are then compressed and equalized to the point where they sound as uplifting on tiny AM radio speakers as would a live gospel choir. By thinking of the recording studio as an essential tool in the creation of music, Spector paved the way for the even more innovative and popular work of Berry Gordy, Brian Wilson, and John Lennon and Paul McCartney in the mid-sixties. —J. C.

78. *Elvis Presley Singing with Country and Western Band*, 1956, photograph by Bruce Roberts

JAZZ: THE BIRTH OF COOL

The 1950s were a remarkably fertile time in the history of American music. Rock 'n' roll, arguably the dominant form of mass expression in the late twentieth century, was born. Experimental musicians such as John Cage began to influence a wide range of artists in all media. And bebop jazz, begun by Charlie Parker, Dizzy Gillespie, and Thelonious Monk, in the forties crossed over into the mainstream.

At mid-century the Royal Roost was a popular New York City nightclub and Parker was the reigning star. By 1950, bebop had permanently transformed jazz from dance-oriented big band swing to contemplative abstract jams. The Royal Roost performances were broadcast on radio and later released on record. Careful listeners noticed that a teenage trumpet player named Miles Davis had replaced Dizzy in Parker's group. In these early performances Davis is remarkably self-assured, but still learning from the master. Within a few years, he grew to become the preeminent jazz musician of the fifties and the progenitor of a sound almost as important as bebop itself. It came to be known as cool jazz (fig. 79).

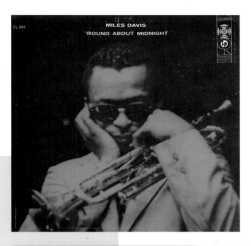

Jazz itself was born at the turn of the century when black
musicians in New Orleans began playing a new syncopated form
of music that adapted African rhythms and "bent" or "blue" notes
to European instruments like the trumpet, trap drum, and piano.
Early composers such as Jelly Roll Morton, Eubie Blake, and
James P. Johnson gave a form to these early experiments that was
called ragtime. During the early 1920s, a remarkable trumpet
player, Louis Armstrong, developed the idea of the jazz solo, one
instrument taking the lead rather than tight-knit ensemble playing
that had been the norm in both popular and classical groups. By
the late 1920s, the great Duke Ellington began a more sophisti-
cated style of ensemble playing that came to be known as swing.
This became the dominant form of American music through the
1940s, popularized by bandleaders such as Benny Goodman,
Glenn Miller, and Count Basie, and singers such as Frank Sinatra
and Ella Fitzgerald.

By the mid-forties, a few innovative young musicians from
popular swing bands, particularly Charlie Christian, Max Roach,
Monk, Parker, and Gillespie began to jam together after-hours in a
Harlem nightclub called Minton's. They abandoned the relatively
conservative structure of the dance music they were paid to play,
and experimented with a far more abstract form of music they
called bebop. Bop was meant to be listened to carefully, not just
treated as entertainment. For example, drumming in this new form
of music implied the beat rather than emphasizing it, soloists
played much longer than the standard eight bars, and references
to popular tunes, notably by Cole Porter and George Gershwin,
gave a sense of inspired play rather than studied virtuosity. The
music still followed the jazz tradition of playing hot and wild,
but abandoned the use of apparent formal structures to ground
increasingly daring solos. Cool jazz built upon this radical shift in how music was
played and listened to, but added an even greater emphasis upon aural atmospheres
that provoked contemplation rather than melodies you could hum or rhythms you could
dance to.

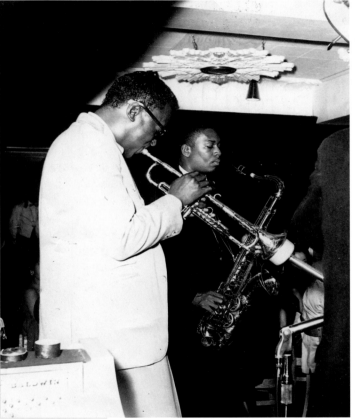

80. *Miles Davis and John
Coltrane*, 1956

One can hear the birth of cool in Monk's "'Round Midnight," Parker's ballads
such as "Embraceable You," and in the impressionistic tonality of his occasional band-
mate, the pianist Lennie Tristano. Tristano, in turn, mentored another saxophone player,
Lee Konitz, who helped inaugurate a jazz scene on the West Coast where the new cool
style thrived and was popularized through the work of Chet Baker, Gerry Mulligan, and
Stan Getz.

In the mid-fifties, Davis had found his own voice. He began to take his music in an
entirely new direction by working with a brash young saxophonist named John Coltrane
(fig. 80). The first Miles Davis Quintet recorded what many consider some of the finest

BEAT CULTURE

More than any other group in the 1950s, it was the Beats whose lives and literary creations rebelled against the conformity of American culture, which they took as a sign that the American promise had not been fulfilled. Poets and writers who started as a small underground in the early 1950s, the Beats believed that if you loved your country, you *had* to be a rebel. The Beat movement began in New York in the mid-forties, with the meeting of the writers William Burroughs and Jack Kerouac and the poet Allen Ginsberg. A decade later, the Beats overlapped with another underground movement, which had also been active since the forties—the San Francisco Renaissance. In 1955, San Francisco poet Michael McClure invited Ginsberg to give his first public reading of "Howl" (1956) at the Six Gallery, a vanguard artists' cooperative. The reading is now legendary: the artists and poets in the audience were riveted by the power of the poem, by Ginsberg's delivery of what would become the Beat anthem: "I saw the best minds of my generation destroyed by / madness, starving hysterical naked / dragging themselves through the negro streets at dawn / looking for an angry fix . . ."—and by Kerouac's gospel-like shouting refrains from the sidelines.[50]

ensemble jazz ever played, but broke up in 1957. Fortunately, they regrouped in 1959, adding saxophonist Cannonball Adderley and pianist Bill Evans, who built upon Tristano's style of combining abstract jazz with classical influences from Claude Debussy and Erik Satie. Together they recorded what is often regarded as the greatest jazz album of all time, *Kind of Blue* (1959).

Legend has it that Davis and Evans came up with the basic "modalities" for the session and then had the musicians perform directly on tape without extensive rehearsal. This was called "modal" jazz because improvisations were based on scales rather than on chord changes or harmonies. All the tracks, except one, were captured on the first take with no overdubs or edits. The result was an album with unique pace and atmosphere, different from anything heard before. On one hand, that sound is defined by the utter melodic simplicity of Davis' and Evans' approach, anchored by the subtle pulse of Paul Chambers and Jimmy Cobb's rhythm section. But Coltrane's arching solos take the record to another place: a kind of blues that is both hot and cool—beauty tempered with the tension of musicians relaxed within themselves, struggling to transcend. —J. C.

81. *On the Road*, by Jack Kerouac, 1951 Original manuscript on teletype paper scroll, 120 ft. (36.6 m) length Collection of the Sampas Family

In coffeehouses in San Francisco, as well as in New York's Greenwich Village and the canyons of Los Angeles, the Beats stood opposed to censorship, the arms race, corporate values, and consumerism. Repudiating bourgeois culture, with its materialism and work ethic, they found ecstasy and wonder in the ordinary and the debased. Beat poetry drew on a vast range of sources and experience: Walt Whitman and slang, drug culture and Zen Buddhism, Hollywood movies and the garbage dump—all were fused in a confrontational but redemptive realism. The Beats redeemed the commonplace by incorporating found objects, words, and sounds to celebrate the subject matter of America itself. In an introduction to Robert Frank's photographic essay *The Americans*, a brilliant, gritty portrait of real-life America (figs. 108–11), Jack Kerouac hailed the vibrant inclusiveness of the images:

> The humor, the sadness, the EVERYTHING-ness and American-ness of these pictures! Tall thin cowboy rolling butt outside Madison Square Garden New York for rodeo season, sad, spindly, unbelievable—Long shot of the night road arrowing forlorn into immensities and flat of impossible-to-believe-America in New Mexico under the prisoner's moon—under the whang whang guitar star—Haggard old frowsy dames of

THE BEAT GENERATION

"America demands a poetry that is bold, modern and all-surrounding and kosmical, as she is herself," wrote Walt Whitman. Although he made his observation soon after the Civil War, Whitman's prescription also applies to the period immediately following World War II, when the Beat generation came of age. The range of figures frequently described as Beat includes writers, artists, filmmakers, and coffeehouse devotees in goatees and T-shirts, but there were only a handful of founding members in the 1940s and early 1950s. The term "Beat generation" was coined by Jack Kerouac in 1948. A decade later, the movement became a national phenomenon, popularly known, in the columnist Herb Caen's coinage, as "beatniks" (Allen Ginsberg considered Caen's shorthand to be the "Frankenstein" version of the Beat generation). Setting the model for dress, drugs, and youth culture, Beat poets were treated like rock stars rather than like ivory tower academics (fig. 82).

82. *Hal Chase, Jack Kerouac, Allen Ginsberg, and William Burroughs, Morningside Heights, New York*, 1944

The Beats were drawn together by personal intimacy and social rebellion as well as by literary aesthetics, and this was apparent from the moment in 1944 when Columbia University student Lucien Carr introduced the three seminal figures of the Beat generation to one another: William Burroughs (age thirty), Jack Kerouac (age twenty-two), and Allen Ginsberg (age eighteen). They served one another as sexual partners, literary agents, mentors, and, above all, developing writers who read and encouraged each other's work when it had not yet found support in the literary establishment. Ginsberg's description of their "New Vision" in the mid-1940s characterizes their later output: (1) uncensored self-expression is necessary to creativity; (2) creativity is expanded through nonrational means and derangement of the senses—hallucinations, visions, drugs, and dreams; (3) art supersedes the dictates of conventional morality.

In the mid-1950s, the Beat generation overlapped with poets associated with Black Mountain College in North Carolina (Robert Creeley, John Weiners) and a group in San Francisco who initiated what became known as the San Francisco Renaissance (including Lawrence

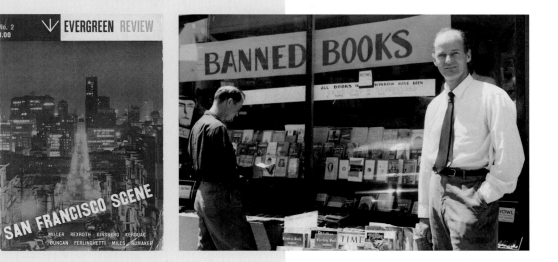

83. *Evergreen Review*, 1, no. 2, 1957

84. *Lawrence Ferlinghetti in Front of City Lights Bookstore, San Francisco*, 1957, photograph by Harry Redl

Ferlinghetti, Bob Kaufman, Philip Lamantia, Michael McClure, Peter Orlovsky, Gary Snyder, and Philip Whalen; figs. 83, 84). For a period of about five years, the San Francisco Renaissance flourished in tandem with the Beat generation, in coffeehouses and in bookstores such as City Lights. From that stimulating West Coast environment

came Lawrence Ferlinghetti's *A Coney Island of the Mind* (1958), which became the twentieth century's best-selling book of American poetry, as well as connections to underground filmmakers (Bruce Conner, James Broughton) and the artists George Herms and Wallace Berman. Like the Beat generation, members of the San Francisco Renaissance were bound together by a sense of collective embattlement in a world that seemed more materialistic than spiritual, more conformist than creative.

The literature of the Beat generation was deeply intertwined with autobiography. The events of their lives—transcontinental car trips, homosexual companionship, and heroin addiction—became sources for three key Beat texts: Kerouac's *On the Road*, Ginsberg's *Howl and Other Poems*, and Burroughs' *Naked Lunch*. Personal candor was essential to these writings, and the books exploded the tight literary conventions in America during the age of New Criticism, which focused on literary themes, language, and imagery and excluded consideration of biographical or historical perspectives. Confronting Beat writers, many critics described them as juvenile delinquents who were set on destroying literature and morality. This shortsighted view ignored the Beats' voracious interest in authors both classical (e.g., William Blake) and contemporary (e.g., William Carlos Williams, Thomas Wolfe) and their desire to forge a new morality based on candid human relationships. Moreover, the Beats' conception of poetry as public performance, often incorporating jazz accompaniment in San Francisco's North Beach clubs (fig. 85), harked back to the ancient tradition of the wandering bard. Beat poetry could evoke the spirituality of the natural environment (Michael McClure), Buddhism and the rigor of meditation (Gary Snyder and Philip Whalen), and the presence of indigenous peoples (Snyder). Using vernacular language, these poets pioneered the rhythms that reflected the improvisations of jazz.

The Beat generation opened many doors for later generations in pop and literary culture. Some have been commercial; as Burroughs observed, "Kerouac opened a million coffee bars and sold a million pairs of jeans to both sexes." More lastingly, by defeating obscenity charges against *Howl* and *Naked Lunch*, the Beats helped defeat America's laws of literary censorship, while providing models and directives for future generations to experiment with language and life, to reinvent the idea of being an American and simultaneously a citizen of the cosmic world. —S. W.

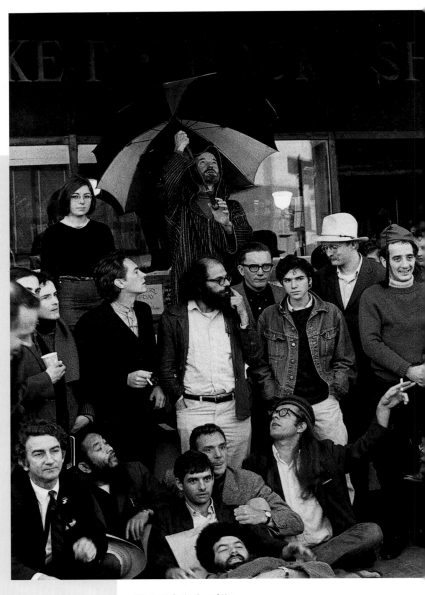

85. *Last Gathering of the Beat Poets and Artists, City Lights Bookstore, San Francisco*, 1965, photograph by Larry Keenan

Los Angeles leaning peering out the right front window of Old Paw's car on a Sunday gawking and criticizing to explain Amerikay to little children in the spattered back seat—tattooed guy sleeping on grass in park in Cleveland, snoring dead to the world on a Sunday afternoon with too many balloons and sailboats. . . .[51]

And Ginsberg, poet laureate of the Beats, exclaimed in "Howl" that everything is holy, "The world is holy! The soul is holy! The skin is holy! The nose is holy! The tongue and cock and hand and asshole are holy!"

REALISM IN THE NOVEL

American writers of the fifties bared the dark side of national affluence. The postwar economic boom had supposedly landed Americans in a placid valley filled with consumer goods: pastel pedal pushers, self-cleaning ovens, and cheeseburgers delivered by waitresses on roller skates. Yet the illusion that economic prosperity had left everyone fulfilled was splintered by American authors who doggedly undermined the prevailing assumption that prosperity guaranteed happiness. In fact, they delivered the opposite message: too much prosperity left people grasping for more, blind to their own immorality, and far from the ideals for which American soldiers had fought and died in World War II.

As Saul Bellow warns in *Seize the Day* (fig. 86), "You want to avoid catching the money fever. This type of activity is filled with hostile feeling and lust. You should see what it does to some of these fellows." Unfortunately, Tommy Wilhelm, Bellow's main character, does catch the money fever. The novel's final scene shows him weeping at a stranger's funeral, mourning the death of genuine human connections in a harsh and victimizing world.

Tommy's grief and isolation ennoble him, since fifties novelists agreed that those who succeeded in this mercenary culture were, in the words of *Catcher in the Rye*'s Holden Caulfield (fig. 87), "phony bastards." Like Tommy, Holden is a misfit because he cannot aspire to the conventional consumerist attitudes of his peers. Yet, like Huckleberry Finn, his predecessor in vernacular realism, Holden fights hypocrisy with a highly developed talent for seeing the cracks in America's seemingly smooth surfaces. Like other fifties misfits, Holden will be ushered into analysts' offices, tranquilized, and made to adapt. For doing so, he will earn the dubious privilege of joining the ranks of America's upwardly mobile.

The achievement of wealth and upper-class status proves to have its pitfalls in several important novels of the fifties. As Mary McCarthy's *The Group* (1963) coldly reports, money and class position only serve to reinforce the prison bars of conformity and compliance, which for women of the decade began to take on frightening dimensions. Those who subordinated themselves to their husbands, abandoning their education and skills, would end up like McCarthy's heroine Kay, beautiful and pedigreed, but institutionalized and suicidal. Indeed, the sordid domestic scene of Kay's marriage, her husband's abuse, the black walls of their friends' apartment, their anxiety about money—all provide a stark contrast to the pictures of the happy homemakers peopling American advertisements. The sexual frankness of this book also startled Americans, who either praised or protested McCarthy's discussions of impotence and orgasm, psychoanalysis and homosexuality, adultery and divorce.

Marital discord occupies center stage in many novels of the fifties, with writers presenting relationships that cannot survive the economic realities the characters must

The Beat exaltation of the lowly and discarded had parallels in the new realist novel and in the confrontational experimental theater of the Living Theater and other groups. It signaled an integral connection between art and life, best seen perhaps in Kerouac's *On the Road*, published in 1957 (fig. 81), which became a manifesto of the Beat generation. *On the Road* was written in one mad, intense session—typed more or less continuously for three weeks on a 120-foot-long roll of paper. This method reflected Kerouac's motto "first thought, best thought." His style was also inspired by the improvisational rhythms and fast-paced riffs of bebop jazz and was called "spontaneous bop prosody."[52] For Kerouac, writing, like

86. *Seize the Day*,
by Saul Bellow
New York: Viking Press,
1956
Harry Ransom Humanities
Research Center at The
University of Texas at
Austin

everything else, was a kind of performance. Art and life were intertwined, part of one carnivalesque mélange of music, conversation, drinking, reading, working, smoking, sex, and traveling.

Though the Beats formed a literary movement, their all-embracing attitude promoted synergy among disciplines. This produced works ranging from jazz poetry performances at the Five Spot, a New York jazz club, or the Living Theater, and independent films such as *Pull My Daisy* (fig. 90), a collaboration between Robert Frank and the painter Alfred Leslie, which featured performances by the poet and Hansa gallery director Richard Bellamy, the poet Gregory Corso, and the painters Alice Neel and Larry Rivers, among others. This film marked the beginning of a new avant-garde film genre, the New American Cinema, which included Bruce Conner, Shirley Clarke, and John Cassavetes. In other cross-disciplinary enterprises, poets wrote about visual artists, and visual artists illustrated many of the books of Beat writers or designed sets for the Beats' experimental plays.

face. In John Updike's *Rabbit, Run* (1960), the hero, Harry "Rabbit" Angstrom, goes to war instead of college and thus can barely manage to support his wife, a heavy drinker, and his children. Eventually, the couple's unhappiness leads to the drowning of their daughter. The novel's conclusion offers no closure and no solution to Rabbit's spiritual malaise; instead of moral pronouncements, Updike renders, with his close descriptions of rural Pennsylvania and its inhabitants, a grim slice of American life.

Updike's brand of social realism had at its root the desire to tell the truth about all segments of the American population. For Philip Roth, that meant focusing his attention on that class of Americans who had just devoured their piece of the expanding economic pie. *Goodbye, Columbus* (fig. 88) cautions against such appetites, finding that ruthless pursuit of wealth defiles the American character and desecrates American values. In Roth's novel, the main character, Neil Klugman, pursues his golden girl, the spoiled, nouveau riche Brenda Patimkin. In her father's suburban mansion, Neil gratifies his materialistic and carnal desires, gorging himself on the summer fruit that falls from the Patimkins' bursting refrigerator. Such cornucopia blinds him to the truth about Brenda. Finally confronting her moral dissolution, and his own, he wonders, "What was it that had turned pursuit and clutching into love, and then turned it inside out again?"

Under the scrutiny of these writers, the facade of a robust and productive America collapses, and behind it rears the wasteland of the national spirit. In John Cheever's premier story, "The Enormous Radio" (1953), a well-to-do couple, living in a Manhattan apartment, buys a radio that receives, instead of planned programming, the conversations of their neighbors. Listening ceaselessly, the wife hears sounds of men and women fighting, wife-beating, drunkenness, anxiety about money, and parental cruelty. Cheever, too, exposed the disparity between the image and the reality of America. For just behind the external signs of prosperity, the shiny new Formica of dinette sets and kitchen counters, lay the neglected: the outcasts, the alcoholics, the poor, the impotent, the abused. Paradoxically, however, in the eyes of these novelists, those who reaped the benefits of economic abundance fared the worst. Blind to the misery just next door, devoted to meretricious values, and seduced by advertisements for the American dream, the greedy suffer the flimsiness of their purchases and the hollowness of their own ideals. —H. F.

87. *Catcher in the Rye*, by J. D. Salinger
Boston: Little, Brown, 1951
Harry Ransom Humanities Research Center at The University of Texas at Austin

88. *Goodbye, Columbus*, by Philip Roth
Boston: Houghton Mifflin, 1959
Harry Ransom Humanities Research Center at The University of Texas at Austin

THE NEW AMERICAN CINEMA

During the late 1950s, a new generation of experimental filmmakers emerged from the bohemian subcultures of New York and San Francisco. Influenced by Beat culture, the anti-narrative experiments of Abstract Expressionist painting, Eastern religion, the radical sound pieces of John Cage, and the new dance forms of Merce Cunningham, this group rebelled against the European-based Surrealist "trance film" model of the 1940s, inspired by Jean Cocteau, which had characterized the groundbreaking work of Maya Deren, Kenneth Anger, and others. Both generations rejected conventional cinema's use of a narrative structure based on the novel, and drew on painting, music, poetry, and popular culture to create a new cinematic language. But whereas the avant-garde film of the 1940s aligned itself to poetry, during the end of the 1950s a new sensibility began to take hold. Stan Brakhage, Ken Jacobs, Jonas Mekas, Jordan Belson, Bruce Conner, and Shirley Clarke developed a new film language, using home-movie techniques and experimenting with unconventional film speeds, color, multiple printing, montage, and special lenses—all of which were used to radically transform film space and subject matter.

Of all the filmmakers creating these new cinematic forms during the 1950s, the dominant, and most prolific, was Stan Brakhage. Producing several films each year between 1952 and 1958, he created what came to be known as the "lyrical" film. His highly subjective, personal form of filmmaking, which took his domestic life, his wife and children, and his own inner struggles as central subjects, greatly influenced the next generation of filmmakers. The key film that marked Brakhage's transition to this new genre was *Anticipation of the Night* (fig. 89); its fragmented images and transformation of film space into multilayered perspectival planes brought filmmaking to new territory. The camera became not an "objective" eye but a subjective expression of a personal vision.

During the 1950s, New York was one of two main hubs of avant-garde filmmaking, centered around the activity of Jonas Mekas, a poet and refugee from Lithuania. Mekas was to become the main champion, critic, distributor, and defender of avant-garde film in America for the next four decades, as well as a filmmaker in his own right. He first established himself in New York through his writing, founding the influential journal *Film Culture* in 1955 and beginning his weekly film column in the newly founded *Village Voice* in 1958. Much influenced by Cinema 16, a group established by Amos Vogel in New York in 1947 in order to present and distribute alternative film, Mekas was to erect a wide-ranging support structure for avant-garde film, creating the Film-makers' Cooperative in 1962 and the Anthology Film Archives in 1970.

It was in New York that another key figure in American avant-garde film, Ken Jacobs, made *Little Stabs at Happiness* (fig. 91), one of his earliest films, featuring the filmmaker Jack Smith. Shirley Clarke filmed the bridges of New York for her multiperspective

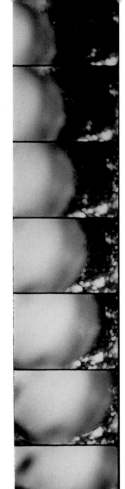

89. **Stan Brakhage**
Anticipation of the Night, 1958
16 mm film, silent, color; 40 min.
Anthology Film Archives, New York

90. **Robert Frank** and **Alfred Leslie**
Pull My Daisy, 1959
16 mm film, sound, black-and-white; 28 min.
Anthology Film Archives, New York

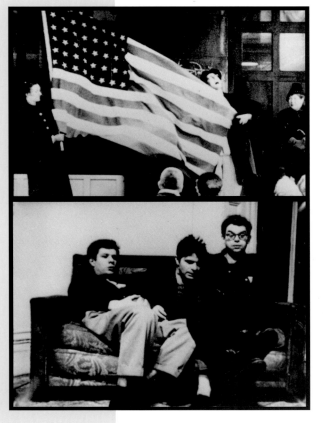

study *Bridges Go Round* (1958). The artist Joseph Cornell made several short films of the city, working with Rudy Burckhardt: *Aviary* (1955), a sketch of Union Square, and *Mulberry Street* (1957), a record of daily life in Little Italy, which recalls the photographer Helen Levitt's film *The Street* (1952). Other important filmmakers working in New York during the fifties included Marie Menken, Willard Maas, and Robert Breer.

Significant avant-garde films were also being produced in San Francisco, which had been a center for experimental film since the 1930s, when European filmmakers such as Oskar Fischinger and Viking Eggeling immigrated to Hollywood. During the 1950s, new experiments in abstraction developed alongside other forms of radical film-making, influenced by the Beat culture of San Francisco. The resulting rich mixture of different styles and sensibilities included films by Bruce Conner, James Whitney, Jordan Belson (fig. 205), Harry Smith, Ron Rice, Gregory Markopoulos, and Kenneth Anger. The pulsating, abstract biomorphic forms of Belson's *Mandala* (1953) and *LSD* (1954) and James Whitney's *Yantra* (1950–55), suggesting both cosmic space and inner consciousness, prefigured the psychedelia, light shows, and expanded cinema events of the sixties.

A Movie (fig. 92), the first film made by the San Francisco assemblage artist Bruce Conner, is infused with a strong Beat sensibility and marks another important development in experimental filmmaking. Conner assembled a figurative collage film from found footage, newsreels, and movie clips, montaging fact and fiction in disparate sequences of, among other subjects, Marilyn Monroe, war torpedoes, and an atomic explosion to construct a new, ironic meta-narrative. Stan Vanderbeek's similarly mocking critique of the Cold War and the space race in his satirical animation film *Science Friction* (1959) echoed the younger generation's criticism of 1950s McCarthyite politics.

The year 1959 saw America on the brink of a new era. The Beat movement had reached its zenith and was becoming absorbed into the mainstream. In November, the photographer Robert Frank's film *Pull My Daisy* (fig. 90), the quintessential Beat film, codirected with the painter Alfred Leslie, received its premiere at Cinema 16 in New York; it was screened alongside John Cassavetes' more conventional Beat film *Shadows* (1957–59). Jonas Mekas hailed *Pull My Daisy* as marking "the dawn of a new epoch in American cinema." Its apparent spontaneity and quasi-documentary informality seemed to signal new possibilities for cinema. Depicting everyday bohemian life in a downtown loft in New York City and narrated by the Beat writer Jack Kerouac, the film's radicalism stemmed partly from its counterculture subject matter—Beat poets, painters, musicians, and writers, including Allen Ginsberg—and partly from its disjunctive home-movie structure, which echoed the freewheeling improvisation of jazz. Yet the greatest impact of *Pull My Daisy* lay in its depiction of a younger generation's existential rebellion against the American social and political consensus. —C. I.

ASSEMBLAGE, COLLAGE, AND JUNK SCULPTURE

The West Coast visual artists Jess (Collins), Wally Hedrick, Wallace Berman, Jay DeFeo, George Herms, and Bruce Conner were closely affiliated—both socially and philosophically—with the Beat poets and poets of the San Francisco Renaissance. Like the poets, they were keenly interested in accumulations of materials—materials found on the street or in the cool beat of bebop—from which they made "assemblages" of objects (figs. 93–98). (The term "assemblage" was coined by the French artist Jean Dubuffet in 1953 for his pasted constructions.) *Watts Towers* in Los Angeles, the most amazing monument of assemblage, was completed by the outsider artist Simon Rodia in 1954 and became an inspiration to many California artists (fig. 100).

Assemblage artists were drawn to the process partly because it allowed a certain spontaneity as well as the use of cheap and available materials. More important, in contrast with Abstract Expressionist painting, which they perceived as detached and inward looking, assemblage incorporated elements from the real world. Cast-off nylon stockings, old photographs, feathers, sequins, and lace are combined in Bruce Conner's eerie, noir, and psychosexually charged works (figs. 96–98). Jay DeFeo made perhaps the most ambitious assemblage of the time—*The Rose*—which she worked on exclusively for a period of seven years between 1958 and 1966 (fig. 101). The monumental ridged relief is almost 11 feet high and bellies out to 11 inches thick, with lines radiating from the center as in an atomic blast or a mandala. It consists of more than 2,200 pounds of paint and has many objects and multiple canvases embedded in it. This masterpiece, memorialized in Bruce Conner's 1967 film *The White Rose* (to a Miles Davis soundtrack), is a marriage of painting and sculpture, the organic and the cosmological.

Visual artists on both coasts were raiding the streets for common objects to incorporate into their works. Junk sculpture, as it came to be known, was an extension of Symbolist and Surrealist collage traditions into three dimensions. Even if it was on the wall, junk sculpture extended into the viewer's space in a confrontational manner. The work of the assemblagists Richard Stankiewicz, John Chamberlain, Mark di Suvero, Robert Rauschenberg, and Louise Nevelson on the East Coast, like that of their California counterparts, was not polite or well behaved and was often

93. Jess
Tricky Cad, Case 1, 1954
Bound book of twelve collages, 9⁷⁄₁₆ x 7¹³⁄₁₆ in. (24 x 19.8 cm) each sheet; 10¼ x 9⅜ x ⅜ in. (26 x 23.8 x 1 cm) closed
Whitney Museum of American Art, New York; Purchase, with funds from the Contemporary Painting and Sculpture Committee, the Drawing Committee, and the Tom Armstrong Purchase Fund 95.20a–m

94. Jess
Boob #3, 1954
Collage, 30 x 35 in. (76.2 x 88.9 cm)
Courtesy Odyssia Gallery, New York

95. George Herms
The Librarian, 1960
Wood box, newspaper,
brass, books, and painted
stool, 57 x 63 x 21 in.
(144.8 x 160 x 53.3 cm)
Norton Simon Museum,
Pasadena, California; Gift
of Molly Barnes, 1969

98. Bruce Conner
*PORTRAIT OF ALLEN
GINSBERG*, 1960
Wood, fabric, wax, tin
can, glass, feathers,
metal, string, and spray
paint, 20 x 11¼ x 21⅜ in.
(50.8 x 28.6 x 54.3 cm)
Whitney Museum of
American Art, New York;
Purchase, with funds from
the Contemporary Painting
and Sculpture Committee
96.48

97. Bruce Conner
BLACK DAHLIA, 1960
Mixed-media assemblage,
26¾ x 10¾ x 2¾ in.
(67.9 x 27.3 x 7 cm)
Collection of Walter Hopps

96. Bruce Conner
LOOKING GLASS, 1964
Paper, cotton, cloth, nylon,
beads, metal, twine, glass,
leather, plastic, wood, and
masonite, 60½ x 48 x 14½ in.
(153.7 x 121.9 x 36.8 cm)
San Francisco Museum of
Modern Art; Gift of the
Modern Art Council

99. **Edward Kienholz**
The Illegal Operation,
1962
Mixed media, dimensions
variable
Collection of Betty and
Monte Factor

100. **Simon Rodia**
*Watts Towers, Los
Angeles, California*,
1921–54, photograph by
Julius Shulman

101. **Jay DeFeo**
The Rose, 1958–66
Oil with wood and mica on
canvas, 128⅞ x 92¼ x
11 in. (327.3 x 234.3 x
27.9 cm)
Whitney Museum of
American Art, New York;
Gift of the Estate of Jay
DeFeo and purchase,
with funds from the
Contemporary Painting
and Sculpture Committee
and the Judith Rothschild
Foundation 95.170

102. **Louise Nevelson**
Dawn's Wedding Chapel II,
1959
Wood, 115⅞ x 83½ x
10½ in. (294.3 x 212.1 x
26.7 cm)
Whitney Museum of
American Art, New York;
Purchase, with funds from
the Howard and Jean
Lipman Foundation, Inc.
70.68

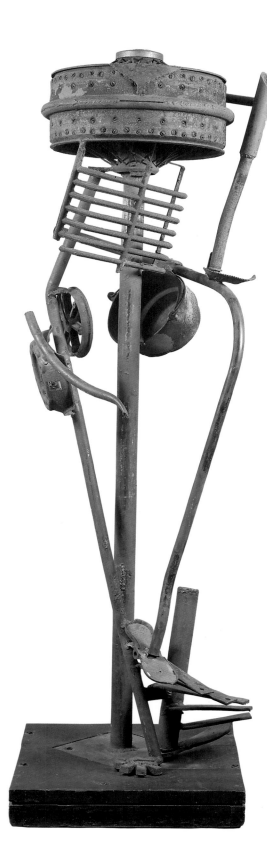

103. **Richard Stankiewicz**
Kabuki Dancer, 1954
Iron and steel, 84 in.
(213.4 cm) height
Whitney Museum of
American Art, New York;
Purchase, with funds from
the Friends of the Whitney
Museum of American Art
57.12

104. **John Chamberlain**
Velvet White, 1962
Painted and chromium-
plated steel, 80¾ x 53 x
49⁷⁄₁₆ in. (205.1 x 134.6 x
124.9 cm)
Whitney Museum of
American Art, New York;
Gift of the Albert A. List
Family 70.1579a–b

105. Mark di Suvero
Hankchampion, 1960
Wood and chains, 77½ x
149 x 105 in. (196.9 x
378.5 x 266.7 cm)
Whitney Museum of
American Art, New York;
Gift of Mr. and Mrs.
Robert C. Scull 73.85

full of humor and irreverence. Stankiewicz fashioned old car parts and metal pipes into figurative totems like *Kabuki Dancer* (fig. 103); Nevelson used found bits of wood to construct her abstract and atmospherically evocative environments like *Dawn's Wedding Chapel, II* (fig. 102). Chamberlain scavenged autobodies and fit them together in a three-dimensional extension of Action Painting (fig. 104), and di Suvero assembled mammoth timbers into dramatic constructions of gesture and balance (fig. 105). West Coast assemblagists—Conner, Edward Kienholz, and Berman—took a more political approach in their work, often addressing moral issues of the moment such as capital punishment and illegal abortions (fig. 99).

Assemblage artists worked without expectation of sales or institutional support and sometimes with open disdain for the art establishment. Their work was often ephemeral or made with materials that easily deteriorated. Some forward-looking museum curators, however, were not put off by the artists' indifference or by the fragility or commonness of the materials. Gradually, assemblage began to gain respect in the very world whose authority it challenged. In 1961, William Seitz gave it the highest institutional imprimatur when he organized the exhibition "The Art of Assemblage" at The Museum of Modern Art in New York.

A NEW LENS ON AMERICA

The photographers grouped in what is often called the New York School of photography, which paralleled the development of New York School painting in the postwar years, also had an unromanticized view of life and took to the streets in search of the "real" America. Although they built on the methods of documentary journalism, they rejected its anecdotal descriptiveness, instead forging a style that mingled the spirit of existentialism with Hollywood film noir.[53] And in place of the formal pretensions of earlier photographers, they developed a "snapshot aesthetic" analogous to the found materials of assemblage art and Beat writing. Their work, too, expressed the isolation, alienation, abrasiveness, and social malaise of the contemporary urban experience.

Robert Frank, Diane Arbus, Richard Avedon, William Klein, Lisette Model, Helen Levitt, and Weegee (figs. 106, 107, 114, 115) took spontaneous and candid shots of street and crime scenes, city subways, circus freaks, and Coney Island. Individually and together, their works portray the diversity of urban life, from high style to squalor.[54] Adding to this picture is the work of Roy DeCarava. Although not normally grouped with the New York School, DeCarava was socially affiliated with many of those photographers. He took straightforward, passionate photographs of life in New York, particularly in Harlem—portraits of great jazz musicians (John Coltrane, Lester Young, Billie Holiday) as well as ordinary people—creating a remarkable pictorial record that inspired Langston Hughes' story "The Sweet Flypaper of Life," which was published as a book with some of DeCarava's photographs.

The Swiss-born Robert Frank, although based in New York in the 1950s, surveyed the entire expanse of America with the blunt candor of his lens. In 1955, Frank received a Guggenheim Fellowship to travel across the country, documenting America's people. The resulting book (and series of photographs), *The Americans* (1958–59), is a brilliant portrait of the real life of America that celebrates the beauty in the everyday: the noble and sophisticated, the rich and poor, the common

106. **William Klein**
St. Patrick's Day, 5th Avenue, 1955
Gelatin silver print, 10 x 12 in. (25.4 x 30.5 cm)
Courtesy Howard Greenberg Gallery, New York
© William Klein

107. **William Klein**
Selwyn, New York 1955 (42nd Street), 1955
Gelatin silver print, 11⅞ x 9⁷⁄₁₆ in. (30.2 x 24 cm)
Whitney Museum of American Art, New York; Purchase, with funds from the Photography Committee 96.64
© William Klein

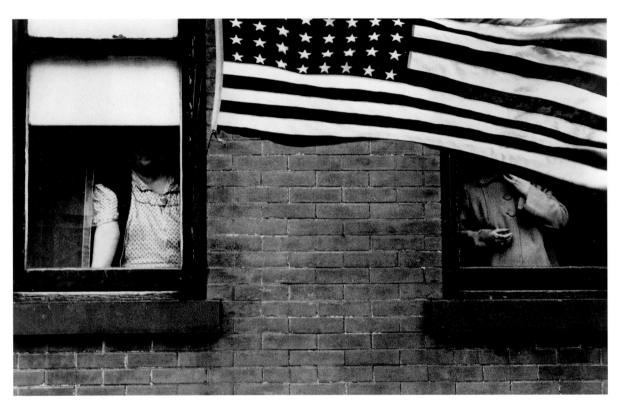

108. **Robert Frank**
Parade: Hoboken, New Jersey, from the series *The Americans*, 1953–57
Gelatin silver print, 12¼ x 18¾ in. (31.1 x 47.6 cm)
Philadelphia Museum of Art; Purchase, with funds from Dorothy Norman
© Robert Frank

109. **Robert Frank**
Restaurant: U.S. 1 Leaving Columbia, South Carolina, from the series *The Americans*, 1953–57
Gelatin silver print, 9 x 13¼ in. (22.9 x 33.7 cm)
Collection of Barbara Schwartz
© Robert Frank

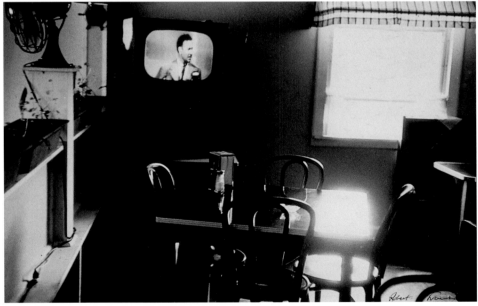

110. **Robert Frank**
Newburgh, New York, from
the series *The Americans*,
1953–57
Gelatin silver print, 13⅜ x
8¹³⁄₁₆ in. (33.8 x 22.4 cm)
The Art Institute of
Chicago, Photography
Gallery Fund
© Robert Frank

111. **Robert Frank**
*Charleston, South
Carolina*, from the series
The Americans, 1953–57
Gelatin silver print, 8¹³⁄₁₆ x
13⅜ in. (22.4 x 33.8 cm)
Addison Gallery of
American Art, Phillips
Academy, Andover,
Massachusetts
© Robert Frank

and exotic, the mix of races, the rural desolation and urban anomie (figs. 108–111). Frank crisscrossed the country, catching Yom Kippur in New York, a political rally in Chicago, a movie premiere in Hollywood, a navy recruiting station in Butte, Montana. His camera took in the transition from the old—log cabins and coal mining towns—to the new—jukeboxes and drive-ins. The candid character of Frank's photographs, their slice-of-life realism, owes much to the off-center, seemingly casual framing of each image, a technique some photographers regarded as a violation of professional photographic standards—just as assemblage and Beat literature violated the purist norms of art.

Frank represented the unvarnished diversity of America, and his realism inspired other artists. It was Edward Steichen, however, who represented the popular mainstream in *The Family of Man*, a 1955 photo-essay that accompanied an epochal exhibition at The Museum of Modern Art, New York. Steichen assembled 503 pictures by photographers from sixty-eight countries in an extravagant installation that he "conceived as a mirror of the universal elements and emotions in the everydayness of life—as a mirror of the essential oneness of mankind throughout the world" (fig. 112).[55] In the process of culling images from around the globe to make a grand, sentimental statement about the range of human experience, Steichen blurred cultural differences. Frank, on the other hand, was investigating a particular country in all its facets in order to produce a poetry of place—one tougher, more troubling, and nuanced. Frank's America was a country of carnivalesque urban rhythms and lonely barren expanses of open road.

Robert Frank initiated a kind of photographic realism that continued into the next decade. Breaking with conventional standards of pictorial composition, Garry Winogrand took pictures of crowded parties and street scenes with a random, almost accidental quality (fig. 113). Lee Friedlander's deadpan urban scenes—storefronts, display windows, and street signs—presented a view of America that was chaotic, disjointed, and often surreal. Diane Arbus cast an honest eye toward the ordinary and exotic in her memorable portraits of midgets, socialites, transvestites, and adolescents. Her pictures were immensely powerful in their dispassionate examination of lives and worlds that others overlooked (figs. 114, 115).

112. Installation view of "The Family of Man" at The Museum of Modern Art, New York, 1955

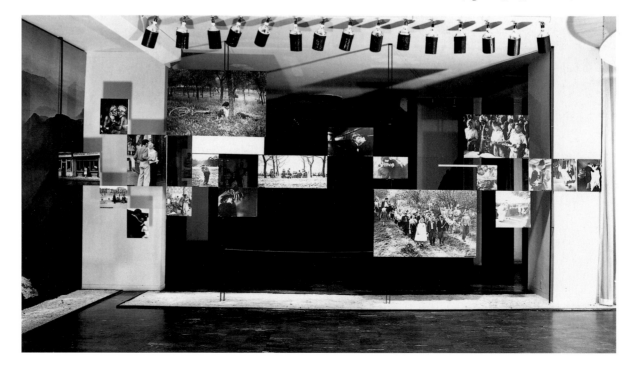

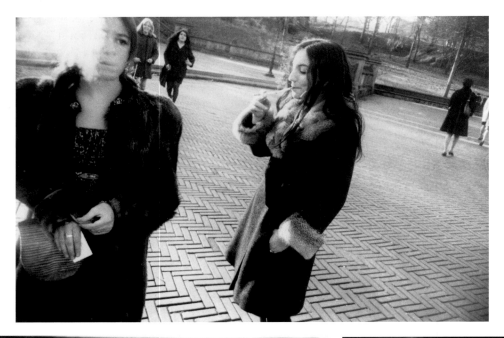

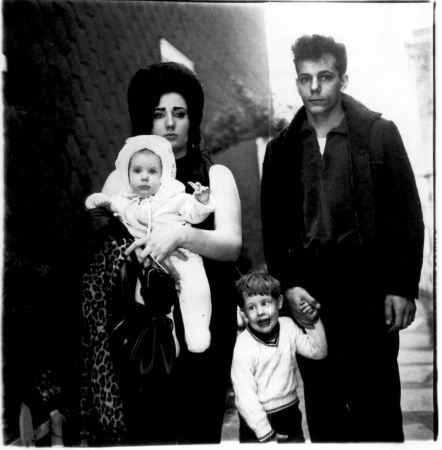

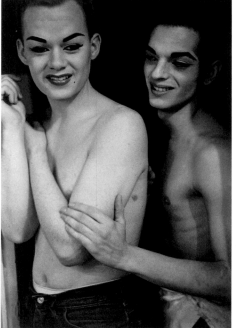

Closing the Gap Between Art and Life

RAUSCHENBERG, CAGE, JOHNS, CUNNINGHAM

The artist who most clearly redefined the boundaries of art in the 1950s by bringing real life into it was Robert Rauschenberg. "I don't want a picture to look like something it isn't. I want it to look like something it is. And I think a picture is more like the real world when it's made out of the real world."[56] One of the most prolific artists of the last fifty years, he began in 1953–54 to incorporate real objects into his assemblages and by 1955 was producing what he called "Combine" paintings—neither painting nor sculpture, but both (figs. 117–21, 134). No object was too lowly for his art. The cast-off and the discarded were redeemed through his energetic combinations and overlays that celebrated memory as well as the raw sense of everyday life. A shirt, a sock, a tire, a quilt, a parachute, a street sign, a Coca-Cola bottle, a stuffed goat—each found its way into his hybrid constructions. These works were a far cry from the iconic distillations of Abstract Expressionism.

In this spirit of redefinition, Rauschenberg had erased a de Kooning drawing in 1953, an act of tribute and oedipal defiance that wiped the slate clean (fig. 116). He had already executed a series of white paintings designed to register the play of shadows rather than make a pictorial statement. These works were shown at his first one-artist exhibition, at the Betty Parsons Gallery, New York, in 1951. That same year, he embarked on a series of black and then red paintings, applying newspapers to the canvas and then coating them in enamel, a buildup that evoked the urban decay and rawness of life in Lower Manhattan. Though clearly indebted to the work of earlier European collagists and the constructions of Joseph Cornell, Rauschenberg took the collage tradition into a new realm. In some works from the period, such as *Rebus* or *Factum I* and *II* (figs. 117, 118), he affixed differently scaled images and pieces of cloth to the picture in a montage-like fashion, overlaying them with brushstrokes.

Further merging collage with painting, Rauschenberg's later three-dimensional Combines, *Monogram*, *Satellite*, and *Canyon* (figs. 119–21), spill into the viewer's space, offering an experience of multiplicity and random order. Rauschenberg brought the world into his art, in content as well as form. His was an inclusive vision—generous, engaging, and physically extroverted. "Painting relates to both art and life," he said. "Neither can be made. (I try to act in that gap between the two.)"[57]

John Cage, the avant-garde musician and Rauschenberg's friend, would write, "These are the feelings Rauschenberg gives us: love, wonder, laughter, heroism (I accept), fear, sorrow, anger, disgust, tranquillity."[58] Like his Beat compatriots, Rauschenberg expressed the full range of human experience and emotions even if it violated social taboos. "Where does beauty begin and where does it end? Where it ends is where the artist begins," said Cage. He proclaimed Rauschenberg "the giver of gifts," someone who redefined beauty by looking at things that we thought were ugly or that had grown too familiar to be seen.[59] Rauschenberg's work transformed our everyday experience, sensitizing us to the beauty of a derelict sign or a crumbling wall.

Rauschenberg had learned much from Cage, whose aesthetic derived in part from Zen Buddhism. Zen philosophy valued chance over structured sequence and rejected the polarities of good and bad, ugly and beautiful. Everything is subsumed

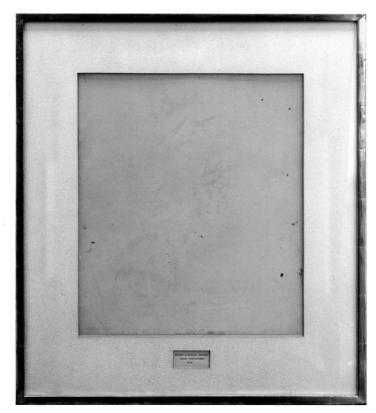

116. **Robert Rauschenberg**
Erased de Kooning Drawing, 1953
Traces of ink and crayon on paper in gold-leaf frame, 25¼ x 21¾ in. (64.1 x 55.2 cm)
San Francisco Museum of Modern Art; Purchased through a gift of Phyllis Wattis
© Robert Rauschenberg/ Licensed by VAGA, New York, NY

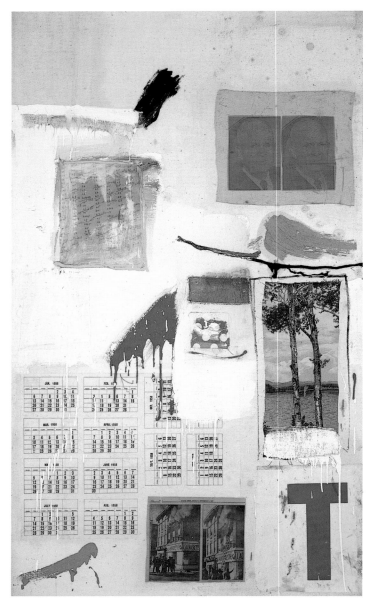

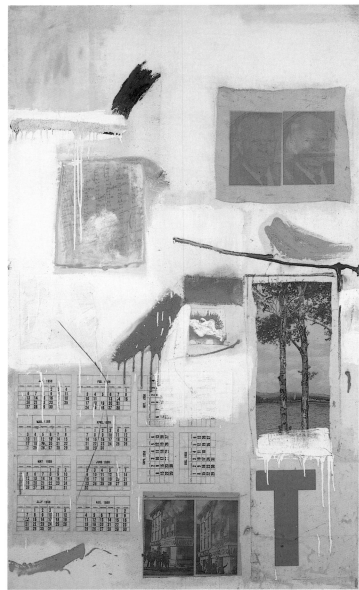

117. **Robert Rauschenberg**
Factum I, 1957
Combine painting, 61½ x
35¾ in. (156.2 x 90.8 cm)
The Museum of
Contemporary Art,
Los Angeles; The Panza
Collection
© Robert Rauschenberg/
Licensed by VAGA, New
York, NY

118. **Robert Rauschenberg**
Factum II, 1957
Combine painting, 62 x
35½ in. (163.7 x 90.2 cm)
The Morton G. Neumann
Family Collection
© Robert Rauschenberg/
Licensed by VAGA, New
York, NY

119. **Robert Rauschenberg**
Monogram, 1955–59
Combine painting, 42 x
63¼ x 64½ in. (106.7 x
160.7 x 163.8 cm)
Moderna Museet,
Stockholm
© Robert Rauschenberg/
Licensed by VAGA, New
York, NY

120. **Robert Rauschenberg**
Satellite, 1955
Combine painting, 79⅜ x
43¼ x 5⅝ in. (201.6 x
109.9 x 14.3 cm)
Whitney Museum of
American Art, New York;
Gift of Claire B. Zeisler
and purchase with funds
from the Mrs. Percy Uris
Purchase Fund 91.85
© Robert Rauschenberg/
Licensed by VAGA, New
York, NY

121. **Robert Rauschenberg**
Canyon, 1959
Combine painting, 81¾ x
70 x 24 in. (207.6 x
177.8 x 61 cm)
Sonnabend Collection,
New York
© Robert Rauschenberg/
Licensed by VAGA, New
York, NY

by ultimate oneness. Hierarchies and judgments are irrelevant because nothing is better than anything else. This holds true for art as well: instead of being a privileged activity different from life, art becomes an act within life.

Cage was also the bearer of the legacy of Marcel Duchamp, whom he had known since the 1940s. As early as 1913, in an anti-art movement known as Dada, Duchamp had invented the "readymade," the transformation of non-art objects—a bicycle wheel (fig. 122), a bottle rack, and a urinal—into art by the mere act of call-

122. **Marcel Duchamp**
Bicycle Wheel, 1913
(1964 edition)
Wood, steel, and aluminum, 50¾ x 25¼ in. (128.9 x 64.1 cm)
Philadelphia Museum of Art; Gift of Schwartz Galleria d'Arte

ing them art. Cage's ready-made music owed a great deal to Duchamp's original concept of the "found object," and Cage was an important conduit for Duchamp's idea that the work of art is completed by the observer.[60] Together with the Zen reliance on chance operations and on a nonhierarchical philosophy of beauty, the idea of the readymade helped upend preconceived notions about the function, meaning, and context of art. The sensibility of the most important young composers, painters, sculptors, and choreographers of the 1950s was influenced by Cage's practice.

Rauschenberg and Cage first met at Black Mountain College in Asheville, North Carolina, in 1949. Black Mountain was an experimental school dedicated to active student involvement in the administration and a progressive curriculum. It was also a kind of commune or experiment in living. Josef Albers, the Bauhaus artist, had come to teach there and in the 1940s built a particularly strong program in the arts. After Albers' departure in 1949, the poet Charles Olson became the dominant force at Black Mountain, turning it into a nurturing ground for great talent, until the school closed in 1956. Some of the teachers in the late forties and fifties included the designer-engineer Buckminster Fuller, philosopher Paul Goodman, photographer Aaron Siskind, Clement Greenberg, Franz Kline, Willem de Kooning, John Cage, and dancer-choreographer Merce Cunningham.[61]

At Black Mountain, in the summer of 1952, Cage devised a theatrical evening in which several interpenetrating, simultaneous activities took place with no causal relationship. One of the first multimedia events in the United States, it was based on a collage aesthetic: Olson and M. C. Richards recited poetry atop a ladder, while Cunningham danced up and down

123. **Robert Rauschenberg**
Automobile Tire Print, 1953
Monoprint mounted on fabric, 16½ x 264½ in. (41.9 x 671.8 cm)
San Francisco Museum of Modern Art; Purchased through a gift of Phyllis Wattis
© Robert Rauschenberg/ Licensed by VAGA, New York, NY

the aisles pursued by a barking dog; David Tudor played music; and slides and movies were projected. Rauschenberg's paintings were shown as backdrops and Cage delivered a lecture that concluded with "a piece of string, a sunset, each acts."[62] News of the event, later titled *Theater Piece No. 7*, spread by word of mouth, and it became a key precedent for the subsequent performance activities known as Happenings. The following year, Rauschenberg expanded on his own performative "actions," laying a 22-foot-long strip of paper on the street, which Cage then drove over with the inked back wheel of his Ford (fig. 123).

In 1952, in addition to the Black Mountain event, Cage premiered *4' 33"* and *Water Music*. *4' 33"*—a concert inspired by Rauschenberg's white monochromatic paintings—consisted of four minutes and thirty-three seconds of David Tudor sitting silently at the piano. All the random noises within the auditorium during that period of time were considered "music." Cage's use of ambient sound was analogous to the use of found objects in assemblage. The score for another piece, *Water*

124. **John Cage**
Water Music, 1952
Ink on paper, ten sheets,
11 x 17 in. (27.9 x
43.2 cm) each; colophon
sheet, 9½ x 6 in. (24.1 x
15.2 cm)
Whitney Museum of
American Art, New York;
Purchase, with funds from
an anonymous donor
82.38a–j

125. **Marcel Duchamp**
*Étant Donnés: 1° la chute
d'eau, 2° le gaz
d'éclairage*, 1946–66
(view through door)
Mixed-media assemblage,
95 ½ x 70 in. (242.6 x
177.8 cm)
Philadelphia Museum of
Art; Gift of the Cassandra
Foundation

Music, called for a performer to pour water from one vessel into another, prepare the piano by inserting objects between the strings, make duck calls, blow whistles, and play with a radio (fig. 124).

Cage brought his Zen existential utopia to New York through lectures at the Artists' Club and classes in experimental music composition at the New School for Social Research (1958–59). His students included the future Fluxus artists George Brecht, Al Hansen, Dick Higgins, and Jackson Mac Low, as well as Allan Kaprow, who would go on to make Happenings. Cage's embrace of chance, indeterminacy, and ambient sound was as liberating for a younger generation of artists as Jackson Pollock's radical pictorial innovations had been. Cage's philosophy was shared by his friend and lifelong collaborator Merce Cunningham and could be felt in the undramatic movement of Cunningham's choreography, which eliminated narrative and emotion from dance.

If Cage was the contemporary mentor for this new aesthetic attitude, then Marcel Duchamp, living in New York from 1956 until just before his death in Paris in 1968, was the obvious precedent and cult hero. Though he purportedly stopped making art in 1926 to devote himself to playing chess, at the time of his death it was discovered that he had in fact been secretly working on a room-size tableaux, *Étant Donnés*, for almost two decades (fig. 125). Through two peepholes in a wooden door, one looks through a jagged hole in a brick wall at a nude woman lying on her back in a landscape. In her hand, she holds up a glowing gas lamp; in the background, a sparkling waterfall flows. Duchamp's libertine sexual mores, which often included reversals of gender identity, his antipathy to taste and style, his use of found objects, his wordplays, and his sense of irony had profound reverberations in American art from the 1950s on. It is probably safe to assume that his presence in America as an original Dada practitioner was of inestimable importance to the rising tide of Neo-Dada activity in the 1950s, reflected in the work of Cage, Rauschenberg, and many assemblage artists, as well as the paintings and objects of Jasper Johns.[63]

MODERN DANCE: CHANCE AND IMPROVISATION

Modern dance had begun with the explorations of Americans such as Loïe Fuller, Isadora Duncan, and Ruth St. Denis at the turn of the century. By the thirties and forties, historical modern dance (by the choreographers Martha Graham, Doris Humphrey, and José Limón, among others) had crystallized its techniques to emphasize weight and breath, and had established its concerns with political themes and symbolic emotional expression.

In the 1950s, however, several choreographers began to move in new directions, using different dance techniques, employing compositional methods that paralleled innovations in visual art, music, and theater, and collaborating with avantgarde artists and composers. Merce Cunningham had danced with Martha Graham and studied ballet with George Balanchine in the 1940s. He developed his own dance technique, a marriage of the flexible upper body of modern dance and the verticality and brilliant footwork of ballet. In 1951, working closely with John Cage as well as with other avantgarde composers, Cunningham introduced into choreography the chance methods favored by Cage in his musical composition (fig. 126). The effect of these chance techniques was to decentralize the dance in time and space, since both phrasing and spacing were determined aleatorically. Formally, Cunningham's dances bore a resemblance to the work of Abstract Expressionist painters; unlike them, however, Cunningham wanted to eradicate all marks of self-expression.

In 1954, Cunningham commissioned a set from the painter Robert Rauschenberg, who became the company's resident designer for the next ten years (fig. 127). Like Sergei Diaghilev's Ballets Russes earlier in the century, the Merce Cunningham Dance Company became a site where the most advanced experiments in contemporary art,

127. **Robert Rauschenberg**
Minutiae, 1954
Combine on wood structure, created as set for *Minutiae*, by the Merce Cunningham Dance Company
Sonnabend Collection, New York
© Robert Rauschenberg/ Licensed by VAGA, New York, NY

Johns, more than any other American artist, extended the legacy of Duchamp into the area of painting. While Rauschenberg's work seemed spontaneous and exuberant, Johns' was much more studied and his choice of subjects more deliberate. He used public imagery—flags, targets, numbers, and letters—"things the mind already knows," as he said (figs. 131, 132, 135). Although Johns' cerebral work seemed contrary to the vibrant rough edges of the New York School, it nevertheless retained a handmade sensuality through carefully crafted encaustic surfaces, which he achieved by blending pigment into hot wax. The first review of his work noted that "the commanding sensuous presence of [the paintings'] primer-like imagery. . .has the rudimentary, irreducible potency of the best of Abstract Expressionism," but that there was added poignancy in the "beloved, handmade transcription of unloved, machine-made images."[64]

Jasper Johns first came to New York from South Carolina in 1948. Six years later, he met Robert Rauschenberg, a meeting that would irrevocably alter the course of American art history. From 1956 to 1961, the two shared loft space in lower Manhattan. During this period, they nourished and encouraged each other in many ways, producing exceptional bodies of work, opening up territory that would be mined by artists for decades.

music, and dance met on the stage. But in Cunningham's work all three arts retained their autonomy, coexisting without necessarily accompanying one another.

James Waring (fig. 128) was another experimental choreographer whose work in the 1950s diverged from mainstream modern dance. He applied collage techniques derived from visual art to his often witty or fantastical choreography, which made use of ballet technique as well as popular dance styles from earlier periods. He also collaborated with contemporary composers (Richard Maxfield and John Herbert McDowell), visual artists and Happenings makers (Jasper Johns, George Brecht, Robert Indiana, Robert Whitman, and Red Grooms), and poets (Diane DiPrima).

Cunningham and Waring were based in New York from the 1940s on. Anna Halprin, working in northern California, was another influential dancer, choreographer, and teacher during this time. Her analytic approach to anatomy and kinesiology and her use of free improvisation and natural settings (her students worked out-of-doors on a mountain platform) led to an intuitive, community-rooted form of dance that blurred boundaries between art and life (fig. 129). Halprin, too, collaborated with painters, musicians, and poets, as well as her husband, the architect Lawrence Halprin. In the early sixties, her students included Simone Forti, Yvonne Rainer, and Robert Morris.

Though different in many respects, Cunningham, Waring, and Halprin were all committed to experimentation—to regenerating dance through infusions of ideas from the broader culture. In this way, they made the fifties a hotbed of revolution. —S. B.

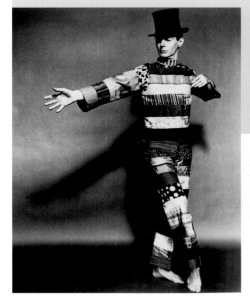

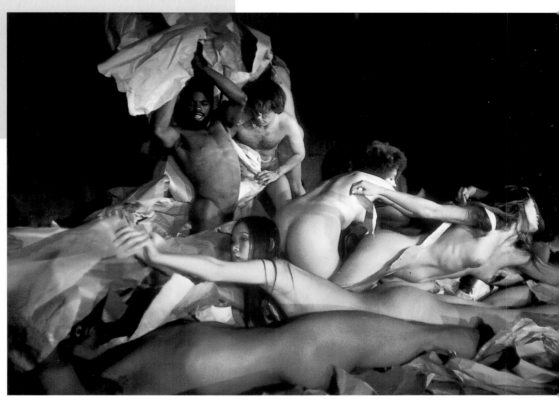

128. *James Waring*, late 1950s–early 1960s Cunningham Dance Foundation, New York

129. Anna Halprin's Dancers' Workshop Multiracial Company in *Parades and Changes*, choreographed by Anna Halprin, 1965, photograph by Paul Fusco/Magnum Photos

130. Jasper Johns
Flag, 1954–55 (dated on reverse 1954)
Encaustic, oil, and collage on fabric mounted on plywood, 42¼ x 60⅝ in. (107.3 x 154 cm)
The Museum of Modern Art, New York; Gift of Philip Johnson in honor of Alfred H. Barr, Jr.
© Jasper Johns/Licensed by VAGA, New York, NY

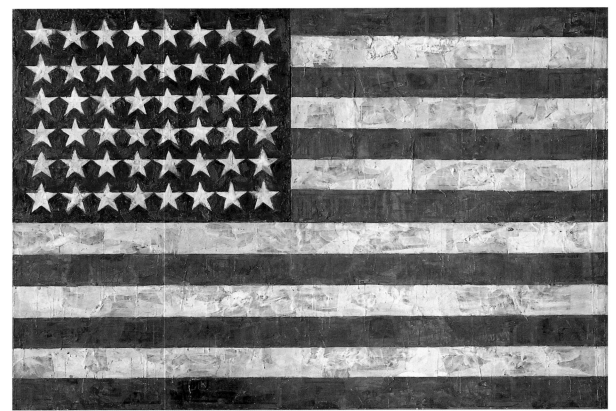

131. Jasper Johns
Green Target, 1955
Encaustic on newspaper and cloth over canvas, 60 x 60 in. (152.4 x 152.4 cm)
The Museum of Modern Art, New York; Richard S. Zeisler Fund
© Jasper Johns/Licensed by VAGA, New York, NY

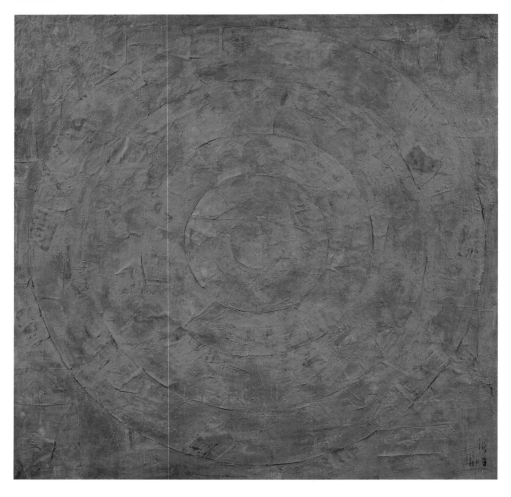

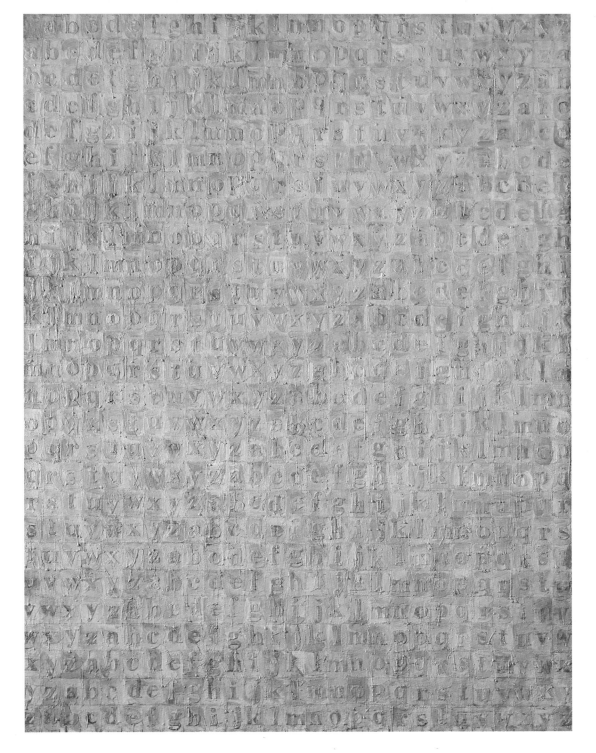

132. **Jasper Johns**
Grey Alphabets, 1956
Beeswax and oil on newsprint and paper on canvas, 66⅛ x 48¾ in. (168 x 123.8 cm)
The Menil Collection, Houston
© Jasper Johns/Licensed by VAGA, New York, NY

Rauschenberg was the better known of the two when he and Johns met. He had already shown at the Betty Parsons Gallery, and Leo Castelli had included him in the infamous "Ninth Street Show" in 1951—an exhibition in a vacant East Village storefront space that brought together older Abstract Expressionists with younger artists (fig. 133). The exhibition was so popular that it was continued as an annual salon-type event at Eleanor Ward's Stable Gallery, dominated by a New York School aesthetic. In 1955, Johns submitted work to the show and was rejected. In response, Rauschenberg made and exhibited *Short Circuit* (fig. 134). This altarlike assemblage contained works by artist friends of Rauschenberg: a small Johns flag painting, the first of this series; a painting by Rauschenberg's wife at the time, Susan Weil; as well as a program from a John Cage concert and Judy Garland's signature (a collage by correspondence artist Ray Johnson and a piece by Stan Vanderbeek were not finished in time). By including artists who had been rejected or neglected, Rauschenberg's entry was literally intended to "short-circuit" the selection process of the "Ninth Street Show."[65]

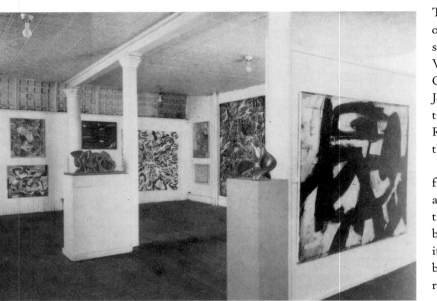

133. Installation view of the "Ninth Street Show" at Leo Castelli Gallery, New York, 1951

At the time of the exhibition, Johns, then only twenty-five, had already produced his breakthrough series of Flags and Targets. Dispensing with the emotional dramatics of the New York School, but retaining the mark of the hand or brushwork, he treated the painting as an object and allowed its literal qualities to dominate. In *Canvas*, for instance, he brought the stretcher bars to the front of the canvas, thus revealing the physical structure of the painting. In a work such as *Flag* (fig. 130), he presented the image-as-object—just as Rauschenberg was presenting the image-as-material. The flag's iconic form corresponds to its depicted shape. Johns' Flags, and the Targets as well, are thus spatial equivalents of their images (fig. 136).

134. **Robert Rauschenberg**
Short Circuit, 1955
Combine painting, 40¾ x 37½ in. (103.5 x 95.3 cm)
Collection of the artist
© Robert Rauschenberg/
Licensed by VAGA, New York, NY

By rejecting the traditional figure-ground relationship in painting—the relationship of a depicted form to the space it inhabits—Johns upset cherished notions about illusion versus reality: are we seeing a rendering of a flag, or a flag? He questioned what an object is and how we know it, and what an image is. His paintings stand as an inquiry into the paradoxical relationship between the object represented and its representation. Johns would later use broad painting strokes—streaks, smears, drips—in a variety of colors as images themselves to parody Abstract Expressionist heroics. But *Painting with Two Balls* (fig. 137) also introduces sexual imagery, another element that persists throughout Johns' work. Personal symbolic references abound, despite the visual air of cool detachment, and we are offered clues and codes that beg deciphering. Johns' layered symbolism was inherited from Duchamp, as was his frequent reference to the body through the inclusion of casts of body parts, handprints, and painted forms. The objecthood of Johns' work would reverberate for decades—in Minimalism, for instance; his use of popular symbols and common images became prototypes for Pop art; and his incorporation of the body established a framework for later generations.

Johns' seminal pieces, such as the Flags and Targets, and Rauschenberg's first Combines were executed around 1955, during the heyday of the Artists' Club and

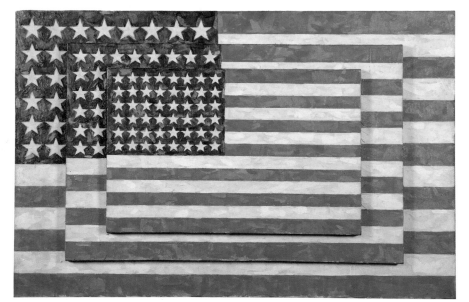

135. **Jasper Johns**
Three Flags, 1958
Encaustic on canvas,
30⅞ x 45½ x 5 in.
(78.4 x 115.6 x 12.7 cm)
Whitney Museum of
American Art, New York;
50th Anniversary Gift of
the Gilman Foundation,
Inc., The Lauder
Foundation, A. Alfred
Taubman, an anonymous
donor, and purchase
80.32
© Jasper Johns/Licensed
by VAGA, New York, NY

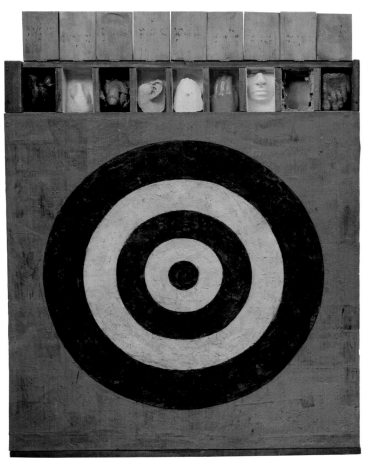

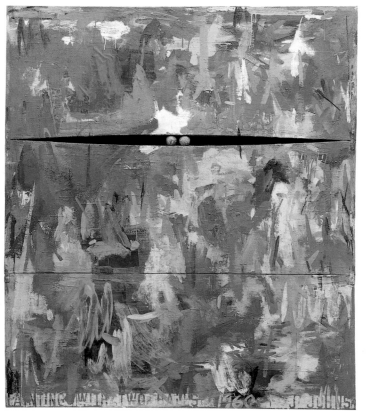

136. **Jasper Johns**
Target with Plaster Casts,
1955
Encaustic and collage on
canvas with objects,
51 x 44 x 2½ in.
(129.5 x 111.8 x 6.4 cm)
Collection of David Geffen
© Jasper Johns/Licensed
by VAGA, New York, NY

137. **Jasper Johns**
Painting with Two Balls,
1960
Encaustic and collage on
canvas with plaster casts,
65 x 54 in. (165.1 x
137.2 cm)
Collection of the artist
© Jasper Johns/Licensed
by VAGA, New York, NY

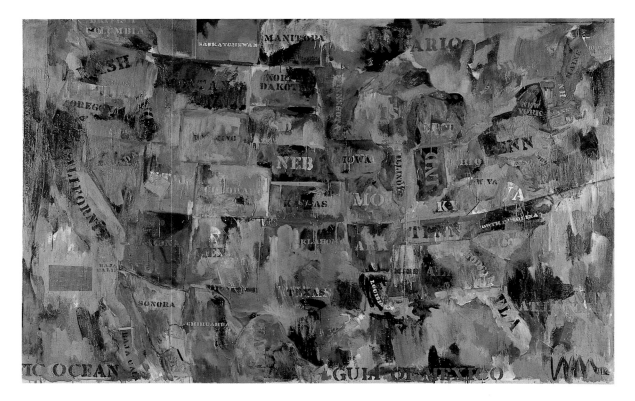

Cedar Tavern. But neither artist came into wide public prominence until 1958, with their first one-artist exhibitions at the Leo Castelli Gallery. In January 1958, Johns' *Target with Four Faces* was on the cover of *Art News*, and Rauschenberg's *Bed* was reproduced in the *Newsweek* article "Trend to the 'Anti-Art.'" The Museum of Modern Art bought four works from Johns' first exhibition. These events took place as Abstract Expressionism was just beginning to receive broad, international recognition. But the instant notoriety Johns and Rauschenberg achieved in 1958 signaled that a change was already afoot in the American art world. Independently and together, they had transformed American art. Both had introduced things looked at but not really seen and had used literal objects of everyday life and blatant American imagery. The strategies in their hybrid works had reconceptualized traditional genres of art by challenging underlying assumptions about representation. Together with Cage and Cunningham, they initiated a new aesthetic, one based on cool detachment and one diametrically opposed to the emotive dramatics of Abstract Expressionism.

ENVIRONMENTS AND HAPPENINGS

Other artists brought real life into art through the creation of environments—actual spaces, often filled with real objects and materials. These artists, however, many of whom began as assemblage sculptors, used visual strategies that owe more to Abstract Expressionism than to the conceptual framework established by Johns and Rauschenberg. The environments of Allan Kaprow, George Segal, Lucas Samaras, Claes Oldenburg, Jim Dine, and Red Grooms are assembled with a spontaneity, visceral energy, and gestural expressiveness that create a three-dimensional assemblage extension of an Abstract Expressionist sensibility.

The environment had precedents in Kurt Schwitters' room-size *Merzbau* (1924–33), a Constructivist sculpture assembled in his own home out of junk, and in the radical, visionary architecture and exhibition design of Frederick Kiesler, whose works include *Endless House* (fig. 140), an unrealized project for proto-

architectural sculpture, and exhibition installations such as "Blood Flames" (fig. 139), in which painted bands of color turned the gallery into a sculptural environment. Even the huge, mural-scale paintings of late Monet or the Abstract Expressionists could be construed as environments. But the environments created by the younger artists, such as Allan Kaprow, conveyed a strong sense of flux, disorder, and impermanence (figs. 141, 142), an effect ill suited to established galleries and museums.

The showcases for this burgeoning art were small, mostly newly formed experimental galleries. Among them, in New York, were the Hansa Gallery (1952), a co-op founded by former students of Hans Hofmann; the Reuben Gallery (1959); the Judson Gallery (1958), in the basement of the Judson Memorial Church; and Red Grooms' City Gallery (at first located in his studio and later transmuted into the Delancey Street Museum). On the West Coast, the Six, Batman, and Dilexi Galleries in San Francisco and the Ferus Gallery in Los Angeles were also hosting

139. **Frederick Kiesler**
Installation of "Blood Flames" at the Hugo Gallery, New York, 1947

140. **Frederick Kiesler**
Model for the Endless House, 1959
Cement and wire mesh with plexiglass, 38 x 97¼ x 42 in. (96.5 x 247 x 106.7 cm)
Whitney Museum of American Art, New York; Gift of Mrs. Lillian Kiesler 89.8

environments and installations by such assemblagists as Wallace Berman, George Herms, Bruce Conner, and Edward Kienholz. These experimental venues—often the same ones that sponsored Beat poetry readings and independent-film screenings—played a critical role in supporting the expanding American avant-garde. Their vision is all the more astonishing given the noncommercial and ephemeral nature of environments.

Jim Dine's *The House* and Claes Oldenburg's *The Street* (fig. 143) were three-dimensional environments shown at the Judson Gallery in 1960. Both were

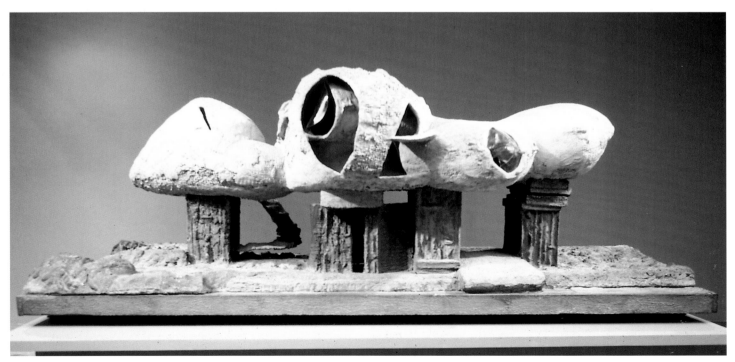

141. **Allan Kaprow**
Yard, 1961
Environment in the
backyard of the Martha
Jackson Gallery, New York
The Getty Research
Institute, Research
Library, Allan Kaprow
Archives, Los Angeles;
Courtesy of Wolfgang
Feelisch, Remscheid,
Germany
Photograph © Robert R.
McElroy/Licensed by
VAGA, New York, NY

142. **Allan Kaprow**
Words, 1962
Environment at the
Smolin Gallery, New York
The Getty Research
Institute, Research
Library, Allan Kaprow
Archives, Los Angeles
Photograph © Robert R.
McElroy/Licensed by
VAGA, New York, NY

143. **Claes Oldenburg**
The Street, 1960
Performance at the Judson
Gallery, Judson Memorial
Church, New York,
photograph by Martha
Holmes

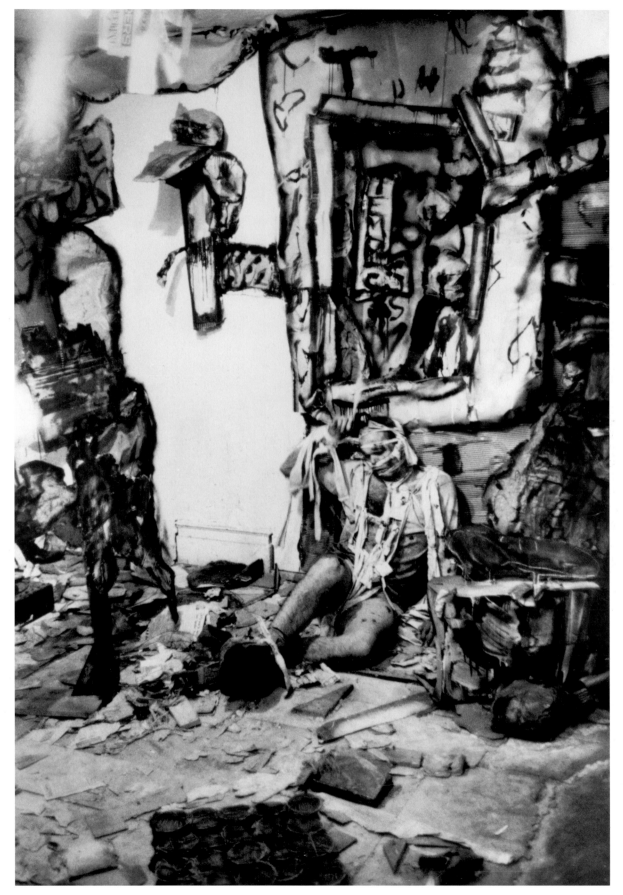

essentially assemblage spaces heavily encrusted with accumulations of found objects. *The House* used scavenged things such as bedsprings and newspapers, while *The Street*, an epic construction of paint on cardboard and newspaper, included drawings of standing, lying, and running figures, signs, marquees, and metamorphosed objects: cigar butts, houses, towers, and cars (fig. 143). Dine and Oldenburg both used urban cast-offs such as rags, cardboard, crates, string, and newspaper to achieve a crude, textural richness and a new palette of browns, blacks, and grays that some viewed as a continuation of the realism of the earlier twentieth-century Ashcan School. In an ecstatic list reminiscent of Jack Kerouac's description of Robert Frank's photographs, Oldenburg described the contrasts, excitement, and rhythms of the street, the tide of life that would be embodied in his installation:

144. **Edward Kienholz**
The Beanery, 1965
Mixed-media environment,
84 x 72 x 22 in. (213.4 x
182.9 x 55.9 cm)
Stedelijk Museum,
Amsterdam

> *There will be men and women and heroes and bums and children and drunks and cripples and streetchicks and boxers and walkers and sitters and spitters and trucks and cars and bikes and manholes and stoplights and shadows and cats and doggys and bright light and darkness; fires and collisions and cockroaches and mornings and evenings and guns and newspapers and pissers and cops and mamagangers and a lot more etc.*[66]

For Oldenburg and other artists, the street was a microcosm of the world and the cycle of life—a place of impermanence and excitation. Like the work of the Beats before him, Oldenburg's art was one of a brutally honest realism:

> *I am for an art that imitates the human, that is comic, if necessary, or violent, or whatever is necessary. I am for an art that takes its form from the lines of life itself, that twists and extends and accumulates and spits and drips, and is heavy and coarse and blunt and sweet and stupid as life itself.*[67]

Edward Kienholz shared Oldenburg's taste for an honest view of all sides of human nature. In his room-scale tableaux of the early sixties, the sordid nature of humanity is conveyed through the searing graphic detail of a freak show. Kienholz was the most important West Coast assemblage artist to extend his work into environments that engaged the body and mind. In *Roxy's*, a re-creation of an Idaho whorehouse, the madam has a boar skull for a head and is surrounded by other chilling hybrid figures, among them Five Dollar Billy with the word "fuck" carved on his base. Kienholz's work is a theater of cruelty suffused with social satire, commenting on capital punishment, illegal abortions, bigotry, and other forms of human degradation. In *The Beanery*, he re-created a West Hollywood bar and café out of junk (fig. 144). This walk-through work features patrons with clocks in place of faces. Time is frozen at 10:10. The palpable presence of death is accompanied by an audiotape of music, clinking glasses, and laughter.

The elaborate and spontaneous tableaux of Claes Oldenburg, Jim Dine, Robert Whitman, Allan Kaprow, and Red Grooms (fig. 151) soon became a stage for public events that led to the emergence of a new art form called Happenings. Happenings, in which the event itself was dominant, grew out of Action Painting and junk environments in combination with John Cage's aesthetic philosophy.

Kaprow, one of Cage's students, had early on seen the potential for literalizing Action Painting—by extending the performative aspect of Abstract Expressionism into both three-dimensional environments and live-performance events for an audience. He envisioned Jackson Pollock's expansive movements carried forward through "total art" in "entirely unheard of happenings and events, found in garbage cans, police files, hotel lobbies, seen in store windows and on the streets, and sensed in dreams and horrible accidents."[68]

The first self-described Happening was Kaprow's *18 Happenings in 6 Parts*, presented for the opening of the Reuben Gallery in 1959 (fig. 145). Translucent

plastic divided the space into three parts, in which various people acted out differ-
ent activities simultaneously in meticulously orchestrated sequences—bouncing a
ball, playing records, performing simple body movements while lights went off
and on and slides were projected on the
walls. The simultaneous actions and
lack of central focus, narrative, or cli-
max were reminiscent of John Cage's
1952 Black Mountain event.

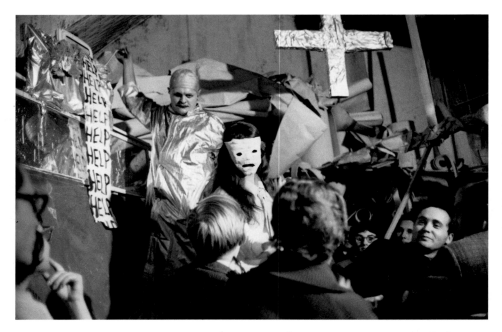

148. **Jim Dine**
Car Crash, 1960
Performance at the Reuben
Gallery, New York
Photograph © Robert R.
McElroy/Licensed by VAGA,
New York, NY

149. **Jim Dine**
The Smiling Workman,
1960
Performances at the Judson
Gallery, Judson Memorial
Church, New York,
photograph by Martha
Holmes

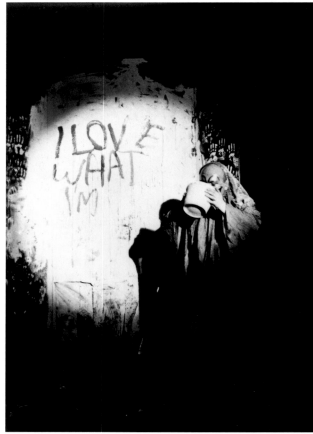

In 1960, in conjunction with his
environment *The Street*, Oldenburg
organized a series of performances
called *Ray Gun Spex*. Spex was short for
"spectacle," which in his native Swedish
referred to burlesque. During one of the
performances, *Snapshots from the City*,
thirty-two tableaux emerged from the
darkness to represent the squalor, danger,
and misery of the urban world (fig. 146),
a mood continued in Oldenburg's *Ray
Gun Theater* performance of 1962 (fig.
147). Dine's installation *The House* also
served as a backdrop for performances.
Dine's performances were more personal
than Oldenburg's—in one, dressed in
a silver suit and his head bandaged, he
recounted his experience in a car crash,
punctuating the narrative with cries for
help (figs. 148, 149).

Many of the Happenings had a
burlesque and carnivalesque spirit. Red
Grooms cultivated a raucous, circus
atmosphere and farcical style using ele-
ments from pop and vernacular culture
such as the comic book character Dick
Tracy and the Statue of Liberty. His
events were an outgrowth of his own
second-generation Abstract Expres-
sionist figurative painting melded with
street life and graffiti (fig. 150). Despite
some differences in approach, all these
artists were part of a small, interlock-
ing community, and many of them
used one another—and mutual friends
such as Lucas Samaras, Alfred Leslie,
George Segal, Robert Whitman, and
Al Hansen—as performers.

Happenings were non-narrative
theatrical events with a fairly limited
audience and they took place primarily
in galleries. In these venues, they challenged the separation between media and
extended art into real space and time—and sometimes into an assault on the audi-
ence. Often forced to stand in semidarkness and endure loud noises, spectators

150. **Red Grooms**
The Burning Building,
1959
Performance at the
Delancey Street Museum,
New York

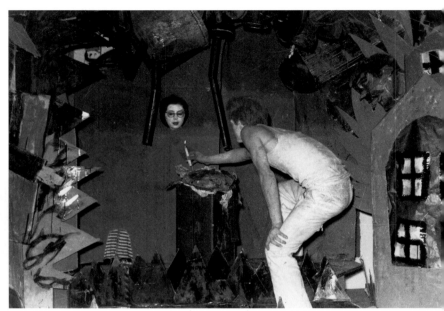

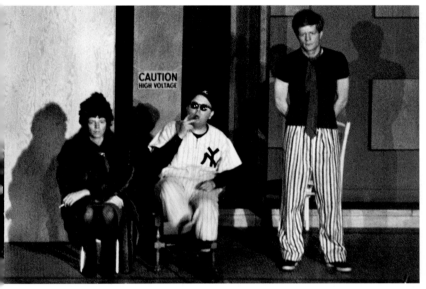

151. **Jill Johnston, Henry
Geldzahler,** and **Red
Grooms**
Dance-Lecture-Event #2,
1962, at Judson Memorial
Church, New York
Photograph © The Estate
of Peter Moore/Licensed
by VAGA, New York, NY

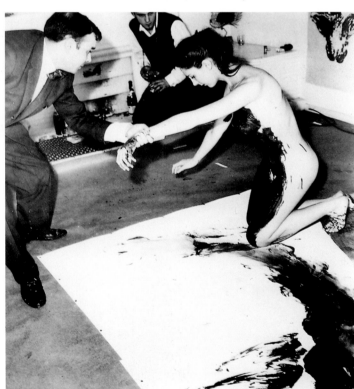

152. **Yves Klein**
*Anthropométries de
L'Époque Bleue,* 1960
Performance at the
Galerie Internationale
d'Art Contemporain, Paris

were in close proximity to the event and thus active participants. The space of the event infringed on, or sometimes included, their own.

Performance events were an international phenomenon by 1960. In Paris, Yves Klein used human bodies as paintbrushes (fig. 152), and Niki de Saint Phalle created ready-made Action Paintings by shooting balloons full of paint onto canvas; in Japan, Kazuo Shiraga crawled through mud to create his art. Whether part of the French Nouveaux Réalistes, the Japanese Gutai Group, or the Viennese Actionists, these artists turned to actions as an expression of a deeply felt existential dilemma.[69] It may have been the existential need to live in the here and now no less than a rejection of establishment values that led these artists to practice a decidedly unsalable form of art. At the time, of course, few artists expected to make a living selling their work, even though by the end of the fifties Abstract Expressionism was catching on commercially (Pollock's *Autumn Rhythm: Number 30*, for example, was sold to The Metropolitan Museum of Art for $30,000 in 1957). Assemblage was difficult for collectors and institutions to accommodate both as a matter of taste and because conservation questions arose about "impermanent" and "unstable" materials. But environments and Happenings were next to impossible to collect and existed completely outside of a commercial framework. The artists wore their marginal position and underground status as a badge of honor. The mainstream nevertheless proved capable of absorbing everything. Even rebels, it seemed, could not avoid publicity or commodification, and soon museums were planning Happenings, and *Newsweek* was running an article entitled "Trend to the 'Anti-Art.'"[70]

In the winter of 1961–62, Oldenburg conceived a clever project that would play off the idea of art as commodity.

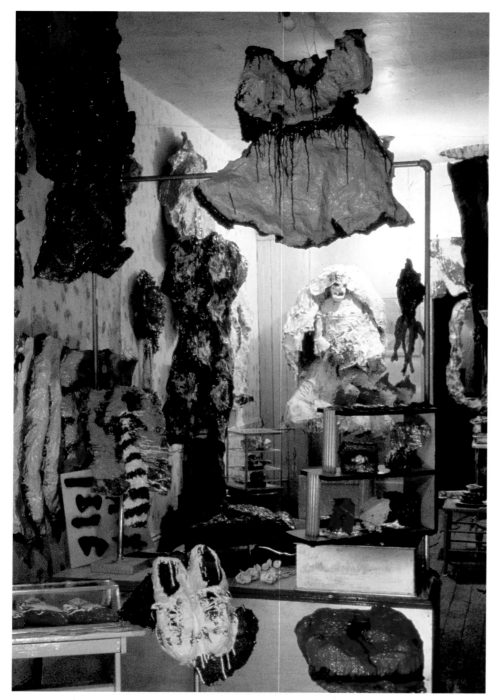

153. **Claes Oldenburg**
The Store, 1961
Mixed-media environment
Photograph © Robert R. McElroy/Licensed by VAGA, New York, NY

In a rented storefront on New York's Lower East Side, he made and arranged more than a hundred plaster items to create the environment of a shop. These items, resembling food, clothing, and jewelry, were offered for sale in *The Store* (fig. 153). When one object was sold, he would make another one on the spot. Oldenburg's project conflated the old dichotomies of studio and gallery, creation and commerce, art and work, while his use of ordinary consumer goods signaled an emerging Pop sensibility.

FLUXUS

The idea of creating a store—a blatant mix of art and commerce where artists could take charge of distribution and make their inexpensive work accessible—also appealed to the Fluxus artists, who opened a "Fluxshop" in 1964 to sell their art and multiples. Fluxus, a loosely organized international art movement, had emerged in the early sixties. The name Fluxus was coined in 1961 by George Maciunas, a Lithuanian-born artist living in New York. Maciunas was the chief promoter and impresario of Fluxus, and he created a manifesto using the dictionary definition of flux: "Act of flowing: a continuous moving on or passing by, as of a flowing stream; a continuing succession of changes."[71] Fluxus echoed the Neo-Dada, anti-art sentiment of so much art of the time and was also indebted to John Cage. Indeed, many of the American artists associated with Fluxus (Dick Higgins, Al Hansen, George Brecht, Jackson Mac Low, La Monte Young) had also studied with Cage at the New School for Social Research.

Though much of Fluxus was expressed through publications, objects, and events, it originated in avant-garde music. In fact, it was the first avant-garde movement of the century driven by music. Maciunas began to organize concerts in 1961 at his AG Gallery in New York; when he moved to Wiesbaden, Germany, the following year, he called them Flux Festivals. The festivals became a forum where a loose association of artists from France, Germany, Denmark, the United States, Japan, and Korea began to form their Fluxus identity. Fluxus, true to its name, was not easily contained geographically or, for that matter, easily defined—its spatial and temporal boundaries were deliberately ambiguous.

154. **Nam June Paik**
Zen for Head, 1962
Performance of La Monte
Young's *Composition 1960
#10 to Bob Morris* at the
Fluxus Internationale
Festspiele Neuster Musik,
Wiesbaden, Germany
© DPA/IPOL

One of the early participants in the Flux Festivals was Nam June Paik, a Korean-born artist who had been a student of avant-garde music. In the late fifties, Paik, then living in Cologne, met John Cage through the German experimental music scene. At the first Flux Festival, in 1962 in Wiesbaden, Paik dipped his head, tie, and hands in a mixture of ink and tomato juice and dragged them along a length of paper. This event, *Zen for Head*, was Paik's interpretation of La Monte Young's earlier score *Composition 1960 #10 to Bob Morris*, whose instructions read, "Draw a straight line and follow it" (fig. 154). As a performance based on a score that produced a visual object, *Zen for Head* perfectly encapsulated the transformative spirit of Fluxus.

155. *John Cage Preparing
a Piano*, c. 1950
Cunningham Dance
Foundation, New York

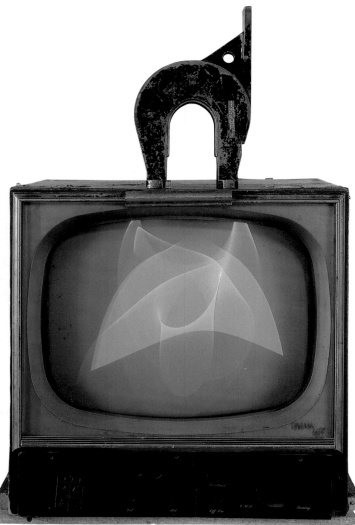

156. **Nam June Paik**
Magnet TV, 1965
Black-and-white 17"
television set with magnet,
28⅜ x 19¼ x 24½ in.
(72.1 x 48.9 x 62.2 cm)
overall
Whitney Museum of
American Art, New York;
Purchase, with funds
from Dieter Rosenkranz
86.60a–b

157. **Nam June Paik**
Integral Piano, 1958–63
Piano with objects, 53½ x
55 x 17¾ in. (135.9 x
139.7 x 45.1 cm)
Museum of Modern Art,
Ludwig Foundation,
Vienna

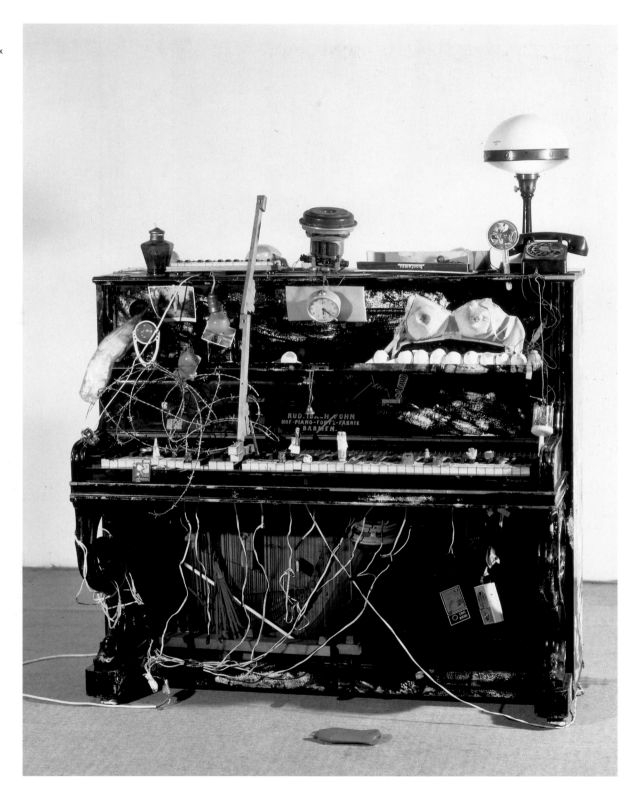

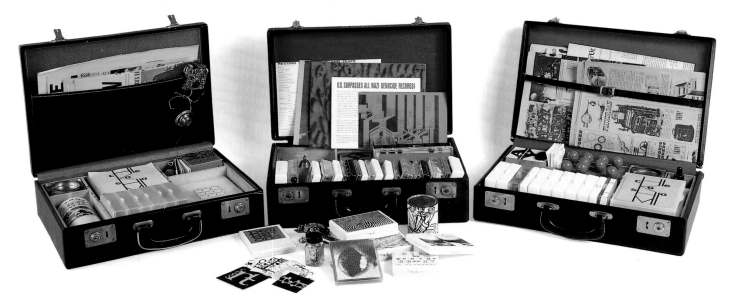

158. **Fluxus**
Fluxkits, 1964–65
Vinyl cases with mixed
media, 12 x 17½ x 5 in.
(30.5 x 44.5 x 12.7 cm)
each
The Gilbert and Lila
Silverman Fluxus
Collection, Detroit

159. **Fluxus**
Flux Year Box 2, c. 1968
Wood boxes with mixed
media, 8 x 8 x 3⅜ in.
(20.3 x 20.3 x 8.6 cm)
each
The Gilbert and Lila
Silverman Fluxus
Collection, Detroit

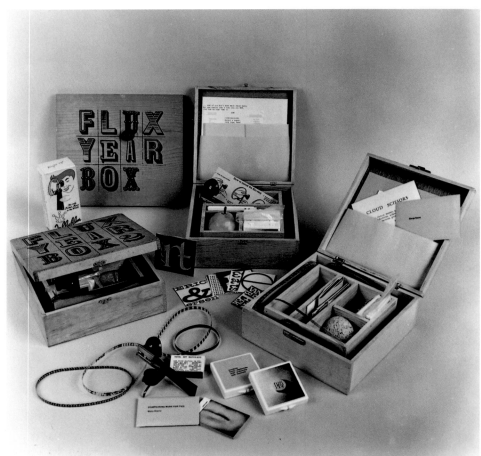

In another work, Paik, taking cues from Cage's notion of the prepared piano—objects placed on or between the strings (fig. 155)—made elaborate assemblages from three pianos, which were then to be performed on (fig. 157). One of the performers was the German artist Joseph Beuys, who hacked a piano apart with an ax. Paik soon extended this practice to "prepared" televisions, in which objects such as magnets affected the pattern on the screen (fig. 156). Creation and destruction were part of one continuous cycle in Fluxus philosophy.

160. **Nam June Paik** and **Charlotte Moorman**
Performance of John Cage's "26' 1.1499" for a String Player" at Café à Go Go, New York, 1965
Photograph © The Estate of Peter Moore/Licensed by VAGA, New York, NY

Taking further impetus from Cage, specifically his idea of the conceptual score, many Fluxus artists, including Paik, George Brecht, La Monte Young, and Yoko Ono, created scores for music-performance events in which a simple, Zen-like phrase served as the instructions. These scores were for single-gesture actions in which personal interpretation, chance operations, and audience participation determined the result. Brecht's *Drip Music (Drip Event)* score, for instance, reads, "For single or multiple performance. A source of dripping water and an empty vessel are arranged so that the water falls into the vessel. Second version: Dripping." Yoko Ono held performance and music events in her downtown loft beginning in 1961. One of her works, *Sun Piece*, instructs, "Watch the sun until it becomes square." Scores by other artists called for climbing into a bathtub full of water or releasing butterflies into the performance area. Nam June Paik performed a piece in which the cellist Charlotte Moorman used his body as an instrument (fig. 160). What these Fluxus pieces tested was the minimum requirement for music. Some Fluxus artists also made Fluxfilms that, like these events, concentrated on one performative action.

Meanwhile, Maciunas dedicated himself to publishing and creating editions and multiples: *Fluxkits, Fluxboxes, Fluxyearbooks* (figs. 158, 159). They contained games, puzzles, event scores, and loose printed materials by Fluxus artists, all assembled in boxes that were sold in the Fluxshop or through mail order. Although the most productive phase of Fluxus was from 1962 to 1964, its spirit lived on. The sparse and conceptual aesthetic of Fluxus—in contrast to the spontaneous experience of the Abstract Expressionists, the Beats, and most of the artists involved with Happenings—provided an important precedent for Conceptual art and Minimalism. But because its boundaries were always in flux, it has often been omitted from official histories of art. To revise these histories, Fluxus must be seen together with Happenings, the Beats, and assemblage as creative inventions that ushered in the real world and brought high art into the realm of everyday life.

New
Frontiers
1960–1967

The 1960s opened with the inauguration of President John F. Kennedy in January 1961—at forty-three, the nation's youngest president. His youth, energy, and charisma inspired confidence and enthusiasm at a time of increasing political and economic influence for the United States. Kennedy's tenure in office was marked by several events that reinforced America's sense of self-assurance in the international sphere. In 1962, when it was discovered that the Soviet Union had installed missiles in Cuba, the president forced the Russians to remove them in a tense encounter that Kennedy won through diplomacy, dialogue, and restraint. The following year, the Soviet Union and the United States signed the Nuclear Test Ban Treaty, an important, if short-lived, relaxation of Cold War tensions. And nothing symbolizes the spirit of the time more than Kennedy's enthusiastic support for the space program, including his ambitious goal of landing Americans on the moon before the end of the decade.

Kennedy also initiated two important pieces of domestic legislation: a tax-cut bill, which stimulated the economy and put money back into the hands of the middle class and corporate America; and the more important civil rights bills, which were ultimately pushed through Congress by his successor, Lyndon B. Johnson. Kennedy had won 70 percent of the black vote in the election, but moved cautiously at first on civil rights reforms, believing that black America should develop

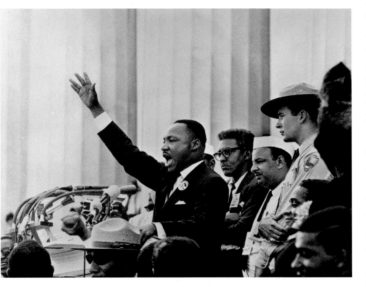

161. *Martin Luther King, Jr., Delivering His "I Have A Dream" Speech on the Steps of the Lincoln Memorial, Washington, D.C.*, 1963, photograph by Bob Adelman

political power through the polls. Only after riots broke out in Birmingham, Alabama, did Kennedy consider serious civil rights legislation. The 1963 march on Washington, D.C., at which Martin Luther King, Jr., delivered his famous "I Have a Dream" speech (fig. 161), galvanized support for civil rights reforms.

John F. Kennedy is also recognized as the first president to fully understand and exploit the power of television. During the election campaign, he debated with the Republican candidate Richard Nixon on live television, and his striking physical presence helped win him votes (fig. 163). In 1962, Jackie Kennedy gave a televised tour of the newly redecorated White House, bringing the domestic milieu of the First Family into the homes of every American. The Camelot years, as they have come to be known, formed a media event in which the entire nation participated—as it did during the tragic days of November 1963, after Kennedy was assassinated, when tens of millions of people watched clips of the shooting over and over again, and attended the solemn funeral through broadcast television (fig. 162).

162. *John F. Kennedy's Funeral Procession*, 1963

As Kennedy understood, the power and the influence of the media was here to stay. The media fed the consumer culture through advertising and the promotion of a lifestyle that encouraged spending on both necessities and luxuries. By 1960, the acquisition of manufactured goods was becoming a national pastime.

Television sets and cars joined apple pie and the flag as quintessential symbols of America.

The culture of consumption had begun to transform America drastically in the fifties. McDonald's was founded in 1955, and the Disneyland Park opened the same year (fig. 164). Standardization and mass production reinforced the status quo, while allowing higher-quality goods to reach ever-larger audiences at home and abroad. Everyone could enjoy a hamburger or a Coke, and, as Andy Warhol said, they tasted the same to the queen of England and the man on the street.

Cognizant of the fierce competition to reach this burgeoning consumer culture, companies employed brilliant designers such as Charles Eames and Donald Deskey to distinguish their products (fig. 166). Many of the era's classic products (the Bertoia chair, Eames lounge chair, Saarinen pedestal table) and packaging designs (Crest, Tide [fig. 165], Brillo, Heinz Catsup, Coca-Cola) are still in production and on the shelves with only slight updatings forty years later.

Promotion, advertising, and market research became billion-dollar industries designed to persuade consumers to buy, even if it meant using sublimated messages and unrealistic promises. A new shampoo could bring you romance, a new laundry detergent a happier home, and a brand of cigarettes greater virility. Motivational analysts were called on to find ways to sell by manipulating subconscious fears, desires, guilt feelings, and anxieties.[72] The imagery of advertising had become so pervasive—and invasive—that it was an essential feature of American life and identity.

163. *Televised Debate Between Vice President Richard M. Nixon and Senator John F. Kennedy*, 1960
UPI/Corbis-Bettman

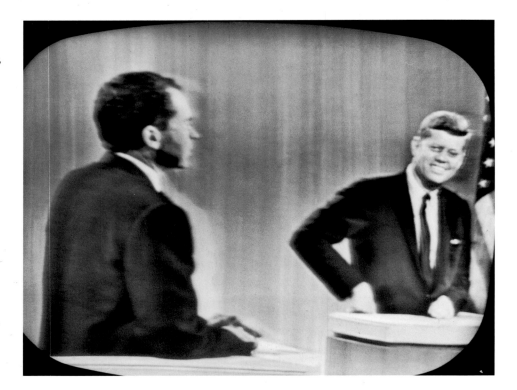

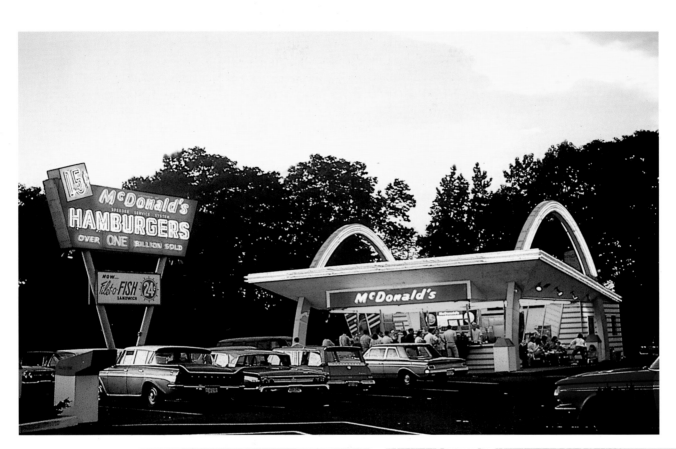

164. *McDonald's Restaurant, Des Plaines, Illinois*, c. 1955–56

165. *Tide Box*, 1958
Procter & Gamble
Archives, Cincinnati

166. *Donald Deskey with Packaging Designs for Procter & Gamble*, 1950s
Procter & Gamble
Archives, Cincinnati

THE 1964 WORLD'S FAIR

The look and atmosphere of the 1964 World's Fair in Flushing Meadows, New York (fig. 167), reflected the new consumer landscape. The 1939 World's Fair, held on the same grounds, had been seen as a beacon of light out of the Depression. The 1964 Fair, by contrast, celebrated the success and monopoly of big business. Robert Moses, president of the Fair, fostered free-market competition. Most of the pavilions were devoted to corporate giants such as General Electric, IBM, Ford, General Motors (GM), Goodyear, and DuPont. Images of consumption in the design of the pavilions were as evident as in Pop art: the Goodyear Ferris wheel in the shape of a tire; the IBM building (designed by Eero Saarinen and Charles Eames) resembling the new Selectric typewriter ball; the GM building's cantilevered, curving wall that inclined away from its base to look like an automobile tail fin. These buildings were blatant advertisements—architecture as signs, in keeping with the developing roadside architecture of the commercial strip or the crazy, fanciful commercial imagery of Las Vegas architecture, which would soon be mined by Pop architects such as Robert Venturi.

167. **Gilmore D. Clarke** and **Peter Muller-Munk Associates**
Unisphere, from the 1964 World's Fair, New York
World's Fair Archives, The Queens Museum of Art, New York

The published themes for the Fair were "achievements in an expanding universe," "peace through understanding," and "it's a small world," all reinforcing the old credo that progress through science and technology would unite the world, that new technologies and broadening communications would foster greater understanding and peace and turn the world into a global village.

Another infatuation of the World's Fair was the new phenomenon of space exploration, following Alan Shepard's foray into space in 1961. Numerous displays, exhibits, and simulated rides into space dominated the Fair. New technologies and communications tools were also featured as the information age dawned: satellites, lasers, undersea cables, computers, photocopying machines, and nuclear power. The Fair also became an occasion to introduce innovative products such as recycling machines, synthetic heart valves, synthetic polymers for clothing, and plastics.

The environmental implications and potential disasters lurking behind these new technologies were not yet comprehended by the public, which accepted the inventions as evidence of progress. It was not until the disasters of Vietnam, the energy crisis, Three Mile Island, Love Canal, acid rain, the hole in the ozone layer, the Star Wars weapons program, Bhopal, Chernobyl, and the explosion of the space shuttle *Challenger* that Americans began to question their naive and idealistic views about the wonders of technology and started to seriously weigh the risks.

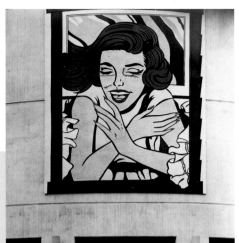

Unlike the 1939 World's Fair, the 1964 version was architecturally undistinguished, even banal. Robert Moses had rejected several visionary proposals by Walter Dorwin Teague and Paul Rudolph, and was not particularly interested in incorporating fine art within the Fair, as had been done in 1939 under his stewardship. His lack of enthusiasm may have resulted from frustrated efforts to persuade Joseph Hirshhorn to place his collection in a pavilion that would become a permanent museum in Queens. (Hirshhorn's collection later went to the Smithsonian Institution in Washington, D.C., as the Hirshhorn Museum and Sculpture Garden.) Moses did however negotiate with the Vatican to bring some of their treasures to the Fair—including Michelangelo's *Pietà*, which drew record crowds who passed by the sculpture on a moving platform. In addition, the Spanish Pavilion, featuring masterpieces by Goya, Velázquez, Picasso, and Miró, was a very popular attraction. The general public was clearly growing interested in art, especially art it could recognize as great.

The architect Philip Johnson, who designed the New York State Pavilion, took some initiative in the direction of contemporary art by inviting several Pop artists to contribute murals and sculptures to the circular facade of the theater: Andy Warhol, Roy Lichtenstein (fig. 168), James Rosenquist, Robert Indiana, Robert Rauschenberg, and John Chamberlain. Warhol's contribution, a mural entitled *Thirteen Most Wanted Men* (fig. 169), was painted over within a few days for political reasons (New York's Governor Nelson Rockefeller feared lawsuits because many of the depicted were reputed Mafiosi, some of whom had been vindicated by the courts). The mural also stood as a reminder of unpleasant social problems nowhere else in evidence at the Fair. —L. P.

Pop Culture Reigns

Pop art, building on the explorations of Johns, Rauschenberg, and the assemblagists, originated as yet another effort to bring art and life into intimate proximity. But rather than reject the materialism that had come to pervade American culture, Pop embraced it by taking consumer packaging and products as well as media icons as source material for a cool, mechanical art. This practice set Pop apart from earlier vanguard movements, which for most of the century had explored various forms of abstraction. Pop was the first representational movement that looked revolutionary rather than reactionary since Stuart Davis and Charles Demuth had celebrated the American vernacular and commercial culture in the 1920s and 1930s.

The Pop artists—Claes Oldenburg, Jim Dine, George Segal, Roy Lichtenstein, Tom Wesselmann, James Rosenquist, Robert Indiana, Richard Artschwager (fig. 183), Marisol (fig. 174), Ed Ruscha, and Andy Warhol—used unprivileged, common images from mass culture and from the man-made environment to create a distinctly American art form. They were responding to the new American visual landscape, a vista of advertising, billboards, commercial products, automobiles, strip malls, fast food, television, and comic strips (figs. 176, 178). They therefore took print, film, and television images from media-based reality and transformed them into art, often through various mechanical means. Their pictures were often images of images, copies of copies, a twice-removed effect that echoed the techniques of mass production, the media, and marketing.

Given their commercial-based techniques and imagery, it is not surprising to find that many of the Pop artists, including Warhol, Lichtenstein, Rosenquist, and Ruscha, had worked as commercial artists, doing advertising illustrations, layout designs, or painting billboards. Rauschenberg and Johns (under the joint pseudonym Matson Jones), Warhol, and Rosenquist all designed window displays for Bonwit Teller and Tiffany's (figs. 177, 179). From this firsthand experience, they understood not only the techniques of display but the importance of presentation. To them, art was another product in the consumer landscape.

The mechanical, impersonal style of imagery associated with Pop masks its history. In fact, the earliest manifestations of Pop art (1958–62) show a connection

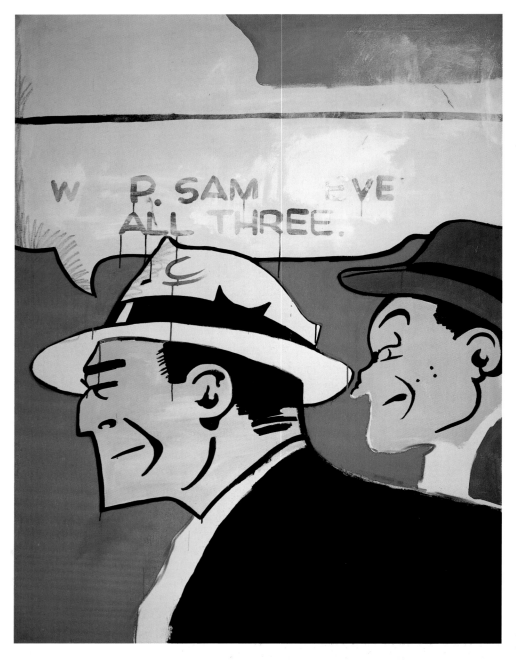

170. **Andy Warhol**
Dick Tracy, 1960
Acrylic on canvas, 79 x 45 in. (200.7 x 114.3 cm)
Collection of David Geffen

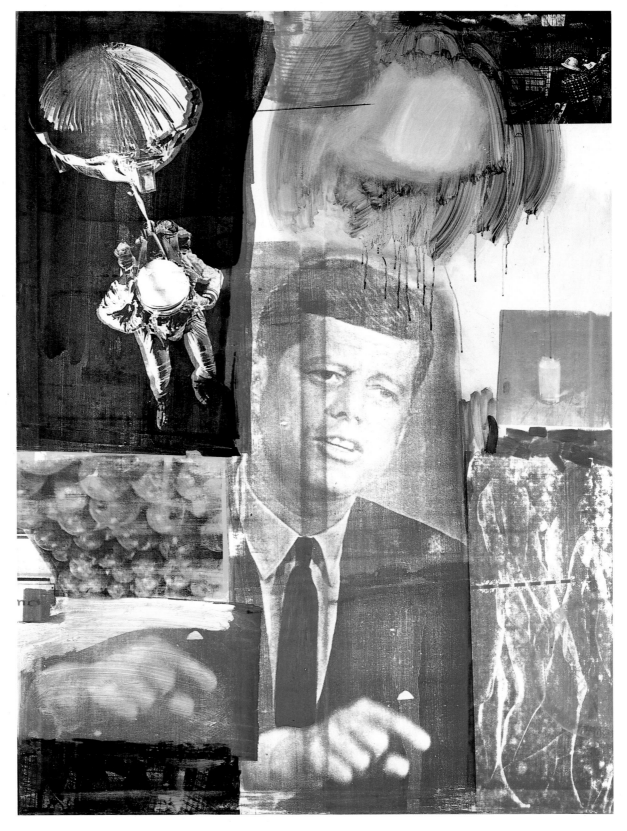

171. **Robert Rauschenberg**
Retroactive I, 1964
Oil on canvas, 84 x 60 in.
(213.4 x 152.4 cm)
Wadsworth Atheneum,
Hartford; Gift of Susan
Morse Hilles
© Robert Rauschenberg/
Licensed by VAGA, New
York, NY

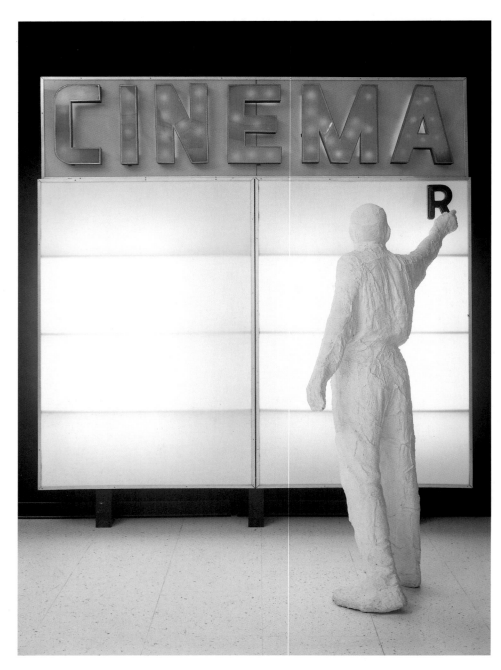

172. **George Segal**
Cinema, 1963
Plaster, illuminated
plexiglass, and metal,
118 x 96 x 30 in.
(299.7 x 243.8 x 76.2 cm)
Albright-Knox Art Gallery,
Buffalo; Gift of Seymour H.
Knox, 1964
© George Segal/Licensed
by VAGA, New York, NY

173. **Jim Dine**
Black Shovel, 1962
Oil on canvas with rope,
shovel, box, earth, and
wall panel, box: 12 x
38 x 12 in. (30.5 x 96.5
x 30.5 cm); wall panel:
96 x 38 in. (243.8 x
96.5 cm)
Sonnabend Collection,
New York

183. **Richard Artschwager**
Le Frak City, 1962
Acrylic, celotex, and
Formica, 44½ x 97½ in.
(113 x 247.7 cm)
Collection of Irma and
Norman Braman

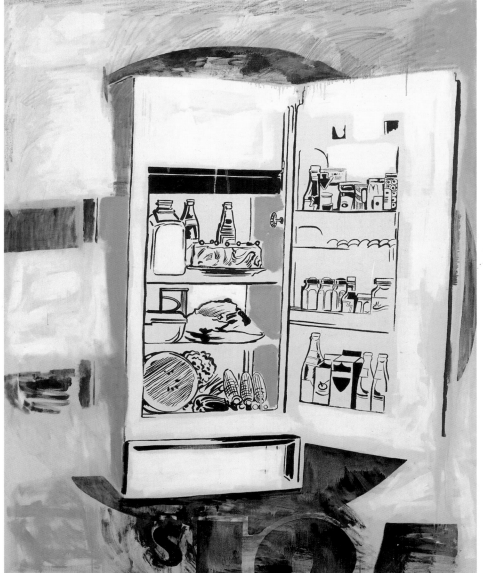

184. **Andy Warhol**
Icebox, 1961
Oil, ink, and graphite on
canvas, 67 x 53⅛ in.
(170.2 x 134.9 cm)
The Menil Collection,
Houston

characteristically blunt statements: "Paintings are too hard. The things I want to show are mechanical. Machines have less problems. I'd like to be a machine, wouldn't you?"[74] Instead of a collage-style agglomeration of images, Warhol selected a single image—Marilyn Monroe, a Campbell's soup can, a Coke bottle—and either presented it alone as an icon or repeated it in a gridlike formation, like a proof sheet from a high-speed press (figs. 185, 187, 188). Warhol also made endless variations of the same image, as if he were thinking in terms of print multiples on canvas. He also applied the technique to wallpaper (fig. 186). And he profoundly rejected the idea of individual creativity by employing assistants. Since the means of production were mechanical, these assistants often had as much of a "hand" in the final work as he did—a far cry from the Abstract Expressionist myth of the artist laboring alone in his studio, expressing existential angst through gestures on

185. **Andy Warhol**
Installation view of *Campbell's Soup Cans* at the Ferus Gallery, Los Angeles, 1962

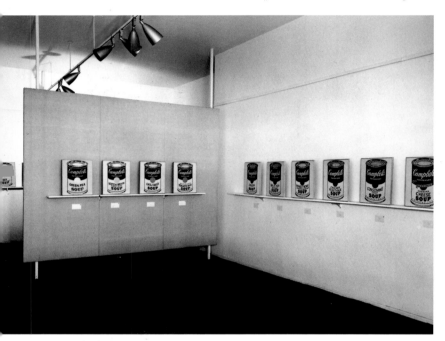

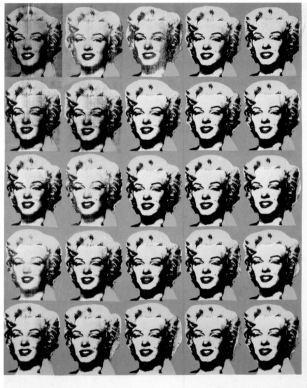

187. **Andy Warhol**
Twenty-five Colored Marilyns, 1962
Acrylic on canvas, 82¼ x 66¾ x 1⅜ in. (208.9 x 169.5 x 3.5 cm)
Modern Art Museum of Fort Worth, Texas; Purchase, The Benjamin J. Tillar Memorial Trust, acquired from the Collection of Vernon Nikkel, Clovis, New Mexico

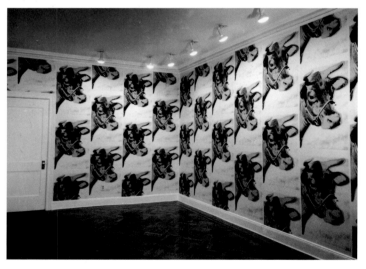

186. **Andy Warhol**
Installation view of *Cow Wallpaper* at the Leo Castelli Gallery, New York, 1966

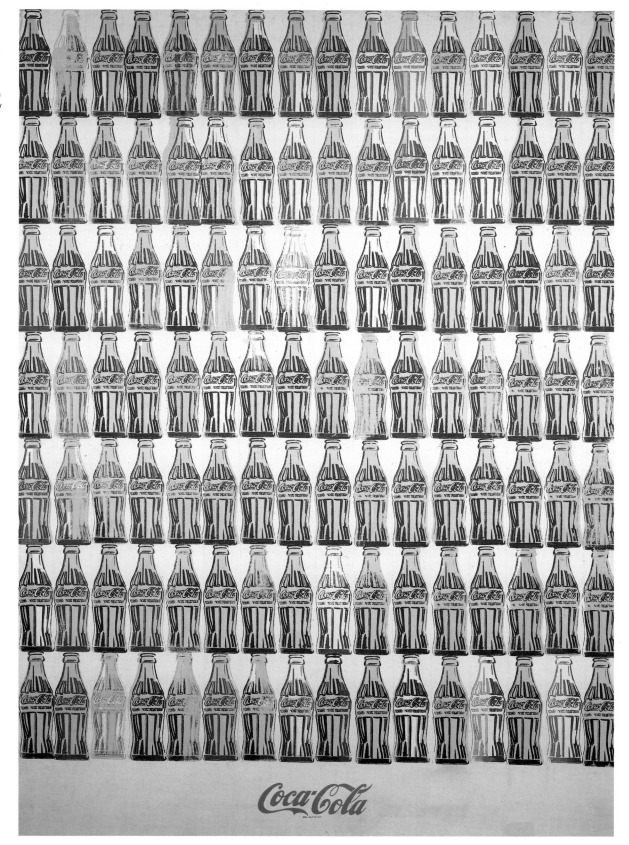

188. **Andy Warhol**
Green Coca-Cola Bottles, 1962
Oil on canvas, 82½ x 57 in. (209.6 x 144.8 cm)
Whitney Museum of American Art, New York; Purchase, with funds from the Friends of the Whitney Museum of American Art 68.25

WARHOL'S FACTORY: THE MANUFACTURE OF ART AND IMAGE

In late 1963, Andy Warhol moved his studio to the top floor of a former hat factory at 231 East 47th Street, New York. Leaving the 4,000-square-foot floor open, partitioned only by mirrors and screens, he engaged a twenty-one-year-old hairdresser and lighting man named Billy Linich (later known as Billy Name) to cover the pipes, windows, ceiling, and crumbling brick walls with silver foil. Whatever could not be covered by foil—floor, cabinets, and a pay phone—was painted silver. Reflective surfaces extended to the bathroom, where even the toilet bowl was silver. A multifaceted ballroom globe hanging from the ceiling revolved slowly, throwing light irregularly throughout the darkened space. Warhol commented on his unusual choice of color: "It must have been the amphetamine but it was the perfect time to think silver. Silver was the future, it was spacey—the astronauts. . . . And silver was also the past—the Silver Screen. . . . And maybe more than anything else, silver was narcissism—mirrors were backed with silver" (fig. 189).

Making reference to its previous function, Warhol's coterie dubbed this insular, self-reflexive environment the silver Factory, or simply the Factory. With an appellation connoting the efficiency and conformity advocated by corporate America, and an ambience redolent of drug use and self-indulgent behavior, the Factory provided a paradoxical new model of the artist's studio that consciously subverted those of the preceding decade. Warhol produced some of his best-known series here, including the Brillo Box sculptures, the Jackie paintings, and the Flower paintings, all images drawn from the worlds of advertising and media. In keeping with their site of production, they were made with the help of his assistant, a poet named Gerard Malanga, among others (fig. 190).

During his four years at the 47th Street Factory, Warhol also directed and produced over fifty films, including *Empire*, *Henry Geldzahler*, *Poor Little Rich Girl*, *The Velvet Underground and Nico*, *The Chelsea Girls*, and *24 Hour Movie*. It was an intensely social place, populated by a cross section of downtown bohemians and uptown socialites—

canvas. Together, Warhol and a succession of assistants cranked out paintings—sometimes as many as eighty a day—in assembly-line fashion in his East 47th Street studio, a workplace appropriately called the Factory.

In the fall of 1962, just as Rauschenberg and Warhol were completing their first silkscreen paintings, Pop art entered public consciousness with a bang through the "New Realists" exhibition at the Sidney Janis Gallery, New York (fig. 192). The artists' blatant, unapologetic reference to mass and consumer culture "hit the New York art world with the force of an earthquake."[75] Janis had previously shown and represented many of the leaders of Abstract Expressionism, but when this show opened, all of them left the gallery in protest, with the exception of de Kooning.[76]

The "New Realists" exhibition introduced the American Pop artists Andy Warhol, Roy Lichtenstein, James Rosenquist, Tom Wesselmann, Jim Dine, Claes Oldenburg, Robert Indiana, George Segal, and Wayne Thiebaud alongside European Nouveaux Réalistes—Arman, Jean Tinguely, Daniel Spoerri, Yves Klein, Martial Rayasse, and Raymond Hains—in an effort to put the Americans in a broader international context. But it was nonetheless clear that a fresh, new American art had arrived, one that was democratic in spirit and validated commercial art and consumer life as high art. Most of the work by Americans in the show featured domestic scenes and common household appliances such as Lichtenstein's *Refrigerator* (fig. 193), Oldenburg's plaster sculpture *The Stove*, Jim Dine's assemblage *Four Soap Dishes*, Segal's plaster and wood tableaux *The Dinner Table*, and Thiebaud's painting *Salad, Sandwiches, and Desserts*. These subjects, drawn from a much larger repertoire of consumer products, were presented in a cool, deadpan style, often using methods drawn from commercial printing (Lichtenstein's Benday dots), billboards (Rosenquist's oversize details and fragments of everyday life [figs. 195–97]), or signage (Indiana's crisp, vibrant graphics, fig. 220). Even Dine and Oldenburg had cleaned up their earlier messy, expressionistic style into a hard-edge, hygienic presentation.

both groups marginal from a mainstream perspective—as well as rock musicians such as Mick Jagger, Lou Reed, and Jim Morrison (fig. 191). From this varied mix of local talent, Warhol selected actors and actresses to star in his largely improvisational films. He was as interested in manufacturing celebrity as in producing the films themselves. Naomi Levine, Baby Jane Holzer, Edie Sedgwick, Brigid Polk, and Viva are some of the best-known underground celebrities—superstars who enjoyed their fifteen minutes of fame.

Early in 1968, Warhol moved the Factory to 33 Union Square West. Six months later, he was shot by Valerie Solanas, a Factory habitué who wanted to be in his films. Although Warhol recovered and continued to direct the new Factory, it never fully recaptured the distinctive energy and vitality of its former years. —E. T.

191. *The Velvet Underground and Nico in Hollywood*, 1966, photograph by Gerard Malanga

192. Installation view of "The New Realists" at the Sidney Janis Gallery, New York, 1962

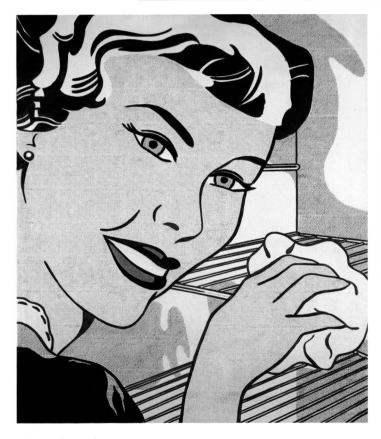

193. **Roy Lichtenstein**
The Refrigerator, 1962
Oil on canvas, 68 x 56 in.
(172.7 x 142.2 cm)
© Estate of Roy
Lichtenstein

194. **Wayne Thiebaud**
Desserts, 1961
Oil on canvas, 24⅛ x
30⅛ in. (61.3 x 76.5 cm)
PaineWebber Group Inc.,
New York

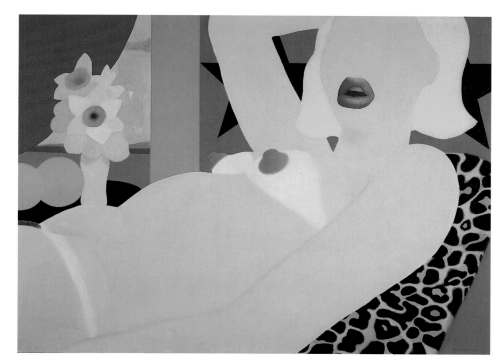

195. **Tom Wesselmann**
*Great American Nude
#57*, 1964
Synthetic polymer paint
on board, 48 x 65 in.
(121.9 x 165.1 cm)
Whitney Museum of
American Art, New York;
Purchase, with funds from
the Friends of the Whitney
Museum of American Art
65.10
© Tom Wesselmann/
Licensed by VAGA, New
York, NY

196. **Tom Wesselmann**
Still Life Number 36, 1964
Oil and collage on canvas,
four panels, 120 x 192¼ in.
(304.8 x 488.3 cm) overall
Whitney Museum of
American Art, New York;
Gift of the artist 69.151
© Tom Wesselmann/
Licensed by VAGA, New
York, NY

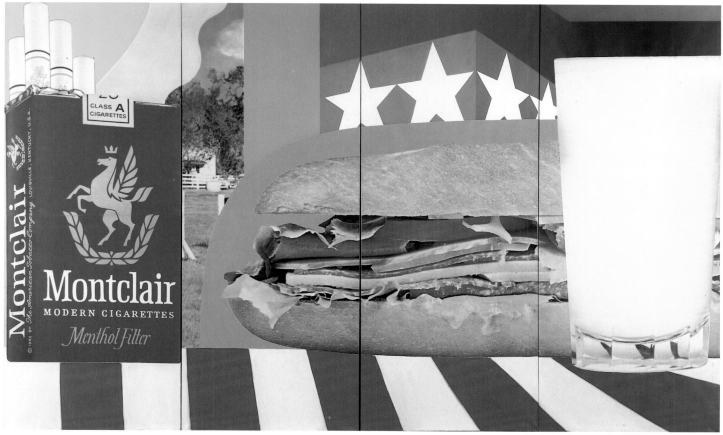

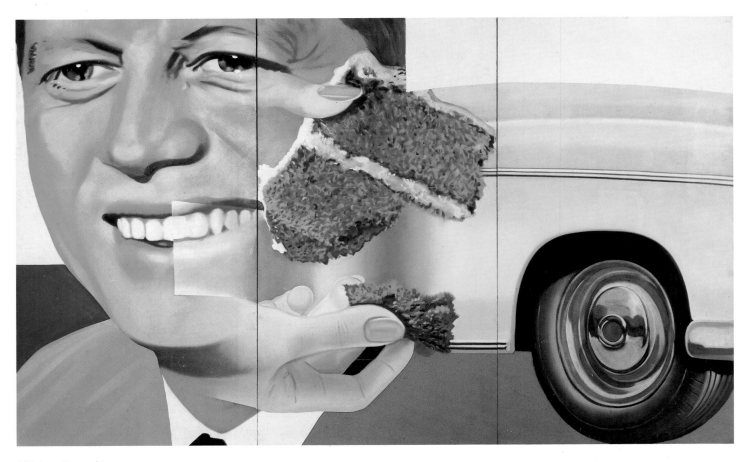

197. James Rosenquist
President Elect, 1960
Oil on masonite, three
panels, 84 x 144 in. (213.4
x 365.8 cm) overall
Musée national d'art
moderne, Centre Georges
Pompidou, Paris
© James Rosenquist/
Licensed by VAGA, New
York, NY

With this exhibition, the Pop artists were thrust into the spotlight and were quickly embraced by dealers, collectors, institutions, and the media. Glossy magazines covered this new phenomenon, nouveau riche collectors clamored for it, and people who didn't know much about art responded to it because it depicted something familiar, something they knew. But one group that did not jump on the bandwagon was the art critics. First of all, Pop was an affront to all those who had supported the humanistic values of Abstract Expressionism. Many thought that the Pop artists' uncritical embrace of consumer culture was tantamount to saying, "If you can't beat it, join it." The British scholar and critic Herbert Read wrote that they were "sacrificing formal rigor" and represented "novelty as distinct from originality."[77] He lamented the lack of a heroic and mythic dimension. Pop was an avant-garde movement that did not follow the modernist prescriptions for aesthetic and utopian monumentality. Most important, it seemed to glorify rather than to critique consumerism, conflating forms of high and mass culture that significantly "served the latter's commodity production as a virtual laboratory of new forms and fashions."[78] The conservative editor of *Arts Magazine*, Hilton Kramer, felt Pop's "social effect is simply to reconcile us to a world of commodities, banalities and vulgarities—which is to say, an effect indistinguishable from advertising art."[79] Another major objection to Pop art was that it did not seem to transform the imagery it appropriated—a deficiency, critics felt, that reduced Pop to something inauthentic, to mere copying. Art historian Dore Ashton exclaimed, "The attitude of the pop artist is diffident. He doesn't aspire to interpret or re-present, but only to present."[80]

Critics saw Pop as decadent, immoral, anti-humanistic, and even nihilistic. They could not abide its apparent transgression of good taste. Some also puzzled at the public's acceptance of Pop, which they took as a signal that "the nature of art collecting, which for centuries meant the gathering together of rare and beautiful objects, has changed in recent years."[81]

These diatribes notwithstanding, Pop continued to captivate audiences in America and abroad, dealing a serious blow to the credibility of the critical establishment. Of course, the artists did have their adherents and champions, including the British critic and Guggenheim Museum curator Lawrence Alloway. It was Alloway, in fact, who first used the term "Pop art" in print, in 1958, in reference to the British Independents Group, whose London exhibition "This Is Tomorrow" had demonstrated early Pop tendencies and the use of images from the mass media. Other Pop advocates included Henry Geldzahler, the young associate curator at The Metropolitan Museum of Art, and Alan Solomon, curator at The Jewish Museum. They acknowledged Pop's underlying ambivalence between celebration and irony—and considered this ambivalence a key to its strength.

Pop art's success in the market was fostered by a new generation of dealers (Allan Stone, Martha Jackson, Richard Bellamy, Sidney Janis, Eleanor Ward, Ivan Karp, Irving Blum, and Leo Castelli) and self-made collectors (Robert Scull, Frederick Weisman, and Ben Heller), who saw collecting as a means to social status. The support of curators, collectors, and dealers more than compensated for the lack of critical affirmation. The new breed of dealers, with Leo Castelli leading the pack, understood the virtues of clever marketing, promotion, and salesmanship. Their sometimes brash approach was as much at odds with the past as the art itself was. Jasper Johns' famous sculpture of Ballantine Ale cans (fig. 198) was a response to de Kooning's quip about Castelli: "That son-of-a-bitch; you could give him two

198. **Jasper Johns**
Painted Bronze (Ale Cans), 1960
Oil on bronze, 5½ x 8 x 4¾ in. (14 x 20.3 x 12.1 cm)
Museum Ludwig, Cologne
© Jasper Johns/Licensed by VAGA, New York, NY

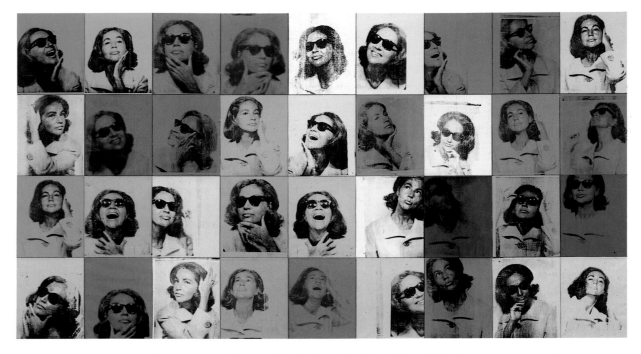

199. **Andy Warhol**
Ethel Scull 36 Times,
1963
Synthetic polymer
paint silkscreened on
canvas,
79¾ x 143¼ in.
(202.6 x 363.9 cm)
Whitney Museum of
American Art, New
York; Gift of Ethel
Redner Scull
86.61a–jj

beer cans and he could sell them."[82] Castelli used his European connections to pro-
mote Pop art abroad—particularly through the Paris gallery of his ex-wife, Ileana
Sonnabend. He developed a network of satellite gallery affiliates throughout the
world, ensuring his artists maximum exposure.[83]

But the artists also understood the benefits of promotion, and as they became
increasingly visible public figures, they learned how to capitalize on the power of
the media. They courted public attention, giving numerous interviews in mass-
circulation magazines, which preempted the negative response of the critics. These
artists could speak directly to their public, without the mediation of professional
interpreters—a phenomenon that dramatically changed the way artists perceived
themselves in society.

Of all the Pop artists, Andy Warhol was the one who most brilliantly exploited
and transformed the culture industry by perfecting the art of publicity. He under-
stood the cult of persona and mined it by celebrating celebrity in his portraits of
"superstars" (a term he coined), such as Elizabeth Taylor, Marilyn Monroe, Elvis
Presley, and Marlon Brando, as well as prominent social figures and friends (fig.
199). He also cultivated his own persona. He was a unique character—cool, pallid,
passive, asexual, with signature eccentric habits such as sporting a silver wig and
speaking in monosyllables. Warhol's ultimate product was himself. He even took
to sending out a double to lecture for him on college campuses. With his entourage
of handsome boys, artists, drag queens, and rock stars (fig. 191), he never failed to
infuse a charge into any social gathering. It was inevitable that, with such a keen
understanding of celebrity, Warhol would soon move directly into the mass media,
directing films such as *The Chelsea Girls* (figs. 200, 201), the first commercially
successful underground film, and in the fall of 1969 publishing his own magazine,
Interview, to give people what he called their "fifteen minutes" of fame (fig. 203).

Regarding his entrepreneurial spirit, Warhol later confessed, "Business art is
the step that comes after Art. I started as a commercial artist, and I want to finish
as a business artist. . . .Being good in business is the most fascinating kind of art."[84]
He was a genius at tapping into the zeitgeist, soliciting suggestions, and putting
other people's ideas into practice. Critics found this particularly galling. It appeared
that he lacked not only technical skills but ideas as well. Over time, it has become

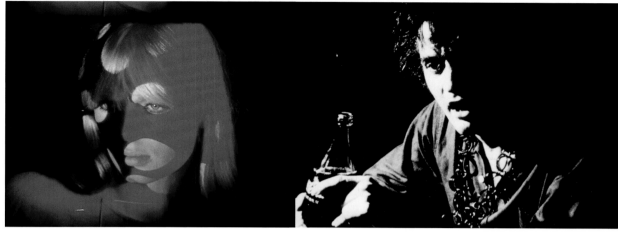

200. **Andy Warhol**
Nico in *Nico Crying*, from
The Chelsea Girls, 1966
© 1967, The Andy Warhol
Museum, Pittsburgh,
A Museum of Carnegie
Institute

201. **Andy Warhol**
Ondine in *The Pope
Ondine Story*, from *The
Chelsea Girls*, 1966
© 1967, The Andy Warhol
Museum, Pittsburgh,
A Museum of Carnegie
Institute

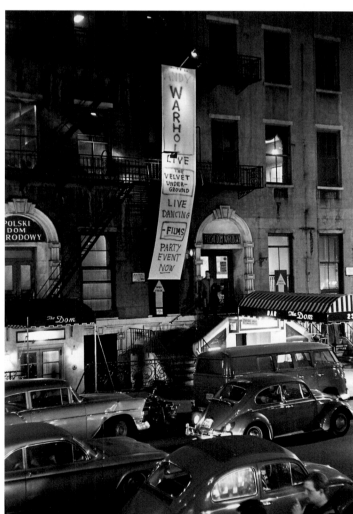

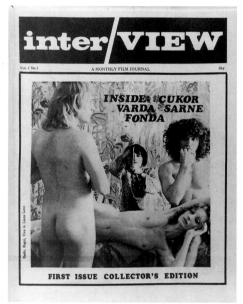

203. The first issue of
Interview magazine, 1969

202. *Banner for an Andy
Warhol Event, New York*,
1966
Photograph copyright ©
Fred W. McDarrah

clear that Warhol lacked neither. Rather, he was a brilliant and complex individual who permanently altered the relationship between art and society through his brazen love of money, famous people, and superstar status. He reflected something at work in the culture at large—the notion that celebrity had replaced genius as the new authority.

Pop art also signaled a change in the economic structure of the art world: for the first time, an avant-garde art movement was both the height of "chic" and embraced by upper-middle class urban sophisticates, who flocked to super-charged openings in droves. Sales of works—such as Rosenquist's *F-III* (fig. 218) to Robert Scull for $60,000—were covered on the front page of *The New York Times* and in *Time* magazine.[85] Contemporary art became big business, hard currency, a profitable investment, and a speculative growth stock during the boom years of the sixties. The "art public" was no longer a select, small group, as Allan Kaprow observed,

> upon whom an artist can depend for a stock response, favorable or otherwise. It is now a large, diffused mass, soon to be called "the public-in-general." This expanding audience [is] comprised of readers of the weeklies, viewers of T.V., visitors to Worlds Fairs here and abroad, members of "culture" clubs and subscribers to mail-order art lessons, charitable organizations, civic-improvement committees, political campaigners, schools and universities—

AMERICAN UNDERGROUND CINEMA: 1960–1968

The exuberant, carnivalesque atmosphere of the early 1960s produced a rich mixture of new alternative practices and an unprecedented crossover between different artistic media, out of which emerged the avant-garde genre that came to be known as underground film. Centered in New York, it began in 1959 with Robert Frank and Alfred Leslie's Beat film *Pull My Daisy* (fig. 90) and soon gained notoriety for its sexually explicit imagery. By the end of the 1960s, with the loosening of censorship laws, the movement petered out. Underground film developed alongside, and was influenced by, Performance art, Happenings, Pop, Fluxus, alternative theater, rock music, and dance, as well as by the new civil rights movement and hallucinogenic drugs, forming a key strand in early sixties counterculture. Filmmaking became an improvisational activity, a performance. Between 1962 and 1966, a group of artists, poets, musicians, writers, and scientists—including Nam June Paik, Yoko Ono, Paul Sharits, George Brecht, George Maciunas, Robert Watts, and Mieko (Chieko) Shiomi—made forty short Fluxfilms, experimental conceptual pieces often focused on a single performative action.

In 1962, Jonas Mekas, Stan Brakhage, Shirley Clarke, and others established the Film-makers' Cooperative, which replaced Amos Vogel's Cinema 16 and was unique in its practice of accepting and distributing all submitted films. As performance and Happenings took place in alternative spaces, so Mekas screened underground film in various small cinemas around New York.

The counterculture of the early sixties challenged middle-class taste and standards by celebrating, among other things, the "grotesque" body and the sexual body as sources of power and symbols of liberation. Many of the films screened by Mekas—Jack Smith's *Flaming Creatures* (fig. 204), Andy Warhol's early films *Kiss* (1963) and *Blow Job* (1964), Kenneth Anger's *Scorpio Rising* (fig. 206) and *Inauguration of the Pleasure Dome* (1966), and Barbara Rubin's *Christmas on Earth* (1963)—epitomized this blatantly transgressive, homoerotic mode. Mainstream Hollywood cinema was referenced ironically in camp tableaux, meshing taboo with fantasy.

In Smith's *Flaming Creatures*, a flamboyant mélange of androgenous naked bodies and transvestites indulge in unashamed erotic and, in places, sadistic theater. The sexual explicitness of the film led to Mekas' arrest when he showed it in 1964 at the New Bowery Theater in New York. As the censorship of underground film continued through that year, Mekas and the movement were cast in a besieged role, battling against the establishment. Ken Jacobs' *Blonde Cobra* (1959–63), made with Bob Fleischner and featuring Smith in vignettes of childish despair, sexual longing, and camp, was so anarchic and unstructured that it appeared to reject the very existence of cinematic structure.

A less direct attack on mainstream cinema was made by the Kuchar brothers, George and Michael. In George Kuchar's *Hold Me While I'm Naked* (1966), a parody of

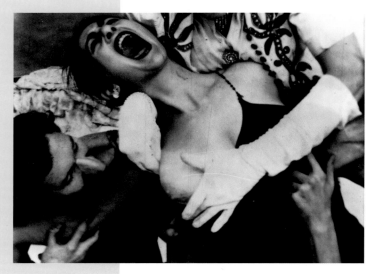

204. **Jack Smith**
Flaming Creatures, 1962
16 mm film, sound,
black-and-white; 45 min.
Anthology Film Archives,
New York

a Hollywood B movie, Kuchar appears as both director and actor. Anger's classic *Scorpio Rising* adopts a similarly ambivalent attitude toward Hollywood cinema, simultaneously rebelling against it and interacting with it. Fantasy images of the hero Scorpio and of homosexual motorbike subculture are intercut with found footage of James Dean and a religious gathering, set to pop music.

The films of Andy Warhol came to epitomize the sensibility of American underground filmmaking in the sixties. Warhol embraced Hollywood's power as a mass medium and used it in his films, just as he had incorporated celebrities and advertising into his paintings. He saw many of Mekas' screenings and was strongly influenced by the work of Jack Smith. Warhol's filmmaking was a logical extension of his painting. His early films, including *Kiss*, *Empire* (8 hours long, with Mekas as cameraman), *Sleep* (6 hours), *Eat*, *Haircut*, and *Blow Job*, all made in 1963–64, recorded a single, simple action over a long period of time. Each film was black-and-white, silent, unedited, shot in a fixed frame, and screened at 16 frames-per-second, a slower speed than the normal 24 frames-per-second. The films' minimal content and focus on a single subject evoked both Warhol's portrait paintings and the spareness of Minimalist art. They also anticipated the conceptual framework of Structuralist film, which emerged in the late sixties, in their investigation of the medium of cinema and in their emphasis on temporal duration.

Some of Warhol's early films included sound, script, and camera movement as well. At the beginning of 1965, he bought a sound camera, and the focus of his production shifted to feature-length sound films, including *Poor Little Rich Girl*, *Vinyl*, *Camp*, and *My Hustler* (all 1965). Warhol revived and parodied the classic Hollywood star system. His film activity at the Factory attracted drag queens, hustlers, friends, would-be actors, the outcast, and the eccentric, all of whom he cast into the same glamorous limelight. Edie Sedgwick, Ronald Tavel, Gerard Malanga, Taylor Mead, Baby Jane Holzer, Ondine, and others all became Warhol "stars." The low-budget, deadpan format of the porn movie that Warhol adopted in *Couch* (1964), *Blow Job*, *Kiss*, and later, most explicitly, *Blue Movie* (1968), similarly subverted the structure and expectations of mainstream cinema.

In 1965 and 1966, Warhol experimented with double-screen projection and multi-screen environments, which culminated in a series of performances with the Velvet Underground in 1966. One of these, *The Exploding Plastic Inevitable*, combined slide and film projections, light shows, and live rock music. Following his first commercial success, the double-screen film *The Chelsea Girls* (figs. 200, 201), Warhol's films became more professionally structured. Color features such as *Flesh* (1968), *Trash* (1970), and *Heat* (1972) were directed by Paul Morrissey, and Warhol distanced himself from the social circle that had generated his earlier films. —C. I.

205. **Jordan Belson**
Samadhi, 1966–67
16 mm film, sound, color;
6 min.
Anthology Film Archives,
New York

206. **Kenneth Anger**
Scorpio Rising, 1963
16 mm film, sound, color;
29 min.
Anthology Film Archives,
New York

not to mention the boom of new galleries and museums. . . . [T]his widening interest in art stimulates its practice.[86]

Pop and the public had developed a symbiotic relationship.

This congenial alliance between the public and the avant-garde was not restricted to New York. Los Angeles, a mecca of popular culture, developed a thriving Pop art scene of its own in the sixties. The special subcultures of Southern California were producing a distinctive brand of Pop, as artists such as Ed Ruscha, David Hockney, Vija Celmins, Joe Goode, and Billy Al Bengston responded to the strip development, crazy signs, hot-rod and surfer culture, Hollywood, and the particular light, weather, and smog of Los Angeles (figs. 208–12).

Ed Ruscha, perhaps the leading Los Angeles Pop artist, made linguistically witty word paintings that often incorporated a surreal play on letters as images. Painted with trompe l'oeil precision, words such as "Ace," "honk," "Hollywood," "Spam," or "20th Century Fox" appear as liquid spills, floating apparitions, drops of water, rays of light, or three-dimensional blocks of type (fig. 209). In *Actual Size* (fig. 208), a can of Spam is hurtling through space like a comet, perhaps a pun on Roy Lichtenstein's dynamic war cartoon *Blam* (fig. 207). Other works by Ruscha, including drawings, paintings, and photographic books, incorporate the vernacular landscape of Los Angeles—the Hollywood sign, palm trees, gas stations, and apartment houses and buildings along the Sunset Strip.

Vija Celmins mined the strange incongruities of Surrealism in her depictions of common domestic objects such as a heater, comb, and eraser (figs. 210, 211),

207. **Roy Lichtenstein**
Blam, 1962
Oil on canvas, 68 x 80 in.
(172.7 x 203.2 cm)
Yale University Art Gallery,
New Haven; Gift of
Richard Brown Baker,
B.A., 1935
© Estate of Roy
Lichtenstein

208. **Ed Ruscha**
Actual Size, 1962
Oil on canvas, 67⅟₁₆ x
72⅟₁₆ in. (170.3 x 183 cm)
Los Angeles County
Museum of Art;
Anonymous gift through
the Contemporary Art
Council

209. **Ed Ruscha**
*Large Trademark with
Eight Spotlights*, 1962
Oil on canvas, 66¾ x
133¼ in. (169.5 x
338.5 cm)
Whitney Museum of
American Art, New York;
Purchase, with funds from
the Mrs. Percy Uris
Purchase Fund 85.41

210. **Vija Celmins**
Pink Pearl Eraser, 1967
Acrylic on balsa wood,
6⅝ x 20 x 3⅛ in.
(16.8 x 50.8 x 7.9 cm)
Orange County Museum of
Art, Newport Beach,
California; Gift of Avco
Financial Services, Newport
Beach

212. **Billy Al Bengston**
Sterling, 1963
Oil and lacquer on board,
58⅜ x 58⅜ in.
(148.3 x 148.3 cm)
Whitney Museum of
American Art, New York;
Purchase, with funds from
the Friends of the Whitney
Museum of American Art
69.30

211. **Vija Celmins**
Heater, 1964
Oil on canvas, 47⅞ x
48 in. (120.5 x 121.9
cm)
Whitney Museum of
American Art, New York;
Purchase, with funds from
the Contemporary Painting
and Sculpture Committee
95.19

reminiscent of René Magritte in their hard-edge realism and distortions of scale. Joe Goode used lush expanses of color behind a common milk bottle to suggest the light and atmosphere of suburban Los Angeles. The transplanted British artist David Hockney similarly painted the specific light, vegetation, tract houses, and swimming pools that distinguished Los Angeles, while Billy Al Bengston employed motorcycle emblems and logos in his simple, hard-edge paintings of repeated motifs

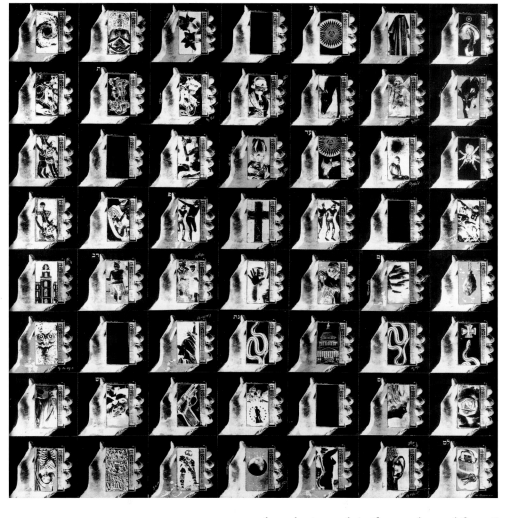

213. **Wallace Berman**
Untitled (A7-Mushroom, D4-Cross), 1966
Verifax collage mounted on panel, 45½ x 48 in. (115.6 x 121.9 cm)
Estate of the artist and L.A. Louver Gallery, Venice, California

such as chevrons, hearts, and irises (fig. 212). Even the Beat shaman Wallace Berman was making a Pop variant in the sixties, settling on a gridded Verifax format of repeated transistor radios filled with popular images, occult references, and surreal juxtapositions (fig. 213). In their personal invention and strong attraction to Surrealism, these artists somewhat resisted the category of Pop as defined by the East Coast practitioners.

The art community in Los Angeles expanded in the 1960s, enhanced by a booming economy. A cluster of adventurous galleries opened on La Cienega Boulevard. The Ferus Gallery, once run by Walter Hopps and Edward Kienholz, and then by Irving Blum, was supporting local artists, among them Billy Al Bengston, Ed Ruscha, and John Altoon, who soon received national attention. Ferus also gave Warhol his first one-artist show, in 1962, exhibiting fifty nearly identical paintings of Campbell's soup cans. The Dwan Gallery in Westwood also supported the new art. The art scene received a further boost in 1964 when the journal *Artforum* relocated from San Francisco to Los Angeles (where it remained until it moved to New York in 1966). Under the stewardship of Philip Leider and John Coplans, the publication gave the city a national cultural profile by providing regular coverage of local art activities. (The graphic design and layout was done by Ed Ruscha under the pseudonym Eddie Russia.) Another important element in the development of the Los Angeles cultural scene was the presence of June Wayne's Tamarind print workshop, the first devoted to lithography, established through a Ford Foundation grant in 1960. Her master printer, Ken Tyler, eventually established his own workshop, Gemini, in 1965. Both attracted artists from across the country to work on projects in Los Angeles.

Pop art was snappy, fresh, the epitome of "cool," and it is not surprising that it had great appeal to young people, whose numbers and influence in the "swinging sixties" was increasing every year. Thanks to the baby boom, by the end of the sixties, half the American population was under twenty-five. Artists and collectors, too, were more youthful than ever before. As Robert Motherwell commented in 1967, "The art world is much younger, like the population as a whole."[87] The young Americans who first became a consumer force in the 1950s embraced Pop art as a

mirror of their own lives. They, too, were media oriented, focused on fame, spectacle, and style—and they had a president who was a media celebrity. John F. Kennedy was the first American leader with whom the youth of the nation could identify; the magic of Camelot was enthralling (fig. 214).

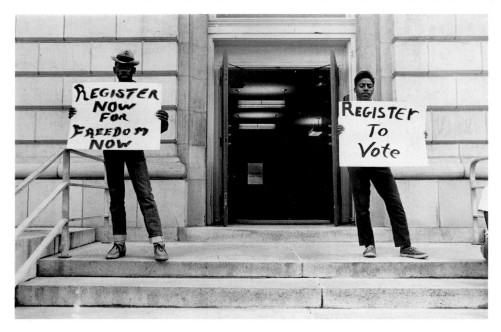

214. *John F. Kennedy with Jacqueline and Caroline Kennedy*, early 1960s

But just as in the 1950s, when black teenagers bravely stood up to the forces of entrenched segregation, in the 1960s not all young people were materialistic and glamour-struck (fig. 215). Freedom rides in the South, massive civil rights marches such as that in Washington, D.C., in 1963, the Free Speech movement at the University of California at Berkeley, and, by 1967, vehement demonstrations against the war in Vietnam—this social activism was as much a part of youth culture as consumerism (fig. 216). And here, too, Kennedy's own actions offered an incentive. He established the Peace Corps, an organization that sent young Americans to serve as teachers and technical advisers in underdeveloped countries. As we have seen, he also initiated civil rights legislation. But the president's most influential act may have been his inauguration speech in January 1960. Like Martin Luther King, Jr.'s "I Have a Dream," Kennedy's words inspired a generation: "Ask not what your country can do for you—ask what you can do for your country."

215. **Danny Lyon**
Two SNCC Workers, Selma, Alabama, 1963
Gelatin silver print, 7⁵⁄₁₆ x 10⁹⁄₁₆ in. (18.3 x 26.8 cm)
Whitney Museum of American Art, New York; Purchase, with funds from the Photography Committee 95.6

216. *Gloria B. Richardson, Head of the Cambridge Nonviolent Action Committee, Responds to an Order from National Guardsmen Enforcing Martial Law, Cambridge, Maryland*, 1963

Where does Pop art fit into this emerging social activism? In chronological terms, Pop developed during a transitional time in America—between the confidence of consensus culture that pervaded the nation at Kennedy's inauguration and the fragmentation of this culture that marked the years after his assassination. A handful of Pop works

219. **Peter Saul**
Saigon, 1967
Oil on canvas, 92¾ x
142 in. (253.6 x
360.7 cm)
Whitney Museum of
American Art, New York;
Purchase, with funds from
the Friends of the Whitney
Museum of American Art
69.103

220. **Robert Indiana**
Eat/Die, 1962
Oil on canvas, two panels,
72 x 60 in. (182.9 x
152.4 cm) each
Private collection; cour-
tesy Simon Salama-Caro

221. **Romare Bearden**
Mysteries, 1964
Photomontage, 49 x 61½ in.
(124.5 x 156.2 cm)
Estate of Romare Bearden
© Romare Bearden
Foundation/Licensed by
VAGA, New York, NY

222. **Andy Warhol**
Black and White Disaster,
1962
Acrylic and silkscreen
enamel on canvas,
96 x 72 in. (243.8 x
182.9 cm)
Los Angeles County
Museum of Art; Gift of
Leo Castelli Gallery and
Ferus Gallery through the
Contemporary Art Council

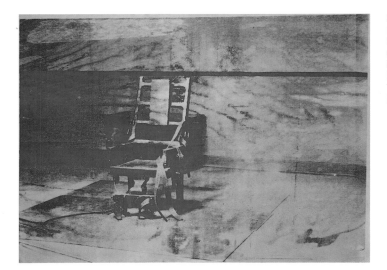

223. **Andy Warhol**
Big Electric Chair, 1967
Synthetic polymer and
silkscreen ink on canvas,
54 x 73⅛ in. (137.2 x
185.7 cm)
The Menil Collection,
Houston

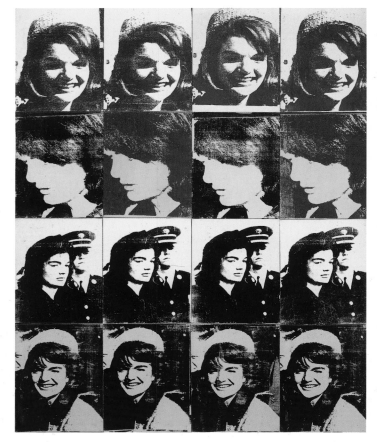

224. **Andy Warhol**
16 Jackies, 1964
Acrylic and enamel on
canvas, 80⅜ x 64⅜ in.
(204.2 x 163.5 cm)
Walker Art Center,
Minneapolis; Art Center
Acquisition Fund

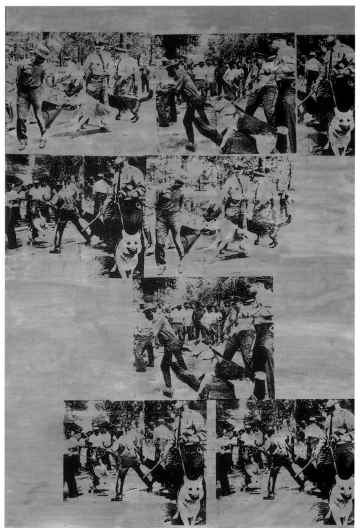

225. **Andy Warhol**
Red Race Riot, 1963
Synthetic polymer and
silkscreen ink on canvas,
137 x 82½ in. (348 x
209.6 cm)
Museum Ludwig, Cologne

SPACE INTO ENVIRONMENT: NEW FORMS OF CRITIQUE

In 1961, Jane Jacobs, a popular journalist and outsider to archi-
tecture, wrote a scathing critique of the architectural profession
and of modernism in general in her best-selling book *The Death
and Life of Great American Cities*. Attacking the technocratic
regime of city planners and social engineers, Jacobs' book regis-
tered a growing anxiety about the dehumanization of American
urban life. Enormous housing blocks, such as the Pruitt-Igoe
complex in St. Louis built by Minoru Yamasaki in the 1950s
(fig. 226)—torn down in 1972 in belated agreement with Jacobs'

226. *Demolition of Pruitt-
Igoe Public Housing
Complex, St. Louis*, 1972
UPI/Corbis-Bettmann

critique—urban renewal and slum-clearing schemes, and monumental master planning
for city centers were singled out as especially destructive to the quality of everyday
life. Jacobs was not alone in her increasingly environmental concerns, although the
forms this populism took differed widely. For some architects, such as Charles Moore,
the solution to the perceived formalism of high modernism and the alienation it was
believed to have caused was a return to local building styles,
familiar materials, and informal, picturesque planning. Moore's
Sea Ranch, California, complex of 1963 marks an important
moment in the evolution of American neopopulist architecture.
For other architects, social activism and grassroots community
development became the means of combating the impersonal
impositions of government planning authorities. Neighborhood
watches, studies of how design could control urban crime, and
local design review boards and historic-preservation groups grew
out of this form of critique.

Still another response, which had perhaps the greatest
influence on the subsequent development of architecture as a
discipline—precisely the authority Jacobs sought to undermine—
paralleled the acerbic social critique of Pop art and was spear-
headed by the work of Robert Venturi and Denise Scott Brown.
Venturi had already begun his version of what would become
known as postmodernism, when he published his "gentle mani-
festo" against modernist formalism, *Complexity and Contradiction
in Architecture* (1966). With his now famous dictum "less is a
bore," Venturi sought to undermine the singular and heroic logic of
modernism, particularly that promulgated by Ludwig Mies van der
Rohe, with more historically complex and apparently socially inclu-

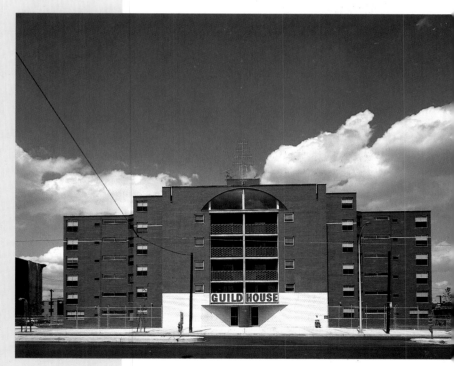

227. **Venturi, Scott Brown,
and Associates**
Guild House, Philadelphia,
1960–63

sive architectural forms. Venturi had recently completed a housing complex for elderly
Quakers in Philadelphia, the Guild House (fig. 227), which combined the simple red
bricks and double-hung windows typical of innumerable anonymous residential buildings
with the massing, proportions, and formal ironies of sixteenth-century Italian Mannerism.
All this was to have been crowned by a massive aluminum television antenna. While the
latter offended local community sensibilities, the formal modesty of the building itself

seem to respond to the moral issues of the age, albeit with characteristic camp ambiguity. There are Lichtenstein's action-packed war cartoons (figs. 207, 217); Rosenquist's mural *F-III*, with its spectacle of an atomic blast and war planes in proximity to visceral foodstuffs and other consumer objects (fig. 218); Robert Indiana's *Eat/Die* (fig. 220); Peter Saul's cartoon satires (fig. 219); Romare Bearden's vibrant collages and photomontages, which conveyed the dynamic street life of Harlem as well as the turbulent history of African Americans in the twentieth century (fig. 221); and, finally, Warhol's powerful death and disaster series (figs. 222–25). In this series, which was not commercially profitable at first, Warhol screened images of electric chairs, car crashes, tabloid headlines about plane disasters, race riots, and multiple images of Jackie Kennedy, at President Kennedy's funeral (fig. 224).

offended the architectural status quo for many decades. In 1972, Venturi and Scott Brown continued their radical critique of modernism in a groundbreaking study, *Learning from Las Vegas* (fig. 228), which was particularly influenced by Herbert Gans, a sociologist of middle-class American culture. With this publication, which for the first time addressed commercial architecture with seriousness rather than scorn, the great divide between the avant-garde and popular culture long upheld by modernist critics began finally to collapse. Instead of despising urban sprawl and commercial culture (as did both Jane Jacobs and many city planners), Venturi and Scott Brown studied the processes of signification and production that made strip malls, casinos, freeways, and suburban decoration into coherent semiological systems—a revisionist focus that makes them the first theorists of information architecture. —S. L.

228. *Learning from Las Vegas*, by Robert Venturi, Denise Scott Brown, and Steven Izenour
Cambridge, Massachusetts: MIT Press, 1972

On the whole, though, Pop art manifested little interest in sociopolitical issues. It did, however, capture the contradictions of the "spectacular" culture of consumer capitalism, its glamour and its utter banality. Furthermore, the Pop artists, by using found images from popular culture, repetition and serial production, as well as mechanical techniques, challenged the modernist (not to mention the Old Master) belief in the artist's creative originality and initiated a polemic against elitist views about uniqueness and aesthetic hierarchies. In the Combine painting *Factum I* and its painted facsimile *Factum II* (figs. 117, 118), Rauschenberg had clearly asked, What is real and what is a copy? The Pop artists pushed the question to an extreme. The idea of authenticity, long the cornerstone of artistic production and critical theory, was crumbling.

Minimalism: A Quest for Order

Contemporaneous with Pop was an art of pure geometric abstraction that seemed even more oblivious to the mounting social crises of the day. It has been variously described as "ABC Art," "Primary Structures," "Systemic Art," "concrete objects," and "Single Image" art, but the name that ultimately prevailed was "Minimalism." Minimalism was a coast-to-coast phenomenon that included sculptors and painters: Tony Smith, Donald Judd, Dan Flavin, Carl Andre, Sol LeWitt, Ellsworth Kelly (figs. 229, 268), Robert Morris, Frank Stella, Kenneth Noland, Jo Baer (fig. 232), Robert Ryman, Agnes Martin, Brice Marden, Robert Mangold (fig. 230), Al Held, Larry Bell, and John McCracken. Their works assert a physical presence through a pared-down, simplified format and the use of elementary geometric structures. It is an art that would seem to be diametrically opposed to Pop, yet Minimalism shared some of Pop's formal qualities and methods: the use of repetition and serial forms, a machine aesthetic, and a cool, deadpan presentation. And just as Pop art enshrined mass-produced consumer items, so Minimalist sculpture used mass-produced industrial components, replacing manufactured images with units of manufacturing. Again like Pop art, Minimalism celebrated materialism—but in its own way. Minimalist artists were preoccupied with the literal nature of materials, with the solid, empirical, and immediate world. The emphasis on concreteness also sets Minimalist artists apart from many Abstract Expressionists, who conceived their imagery as "relational," that is, with colors and forms balanced in relation to one another. To the Minimalists, nothing was more suspect than the self-conscious manipulation of composition for visual effect; they saw it as artiness and posturing, an imposition of the artist's persona that compromised the literal objectness of the work.

There is nothing "besides the paint on the canvas" and "what you see is what you see," said Frank Stella, whose black pin-striped paintings of 1959–60 were among the earliest manifestations of this new attitude (fig. 231).[88] Stella's Black paintings, like those of Ad Reinhardt (fig. 233), projected a rational, empiricist order. The configuration of the stripes conforms to the structure of the painting—to the cruciform support of stretcher bars behind the canvas and their relation to the edges.

Stella's statement is not far removed from Andy Warhol's practically contemporaneous announcement: "Just look at the surface of my paintings and films and me, and there I am. There's nothing behind it."[89] Like Pop artists, the Minimalists employed standard units in an attempt to deny both uniqueness and self-expression —to remove the artists from the consideration of the art. The serial sequences and repetitive structures of Minimalism—like Warhol's serial silkscreen paintings and his accumulation of simulated objects (fig. 176) abetted the campaign against authorship. Sometimes Stella, Noland, and Flavin used simple shapes, often reiterating a

229. **Ellsworth Kelly**
Green, Blue, Red, 1964
Oil on canvas, 73 x 100 in.
(185.4 x 254 cm)
Whitney Museum of
American Art, New York;
Purchase, with funds from
the Friends of the Whitney
Museum of American Art
66.80

230. **Robert
Mangold**
*1/2 Manila
Curved Area*, 1967
Oil on board, 72 x 144
in. (182.9 x 365.8 cm)
Whitney Museum of
American Art, New York;
Purchase, with funds from
the Friends of the Whitney
Museum of American Art
68.14

236. **Sol LeWitt**
Installation view of
Incomplete Open Cubes,
1974
122 painted wood struc-
tures on a painted wood
base and 122 framed
photographs and drawings
on paper, 8 x 8 x 8 in.
(20.3 x 20.3 x 20.3 cm)
each structure

THE SOUNDS OF SILENCE: SERIOUS MUSIC SURVIVES

Over the past fifty years, abstract music has developed and thrived on the margins of the pop music industry. Perhaps the most influential figure in this regard is an eccentric French composer named Erik Satie, who worked at the turn of the century, was much admired by modern artists, and made his living playing popular tunes on the piano in bohemian nightclubs. Satie developed what he called "furniture" music, which involved the use of boredom and repetition to change the sense of how music is used and enjoyed in modern society.

A brilliant American composer, John Cage, turned Satie's ideas into the foundation of serious music in the latter half of the twentieth century. Cage began by imitating the haunting tone poetry of Satie's *Gymnopédies* in solo piano pieces he called "Imaginary Landscapes." He soon moved beyond imitation, however, to develop Satie's concept of ambient sound as a kind of aural sense of negative space. He became notorious for a piece named *4' 33"*, which is literally four minutes and thirty-three seconds of silence—the point being, of course, that there is no such thing as silence and that people should be more aware of the sounds that surround their daily lives. Cage also developed compositional techniques, inspired by Marcel Duchamp, based on chance and the mixing of traditional performance with "found" sounds accessed through live radio broadcasts and records played on a turntable. One of the most famous of these pieces, *Credo in US*, inspired not only a generation of academically trained composers but also the most famous pop group of our time, the Beatles. By 1967, John Lennon had come under the influence of Yoko Ono, a Fluxus artist who was a student of Cage's. On the Beatles' so-called *White Album* (1968), Lennon included a direct homage to Cage's work, "Revolution Number 9," the first piece of pop music constructed entirely from preexisting sounds.

But Cage's most significant disciple in the pop arena was a British keyboard player, Brian Eno, who got his start in the glitter rock band Roxy Music. By the late 1970s, Eno began to develop what he called ambient music, a close relative to the furniture music created by Satie. However, Eno started to apply the concept to the recording process itself rather than to performance. Many musicians at that time were experimenting with electronic synthesizers, which allowed entirely new sounds to be made. But Eno was among the first to understand that the synthesizer was more than a novel instrument: it signaled, rather, a fundamental shift in the way music could be made and disseminated.

In the field of what used to be called classical music, the composer La Monte Young adapted Cage's conceptual ideas to a compositional style that has come to be known as Minimalism (fig. 237). Young's radical approach was to think of music as a system of vibrations registered as frequencies that could be set into deliberate formal permutations. By the mid-seventies, a new generation of composers was creating

237. La Monte Young and Marian Zazeela performing *Map of 49's Dream the Two Systems of Eleven Sets of Galactic Intervals Ornamental Lightyears Tracery* in the *Dream House*, 1970

remarkably complex and pleasurable pieces based on the ideas of sonic abstraction and modal repetition first explored in the work of Satie, Cage, and Young.

Steve Reich's *Music for 18 Musicians*, created between 1974 and 1976, added a new dimension of rich harmonic and structural innovation to

his signature style of creating compositions from a steady repetitive pulse and rhythm (fig. 238). The piece was directly inspired by the Balinese gamelan tradition, which, like much tribal music, is based upon interlocking performances by large groups in which the sound is governed by the natural limits of breath and physical stamina rather than by a conductor and score. The overall effect of these organic layers is a shimmering pulse that overshadows any individual performance. On another level, the use of tribal forms in Reich's work exemplifies a significant feature of most important music of the late twentieth century—that it is the product of a clash between European and non-Western principles. This is not limited to classical music. In the genres of jazz and funk, Miles Davis and James Brown, respectively, were doing something quite similar by reducing rhythms to minimal repetitive patterns and then changing them over time to add a sense of form and structure.

Contemporaneously with Reich, Philip Glass emerged from the downtown New York art scene to create stunningly modern music based on the repetition of seemingly minimal forms (fig. 239). This approach reached its apex in the opera *Einstein on the Beach* (1976), created in collaboration with Robert Wilson. It is an artistic meditation on the relativity of time, using music, choreography, lighting and stage design to transport the audience into another dimension, where the hidden nature of things becomes apparent (fig. 410).

Over the past fifty years the distinction between serious and popular music has become so blurred that it no longer makes much sense. We are left to judge music from a variety of expected and unexpected sources in terms of its intrinsic value rather than its adherence to any particular form or tradition. This is in large part due to the tendency in the arts of our century to break down conventional barriers between and within genres. But it is also attributable to the growing sophistication of audio recording, which allows musical performances to be as highly manipulated and constructed as compositions were during the golden age of Western classical music. —J. C.

238. Steve Reich in spread from *Anti-Illusion: Procedures/Materials* New York: Whitney Museum of American Art, 1969

239. *Philip Glass in Rehearsal at the Peppermint Lounge, New York*, 1980, photograph by Paula Court

Dan Flavin used an available standard fluorescent tube—first a single white one placed at a 45-degree angle on the wall, then others in various configurations and color combinations (figs. 240, 241). Like his colleague Carl Andre, Flavin was indebted to the geometric idealism of the Russian Constructivists—one of his 1969 light pieces pays homage to Vladimir Tatlin's famous *Monument to the Third International* of 1919–20.[92] Andre, who started out in the fifties creating totemic wood sculptures (fig. 244), made an abrupt changeover in the next decade to standardized industrial materials—first using bricks lined or stacked on the floor, then working with metal plates spread out on the floor in a line or grid (figs. 242, 243). For Andre and other Minimalists, the sculptural act lay not in creating the forms but in selecting and placing them. To emphasize a lack of preciousness and more closely involve the audience in the "experience" of the sculpture, viewers were permitted to walk on Andre's work, which, like a rug, ran along the plane of the floor.

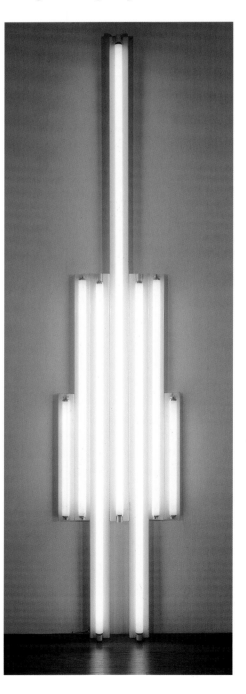

240. **Dan Flavin**
Installation view of "Dan Flavin" at the Green Gallery, New York, 1964

241. **Dan Flavin**
"Monument" for V. Tatlin, 1969
Fluorescent lights, 119 x 23 x 4 in. (302.3 x 58.4 x 10.2 cm)
Courtesy Leo Castelli Gallery, New York

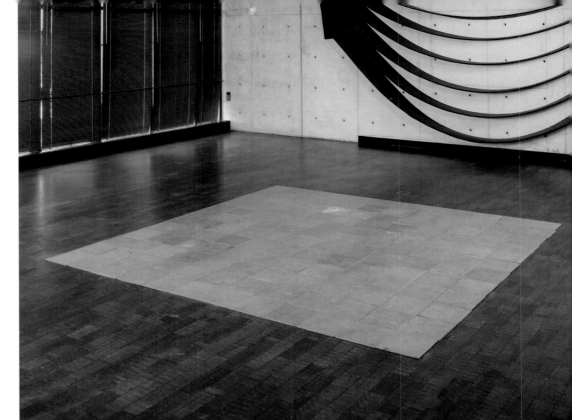

242. **Carl Andre**
144 Zinc Square, 1967
Zinc, 144 x 144 in.
(365.8 x 365.8 cm)
Milwaukee Art Museum;
Purchase, National
Endowment for the Arts
Matching Funds
© Carl Andre/Licensed by
VAGA, New York, NY

On wall:
Robert Morris
Untitled, 1970 (detail)
Felt, 10 x 25 ft.
(3 x 7.6 m)
Milwaukee Art Museum;
Gift of Friends of Art

243. **Carl Andre**
Lever, 1966
137 firebricks, 4½ x 8⅞ x
348 in. (11.4 x 22.5 x
883.9 cm)
National Gallery of
Canada, Ottawa;
Purchased 1969
© Carl Andre/Licensed by
VAGA, New York, NY

244. **Carl Andre**
Last Ladder, 1959
Wood, 84¼ x 6⅛ x 6⅛ in.
(214 x 15.6 x 15.6 cm)
Tate Gallery, London
© Carl Andre/Licensed by
VAGA, New York, NY

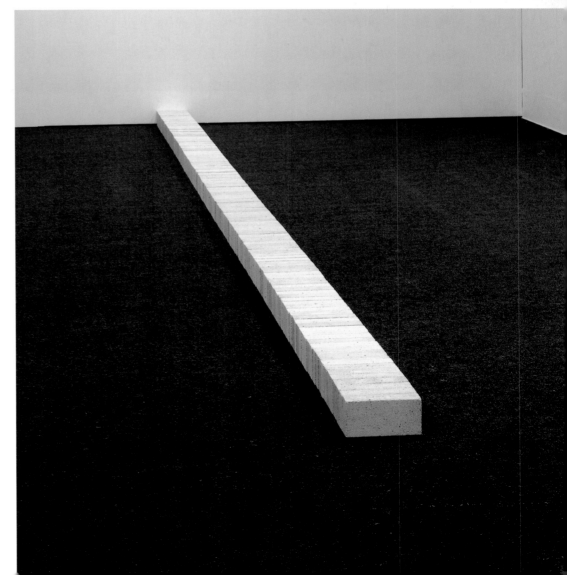

The artist who most epitomized the philosophical rigor of Minimalism was the sculptor Donald Judd. A master of exacting forms, technique, and incisive prose, he made his living as an art critic between 1959 and 1965, writing some of the first reviews of his peers, including Frank Stella, Dan Flavin, and John Chamberlain. Though he had studied painting, he began to make painted reliefs around 1961–62 (fig. 245) and then quickly moved into three-dimensional forms—most of them variations on the hollow box (fig. 246). He made horizontal progressions on the wall, and stacks of evenly placed units from floor to ceiling (fig. 248). Judd's emphasis was on space as opposed to mass, and the resulting hollowness appealed to his belief that nothing should be hidden.

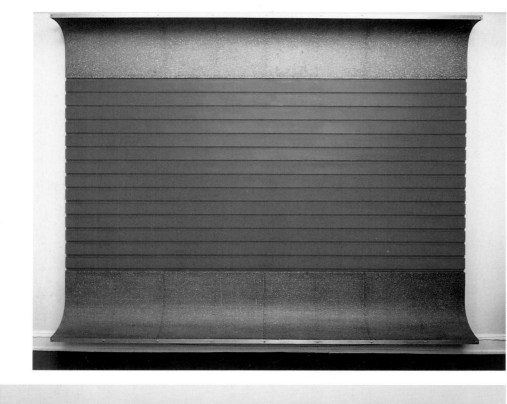

In 1965, Judd wrote an essay entitled "Specific Objects," in which he espoused "actual space" as the means of defeating illusionism. He accepted internal compositional motifs only if they had an explicit connection to overall shape and structure, echoing the frame edge, for instance, as Stella's Black paintings had.[93] Judd agreed with Clement Greenberg's prescription that the pure plastic qualities of art should be emphasized, which required eliminating spatial illusionism. Greenberg, however, did not care for Minimalism and considered it an idea that remained an idea, "something deduced instead of felt and discovered."[94]

Judd was uncompromising and authoritarian. His desire for total control over the presentation of his work (and perhaps his life) ultimately led him in 1971 to create a massive complex in Marfa, Texas (fig. 247). He virtually transformed this dusty town (where the 1950s movie classic *Giant* had been filmed) into a public environmental installation of his art and a monument to his philosophy. Many of the town's residents became his employees, painstakingly restoring buildings (most

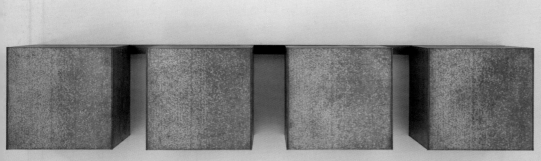

of them army Quonset huts) and maintaining the proper conditions for the sculpture. Everything in this complex was carefully designed by Judd—from the installation of his work both indoors and out, to the architectural details, right down to the furniture and barbecue. Only the environmental projects of Frank Lloyd Wright, such as Taliesin West in Phoenix, Arizona, begun in 1938, or the Shaker Village, a utopian community founded in 1787 in upstate New York on standards of simplicity and harmony, can approach the total environment of Marfa.

The sculpture of Judd, LeWitt, Andre, Flavin, and Morris was a far cry from both the emotional, open-welded sculpture of the fifties and improvisational junk

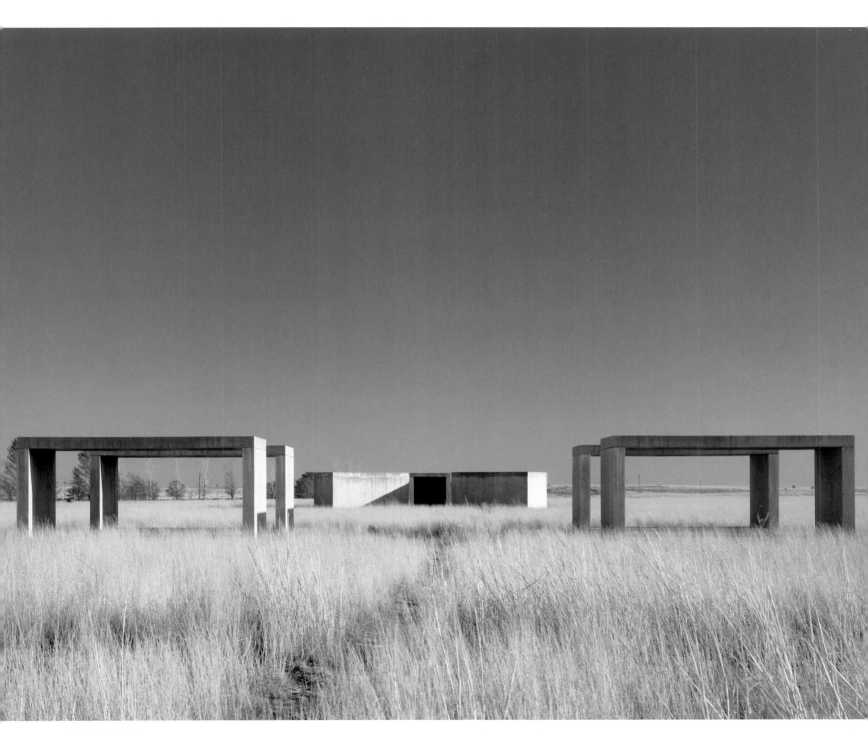

247. **Donald Judd**
Untitled, 1982
Concrete and steel, three
units, 98⁷⁄₁₆ x 196⁷⁄₁₆ x
98⁷⁄₁₆ in. (250 x 499 x
250 cm) each
The Chinati Foundation,
Marfa, Texas
© Donald Judd/Licensed
by VAGA, New York, NY

248. Donald Judd
Untitled, 1969
Brass and colored
fluorescent plexiglass on
steel brackets,
116½ x 27 x 24 in.
(295.9 x 68.6 x 61 cm)
Hirshhorn Museum and
Sculpture Garden,
Smithsonian Institution,
Washington, D.C.; Gift of
Joseph H. Hirshhorn,
1972
© Donald Judd/Licensed
by VAGA, New York, NY

249. David Smith
Cubi I, 1963
Stainless steel,
124 x 34½ x 33½ in.
(315 x 87.6 x 85.1 cm)
The Detroit Institute of Arts
© David Smith/Licensed by
VAGA, New York, NY

sculpture. It was closer to the American Precisionist aesthetic of the 1920s or the earlier Arts and Crafts ethic of "truth to materials." In fact, Minimalist sculpture seemed to have more in common with architecture—with the International Style's "less is more" and its clear, sober geometries, or with new Brutalist works such as

250. **Marcel Breuer**
Whitney Museum of American Art, New York, 1966

Marcel Breuer's Whitney Museum of American Art, completed in 1966, which was ideally suited to exhibit Minimalism (fig. 250).

Tony Smith, an architect by training, was an older artist who had anticipated the developments of Minimalism, though his work was exhibited contemporaneously. As an architect, he had been attracted to the modular systems of Frank Lloyd Wright and the structural simplicity of the tatami mats around which Japanese houses were designed, as well as the structural regularity and unilateral symmetry of the International Style. In his early paintings, he had experimented with geometric modules and gone on to use modular structures in his sculptures. Though he had already been at work

251. Installation view of "Primary Structures" at The Jewish Museum, New York, 1966
Left to right: Donald Judd, *Untitled,* 1966, and *Untitled,* 1966; Robert Morris, *Untitled (2 L-Beams),* 1965; Robert Grosvenor, *Transoxiana,* 1965

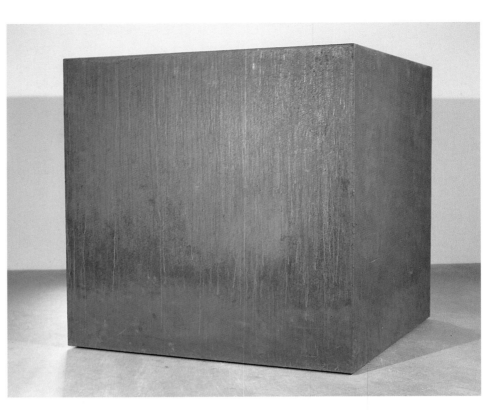

252. **Tony Smith**
Die, 1962
Steel, 72⅜ x 72⅜ x 72⅜ in.
(183.8 x 183.8 x
183.8 cm)
Whitney Museum of
American Art, New York;
Purchase, with funds from
the Louis and Bessie Adler
Foundation, Inc., James
Block, the Sondra and
Charles Gilman, Jr.,
Foundation, Inc., Penny
and Mike Winton, and the
Painting and Sculpture
Committee 89.6

for twenty years, it was not until 1963 that his sculpture was publicly shown, at Hartford's Wadsworth Atheneum, followed in 1966 by his inclusion in the seminal "Primary Structures" exhibition at The Jewish Museum, New York, the first time Minimalist sculpture received institutional recognition (fig. 251). A generation older than the other emerging Minimalists, he had been well known as a teacher (Robert Morris was among his students). Some of Smith's works were simple, like *Die* (fig. 252); others explored more complex aggregates of tetrahedral forms in works that shifted dynamically as the viewer moved around them (fig. 253). In a work such as *Die*, the title as well as the roughly human height of the simple cube conjure up not only industrial but emotional associations. Through this junction of affect and industry, Smith served as a bridge figure between the Abstract Expressionists and the Minimalists.

The Minimalist aesthetic of functionalism, repetition, and serial forms echoed through other media at the time—in the dance of the Judson Dance Theater, in the serial music of La Monte Young, Terry Riley, Steve Reich, and Philip Glass, and in the structuralist films of Paul Sharits, Michael Snow, and Hollis Frampton.

The Judson Dance Theater was founded in 1962 by disciples of Merce Cunningham in New York and Anna Halprin in San Francisco. The Judson dancers were intent on breaking free from the conventions of dance—from structure, rules, and techniques. They emphasized the body, freed dance from its dependence on music, used untrained dancers, and often produced dances from written scores specifying repetitive actions and commonplace tasks such as sleeping, walking, and eating that each individual dancer would interpret (fig. 258). The dancers sometimes performed nude, stripped down, as it were, to "bare" essentials.

There was a literal connection between visual arts and performance in the Judson Dance Theater as well. Robert Morris, a member of the Theater who had studied under Anna Halprin in San Francisco, was making sculpture at the same time he was performing. Some of his early works were performing objects,

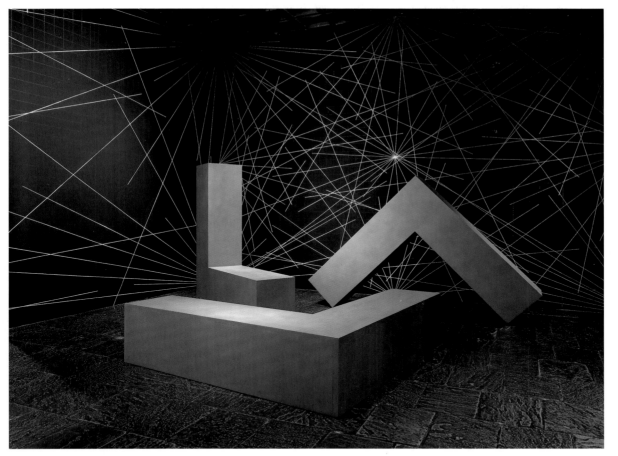

261. **Robert Morris**
Untitled (L-Beams), 1965
Stainless steel, three
parts, 96 x 96 x 24 in.
(243.8 x 243.8 x 61 cm)
overall
Whitney Museum of
American Art, New York;
Gift of Howard and Jean
Lipman 79.29a–c

On walls:
Sol LeWitt
*A Six-inch (15 cm) Grid
Covering Each of the Four
Black Walls*, 1976
Crayon and graphite,
dimensions variable
Whitney Museum of
American Art, New York;
Purchase, with funds from
the Gilman Foundation,
Inc. 78.1.1–4

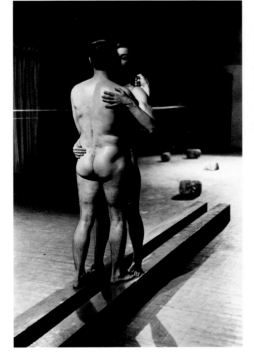

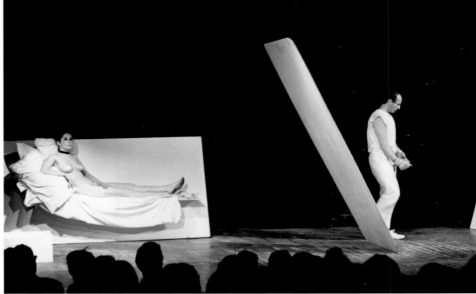

262. **Robert Morris**
Waterman Switch, 1965
Performance by Robert
Morris, Lucinda Childs, and
Yvonne Rainer at Festival
of the Arts Today, Buffalo,
New York
Photograph © The Estate
of Peter Moore/Licensed by
VAGA, New York, NY

263. **Robert Morris** and
Carolee Schneemann
Site, 1964
Performance at Judson
Memorial Church, New York
Photograph © The Estate
of Peter Moore/Licensed by
VAGA, New York, NY

famous reclining nude in Édouard Manet's painting of the same name, was concealed behind four sheets of plywood. The performance consisted of Morris' moving the plywood around until Schneemann was revealed to the audience, then continuing to move it around until she was again hidden.

In retrospect, Morris' hide-and-seek game of exposure and concealment laid bare one of the paradoxes of Minimalism: though most of the Minimalists had an aversion to psychological interpretation, and sought to purge personality and expression from their work, at the end of the day it could not be avoided.[95] Their art had as powerful a signature style as that of the Abstract Expressionists. As the critic Lawrence Alloway observed, "none of this legible and consistent sculpture is really impersonal."[96] From the contingent gestalts of Robert Morris, the obsessive latticed logic of Sol LeWitt, the hermetically sealed boxes of Larry Bell (fig. 264), or the lyrical, almost sublime lightworks of Dan Flavin, personality could not be removed from the work.

264. **Larry Bell**
Untitled, 1967
Mineral-coated glass and rhodium-plated brass on plexiglass base, 57⅛ x 24¼ x 24¼ in. (145.1 x 61.6 x 61.6 cm)
Whitney Museum of American Art, New York; Gift of Howard and Jean Lipman 80.38a–b

Much of Minimalism was difficult; its bluntness was interpreted as hostile and its monumentality as arrogant. Its ever-increasing scale aspired to the condition of architecture and often was deliberately too big to be accommodated in homes and museums. Though this was a defiant gesture, a sign of uncompromising principles, Minimalism, paradoxically, was quickly adopted by the business world: its clarity, directness, and self-assurance made it the perfect ambassador for corporate power. Furthermore, its lack of subject matter made it safer—something that could be incorporated into graphic designs and logos and exported throughout the world. This was doubly ironic because the artists were anti-commodity and even considered themselves "workers" in the proletarian sense, developing a common-man poetics.

The strong, physical forcefulness of Minimalist sculpture, like much Action Painting, also seemed a thinly disguised exaltation of male power.[97] Some Minimalist work, however, resisted this encompassing sense of domination. In the Judson Dance Theater group, women assumed a leadership role, perhaps because dance was traditionally an acceptable profession for women. Among painters, Agnes Martin's austere, linear or gridded works look "Minimal," but emphasize touch, with all the lines drawn carefully by hand (figs. 265, 266). Their sense of solitude conveyed a metaphysical message, as did the works by other "Minimal" painters, such as Brice Marden, whose sensual encaustic paintings are evocative of nature (fig. 267); or Ellsworth Kelly, whose curved shapes on

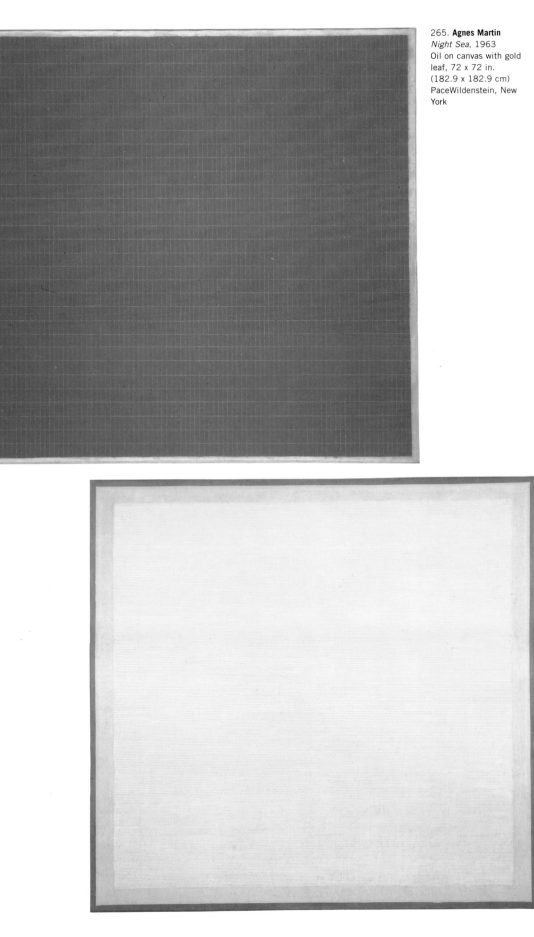

265. **Agnes Martin**
Night Sea, 1963
Oil on canvas with gold
leaf, 72 x 72 in.
(182.9 x 182.9 cm)
PaceWildenstein, New
York

266. **Agnes Martin**
Milk River, 1963
Oil on canvas, 72 x 72 in.
(182.9 x 182.9 cm)
Whitney Museum of
American Art, New York;
Purchase, with funds from
the Larry Aldrich
Foundation Fund 64.10

267. **Brice Marden**
The Dylan Painting, 1966
Oil and beeswax on
canvas, 60 x 120 in.
(152.4 x 304.8 cm)
San Francisco Museum of
Modern Art; Helen Crocker
Russell Fund, purchase
and partial gift of Mrs.
Helen Portugal

268. **Ellsworth Kelly**
Atlantic, 1956
Oil on canvas, 80 x 114 in.
(203.2 x 289.6 cm)
Whitney Museum of
American Art, New York;
Purchase 57.9

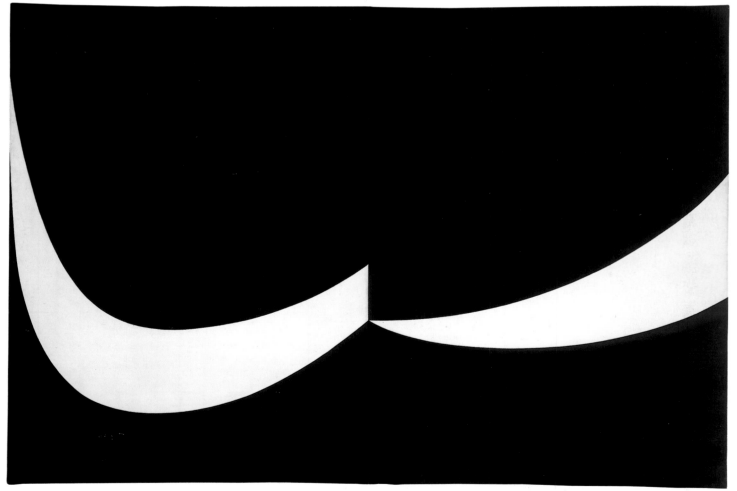

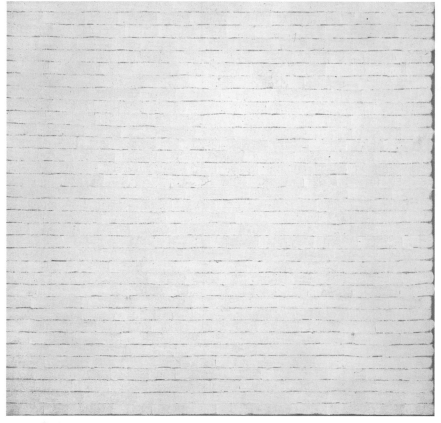

269. **Robert Ryman**
Winsor 34, 1966
Oil on linen, 63 x 63 in.
(160 x 160 cm)
PaceWildenstein, New
York

270. **Myron Stout**
*Untitled (Wind Borne
Egg)*, 1959 and 1980
Oil on canvas, 26 x 20 in.
(66 x 50.8 cm)
Whitney Museum of
American Art, New York;
Purchase, with funds from
the Mrs. Percy Uris
Purchase Fund 85.42

271. **Barnett Newman**
The Three, 1962
Oil on canvas, 76½ x 72
in. (194.3 x 182.9 cm)
Collection of Mr. and Mrs.
Bagley Wright

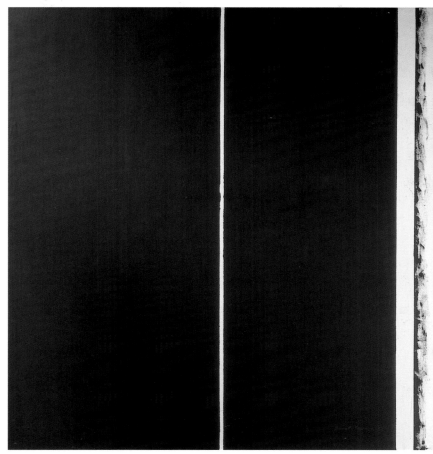

272. **James Turrell**
Shanta, 1967
Xenon projection,
dimensions variable
Whitney Museum of
American Art, New York;
Gift of Philip Johnson
81.9a–k

273. **Robert Irwin**
No Title, 1966–67
Acrylic on aluminum,
48 x 48 x 13 in. (121.9 x
121.9 x 33 cm)
Whitney Museum of
American Art, New York;
Purchase, with funds from
the Howard and Jean
Lipman Foundation, Inc.
68.42

canvas or metal, begun in the fifties, derived from abstracted natural or architectural forms (fig. 268); and Robert Ryman, whose investigations of white paint are often decidedly atmospheric (fig. 269). These artists eschewed gesture, but retained an interest in touch and surface inflection that was more closely aligned with the sublime paintings of Barnett Newman (fig. 271) and Mark Rothko.

The metaphysical dimension of light and space was further explored in the 1960s by a group of Los Angeles artists: Larry Bell made ionized plexiglass boxes (fig. 264); Robert Irwin, floating discs (fig. 273); and James Turrell, volumes of pure light (fig. 272). These works had an ethereal presence directly related to the hard-edge polished, reflective surfaces of Craig Kauffman and John McCracken (fig. 274)—whom one critic called "finish fetish" artists. They combined Pop and Minimalism in their sensuous use of plastics, lacquer, and bright candy colors to evoke the highly finished surfaces of surfboards, hot rods, and motorcycles.

274. **John McCracken**
Dark Blue, 1970
Polyester resin, fiberglass, and plywood, 96 x 22 x 3 in. (243.8 x 55.9 x 7.6 cm)
Courtesy L.A. Louver Gallery, Venice, California

By the late 1960s, the Minimalist movement was, to a large degree, codified and enshrined by major institutions. The "Primary Structures" exhibition at The Jewish Museum in 1966, "Systemic Painting" at the Guggenheim Museum in 1966, and "Art of the Real" at The Museum of Modern Art in 1968 were some of the major exhibitions devoted to it. Though the practitioners of Minimalism had sought to avoid the commodity references of the Pop artists, they were even more dependent on commercial and institutional spaces to provide a clean, well-lit arena and controlled environment for their art. Once deemed blank, impersonal, and boring, even the most rigorous of the Minimalists are today appreciated as elegant, artful, and serene.

But the insularity of Minimalism and its sober, puritanical bent was nevertheless out of step with the changing times. The critic Gregory Battcock, reviewing "The Art of the Real," observed, "No doubt one of the targets of the protesting students at Columbia University was just this type of bureaucratic excess that is developed within modern institutions in order that they may become free from real responsibility and significant action."[98] Decrying "obsolete institutions," he concluded that this exhibition would be the last that could be logically connected to the period in Western history that began with the Renaissance. Minimalism, an extreme end point of modernism, had become associated with outmoded practices and attitudes. The role of art was due for a reappraisal.

America
at the
Crossroads
1964–1976

As the 1960s progressed, more and more Americans began to question institutional authority. The rebellion initiated in the fifties by the Beats, on the one hand, and civil rights activism, on the other, exploded into a full-fledged counterculture by 1968. This counterculture gained momentum alongside reforms legislated by the government. Lyndon B. Johnson, who became president after John F. Kennedy was assassinated in November 1963 (fig. 275), was responsible for enacting the most extensive array of social reforms since President Franklin D. Roosevelt's New Deal in the 1930s. Johnson's domestic agenda was designed to create what he called the "Great Society," and included welfare reforms, Medicare, and a "War on Poverty."

275. *Vice President Lyndon B. Johnson, with His Wife and Jacqueline Kennedy, Taking the Presidential Oath of Office on* Air Force One *Immediately After President John F. Kennedy's Assassination,* 1963
UPI/Corbis-Bettmann

276. *Robert F. Kennedy Lying Wounded on the Floor of the Ambassador Hotel, Having Been Shot Shortly After His Victory Speech in the California Primary Election,* 1968
Photograph © Ron Bennett
UPI/Corbis-Bettmann

From 1964 to 1968, more than fourteen million Americans saw their incomes rise above poverty levels, which dropped from 22 percent to 11 percent of the population. Johnson offered something for all: tax cuts for big business, additions to the National Parks, air and water pollution standards, mass transit, and truth-in-packaging for consumers.

But one of the most significant accomplishments of Johnson's presidency was the passage of the 1964 Civil Rights Act, initiated a year earlier by John F. Kennedy. The most sweeping civil rights legislation since the Reconstruction years following the Civil War, this act outlawed segregation in schools and public facilities and spaces, provided for fairness in housing and employment, and banned discrimination in business and education. Though the "separate but equal" Jim Crow laws had been defeated in the 1954 *Brown* v. *Board of Education* Supreme Court ruling, four Southern states had failed as late as 1960 to integrate any of their public schools. The 1964 Civil Rights Act sent a clear signal that pervasive racial discrimination would no longer be officially tolerated. The following year, protests in Alabama against racial discrimination in voter registration rules prompted the passage of the 1965 Voting Rights Act.

For some black leaders, however, change was too slow in coming. Frustrated by the inconsistencies between America's egalitarian ideals and the inequality of legal, social, and economic conditions, they preached separatism in the form of black nationalism. Others advocated violence or promoted the Black Power movement, which was reinforced by the Student Organization for Black Unity and the Black Panther party—the latter a radical group founded in Oakland, California, in 1966. Race riots broke out across America—in Los Angeles in 1965; in Chicago, New York, Cleveland, and Baltimore in 1966; and, in 1967, in Detroit, Newark, New Jersey, Rochester, New York, Birmingham, Alabama, and New Britain, Connecticut.

In these same years, other newly empowered voices began to be heard. Native Americans and feminists joined the growing ranks of students and blacks who were becoming increasingly disillusioned with the social and political status quo. Groups such as the Students for a Democratic Society and the National

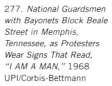

277. *National Guardsmen with Bayonets Block Beale Street in Memphis, Tennessee, as Protesters Wear Signs That Read, "I AM A MAN,"* 1968
UPI/Corbis-Bettmann

278. *Anti-Vietnam War Demonstrator Shot by National Guardsmen at Kent State University, Ohio,* 1970, photograph by John Filo

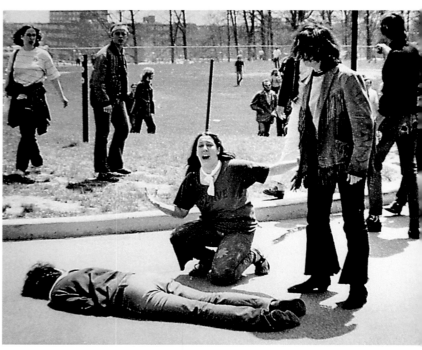

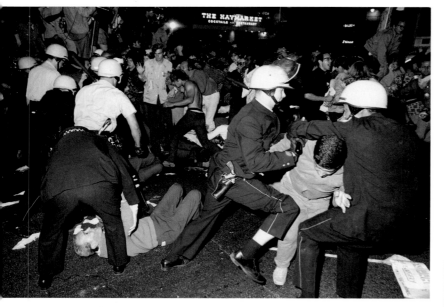

279. *Police and Antiwar Demonstrators Clashing on Michigan Avenue During the 1968 Democratic National Convention in Chicago*
UPI/Corbis-Bettmann

280. *Anti-Vietnam War Peace March, Washington, D.C.,* 1967

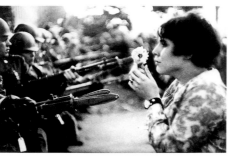

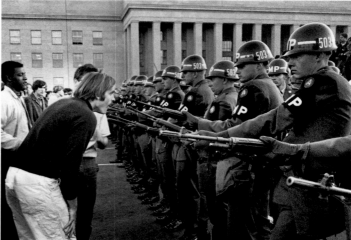

281. *A Peace Demonstrator Taunts Military Police in Front of the Pentagon During an Anti-Vietnam War Protest, Washington, D.C.,* 1967
UPI/Corbis-Bettmann

Organization for Women gained political power by organizing and challenging assumptions about technological progress, war, sexual mores, and gender and racial stereotypes. This mounting insurgency culminated in the global revolutionary events of 1968, as students rioted in Paris, at Columbia University in New York, and at the University of California at Berkeley.

Nationwide violence put an end to the mood of optimism and idealism that had opened the decade. In the wake of Kennedy's assassination came a wave of political assassinations that stunned the nation and further shook America's self-confidence. The black nationalist leader Malcolm X was shot at a rally in New York in 1965; in 1968, Martin Luther King, Jr., and Robert F. Kennedy were both slain by assassins' bullets (fig. 276). Public figures were moving targets, even in the art world: the day before Robert Kennedy's murder, an attempt had been made on Andy Warhol's life. All these events, along with America's involvement in Vietnam, initiated a dark period in America, a period of cynicism, fear, and anger. Many began to wonder what was wrong with the country.

Americans responded to the growing undercurrent of violence in different ways: some retreated to pre-industrial forms of life—like the hippies living in self-sufficient communes, preaching peace, love, and "flower power" (fig. 286). Along with a dreamy narcissism, more than a few opted for "dropping out" through drugs. Others, as we have seen, engaged in radical politics and protest, through both nonviolent means and violent confrontations that had links to student revolutions and liberation movements around the globe (fig. 277). Young people's anguished self-examination led to an oedipal hostility toward the older generation and establishment institutions such as the government and police (fig. 279).

Consensus culture in America, which had been disintegrating around civil rights issues, unraveled in the late 1960s over U.S. involvement in Vietnam. After the French withdrew from Vietnam in 1954, the country was divided, with a pro-Communist regime taking control of the North. President Eisenhower sent military advisers to

THEATER IN THE VIETNAM ERA

The American theater experienced one of its most radically experimental and political phases between 1965 and 1979. In the mid-1960s, it was sharply divided between the staid aesthetic and commercial tendencies of Broadway and most of Off-Broadway, on the one hand, and the bohemian experimentalism of Off-Off-Broadway, on the other. There were nevertheless glimmers of social consciousness on Broadway: Howard Sackler's Pulitzer Prize-winning *The Great White Hope* (1968) addressed race relations, while the musical *Hair* (fig. 282), originally produced Off-Broadway in 1967, was the Great White Way's highly successful representation of the hippie counterculture. Far more typical were comedies such as Neil Simon's *The Odd Couple* (1965) and Woody Allen's *Play It Again, Sam* (1969). Good examples of a popular Broadway genre, they reflect the commercial theater's obliviousness to the social upheavals surrounding the civil rights and antiwar movements.

The American theatrical avant-garde had earlier in the decade come to regard Off-Broadway theater as overly commercial and had shifted its base of operations to Off-Off-Broadway. Partly because of licensing regulations, many Off-Off-Broadway "theaters" were not theaters at all, but coffeehouses or clubs. A few, like La Mama Experimental Theater Club, founded in 1963 by Ellen Stewart, evolved into important theatrical institutions. Among the major American playwrights who began their careers Off-Off-Broadway were Sam Shepard, Lanford Wilson, Terrence McNally, and John Guare.

Off-Off-Broadway offered a vast range of sensibilities and subjects—and not all of them were focused on literary values. By 1964–65, the highly influential Living Theater was moving away from its earlier commitment to a poetic theater and toward a performance style based on physical improvisation and anarchist politics. The Living Theater inspired the formation of many aesthetically, politically, and socially radical troupes Off-Off-Broadway, among them the Open Theater, the Bread and Puppet Theater, the Manhattan Project, and the Performance Group. Unlike Broadway companies, they directly addressed social issues, particularly the Vietnam War. Like the antiwar movement itself, the radical theater was national in scope: by the late 1960s, almost every medium- to large-sized American city had at least one experimental theater company. —P. A.

282. Paul Jabara, Steve Gamet, Leata Galloway, and Suzannah Norstrand in the stage production of *Hair*, 1968
UPI/Corbis-Bettmann

train the anti-Communist South Vietnamese. During Kennedy's term of office, the number of advisers rose from 2,000 to 15,000. In 1964, the war escalated when Johnson ordered retaliatory air strikes against a North Vietnamese offensive. By 1968, some 525,000 American soldiers were fighting in a small Southeast Asian country that most Americans had never heard of, let alone could find on a map. The war in Vietnam bitterly divided the nation (figs. 280, 281). There was increasing suspicion that America was driven by anti-Communist paranoia, or by the economic greed of the military-industrial complex, or by racist attitudes. But most Americans were pragmatists: American troops and high-tech weaponry seemed unable to defeat the North Vietnamese and their guerrilla warfare tactics, and the cost in American lives was becoming too high. Marches on Washington to protest the war began in 1965. Over the next three years, such protests spread around the country and some of them were violent; police and protesters clashed and thousands were arrested. When National Guardsmen shot and killed four demonstrating students at Kent State University in Ohio in 1970, the country appeared to be on the verge of a civil war (fig. 278).

ANTI-ESTABLISHMENT AND DISESTABLISHMENT IN THE FILM INDUSTRY

Although the decrease in moviegoing and the apparent demise of the studios were thought to be fatal stakes through the heart of Hollywood, the creature did not die. Instead, its vitals were transplanted to pump life into massive conglomerates that one by one acquired the major studios during the 1960s and 1970s and collectively created a new beast called the entertainment industry. This period of corporate upheaval in the studios coincided with an epoch of political and social upheaval bracketed by the assassination of John F. Kennedy in 1963 and the resignation of Richard Nixon in 1974.

In 1968, the Motion Picture Production Code of 1934, which had barred all but discreet depictions of sex and violence, was replaced with a ratings system that permitted graphic content. And as institutions everywhere from Washington to Hollywood collapsed, a cultural gap emerged that divided America much as did the undeclared war in Vietnam. Certain filmmakers revered the stability of the old order, while others celebrated a dizzying new disorder. On one side of this divide was a grizzled John Wayne as the law-abiding marshal Rooster Cogburn in *True Grit* (1969, Henry Hathaway) aiming his six-guns toward the other side—at outlaw heroes such as Faye Dunaway and Warren Beatty in *Bonnie and Clyde* (fig. 283). Ideologically and cinematically, these two films illustrate an emerging generation gap, the formidable Wayne reinforcing traditional values and storytelling techniques, the ambivalent Beatty challenging both in a film startling for its amorality and jump cuts.

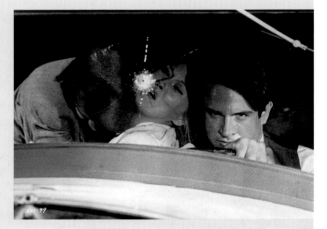

Institutional authority was the constant and beleaguered target of the era, in musicals (*Camelot*, 1967, Joshua Logan), in comedies (*The Graduate*, 1967, Mike Nichols), and in police thrillers (*In the Heat of the Night*, fig. 284). Whether it was Lancelot (Franco Nero) betraying King Arthur, the collegian Benjamin Braddock (Dustin Hoffman) kidnapping his girlfriend during her wedding to another fellow, or Mr. Tibbs (Sidney Poitier) provoking a redneck sheriff, the authority of monarch, church, and state was decisively challenged.

Poitier, as Tibbs and as the black scientist engaged to the daughter of white liberals in *Guess Who's Coming to Dinner* (1967, Stanley Kramer), represented the intellectually and morally superior black man whom Hollywood endorsed as inspirational to white Americans. Only independently made films, such as *Nothing But a Man* (1964, Michael Roemer), showed blacks enduring extraordinary prejudice while trying to lead ordinary lives.

The cultural ambivalence toward authority is the stuff of high satire in *Dr.*

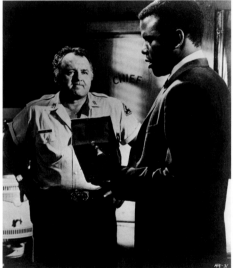

283. Faye Dunaway and Warren Beatty in *Bonnie and Clyde*, directed by Arthur Penn, 1967 Courtesy Warner Bros.

284. Rod Steiger and Sidney Poitier in *In the Heat of the Night*, directed by Norman Jewison, 1967 Courtesy United Artists

Questioning the Canon

The convulsive social and political events of the sixties were reflected everywhere in the arts of the time. From the radical sounds of electronic rock by such musicians as the The Doors and Jimi Hendrix to countercultural films like *Easy Rider* and *Midnight Cowboy* and the political activism of the Bread and Puppet Theater, a shake-up of the old social order was evident. In the visual arts, there was intense questioning of the modernist "canon," and a simultaneous redefinition of boundaries. It was a revolutionary period in American art that, in the years between 1966 and 1972, produced such fecund new forms and overlapping movements as Postminimalism, Earthworks, Conceptual art, Body art, Performance art, and video. The climate of questioning and experimentation in the visual arts was intensified by new federal subsidies for the arts through the National Endowment for the Arts (NEA) and the National Endowment for the Humanities (NEH). These agencies, created in 1965 as part of President Johnson's Great Society, provided indispensable support for vanguard artists, new art forms, and new venues, and they raised public consciousness about art. For the next twenty years, the NEA's policy of unrestricted grants to

Strangelove (1964, Stanley Kubrick), in which U.S. generals (Sterling Hayden and George C. Scott), fearful of a Communist doomsday device, launch nuclear warheads toward Moscow. Ambivalence is the stuff of high tragedy in *Patton* (1970, Franklin Schaffner), also starring Scott, a portrait of the World War II antihero General George S. Patton as a maniacal and self-destructive genius.

The common theme of movies as diverse as *Dr. Strangelove*, *Patton*, *The Wild Bunch* (1969, Sam Peckinpah), and *Easy Rider* (fig. 285) was America, land of random violence. Although Peckinpah's elegy to the American West was set in pistol-packing 1914 and Hopper's mod odyssey in pot-smoking 1969, the landscape of suspicion that turns American pilgrims into mercenary outlaws is interchangeable. Even the serio-comedy *Butch Cassidy and the Sundance Kid* (1969, George Roy Hill), starring Paul Newman and Robert Redford, cheers the outlaw heroes who outwit the sheriff's posse.

Stanley Kubrick's *Dr. Strangelove* and *2001: A Space Odyssey* (1968) were visual trendsetters. Moreover, the chrome-and-neon decors of the one and the machine aesthetic of the other mirrored the methods and the materials of Minimalist art. Both movies express a simultaneous love and fear of man-made devices (the bomb, the computer), making their mixed messages something akin to Technology equals Liberation equals Death.

In this valley of ambivalence, the laughs came from the stampede of stand-up comics—among them Woody Allen and Mel Brooks—armed with irreverence. Allen's *Take the Money and Run* (1969), which he wrote, directed, and starred in, profiled a compulsively funny compulsive thief. Similarly, Brooks' *The Producers* (1968) starred Zero Mostel and Gene Wilder as Broadway hustlers who sell 25,000 percent of a surefire flop—an upbeat musical about Hitler—that turns out to be a runaway hit.

No film was more irreverent than Robert Altman's *M*A*S*H* (1970), a black comedy set in an army hospital during the Korean War that potently linked war, gore, and absurdism. Compare this with *The Love Bug* (1969, Robert Stevenson), a family-friendly Disney affair about a temperamental Volkswagen, and you have the most extreme example of the era's yin and yang. —C. R.

285. Dennis Hopper, Peter Fonda, and Jack Nicholson in *Easy Rider*, directed by Dennis Hopper, 1969
Courtesy Columbia Pictures

individual artists was crucial to the development of avant-garde art in America.

Like much else in the late 1960s, the art world was in a state of instability, uncertainty, and discovery. Although artists reacted in different ways, the new art of this period shared certain general characteristics: an emphasis on disorientation, dislocation, dematerialization, and debris—qualities that paralleled the dismantling of institutional structures in the larger social sphere (fig. 287). Whether the artist unloaded a pile of rocks on the floor of a gallery, drew a chalk line on the desert ground, or removed chunks of a building, political attitudes infiltrated form. In another sense, however, these practices can be seen as part of a countertradition that had been developing since the fifties, when traditional genres and categories were fractured and the prosaic materials and imagery of the real world were welcomed into art.

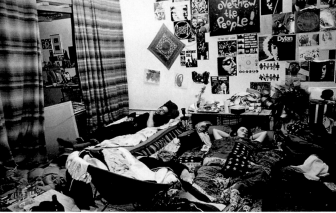

286. *Hog Farm Commune, New York City*, 1969

287. **Robert Morris**
Untitled, 1968
Thread, mirrors, asphalt, aluminum, lead, felt, copper, and steel, dimensions variable
Leo Castelli Gallery, New York

Hippie culture, rock music, and drugs were also important influences on the visual arts as the sixties went on, as was the new global culture connected through enhanced communications technologies, such as improvements in international telephone service and jet travel, which made possible ever faster transmission of information. It was an era whose art works were more interrogative than declarative and repudiated absolutes, mirroring the tendency of society at large.

Artists continued to ask "What is an object?" but in contrast to Donald Judd, who in 1965 drew the blunt conclusion that clear unitary forms best expressed the "thingness" of art, many artists now preferred to ask "How do we know or experience an object?" The stern formalism of the Minimalists and their absolute certainties had come to seem both utopian and puritanical—and uninvolved with the world. Some younger artists conceived of objects as mutable—as things in process—and therefore unstable, irregular, and disorderly. To emphasize the process of art making and its effect on materials, they often relocated the work to an expanded field that could include outdoor and architectural contexts. Other artists stressed the thought process over form, declaring the conception of the work to be the end product. One critic described these two tendencies, the process-oriented and the conceptual, as "the tidal pull between epistemological and ontological concerns."[99]

POP APOTHEOSIS: ROCK MUSIC RULES

As the 1960s began, the quality of popular music hit an all-time low. However, it was a great time for jazz music, particularly the emergence of John Coltrane from the Miles Davis Quintet. Coltrane's transformation from leading soloist to legendary artist culminated in one of the greatest artistic achievements of our time, the thirty-five-minute masterpiece *A Love Supreme*, recorded in 1964.

While Coltrane and contemporaries such as Ornette Coleman freed jazz to attain new levels of expression, other indigenous genres of music (blues, folk, and country) were being swept aside by the explosion of rock and pop. In England, however, young kids crazed for traditional American music seemed better able to enjoy and emulate the black musicians who had been replaced by bland white versions in the U.S. marketplace. This so-called British invasion was led by two childhood friends from Liverpool, John Lennon and Paul McCartney. Their band, the Beatles, started out as one of many covering rhythm and blues hits from the United States. They were soon joined by many other groups, most of which faded into obscurity after a hit or two. The Beatles, however, along with the Rolling Stones and, later, Eric Clapton, the Who, and Led Zeppelin, began to write and record original material that expanded on their blues roots, developed the idea of records as an album of related material, and established the basic format of a rock 'n' roll band. Lennon, in particular, experimented with song structures, unusual instrumentation, and wordplay, in a way that illuminated a new path for everyone around him.

At roughly the same moment in the mid-sixties, Bob Dylan began performing in New York (fig. 288), adopting the guise of an old folk musician in direct imitation of Woody Guthrie. But Dylan, like the Beatles, quickly moved beyond his roots to write complex lyrical songs that ranged from powerful social commentary to symbolic tales with profound poetic imagery. In 1966, he stunned his fans by recasting his music with an electric rock 'n' roll band whose raw power amplified his increasingly caustic and inventive lyrics. The Beatles and the Stones grew equally more inspired by mid-decade, lacing their work with unexpected sounds and using the studio itself as an instrument, manipulating tape to create unheard-of effects and ever more complex compositions. In fact, the Beatles' music grew so dependent upon studio effects that by the time their albums *Revolver* (1966) and *Sgt. Pepper's Lonely Hearts Club Band* (1967) were released, they could no longer re-create the music live and stopped giving concert performances altogether.

While British bands revitalized rock, American music continued to break new

289. *The Supremes on The Ed Sullivan Show*, 1966

290. *The Grateful Dead*, 1975
© Larry Hulst

ground, largely through the growth of soul and psychedelic music. Soul began in the late 1950s when artists such as Ray Charles and Sam Cooke combined gospel fervor with the secular concerns of blues and rock. By the mid-1960s, Berry Gordy, the founder of Motown Records, turned the formula into the biggest hit factory in the world. The quality of music he produced is astounding. In partnership with the great singer-songwriter Smokey Robinson, Gordy matched performers—the Temptations, the Supremes (fig. 289), Marvin Gaye, and Stevie Wonder—with writer-producers such as Holland-Dozier-Holland and Norman Whitfield to create tracks that combined innovative arrangements, clever lyrics, and catchy melodies with irresistible rhythms that made everyone want to dance.

By the late 1960s, the Motown formula had grown stale and certain artists, notably Gaye and Wonder in the albums *What's Going On* (1971) and *Innervisions* (1973), respectively, branched out to produce intense personal and social statements. Their work reflected the country's turmoil at the time by the incorporation of direct social commentary, and it provided stunning musical innovations through the use of electronic instruments, sound effects, and modular rhythms that continue to have a profound influence on popular music.

Changes at Motown were also precipitated by the rise of so-called psychedelic music, begun on the West Coast by the Byrds in Los Angeles and the Grateful Dead in San Francisco (fig. 290), and then popularized through the meteoric careers of Jim Morrison, Janis Joplin, and Jimi Hendrix. These artists ripped apart musical and social conventions through long instrumental jams fueled by a sense of personal intensity and abandon only hinted at by wild rockers in the fifties such as Elvis and Little Richard.

By the end of the sixties, young people around the world, inspired by the social and creative freedom expressed in the new pop music, developed an optimistic sense of their own purpose and ability to shape the future. This culminated in what remains the biggest communal youth event of all time, Woodstock, in 1969 (fig. 291). Unfortunately, the sense of positive social change that music helped generate in the 1960s gave way to a long, bland winter of discontent as the revolutionary aspirations of music and culture yielded to the commercial realities of the marketplace in the 1970s. Yet, as the decade closed, John Lennon emerged from the breakup of the Beatles to forge a new form of confessional performance out of his oddly alienated pop songs, such as "Help!" and "In My Life." His first solo album with the Plastic Ono Band in 1970 signaled the end of the sixties and the beginning of a less heroic, but more humanistic, approach. In this sense, Lennon, along with other exiles from the excesses of the decade—Neil Young, Joni Mitchell, Van Morrison, Paul Simon, and Bob Dylan—helped galvanize what was called the singer-songwriter movement. —J. C.

291. *Woodstock, Sullivan County, New York*, 1969

301. **Lee Bontecou**
Untitled Relief, 1964
Mixed media,
approximately 72 x
264 in. (182.9 x
670.6 cm)
Lincoln Center for the
Performing Arts, Inc., New
York

302. **Keith Sonnier**
Flocked Wall, 1969
Latex, rubber, and flocking,
132 x 84 x 31 in.
(335.3 x 213.4 x 78.7 cm)
Collection of the artist

POSTMINIMALISM: ANTI-FORM

By 1968, many practitioners of Eccentric Abstraction had extended their use of sensual materials and irregular, enigmatic forms into more dispersed "fields," in an art that has come to be known as Postminimalism. In April 1968, Robert Morris wrote an essay for *Artforum* entitled "Anti-Form," which described this new movement and the growing predilection for nonrectilinear, nonrigid forms; for sculpture that was not built; and for work that in general investigated the properties of the materials.[101] The essay was followed by the landmark exhibition Morris organized later that year at Leo Castelli's warehouse space on Manhattan's Upper West Side (fig. 303). "9 at Leo Castelli" included the work of Richard Serra, William Bollinger, Eva Hesse, Alan Saret, Bruce Nauman, Steve Kaltenbach, and Keith Sonnier, along with that of Giovanni Anselmo and Gilberto Zorio, Italian artists who were part of the Arte Povera movement, a European equivalent of Postminimalism.

This Postminimal, "anti-form" work was radical: open and indeterminate, a revival of the painterly and gestural attitudes of Abstract Expressionism, and of Jackson Pollock in particular. The artists used unorthodox materials, such as molten lead, rubber, neon, foam, felt, wire, flocking, salt, flour, mirrors, and earth (figs. 304–06). Sometimes these materials, which often became signature elements of an artist's work, were scattered and spread out over large areas, in seemingly unpremeditated arrangements. Their amorphous fields renounced mass, verticality, and even volume, as in Serra's *Scatter Piece* (fig. 307), where pieces of rubber latex looked like the remnants from a light industrial workshop, or Barry Le Va's *Continuous and Related Activities* (fig. 308), in which felt and glass were strewn across a floor area. The artist's decision about the form of the work depended on the physical space in which it was located. These works could not be transported; they were therefore ephemeral and often dispensed with once an exhibition closed.

303. Installation view of "9 at Leo Castelli," New York, 1968
On floor, clockwise from left: William Bollinger, *Untitled*; Steve Kaltenbach, *Untitled*; Bruce Nauman, *John Coltrane Piece*; Gilberto Zorio, *Untitled*; Eva Hesse, *Augment*; on wall: Keith Sonnier, *Untitled* and *Mustee*

305. **Richard Serra**
*Thirty-five Feet of Lead
Rolled Up*, 1968
Lead, 5 x 24 in.
(12.7 x 61 cm)
Collection of Anita and
Horace Solomon
Photograph by Peter Moore

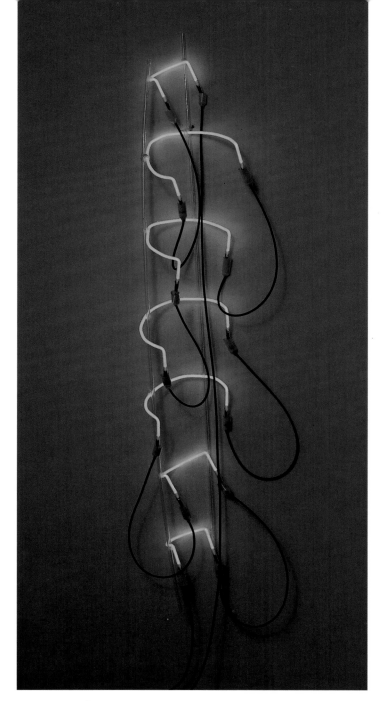

304. **Bruce Nauman**
*Neon Templates of the
Left Half of My Body
Taken at Ten-Inch
Intervals*, 1966
Neon tubing with clear
glass tubing suspension
frame, 70 x 9 x 6 in.
(177.8 x 22.9 x 15.2 cm)
Collection of Philip
Johnson

306. **Richard Serra**
Rosa Esman's Piece,
1967
Vulcanized rubber, 36 x
15 in. (91.5 x 38 cm)
Collection of Richard
Serra and Clara Weyergraf-
Serra
Photograph by Peter
Moore

307. **Richard Serra**
Scatter Piece, 1967
Rubber latex, dimensions
variable
Estate of Donald Judd

308. **Barry Le Va**
*Continuous and Related
Activities: Discontinued by
the Act of Dropping*, 1967
Felt and glass, dimensions
variable
Whitney Museum of
American Art, New York;
Purchase, with funds from
the Painting and Sculpture
Committee 90.8a–c

This kind of sculpture was the opposite of structured, monumental, and rigid Minimalism. It was almost as if the Postminimalists had taken Donald Judd's statement that his work was "single and not partial and scattered" and inverted it, making works out of parts and scattering them about.[102] For the Postminimalists, aesthetics was not an end product and experience was fragmented and decentered. Their provisional, indeterminate forms were profoundly disorienting, prompting one critic to call the show at Castelli's warehouse space "a liberating spectacle of acts of disorientation."[103] The space itself was industrial, and such spaces—particularly in the historic district of cast-iron loft buildings in the nascent artists' neighborhood of SoHo—became the preferred setting for the random pilings, loose stackings, and hanging forms that made up the new sculpture. Conceptually, too, an industrial space paralleled the sculpture's sense of transformation from raw to processed materials.

Richard Serra threw molten lead where the wall meets the floor to produce *Splash Piece: Casting* (fig. 311). Both the process and the look of the work refer to the always mutating state of

FICTION: ESCAPING LINEAR NARRATIVE

From the early sixties to the late seventies, American fiction went through a period of radical experimentation, which culminated in the appearance of a number of the most complex and formidable novels of the postwar era. For Thomas Pynchon, Kurt Vonnegut, Robert Coover, Ishmael Reed, and Joseph McElroy, all of whom produced exceptionally challenging work in these years, the conventions of social realism were inadequate for capturing the bewildering qualities of contemporary American life. Faced with a world of rampant consumerism and media images, political secrecy and countercultural revolt, the commonsense assumptions of the realist novel seemed ever more untenable. Well-rounded characters and shapely plots, transparent language and moral seriousness, all fell victim to the scathing wit of sixties experimental fiction.

Jorge Luis Borges, Samuel Beckett, Vladimir Nabokov, and the practitioners of the French *nouveau roman*, as well as such American originals as William Burroughs, John Hawkes, and William Gaddis, provided the inspiration for a new kind of writing, one that was both playful and highly self-conscious—slapstick and absurdist in its sensibility, abstrusely philosophical in its concerns. Such fiction could no longer be described as a mirror of the social world. Instead, writing was better understood as a performance or a game: the finished product was a puzzle or a playground, not a picture of reality. A fiction that turns its scrutiny on its own meaning-making apparatus (a practice also being explored in vanguard movements in the visual and performing arts) is capable of dramatizing the ways in which sense and nonsense are generated in the languages of politics and history. The disruption of narrative sequence poses a challenge to ideas of human action and identity, tearing effects from causes and hinting that the appearance of order and plot in the world might prove delusional, no more than the projection of a disordered psyche.

Two of the most powerful novels of the period—one a best-seller, the other a cult classic—exemplify the methods and significance of nonlinear fiction. Kurt Vonnegut's *Slaughterhouse-Five* (fig. 309) and Thomas Pynchon's *Gravity's Rainbow* (fig. 310) mix high and low forms, play with temporal succession, and break down character to depict historical experience as a nightmarish carnival. At the heart of Vonnegut's immensely popular book lies his struggle to write about his experiences during World War II. Such material, he explains, cannot be cast into lucid and elegant designs; instead, the book is "short and jumbled and jangled," a text that plays tricks with time and perspective, bouncing back and forth between terse historical re-creation and comic fantasy. Billy Pilgrim, the protagonist of *Slaughterhouse-Five*, has, like

309. *Slaughterhouse-Five or The Children's Crusade*, by Kurt Vonnegut
New York: Delacorte Press, 1969
Harry Ransom Humanities Research Center at The University of Texas at Austin

310. *Gravity's Rainbow*, by Thomas Pynchon
New York: Viking Press, 1973
Harry Ransom Humanities Research Center at The University of Texas at Austin

matter. In other works, Serra employed what he called props—lead slabs propped up by steel pipes—whose seemingly precarious construction provokes a sense of threat and uncertainty in the viewer (fig. 312). The expressive potential of Serra's work took a more romantic turn later, when he exploited the markings and oxidation of Cor-ten steel to make surfaces that allude to Abstract Expressionist painting. Alan Saret's ethereal wire tangles extend the improvisatory gestural idiom of Abstract Expressionism, but without its emotional intensity (fig. 314).

The expressive possibilities of anti-form ranged wide, from Bruce Nauman's rather abject piece of cloth draped in a corner (fig. 315) to Robert Smithson's layering of mirrors and dirt (fig. 317); in both pieces, the final shape is determined in part by gravity and other natural forces such as entropy (the depletion of energy through the rapid conversion of physical matter). Eva Hesse's *Accession II* (fig. 320)—a rigid box of perforated steel lined with fingers of soft plastic tubing—or her more amorphous, weblike resin and rope pieces (figs. 319, 321, 322)—have strong anthropomorphic associations. In fact, many of the soft, decentered forms by male and female Postminimalists were coded as "female," since softness was considered a female attribute: Hesse's flowing appendages of latex; Morris' limp, hanging felt works (fig. 318); Richard Tuttle's irregular cloth shapes (fig. 325); Lynda Benglis' poured accretions of polyurethane foam (fig. 316); or Jackie Winsor's twine-bound geometric forms (fig. 326). Some critics have also interpreted the sensuality of Postminimalism as a desublimation of the sexual liberation of the period.[104]

Vonnegut, survived the firebombing of Dresden, but in consequence has "come unstuck in time": he finds himself hurled randomly about in his life, an old man one instant, a prisoner of war the next. Schooled by space aliens, whose existence may be a symptom of his madness, Billy learns to offset the unpalatable wartime experiences with happy ones, finding a modicum of value in human life at a moment when history seems intent on denying it. Freed from linear time, he has the capacity to see terrible events reversed: at one point, he watches a war movie run backwards, bombers scooping fire and death into their fuselages, magically undoing destruction from the air. But the cost of this vision is moral paralysis, the numbing realization that people are "the listless playthings of enormous forces."

The characters in Thomas Pynchon's huge, encyclopedic novel of World War II are also subject to enormous forces. Yet in *Gravity's Rainbow* the overwhelming powers are agencies of governments and cartels, sinister and shadowy organizations that are shaping a new world order out of the ruins of Europe. At the center of the book is an apparent reversal of time: the German V-2 rocket crashes destructively to earth *before* it is heard "screaming across the sky." Even before the weapon is launched, an American lieutenant, Tyrone Slothrop, experiences sexual arousal at the very place where the rocket will strike. Slothrop's unusual gift becomes the focus of multiple plots that proliferate in a fashion resembling both the molecular arrangement of plastic—that essential modern material—and the intricate structure of multinational corporations. *Gravity's Rainbow* follows the unfortunate American across the shattered landscape of Western Europe, eliciting significance from fields as varied as rocket science and parapsychology, comic books and myth. As Slothrop vanishes among legends and rumors, Pynchon constructs an image of a world driven insane by the confusion of living beings with machines. It is an apocalyptic vision unmatched in postwar American literature. —J. G.

Repetitive actions and procedures were a common practice in Postminimalism. The relentless one-thing-after-another of Minimalism was transformed into one-action-after-another in a work such as Richard Serra's film *Hand Catching Lead*, in which the camera is fixed on his hand opening and closing into a fist in an attempt to catch a falling stream of lead particles (fig. 313). Like the task performances of Judson Dance Theater choreography, where the dance is determined by a simple action, Serra's chief compositional strategy is the real operational time of the given task or procedure. A running list of transitive verbs he composed in 1967–68 ("to roll, to crease, to fold, to store, to bend, to shorten, to twist, to twine, to dapple, to crumple, to shave, to tear, to chip, to split, to cut, to sever, to drop") lays out many of the actions he would perform on materials.[105]

Though some critics described the new Postminimalist sculpture as the dematerialization of the art object because mass and volume were abandoned in favor of materials and procedures, form in fact was never abandoned; it was just reconceived and relocated. Where it was located was key. As artists sought to make stronger

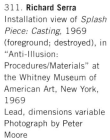

311. **Richard Serra**
Installation view of *Splash Piece: Casting*, 1969 (foreground; destroyed), in "Anti-Illusion: Procedures/Materials" at the Whitney Museum of American Art, New York, 1969
Lead, dimensions variable
Photograph by Peter Moore

312. **Richard Serra**
Prop, 1968
Lead antimony, 97½ x 60 x 43 in. (247.7 x 152.4 x 109.2 cm)
Whitney Museum of American Art, New York; Purchase, with funds from the Howard and Jean Lipman Foundation, Inc. 69.20a–b

313. **Richard Serra**
Hand Catching Lead, 1968
16 mm film, black-and-white, silent; 3½ min.
Collection of the artist

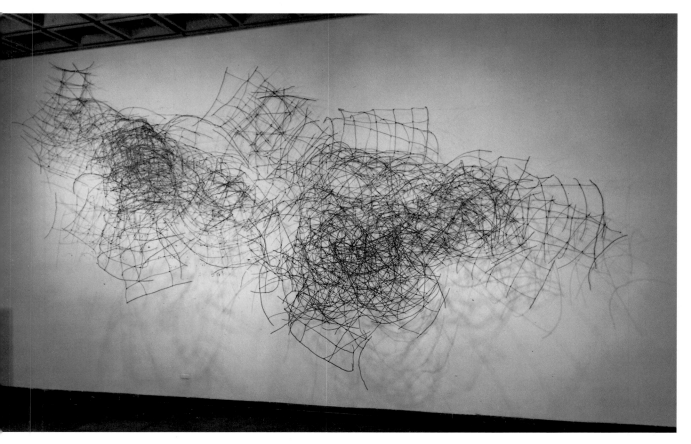

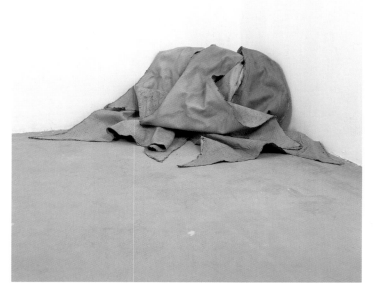

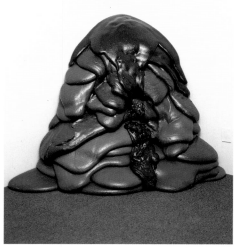

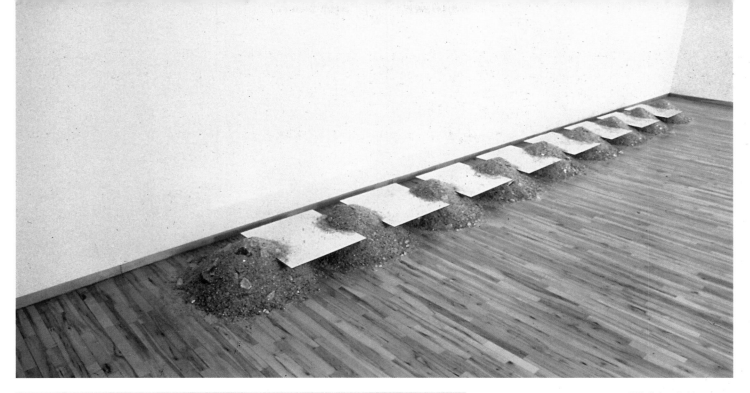

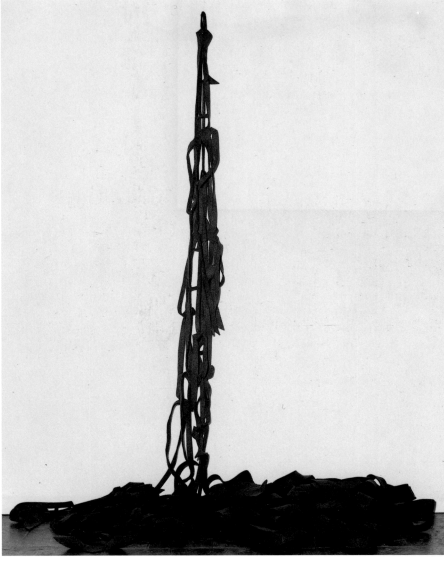

317. **Robert Smithson**
Eight Part Piece (Cayuga Salt Mine Project), 1969
Rock salt and mirrors,
11 x 360 x 30 in.
(27.9 x 914.4 x 76.2 cm)
Estate of the artist
© Estate of Robert Smithson/Licensed by VAGA, New York, NY

318. **Robert Morris**
Felt, 1967–68
Felt, dimensions variable
Whitney Museum of American Art, New York; Purchase, with funds from the Howard and Jean Lipman Foundation, Inc.
69.23

319. Eva Hesse
Sans II, 1968
Fiberglass, 38 x 170¾ x
6⅛ in. (96.5 x 433.7 x
15.6 cm) overall
Whitney Museum of
American Art, New York;
Purchase, with funds from
Ethelyn and Lester J.
Honig and the Albert A.
List Family 69.105
© The Estate of Eva
Hesse

320. Eva Hesse
Accession II, 1969
Galvanized steel and
plastic tubing, 30¾ x
30¾ x 30¾ in. (78.1 x
78.1 x 78.1 cm)
The Detroit Institute of
Arts; Founders Society
Purchase, Friend of
Modern Art Fund and
Miscellaneous Gifts Fund
© The Estate of Eva
Hesse

321. Eva Hesse
Untitled, or Not Yet, 1966
Nine dyed fishnet bags
with clear polyethylene,
paper, sand, and cotton
string, 71 x 15½ x 8¼ in.
(180.3 x 39.4 x 21 cm)
overall
San Francisco Museum of
Modern Art; Purchase
through Gift of Mrs. Paul
L. Wattis
© The Estate of Eva Hesse

322. **Eva Hesse**
Untitled (Rope Piece), 1970
Latex over rope, string,
and wire, two strands,
dimensions variable
Whitney Museum of American
Art, New York; Purchase, with
funds from Eli and Edythe L.
Broad, the Percy Uris
Purchase Fund, and the
Painting and Sculpture
Committee 88.17a–b
© The Estate of Eva Hesse

connections between their work and the outside world, a consideration of context became paramount. The forms were often dictated by their site—the surrounding architecture, such as industrial lofts, or landscape. This sculpture in an expanded field focused on the phenomenological experience—our experience of the work in space and time.[106] Duration or temporality was what the formalist critic Michael Fried had so strenuously objected to in his influential polemic "Art and Objecthood," when he reproached the Minimalists for the theatrical character of their work—for expecting the viewer to be in motion to experience it.[107]

The Postminimalists, with their emphasis on site and phenomenology, pushed the idea of spectator participation even further. By 1968, theatricality and the active role of the viewer in space and time had become central to the reformulation of sculpture. The importance of site to the experience of sculpture had been envisioned in the

THE NEW NONFICTION NOVEL

The new nonfiction novel of the 1960s—developed by Tom Wolfe, Truman Capote, Norman Mailer, Joan Didion, and Hunter S. Thompson—was a revolutionary conception with a retrospective touch, antagonistic to the rules that governed postwar fiction and journalism, but respectful of the tradition of literary realism embodied in the novels of Daniel Defoe in the eighteenth century and in those of Charles Dickens in the nineteenth. In part, the new nonfiction writers saw themselves rebelling against the exaltation of modernist experimentation during the 1950s and 1960s, which was to be leading talented authors toward introversion just when the country was filled to bursting with peerless subject matter: "No novelist," Wolfe claimed with characteristic audacity, "will be remembered as the novelist who captured the Sixties in America."

Although these writers saw themselves as filling that gap, they were also assaulting the conventions of journalism—particularly, the idea of "objective distance." Often, they began their careers laboring on the fringes of the journalistic establishment. Tom Wolfe, for example, wrote features for the Sunday supplement of the *New York Herald Tribune*. By the late 1960s, in books such as Wolfe's *Electric Kool-Aid Acid Test* (fig. 323), an astonishing chronicle of the burgeoning LSD culture, Manhattan reporters were displaying a new confidence that meshed with the growing regard for the creative nonfiction of novelists like Capote, who called *In Cold Blood* (1965), his account of a mass murder in Kansas, the "first nonfiction novel," and Mailer, whose *Armies of the Night* (fig. 324) read like a memoir of the antiwar movement co-written by Edward R. Murrow and W. C. Fields. Didion and Thompson (whose writing was dubbed "gonzo journalism") catalyzed a growing California literary scene that balanced East Coast excess with West Coast excess. And dispatches from Vietnam correspondents such as Michael Herr and John Sack matched Herr's claim that "conventional journalism could no more reveal this war than conventional firepower could win it."

If what these authors composed was "realistic," it was not gray or sedate but shared the party-colored politics and skepticism toward authority that marked much of 1960s culture. What stood out about the new nonfiction writers, more often than not, was how rarely they sounded the transparent, neutral voice that had been the trademark of postwar reporting since George Orwell: there was no precedent for Wolfe's freewheeling sentence structure ("Barreling across America with the microphones picking it all up, the whole roar, and microphone up top gets eerie in a great rush and then *skakkkkkkkkkkkkkk* it is ripping and roaring"), Thompson's weaving between reality and

323. *The Electric Kool-Aid Acid Test*, by Tom Wolfe
New York: Farrar, Straus, and Giroux, 1968
Berg Collection of English and American Literature, The New York Public Library, Astor, Lenox and Tilden Foundations

324. *The Armies of the Night*, by Norman Mailer
New York: New American Library, 1968
Harry Ransom Humanities Research Center at The University of Texas at Austin

early 1950s by the sculptor Tony Smith. One evening, he took a group of students to the then unfinished New Jersey Turnpike.

> It was a dark night and there were no lights or shoulder markers, lines, railing, or anything at all except the dark pavement moving through the landscape of the flats, rimmed by hills in the distance, but punctuated by stacks, towers, fumes, and colored lights. This drive was a revealing experience. The road and much of the landscape was artificial, and yet it couldn't be called a work of art. On the other hand, it did something for me that art had never done. At first I didn't know what it was, but its effect was to liberate me from many of the views I had had about art. . . . There is no way you can frame it, you just have to experience it.[108]

Although Michael Fried explicitly attacked Smith's ruminations in "Art and Objecthood," Robert Smithson defended the sculptor in a letter to the editor, praising Smith's recognition of the industrial landscape as suitable, experiential territory for art.

That same year, 1967, Smithson published an article that was also an art work: "The Monuments of Passaic." In this text, accompanied by photographs, Smithson identified as "monuments" pontoons and pumping derricks in the Passaic River, pipes spewing water into the river, and concrete abutments supporting the shoulders of a new highway under construction (fig. 327).[109] He referred to them as postindustrial ruins—ruins in reverse—things that became ruins *before* they were built rather than *after*. Smithson was preoccupied with "penumbral zones"— areas not thought of as picturesque, such as urban fringe developments, the

hallucination ("The rest of that day blurs into madness. The rest of that night too. And all the next day and night"), or even Didion's gorgeous deadpan ("This is the California where it is possible to live and die without ever eating an artichoke"). Readers also tended to notice (and traditional journalists to criticize) how often the new nonfiction writers set themselves up as the third-person omniscient narrator to describe the inner thoughts of their subjects. In their defense, the new nonfiction writers argued, "We had to gather all the materials the conventional journalist was after—and then keep going" (Wolfe). In fact, the new nonfictionists sometimes seemed more like performance artists than writers. George Plimpton's best-selling *Paper Lion* (1966), for instance, followed its half-terrified, half-elated narrator through a pro-football training camp and into the game huddle. But even Plimpton's experiences seemed cautious when compared with Thompson's *Hell's Angels: A Strange and Terrible Saga* (1967), which culminates with the gang members' beating the author into visionary unconsciousness.

The New Journalists and nonfiction novelists were brash, sometimes too brash: amid their stylistic pyrotechnics, a *New York Times* reviewer wondered, "could a reader. . . tell the truth?" At the same time, they seemed to understand better than anyone that the sixties were great theater, an experimental time that did not necessarily require experimental writers, but writers who were willing to do a reporter's legwork. And while many works of new nonfiction lost their sense of timeliness as the decade passed, the movement's influence has endured. *In Cold Blood* helped revive the "true crime" genre, and the influence of writers like Didion can be felt in the newfound respect paid to the memoir and the personal essay. And whereas university courses such as John McPhee's legendary "Literature of Fact" at Princeton were once rare, they now enjoy unprecedented popularity, proof that the new nonfiction has become an established part of American letters. —A. L.

effluvia of industrialization, and other entropic landscapes. Entropy, the inevitable disintegration of matter, was the ultimate destiny of the universe, according to Smithson.[110] (Could he have foreseen that the Passaic River would later be found to contain the country's highest levels of dioxin, an environmental poison, caused by a factory producing Agent Orange?)

"The Monuments of Passaic," which identified the industrial wasteland as a paradigm for art and life, illuminated the direction Smithson's sculpture was taking. By 1967, he was moving away from quasi-Minimalist forms and geometric progressions and beginning to work in the landscape. This enterprise started with a series of "non-sites," as he called them—archaeological samples of rocks from sites in New Jersey such as the Pine Barrens, Franklin Mineral Dumps, and the Palisades in Edgewater (fig. 328). He brought the rocks indoors, placed them in geometric metal bins, added photographs, maps, and written descriptions of the site to create an indoor-outdoor dialectic about industrial archaeology.

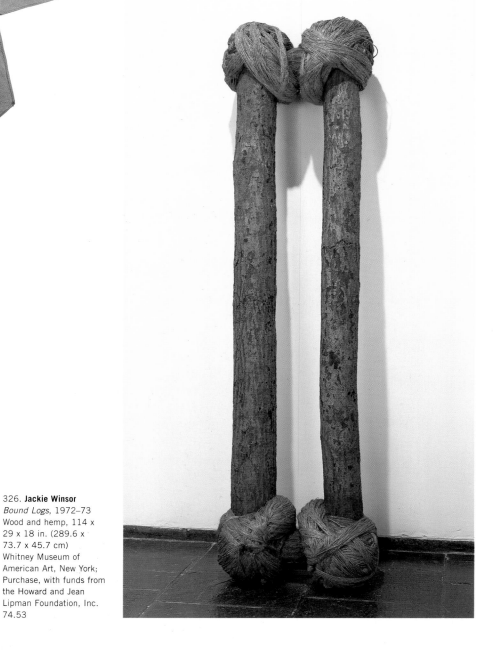

325. **Richard Tuttle**
Grey Extended Seven, 1967
Dyed canvas, 48½ x 59½ in.
(123.2 x 151.1 cm)
Whitney Museum of
American Art, New York;
Purchase, with funds from
the Simon Foundation, Inc.
and the National
Endowment for the Arts
75.7

326. **Jackie Winsor**
Bound Logs, 1972–73
Wood and hemp, 114 x
29 x 18 in. (289.6 x
73.7 x 45.7 cm)
Whitney Museum of
American Art, New York;
Purchase, with funds from
the Howard and Jean
Lipman Foundation, Inc.
74.53

327. **Robert Smithson**
The Monuments of Passaic, 1967 (detail)
Twenty-four gelatin silver prints, 3 x 3 in.
(7.6 x 7.6 cm) each
© Estate of Robert Smithson/Licensed by VAGA, New York, NY

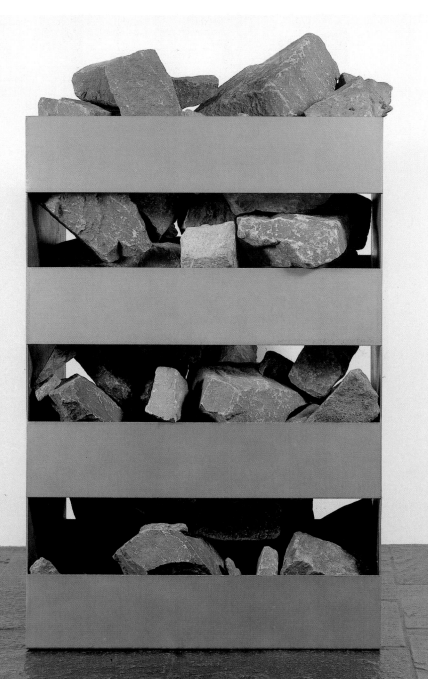

328. **Robert Smithson**
Non-site (Palisades, Edgewater, N.J.), 1968
Enamel, painted aluminum, and stone, 56 x 26 x 36 in.
(142.2 x 66 x 91.4 cm)
Whitney Museum of American Art, New York; Purchase, with funds from the Howard and Jean Lipman Foundation, Inc. 69.6a–b
© Estate of Robert Smithson/Licensed by VAGA, New York, NY

ART REENTERS THE AMERICAN CITY

On Wednesday, July 26, 1967, a *New York Times* headline screamed, "TROOPS BATTLE DETROIT SNIPERS, FIRING MACHINE GUNS FROM TANKS. DETROIT TOLL IS 31." Three weeks later, on August 15, 1967, the *Chicago Tribune* declared, "READY OR NOT, CHICAGO ENTERS ITS PICASSO ERA IN CIVIC CENTER. 50-FOOT SCULPTURE UNVEILED BY MAYOR." These two headlines are intimately related.

After World War II, many cities in the United States went into an economic decline. The new American dream for returning veterans was a suburban home with a yard and a car. As the white middle class fled to the suburbs, followed by corporate offices and factories, the drain on the cities was immense. Meanwhile, African Americans, moving north to avoid Jim Crow laws that limited their horizons in the South, were systematically excluded from the suburbs. Inner cities were becoming largely poor and African American, but the police forces remained mainly white. Tensions grew, and by the mid-1960s riots were a frequent occurrence—twenty-one major riots in 1966, eighty-three the following year. To this grim picture, add the chaos of the public sector: subway strikes, urban mismanagement, the threat of municipal bankruptcy.

Urban planners, architects, and public officials were looking for ways to revitalize and renew American cities. Artists were enlisted in the effort to attract people back to downtown areas. The national move toward public art came in the 1970s, just after the nadir of urban despair. In general, the local public art ordinances passed during this period required that 1 percent of the construction budgets of public buildings be set aside for permanently installed art works. The federal government got involved as well. In 1967, the National Endowment for the Arts had created its Art in Public Places Program; the first work commissioned was Alexander Calder's *La Grande Vitesse*, installed in Grand Rapids, Michigan, in 1969. In these early years, public art was synonymous with internationally recognized artists—Calder, Pablo Picasso, and Henry Moore—who were called upon to create symbols of a new urban identity. Indeed, in an oft-cited success, an image of *La Grande Vitesse* ended up on the Grand Rapids city stationery and graces civic garbage trucks even to this day.

Perhaps the most highly publicized monument installed in an American city during this period was the so-called Chicago Picasso (fig. 329), commissioned for the Civic Center Plaza. Although people on the streets in Chicago had their reservations about it, the rhetoric from public officials was optimistic, and it was very nice to be optimistic about *something* in an American city during the long, hot summer of 1967. Tens of

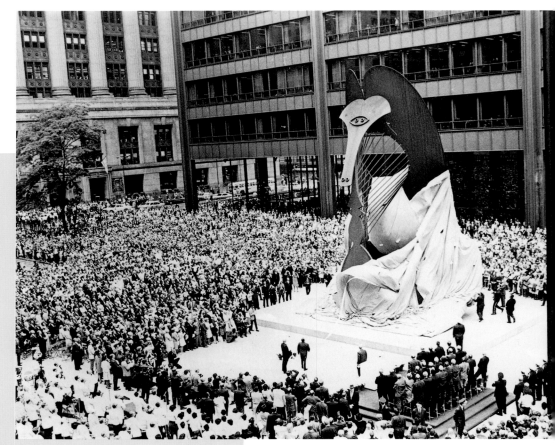

329. *Unveiling of Pablo Picasso's Chicago Civic Center Sculpture*, 1967

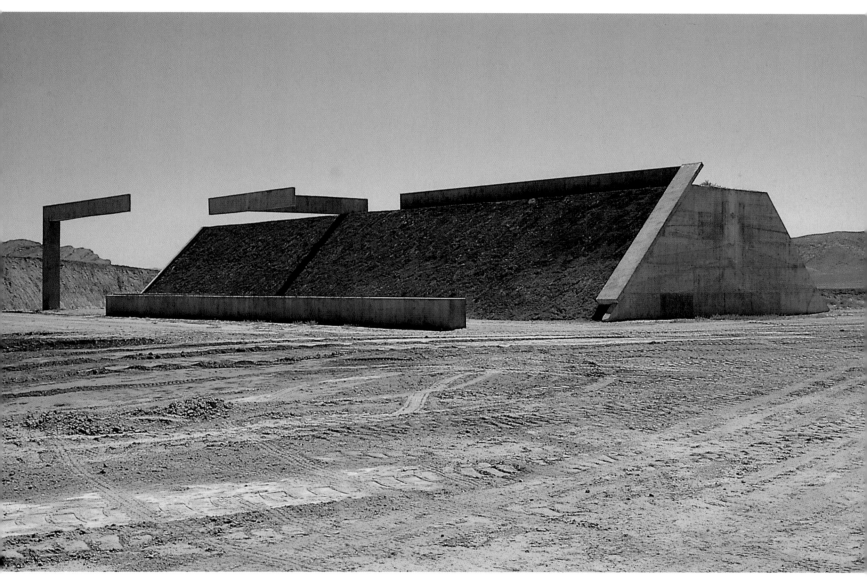

336. **Michael Heizer**
Complex One, 1972
Concrete, steel, and earth
from central eastern
Nevada, 282 x 1680 x
1320 in. (716.3 x
4267.2 x 3352.8 cm)
Dia Center for the Arts,
New York

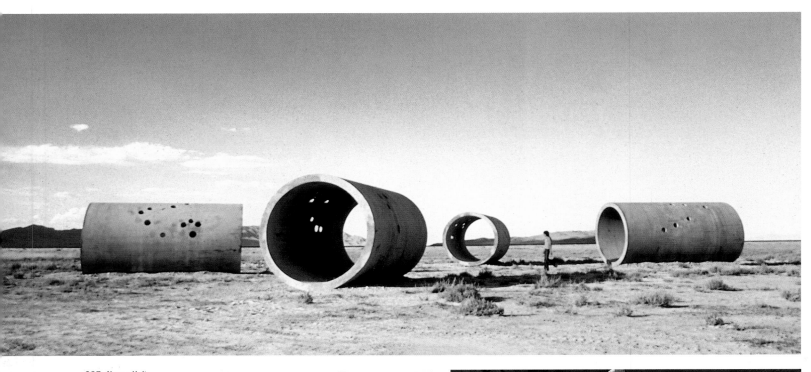

337. **Nancy Holt**
Sun Tunnels, 1973–76
Concrete, four tunnels,
86 ft. (26.2 m) total
length
Great Basin Desert, Utah
© Nancy Holt/Licensed by
VAGA, New York, NY

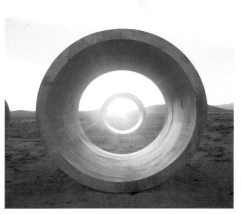

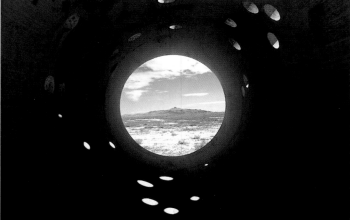

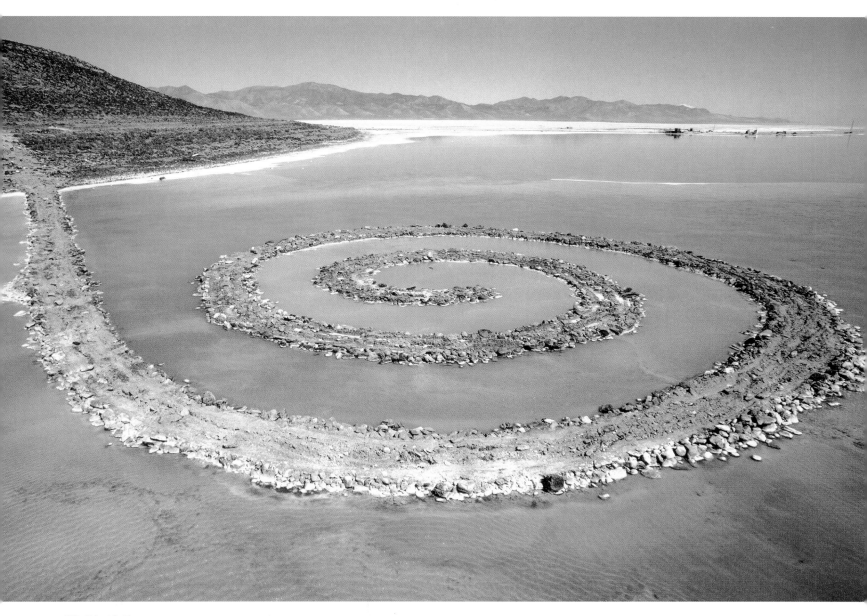

338. **Robert Smithson**
Spiral Jetty, 1970
Rock, salt crystals, earth,
and water with algae,
1500 ft. (457.2 m)
length, approximately
15 ft. (4.6 m) width
Great Salt Lake, Utah
© Estate of Robert
Smithson/Licensed by
VAGA, New York, NY
Photograph © Gianfranco
Gorgoni

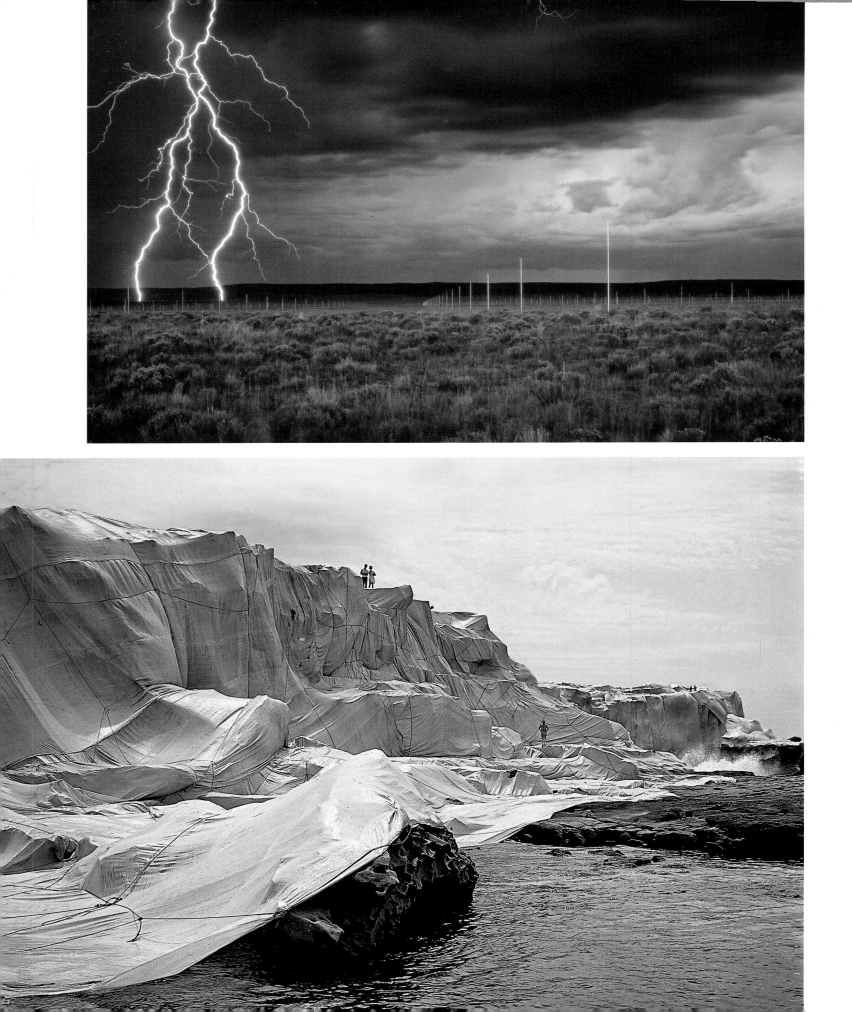

When Earthworks were conceived, they had a noncommercial orientation: they could never be shown in a museum or collector's home. But producing this art required big, expensive machinery (240,000 tons of dirt had to moved for *Double Negative*) and therefore substantial financial support. Though the artists wanted to defy the market, private patronage was critical. Artists became dependent on generous and visionary patrons, among them Virginia Dwan, Heiner Friedrich, the Dia Art Foundation, Robert Scull, Horace Solomon, John de Menil, Bruno Bischofsberger, and Count Panza di Biumo. Some of these patrons were indefatigable collectors who would not be deterred by the monumental and site-specific nature of the works. Robert Scull, for example, purchased Earthworks *in situ*, as did a number of museums and foundations.

341. Dennis Oppenheim
Annual Rings, 1968
Gelatin silver prints,
maps, and text, 40 x 30
in. (101.6 x 76.2 cm)
John Weber Gallery,
New York

The urban counterpart to Earthworks was Anarchitecture. Fusing anarchy with architecture, the anarchitects, which included the artists Suzanne Harris, Jene Highstein, Jeffrey Lew, and Laurie Anderson, revolved around the young and charismatic Gordon Matta-Clark, son of the Surrealist painter Matta (Echaurren). Matta-Clark and his cohorts were mobilized by the revolutionary events of 1968 that called for the radical critique of social structures and, by extension, of culture. Their extemporaneous, ad hoc activities in public spaces, which sometimes broke the law, represented their version of anarchy. In addition, their dismantling of architecture corresponded to the breakdown of social structure.

Matta-Clark became acquainted with Earthworks while studying architecture at Cornell University, where he assisted Dennis Oppenheim with a piece for an Earthworks exhibition. After moving to New York City, he began to work with neglected structures such as abandoned buildings and piers slated for demolition. He was interested in revealing both the formal and the contextual character of the architecture through carefully planned "cuts," as he called them. Using a chain saw, he would slice through a structure or cut up building elements to expose the historical aspects of vernacular architecture or visual vestiges of urban subculture, such as graffiti.

In his seminal work, *Splitting*, Matta-Clark made two parallel cuts straight down the center of a two-story clapboard house in Englewood, New Jersey (fig. 343). He drove a wedge through the middle of this middle-class American home and then cut out the four corners on the second floor—exposing the layers of shingles, plywood, beams, lathing, and sheetrock (fig. 342). By removing and excising pieces, Matta-Clark created form from *absence*, as Michael Heizer had done in *Double Negative*.

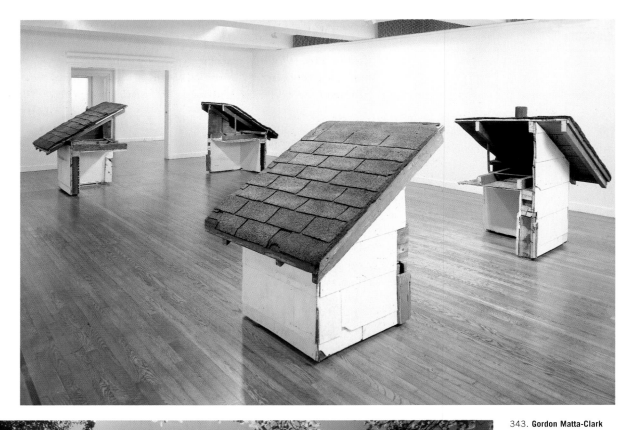

342. **Gordon Matta-Clark**
Installation view of
Splitting: Four Corners,
1974
Four building fragments,
approximately 57 x
42 x 42 in. (144.8 x
106.7 x 106.7 cm) each
Estate of the artist;
courtesy Holly Solomon
Gallery, New York

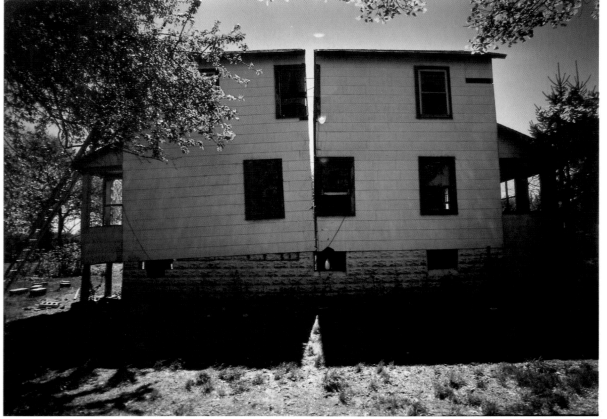

343. **Gordon Matta-Clark**
Splitting, 1974
Silver dye bleach print
(Cibachrome), 30 x 40 in.
(76.2 x 101.6 cm)
Estate of the artist;
courtesy Holly Solomon
Gallery, New York

Like Smithson, Matta-Clark was a catalyzing, charismatic presence. But the two artists belonged to social groups with pronounced differences: Smithson's was a vehemently opinionated, argumentative, male-dominated international clique that showed at the Dwan Gallery and came out of Minimalism. Matta-Clark was part of a more free-spirited group that was preoccupied with the breakdown of form, actively opposed to materialist aspirations—and included many strong women artists, such as Anderson and Harris. The group set up provisional exhibition spaces in SoHo, notably, a dilapidated street-front loft at 112 Greene Street, founded by the artist Jeffrey Lew, and the similarly scrappy 98 Greene Street, operated by Horace and Holly Solomon and built by Matta-Clark. They also congregated in the SoHo restaurant Food, which Matta-Clark had opened in 1971 as a way to employ artists.

Smithson and Matta-Clark were both aesthetic visionaries and loomed large in the seventies despite—or perhaps partly because of—their untimely deaths: Smithson in a plane crash in 1973, at the age of thirty-five, and Matta-Clark from cancer in 1978 at the same age.

THE NEW YORK "SIX" AND THE CALIFORNIA ONE

In the midst of, or perhaps because of, a prevailing populism and demand for communal responsibility in the late 1960s, architecture found itself at risk of being transformed from a form of cultural experimentation and critique into a service industry to be evaluated in only the most mundane of economic terms. In response to this threat, real or perceived, a group of architects, collectively known as the New York Five—Peter Eisenman, John Hejduk, Richard Meier, Michael Graves, and Charles Gwathmey—invented and immersed themselves in what Eisenman, the primary theorist of the group, termed a world of "autonomous" architecture. In this realm, only other architecture had either meaningful or instrumental value. It was this internal reconfiguration that engendered new alternatives.

The primary historical figure whose work was redeployed in this context was Le Corbusier (Charles-Édouard Jeanneret), particularly his villas of the 1920s. Each of the New York Five, in fact, had built or designed a significant Neo-Corbusian house by the late 1960s, such as Meier's Smith House (1965–67), Eisenman's House I (fig. 344), and Graves' Hanselman House (1970). Despite differences among individual architects, they all employed elements of high modernism to produce buildings beyond modernism. If Le Corbusier used platonic geometry to create clarity, Meier used overlapping geometries to produce complexity; where Le Corbusier used white to convey purity, Eisenman used multiple shades of white to suggest ambiguity; Le Corbusier relied on painterly forms for harmony, while Graves used them for collage.

An important aspect of the profound influence of the New York Five was their sense of institutional affiliation and intellectual allegiance. Their work was powerfully shaped by the writings and teaching of Colin Rowe, who wrote the introduction to the publication from which the group's name derives, *Five Architects* (1972). Rowe's writing on Le Corbusier introduced to the New York Five the rigorous formalism of critics such as Clement Greenberg and the generative possibilities of decontextualized comparative analysis. In such analysis, the work of Le Corbusier in the twentieth century and Palladio in the sixteenth, for example, could be seen to perform similar architectural operations, despite historical and cultural disconnection.

The Five remained involved in teaching—Hejduk at Cooper Union, Graves at Princeton, and Eisenman at several universities and, most important, at the Institute for Architecture and Urban Studies, which he founded in New York in 1967. Indeed, it was perhaps the very ambition to elevate architecture to the status of an institution, combined with the rich cultural capital of New York, that led to a bizarre incident and produced what might be regarded as the repressed sixth member of the New York Five.

In 1976, having been invited to participate in an exhibition at the Institute for Architecture and Urban Studies, Gordon Matta-Clark instead came in the middle of

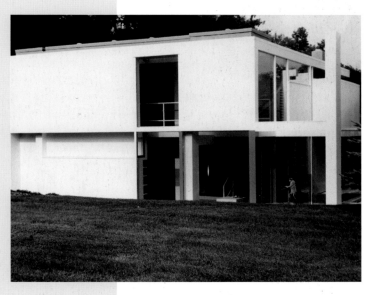

344. **Peter Eisenman**
Peter Eisenman House I, Princeton, New Jersey, 1967–68

pre-opening night and shot out the windows of the exhibition space with a BB gun. Although Matta-Clark had studied architecture at Cornell, was deeply involved with the New York art world, and founded several of its more important institutions, he rigorously rejected the New York Five's formal autonomy. He engaged in a more socially activist practice of Happenings, performances, and "cuts"—chain-saw slices through architectural structures, often focusing not on pristine Corbusian villas but on abandoned warehouses and run-down brownstones. The irony of what Matta-Clark called an "anarchitectural enterprise" is that, particularly in the cuttings and their photographic documentation, it produced spatial effects of Piranesian complexity that rival, within a different ethos, the phenomenological ambiguities sought by the New York Five.

Perhaps the first architect able to discern the underlying link between Matta-Clark and the New York Five and to develop elements of both strategies was Frank Gehry. In his early career, working far outside the New York power structures in the looser world of the Los Angeles art scene, Gehry had a divided practice: half of his work was devoted to socially engaged city planning, urban renewal, and public housing, while the rest—his Danziger Studio of 1964, for example—explored the formal implications of Minimalism for architecture. The explosive struggle to join these apparently disparate concerns finally erupted with the construction of Gehry's own house in 1978 (fig. 345). This pink shingled bungalow wrapped in a concatenation of chain-link and corrugated sheet metal combined the formal density and rigor of the New York Five with the social critique and underground culture of the New York Sixth. Gehry's multiple aspirations continue to drive what has become one of the most successful American architectural practices of the postwar era. —S. L.

346. **Frank Gehry**
Wiggle Side Chair, 1971
Corrugated cardboard and pressed fiber, 33½ x 16½ x 21½ in. (85.1 x 41.9 x 54.6 cm)

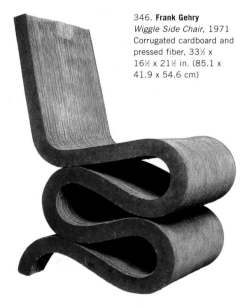

CONCEPTUAL ART

Given all the unorthodox art forms developed in the late 1960s, confused spectators and critics—like those who viewed Duchamp's readymades early in the century—wondered whether art could be art just because the artist said it was. With the growing use of non-art materials—cloth, plastic, dirt, organic matter—and the increasing impermanence and unpredictability of these works, a renewed debate arose about the meaning of art. As the Conceptual artist Joseph Kosuth wrote in 1968, "A work of art is a tautology in that it is a presentation of the artist's intention, that is, he is saying that a particular work of art *is* art, which means, is a *definition* of art. Thus, that it is art is true *a priori*."[112]

In the summer 1967 issue of *Artforum*, Sol LeWitt contributed a seminal essay, "Paragraphs on Conceptual art," in which he proposed a new art form—one where "the idea becomes a machine that makes the art."[113] This art was no longer about morphological characteristics but about an inquiry into what art means. Conceptual

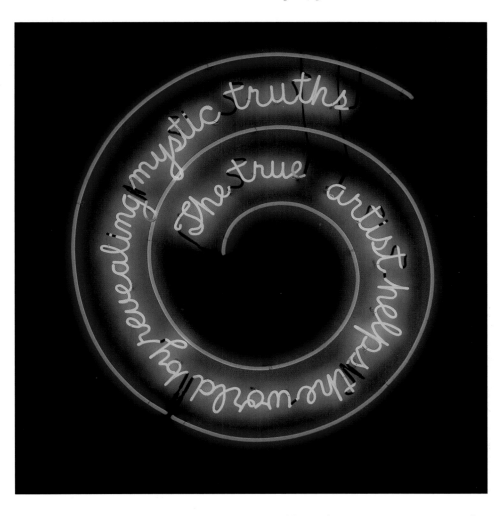

347. Bruce Nauman
The True Artist Helps the World by Revealing Mystic Truths (Window or Wall Sign), 1967
Neon with glass tubing suspension frame, 59 x 55 x 2 in. (149.9 x 139.7 x 5.1 cm)
Private collection

art had a long lineage, beginning with Marcel Duchamp, whose unassisted readymades changed the focus from the form of the work, from "appearance" to "conception." Other proto-Conceptual statements had been made in Europe by Yves Klein and Piero Manzoni, who canned his feces and sold them for their weight in gold; by the American correspondence artist Ray Johnson (fig. 76); and by On Kawara, who obsessively created small paintings with nothing but the date of each day's work painted across the surface.

With Conceptual art's renewed emphasis on the meaning of art, it is not surprising that text and language assumed a more prominent role: as criticism, as writings by the artists, and as texts incorporated into their work. "At its most strict and radical extreme the art I call conceptual is such because it is based on. . .the understanding of the linguistic nature of all art propositions, be they past or present, and regardless of the elements used in their construction," wrote Kosuth in "Art as Idea as Idea."[114] At that time, Kosuth was producing his Definition works, in which an enlarged dictionary definition would stand on its own or next to a photograph of an object, accompanied by the real object itself (figs. 349, 350).

The emergence of language as a medium for advanced art—as in the work of artists such as Kosuth, Lawrence Weiner (fig. 348), and Douglas Huebler—was a radical assault against late modernism and formalist methodologies. But it did allow for a closer relation between art and philosophy, theory, and criticism. Criticism became increasingly important as the divide between the formalists and anti-formalists widened and new aesthetic languages were hotly contested. Theory

348. Lawrence Weiner
Installation detail of
Statement of Intent, 1969
and 1996, at the
Kunsthalle Ritter,
Klagenfurt, Austria, 1996

1. DER KÜNSTLER KANN DAS WERK HERSTELLEN.
2. DAS WERK KANN AUSGEFÜHRT WERDEN.
3. DAS WERK MUSS NICHT AUSGEFÜHRT WERDEN.
JEDE MÖGLICHKEIT IST GLEICHWERTIG
UND JEDE ENTSPRICHT DER ABSICHT DES KÜNSTLERS.
DIE ENTSCHEIDUNG ÜBER DEN ZUSTAND LIEGT
BEI DEM EMPFÄNGER IM MOMENT DER ÜBERNAHME.

1. THE ARTIST MAY CONSTRUCT THE WORK
2. THE WORK MAY BE FABRICATED
3. THE WORK NEED NOT BE BUILT
EACH BEING EQUAL AND CONSISTENT WITH THE INTENT OF THE ARTIST
THE DECISION AS TO CONDITION RESTS WITH
THE RECEIVER UPON THE OCCASION OF RECEIVERSHIP

1. UMETNIK LAHKO USTVARI DELO.
2. DELO SE LAHKO NAREDI.
3. DELA NI TREBA NAREDITI.
VSAKA MOŽNOST JE ENAKOVREDNA IN VSAKA
USTREZA UMETNIKOVEMU NAMENU.
ODLOČITEV NAD STANJEM JE PRI
PREJEMNIKU V TRENUTKU PREVZEMANJA.

red, n. [ME. *red, redde*; AS. *read*; akin to G. *rot*, ON. *rauthr*: from same root come also L. *rutilus, rufus, ruber*, Gr. *erythros*, W. *rhwdd*, Ir. and Gael. *ruadh*, also Sans. *rudhira*, blood.]
 1. a primary color, or any of a spread of colors at the lower end of the visible spectrum, varying in hue from that of blood to pale rose or pink.
 2. a pigment producing this color.
 3. [*often* R–] [senses *a* and *b* from the red flag symbolizing revolutionary socialism.] (a) a political radical or revolutionary; especially, a communist; (b) a citizen of the Soviet Union; (c) [*pl.*] North American Indians.

349. Joseph Kosuth
"Titled (Art as Idea as Idea)," 1967
Photographic enlargement
on board, 48 x 48 in.
(121.9 x 121.9 cm)
Whitney Museum of
American Art, New York;
Gift of Peter M. Brant
74.108

350. Joseph Kosuth
*One and Three Chairs
(Etymological)*, 1965
Chair, gelatin silver print,
and text, dimensions
variable
Collection of the artist

surfaced as a powerful force in the growing opposition to the hegemony of modernism. Many strong critical voices emerged during this period, among them those of Lucy Lippard, Rosalind Krauss, Annette Michelson, and Max Kozloff. Artists themselves were articulate defenders of the new art, and many of them wrote powerful polemical essays in journals such as *Artforum*. After moving from Los Angeles to New York in 1967, *Artforum* established itself, under the editorial leadership of Philip Leider and John Coplans, as the most important ideological battleground in the arts (a position it held for at least a decade).

The eruption of language into the aesthetic field was first felt in the art criticism and writing of Robert Smithson, Donald Judd, Dan Flavin, Robert Morris, Sol LeWitt, Carl Andre, Yvonne Rainer, and Mel Bochner (fig. 351). Their writings signaled a shift from the visual to the verbal field as an arena of expression. The same 1967 issue of *Artforum* that contained LeWitt's article on Conceptual art, for example, also included Michael Fried's "Art and Objecthood" and Robert Morris' "Notes on Sculpture."

The pages of art journals became not only important forums for debate but also "sites" for works of art. It could be argued that Smithson's essays, such as "The Monuments of Passaic," were works in themselves and perhaps his most important legacy. Other artists increasingly sought to use publishing as a means to disseminate their ideas, and these projects also became primary works. For instance, Joseph Kosuth, Dan Graham, and Adrian Piper purchased ad space in magazines and newspapers to *present*—not to *represent*—their art (figs. 352, 353). The Conceptual art promoter Seth Siegelaub reinvented the role of the art dealer by curating "alternate sites," among them publications, artists' books, tapes, and exhibition catalogs, which he believed could be the sole form in which an exhibition took place.[115] These avenues of communication and distribution enabled artists to speed past institutional and geographical boundaries. Books, the mail, advertisements, billboards, and magazines became principal expressive vehicles for the work. As the artist Douglas Huebler stated in 1969, "The world is full of objects, more or less interesting: I do not wish to add any more."[116]

Though Conceptual art was an extreme manifestation of art's dematerialization, it still took various forms—texts, processes, situations, and information—using language, mathematical and organizational systems (fig. 354), photography, publications, notational drawings, video, film, and performance to address the

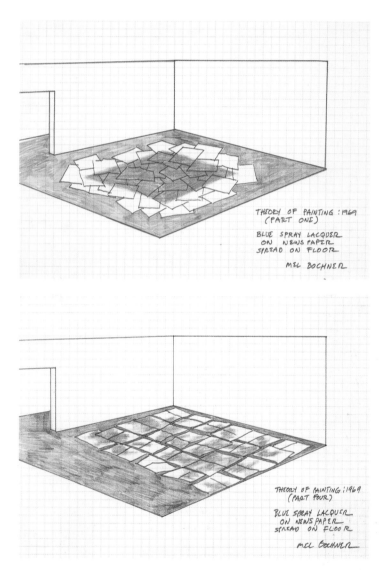

351. **Mel Bochner**
Study for Theory of Painting (Parts One and Four), 1969
Graphite, ink, and colored pencil on paper, 8½ x 11 in. (21.6 x 27.9 cm) each
Collection of Sarah-Ann and Werner H. Kramarsky

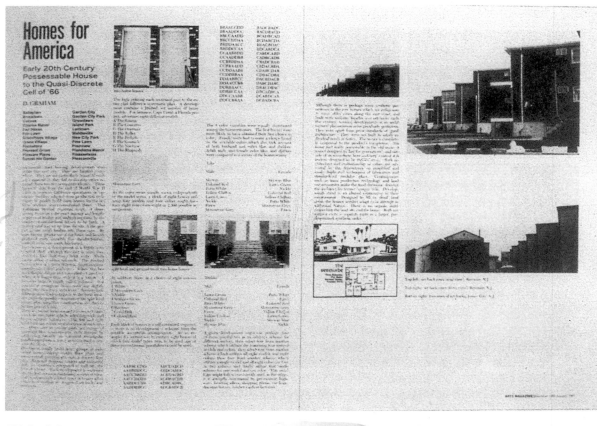

352. **Dan Graham**
Homes for America, from
Arts magazine, 1966

353. **Dan Graham**
Figurative, from *Harper's
Bazaar*, 1965

physical, social, and institutional context of the art object. As a product of the political ferment of the time, some Conceptual art also exposed sociopolitical inequities. The self-referentiality of modernism had shifted to an examination of how art functions as part of a social system.

Hans Haacke took on the Guggenheim Museum board of trustees and corporate art patrons such as the Chase Manhattan Bank, Philip Morris, Mobil, and PaineWebber in a series of phototext pieces that mimic corporate ad campaigns.

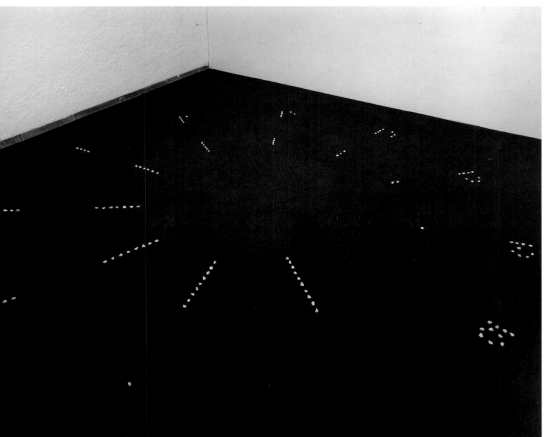

Through these works, he meticulously revealed how key institutional and corporate leaders were affiliated with Third World exploitation, right-wing groups, and the CIA (fig. 357). Support for art, his work tells us, often comes from tarnished dollars. Haacke's distinctive form of muckraking unveiled the politically charged relationships among art, society, and institutions of power.

Most Conceptual artists, exploring the social underpinnings or meaning of a work of art, took an aggressive, anti-style position. John Baldessari went so far as to give up painting in 1966—and destroy all the works that remained in his possession. After 1967, he made photographically based work on canvas with simple, deadpan lines of text executed by a sign painter—"Everything is purged from this painting but art, no ideas have entered this work" or "This is not to be looked at" (fig. 355). Commenting on the ontology of a work of art, he was attempting to make art that did not emanate art signals. In 1970, he made a Conceptual work about the destruction of his early paintings in the form of a newspaper announcement that read, "Notice is hereby given that all works of art done by the undersigned between May, 1953, and March, 1966, in his possession as of July 24, 1970, were cremated on July 24, 1970, in San Diego, California."[117]

Many artists believed that the traditional object of art was irrelevant, unnecessary, and dead. They also extended the "post-studio" movement (Carl Andre's term), where artists had works fabricated, worked on site, or simply made instructions for others to execute. To Conceptual artists, the studio had become more of a thinking space, a study space, or a writing space.[118] Photography, often in combination with text, was an important component of the post-studio Conceptual practice (figs. 355, 356, 358, 359). Just as Earth artists used photography as a documentary record, Conceptual artists valued the photograph as a source of pure, factual information and technical data. Its impersonality, mechanical quality, and supposed objectivity served well the development of an anti-style.

354. **Mel Bochner**
Ten to 10, 1972
Stone, 120 in. (304.8 cm) diameter
Whitney Museum of American Art, New York; Purchase, with funds from the Gilman Foundation, Inc. 77.28

THIS IS NOT TO BE LOOKED AT.

AN ARTIST IS NOT MERELY THE SLAVISH
ANNOUNCER OF A SERIES OF FACTS.
WHICH IN THIS CASE THE CAMERA HAS
HAD TO ACCEPT AND MECHANICALLY
RECORD.

355. **John Baldessari**
*This Is Not to Be Looked
At,* 1966–68
Acrylic and photoemulsion
on canvas, 59 x 45 in.
(149.9 x 114.3 cm)
Collection of Joel Wachs

356. **John Baldessari**
*An Artist Is Not Merely the
Slavish Announcer. . .,*
1967–68
Photoemulsion, varnish,
and gesso on canvas,
59⅛ x 45⅛ in. (150.2 x
114.6 cm)
Whitney Museum of
American Art, New York;
Purchase, with funds from
the Painting and Sculpture
Committee 83.8a–m

357. **Hans Haacke**
Shapolsky et al. Manhattan Real Estate Holdings—A Real Time Social System, As of May 1, 1971, 1971
Six photographic enlargements with typewritten sheets, 20 x 48 in. (50.8 x 121.9 cm) overall
Wadsworth Atheneum, Hartford, Connecticut

358. **Douglas Huebler**
Duration Piece #4, 1968 (detail)
Nine gelatin silver prints with text panel,
7½ x 6 in. (19.1 x 15.2 cm) each print
Estate of the artist

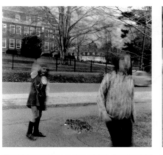
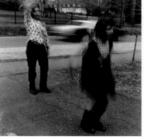

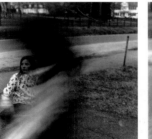
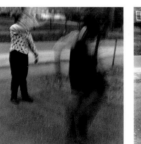

Duration Piece #4
Bradford, Massachusetts

Photographs of two children playing "jump-rope" were made in the following order:

I. Three photographs were made at IO second
 intervals.

II. Three photographs were made at 20 second
 intervals.

III. Three photographs were made at 30 second
 intervals.

The nine photographs have been scrambled out of sequence and join with this statement to constitute the form of this piece.

September, I968 Douglas Huebler

Despite the anti-style and anti-commercial nature of much Conceptual art, it has today taken its place in the art-historical pantheon. Anti-style became a style, rebellion and dissent were historicized, and works that were casual, mass-produced, and ephemeral are now paradoxically considered precious. Even at its inception, Conceptual art was taken up by museums in some of the most daring exhibitions of the day—notably "Live in Your Head: When Attitudes Become Form," at the Kunsthalle Bern (1969), and "Information," at The Museum of Modern Art, New York (1970). Both exhibitions featured Conceptual art, together with process-oriented Postminimalism and Earth art, demonstrating that the boundaries among the three were fuzzy and that the communities overlapped. The international characters of the shows, moreover, signaled that the world was fast turning into a global village. Finally, each exhibition was accompanied by a catalog conceived as a Conceptual publication: in *Information*, the artists designed their own pages, while *Attitudes* was designed in the form of an address book.

Conceptual art provoked the ire of many mainstream critics, prompting Robert Hughes, for one, to announce "The Decline and Fall of the Avant-Garde" in a 1972 article in *Time*:

"Advanced" art—whether conceptual art, process art, video, body art, or any of their proliferating hybrids—avoids the object like the plague. The public has retreated, in turn, from it. This is a worldwide phenomenon, and what now exists is not simply a recession of interest (and talent) but a general weariness—a reluctance to believe in the avant-garde as principle. . . . The inherent purposelessness of anti-object art becomes a real liability in one area: conceptualism. The basic claim of conceptual art is that making objects is irrelevant. . . . And so a thicket of verbiage protects, and supports, the most banal propositions.[119]

What Hughes derided was, for Conceptual artists and advocates, fundamental to their enterprise: the belief that art, indeed vision itself, is determined by language. The sense of sight is not a neutral biological function. What we see is the product of the words we have read and heard—of the language we bring to the act of vision. By extension, the social and cultural structures that control our actions and attitudes are also determined by language. Language, text-based Conceptual artists declared, is central to an understanding of art, culture, and identity. This proposition mapped out the route along which artists, and many critics, would travel for the next thirty years as the old canons of art were finally overturned by a host of new voices.

359. **Vito Acconci**
Hands Down/Side by Side,
1969
Gelatin silver prints and chalk on paperboard,
29⅞ x 39¹⁵⁄₁₆ in.
(75.9 x 101.4 cm)
Whitney Museum of American Art, New York;
Purchase, with funds from the Photography Committee 92.12

The Ascendance of Alternatives

Liberation movements—Black Power, feminism, gay rights—that began in the 1960s at the margins of society soon permeated the mainstream and irrevocably altered American life. As often happens, the root causes of these changes can be found in the social and political climate. In March 1968, President Johnson, unable to resolve the war in Vietnam, announced that he would not run for reelection. That November, the Republican candidate, Richard M. Nixon, was elected president on a promise to make peace in Vietnam. Initially, he seemed to succeed, finalizing the Paris peace talks begun during Johnson's administration. Troop withdrawals started in 1969, but the peace was short-lived. The following year, Nixon extended the war to Laos and Cambodia, and it was not until 1973, in the face of continuing U.S. losses, that American troops withdrew from Vietnam.

On other fronts, however, Nixon's foreign policy was a record of triumphs: in 1972, he made an unprecedented visit to Communist China, reopening relations with it for the first time in more than twenty years; in November 1973, he oversaw a U.S.-sponsored peace accord between Egypt and Israel, ending the war that had broken out the month before; and he relaxed tensions with the Soviet Union through, among

THEATER IN THE 1970S

Both the literary and the radical manifestations of Off-Off-Broadway had lost momentum by 1975—part of the general waning of the counterculture after the Nixon years. Most of the radical troupes disbanded, and Off-Off-Broadway became a training ground for actors, directors, and playwrights who aspired to success in the commercial theater.

Throughout the nation, the avant-garde theater of the 1970s largely turned away from social engagement, in favor of introspection and self-examination. The work of the Performance Group in this period shifted from physical, ritualistic performance to the staging of literary dramas, though in highly unconventional ways. (In 1975, the Performance Group became the Wooster Group, fig. 360.) In 1974, two members of the group, Elizabeth LeCompte and Spalding Gray, formed a workshop to produce more overtly aestheticizing, abstract, and formalistic works derived from Gray's life. *Sakonnet Point* (1975) was a virtually silent, wholly abstract meditation on childhood, while the powerful *Rumstick Road* (1977) dealt with the suicide of Gray's mother. Tendencies toward formalism, abstraction, and autobiography were apparent in the work of other experimental groups of the 1970s, including Michael Kirby's Structuralist Workshop and Mabou Mines. Richard Foreman's productions with his Ontological Hysterical Theater set out to explore consciousness itself by re-creating on stage the processes by which the mind builds an idea of the world outside itself. Robert Wilson's "theater of visions" staged the flow of visual images emanating from his own imagination, making no necessary reference to any external reality.

Yet the activism that had infused the radical theater of the 1960s did not disappear altogether in the 1970s. David Rabe, a Vietnam veteran, wrote a series of powerful plays that forced audiences to confront the legacy of the Vietnam War (*The Basic Training of Pavlo Hummel*, 1971; *Sticks and Bones*, 1971; and *Streamers*, 1976), using the physical and psychological effects of the war as metaphors for problems endemic to American society. But unlike the Off-Off-Broadway playwrights of the 1960s, Rabe was skeptical that social change could be effected: his characters seem trapped, unable to transcend their social circumstances.

The 1970s also saw the emergence of work that addressed not humanity in general but the concerns of particular social and political groups, including African Americans, Asian Americans, Hispanic Americans, feminists, and gays and lesbians. Originating in the avant-garde theater of the late 1960s, this theater moved more toward the

360. **The Wooster Group**
Nayatt School, directed by Elizabeth Lecompte, 1977–78, photograph by Clem Fior

other things, a U.S.-Soviet summit in May 1972 and the first round of the Strategic Arms Limitation Talks. But these accomplishments were eclipsed by the Watergate scandal. In the election year of 1972, five men were arrested while attempting to bug Democratic National Committee headquarters, located in the Watergate apartment complex in Washington, D.C. Nixon at first denied knowledge of their activities, but a few months later evidence of his involvement began to leak out. In August 1974, after the House Judiciary Committee adopted three articles of

mainstream in the course of the next decade. Whereas African American theater of the 1960s had been galvanized by the Black Power movement, by the 1970s African American actors and writers, many of whom had begun their careers in the avant-garde, were gaining visibility in the establishment. The distinguished Negro Ensemble Company, a relatively traditional Off-Broadway theater founded in 1969, consolidated the gains made by its more radical predecessors.

Just as African American actors and playwrights wanted their own theaters, some women performers left radical troupes that did not specifically address their interests. By the end of the 1970s, well over one hundred self-consciously feminist theaters were active in the United States, including some dealing specifically with the lesbian experience. A generation of more mainstream women playwrights, including Beth Henley, Marsha Norman, and Wendy Wasserstein, also emerged in the 1970s. The extravagantly campy productions of the Theater of the Ridiculous pioneered a gay male sensibility in theater from the late 1960s through the 1970s. Sadly, this community was destined to find its strongest theatrical voice with the advent of the AIDS crisis in the 1980s.
—P. A.

361. *President Richard M. Nixon Resigns, Washington, D.C.*, 1974

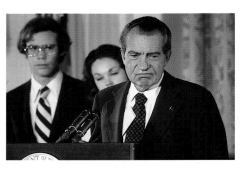

362. *Nuclear Power Plant at Three Mile Island, Pennsylvania*, 1979, photograph by Fred S. Prousor/ Liaison Agency Inc.

impeachment, Nixon resigned, and his vice president, Gerald Ford, was sworn in (fig. 361).

Nixon's duplicity and abuse of authority compounded the sense of disillusionment with the power structure that had begun with America's misadventures in Vietnam. At the same time, Americans became uncomfortably aware of their dependence on the resources of other countries, as when Saudi Arabia and other Arab countries placed an embargo on oil shipments to the United States in 1973 in retaliation for America's support of Israel and Israeli victory in the Yom Kippur War. The embargo caused a steep rise in the prices of heating oil and gasoline, commodities whose relative cheapness Americans had long taken for granted. A deep recession ensued, and the American economy stagnated. In another arena, alarming environmental concerns erupted in the seventies after the discovery of toxic-waste dumping in such areas as the Love Canal in upstate New York; and the dangers posed by nuclear power plants were graphically demonstrated by the malfunction of the Three Mile Island plant in Pennsylvania, which allowed lethal radiation to escape into the surrounding area (fig. 362).

Political betrayals, economic uncertainties, and fears of ecological disaster made many Americans mistrustful, cynical, and critical of official institutions of power and their public statements.

The cynicism of the era, the breakdown of confidence in government, found expression in the anarchism of Punk rock and in dark film dramas such as *Taxi Driver* (1976, Martin Scorsese) and *Apocalypse Now* (1979, Francis Ford Coppola). Some artists retreated into themselves—a new

concern for autobiography and an exploration of consciousness, for example, are evident in the performing arts during the seventies. For many Americans, retreat meant turning away from social and political problems to focus on personal achievements and pleasures—which led the author Tom Wolfe to characterize the seventies as "the me decade."

But, as in the fifties and sixties, there were always social and political activists who made it their responsibility to effect change. A vast underground that included radical political organizations, gay rights activists, and feminists helped fuel a transformation in American life by demanding status for special-interest groups.

THE "MOVIE BRATS" RECONFIGURE HOLLYWOOD

In a country where young men were called upon to fight an unpopular war in Vietnam, the possession and corruption of American youth was a recurring theme of the films of the 1970s. First sounded in Francis Ford Coppola's Mafia opera *The Godfather* (fig. 363), it echoed through William Friedkin's portrait of demonic possession in *The Exorcist* (1973), Martin Scorsese's altar boy-meets-mob story *Mean Streets* (fig. 364), and Brian De Palma's supernatural melodrama *Carrie* (1976). Significantly, Coppola, Scorsese, and De Palma—along with Steven Spielberg and George Lucas—were young filmmakers, the first generation to come out of the film schools proliferating across the country. Because of their youth and encyclopedic knowledge of Hollywood, they were dubbed "the movie brats."

The brats likewise mythologized the other defining event of the era: the break-in of Democratic Party headquarters at the Watergate complex in 1972, which was sanctioned by President Nixon and which led to his resignation in 1974. Films as diverse as Spielberg's *Jaws* (1975) and *Close Encounters of the Third Kind* (1977), Lucas' *Star Wars* (fig. 365), and Hal Ashby's *Shampoo* (1975) had Watergate references and resonances. In *Jaws*, the political establishment in a beach town tries to suppress the news of a shark attack. Set on the eve of Nixon's 1968 election, *Shampoo* depicts the Los Angeles establishment suppressing political and sexual hypocrisy. Coppola's *The Conversation* (1974) eerily presaged Watergate in its depiction of a surveillance expert (Gene Hackman) who invades the privacy of citizens and gets destroyed. Then there was *All the President's Men* (1976, Alan J. Pakula), with Robert Redford and Dustin Hoffman as the investigative reporters who blew the lid off Watergate.

These films represent one extreme of the decade—a cinema that unblinkingly confronted contemporary disillusion and discord. At the other extreme were misty-eyed paeans to "the way we were," to borrow the title of the 1973 Sydney Pollack movie about the 1940s romance between an idealist (Barbra Streisand) and a pragmatist (Robert Redford). Redford was the decade's posterboy of nostalgia for lost illusions, trying to win Mia Farrow in *The Great Gatsby* (1974, Jack Clayton, screenplay by Coppola) and win money with Paul Newman in *The Sting* (1973, George Roy Hill). These movies about glamorous con artists in vintage duds seemed to say that amorality has always been around, but that it looks better worn with a fedora.

The difference between nostalgic excursions such as *Gatsby* and *The Sting* and serious period trips such as *The Godfather* I and II, and *Chinatown* (1974, Roman Polanski) is that the latter movies, which trace the rise and fall of the Corleone crime

363. Al Pacino and Marlon Brando in *The Godfather*, directed by Francis Ford Coppola, 1972
Courtesy Paramount Pictures

364. Robert DeNiro in *Mean Streets*, directed by Martin Scorsese, 1973
Courtesy Taplin-Perry-Scorsese

Artists were not immune to the politics of representation. By the late sixties and early seventies, many artists, such as Carl Andre, Leon Golub, Hans Haacke, Robert Morris, and Nancy Spero (fig. 366), were not only producing political work but also taking direct action. In a spirit of protest, artists organized and formed such groups as the Art Workers' Coalition (AWC, 1969) to fight for artists' rights and express opposition to the war in Vietnam. The Guerrilla Art Action Group (GAAG, 1969–76), another activist organization, took to the streets and organized guerrilla events in a messy performance style—such as throwing money on the steps of The Metropolitan Museum of Art, mopping the floor of the Whitney Museum of American Art, or spilling beef blood in the lobby of The Museum of Modern Art (fig. 367).[120] These groups were mistrustful of the establishment art world and worked to reveal some of the system's hidden machinations. Their energetic activities also brought art communities together in common causes and raised the consciousness of other artists and the public about the inequities of the art world.

Black and Hispanic artists protested their exclusion from the mainstream art scene and began to form their own institutions. In the late 1960s, the Studio Museum of Harlem and the Dance Theater of Harlem were formed, as

empire in New York and the Cross real estate empire in Los Angeles, respectively, were American epics about how a corrupt patriarchy poisons the fruit of the family tree.

Yet other movies purveyed the sweetness of life before the fall. Most prominent was *American Graffiti* (1973, George Lucas), a mosaic of teens, cars, and music, circa 1962—of innocence before the serpent slithered into the American garden. And there was *Rocky* (1976, John Avildsen, written by and starring Sylvester Stallone), championing an underdog fighter who triumphs over the boxing establishment. This us-versus-them mentality pervaded most movies of the era. On the one hand, there was Clint Eastwood in *Dirty Harry* (1971, Don Siegel), brandishing his Magnum against hippie riffraff as the rogue cop Harry Callahan. On the other, there was Sally Field as *Norma Rae* (1979, Martin Ritt), brandishing her strike placard at management as the textile worker who unionizes her shop.

Although America pulled out of Vietnam in 1974, movies kept the debate raging. The antiwar movement was victorious in *Coming Home* (1978, Hal Ashby), while the Pentagon was vindicated in *The Deer Hunter* (1978, Michael Cimino). And in the following year, Coppola released *Apocalypse Now*, which pictured war as mad spectacle, thereby confirming the beliefs of both sides.

Although the seventies marked an era when feminists declared that "sisterhood is powerful," it was not necessarily so on movie screens. Among the precious few females visible were Jane Fonda, as a prostitute in *Klute* (1971, Alan J. Pakula) and a military wife turned pacifist in *Coming Home*; Diane Keaton as the marginalized wife in *The Godfather* and the ditzy love object in *Annie Hall* (1977, Woody Allen); Diana Ross as the drug-addicted singer Billie Holiday in *Lady Sings the Blues* (1972, Sidney J. Furie); and Anne Bancroft and Shirley MacLaine as the professional versus the hausfrau in the ballet melodrama *The Turning Point* (1977, Herbert Ross).

It was not, however, the serious films like these that got the movie brats and their contemporaries taken seriously, but rather the unprecedented success of those blockbuster B movies *Jaws* and *Star Wars*. Blockbuster mania eclipsed smaller and better movies such as *Ordinary People* (1980, Robert Redford), about how too much emotional repression can destroy a family, and *Raging Bull* (1980, Martin Scorsese), a biography of the boxer Jake La Motta, about how too much physical expression also can destroy a family. Blockbuster fever led United Artists to bankroll the young director Michael Cimino's *Heaven's Gate* (1980), an overproduced, underwritten rustlers-versus-ranchers epic that was a failure of *Cleopatra* proportions and made the studios wary of the movie brats. —C. R.

365. Peter Mayhew, Mark Hamill, Alec Guinness, and Harrison Ford in *Star Wars*, directed by George Lucas, 1977
Courtesy Twentieth Century Fox/LucasFilm Ltd

366. **Nancy Spero**
Love to Hanoi, 1967
Gouache and ink on paper,
36 x 24 in. (91.4 x 61 cm)
Collection of Simon Watson

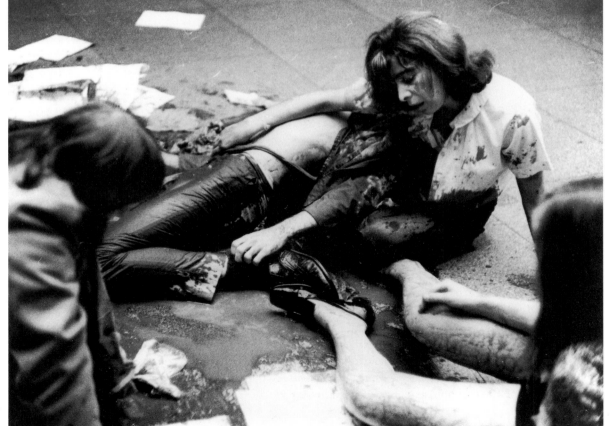

367. **Guerrilla Art Action Group**
Blood Bath, 1969
Action at The Museum of Modern Art, New York

well as El Museo del Barrio in Spanish Harlem, the only U.S. museum dedicated to Latin American culture, and El Taller Boricua, the Puerto Rican art workshop, founded by political activists who were an integral part of El Museo del Barrio. These alternative institutions acknowledged the diversity of American culture and the different traditions from which that culture had emerged. The same acknowledgment occurred beyond the art world. The homogenizing term "Hispanic" was replaced by more culturally specific terms such as "Chicano" or "Afro-Caribbean";

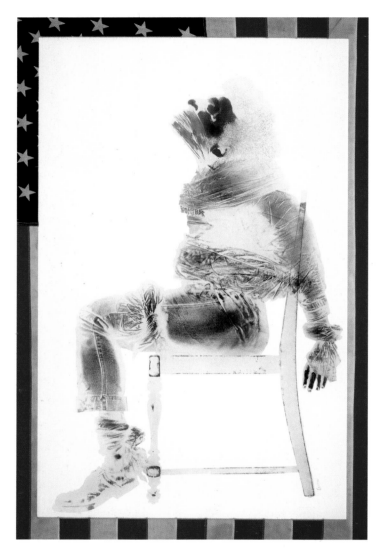

American Indians were now "Native Americans"; "black" replaced "Negro," which had long connoted second-class citizenship, and "African American" later came into usage. Television bore witness to the new voice of African Americans. The enormously popular miniseries *Roots*, broadcast in 1977, dramatized the journey from Africa to slavery in America and through the ongoing struggle for civil rights. Other television programs, such as *Good Times* and *The Jeffersons*, focused, for the first time, on the lives of black families.

Black artists were even more active than their Latino counterparts in seeking equal representation in the museum world. Members of the Black Emergency Cultural Coalition protested the Whitney Museum's exclusionary exhibition program; the result was the survey exhibition "Contemporary Black Artists in America," curated by Robert Doty in 1971. Several artists withdrew before the opening because the figurative artists were segregated in a small gallery, implying that content would be marginalized in favor of the "universal" language of abstraction.[121] "Harlem on My Mind," a huge exhibition at The Metropolitan Museum of Art in 1969, also elicited angry responses from black artists because the history of their community and its representation in the exhibition had been interpreted exclusively by white men and, moreover, not a single contemporary visual artist was included.

In the meantime, black artists such as Romare Bearden, David Hammons, Betye Saar, Faith Ringgold, and Robert Colescott were beginning to draw on their particular historical and artistic traditions—folk art, jazz, and protest art—to produce work as rich and diverse in style and attitude as their cultural heritage (figs. 368–70). Community murals soon appeared all across America, a practice that was initiated by the Organization of Black American Culture on Chicago's South Side in the spring of 1967 with the *Wall of Respect*, which presented painted images of important black Americans. On the West Coast, Chicano artists organized community-based mural projects, among them Judy Baca's *The Great Wall of Los Angeles* (fig. 371), in an enterprise that soon became a veritable movement.[122] The Chicano movement produced murals on the walls of abandoned buildings, commercial businesses, and community organizations in the Chicano neighborhoods of East L.A., San Francisco's Mission district, and East Bay/Oakland. Mobilized by the activism of César Chávez and the United Farm Workers as well as the Chicano civil rights movement, the muralists Willie Herrón, David Rivas Botelli, Antonio Bernal, and Judy Baca made allegorical wall works that gave Chicanos a sense of community pride and history. In matters of style, these artists drew on their pre-Columbian heritage as well as on the work of the great Mexican muralists, many of whom had worked in California in the 1930s,

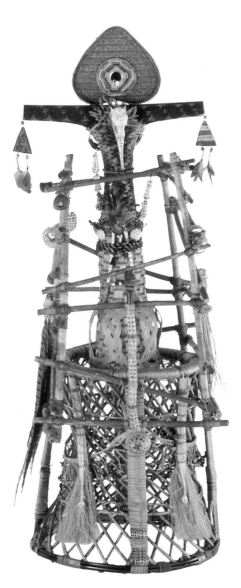

369. **Betye Saar**
Spirit Catcher, 1976–77
Mixed-media assemblage,
45 x 18 x 18 in.
(114.3 x 45.7 x 45.7 cm)
Collection of the artist

370. **Robert Colescott**
*George Washington Carver
Crossing the Delaware: Page
from an American History
Textbook*, 1975
Acrylic on canvas, 84 x
108 in. (213.4 x 274.3 cm)
Collection of Robert H.
Orchard

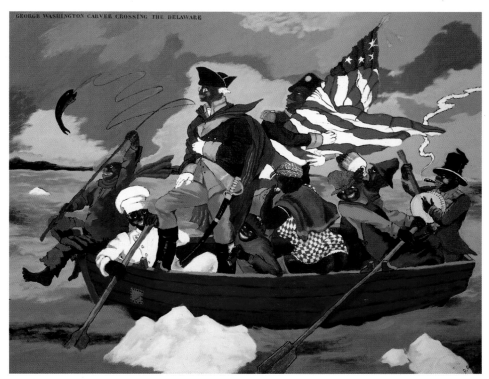

371. **Judy Baca**
*Division of the Barrios and
Chavez Ravine*, from *The Great
Wall of Los Angeles*, 1967–84
(detail of the 1950s section)
Mural
Tujunga Wash Drainage Canal,
Los Angeles

such as Diego Rivera. In terms of content, however, many artists of the seventies addressed contemporary social themes, including the death of Rubén Salazar, the *Los Angeles Times* reporter who was killed by tear gas while covering a Chicano antiwar protest in the summer of 1970. The muralists, both Chicano and African American, soon received local and federal support when governments realized that the murals offered an inexpensive way to revitalize blighted urban areas.

FEMINISM

In retrospect, feminist activity in the arts emerged as one of the most significant developments of the seventies. As in society at large, feminist ferment was empowering women to demand equal status with men. In 1970, women were paid half the wages of the average male, illegal abortions were killing thousands of women each year, divorce laws were written as "male prerogatives," and most Ivy League colleges still did not accept women. The women's liberation movement was galvanized into action in 1968 in reaction to male-dominated student movements. (At a meeting of the Students for a Democratic Society, a nationwide organization, two women pressed for the inclusion of women's rights in the platform—and were pelted with tomatoes.) By the mid-seventies, such activism and consciousness-raising were producing rapid and significant change.

In 1971, the art historian Linda Nochlin wrote an influential essay, "Why Have There Been No Great Women Artists?," which pointed out that a patriarchal society kept women from functioning at their full creative capacity and tended to undervalue what contributions they did make.[123] To redress this imbalance, in 1976 Nochlin and another art historian, Ann Sutherland Harris, organized a huge exhibition for the Los Angeles County Museum of Art, "Women Artists 1550–1950," to affirm women's achievements over the centuries.

During these years, women artists across America were forming their own co-op galleries and collectives, among them the A.I.R. Gallery in SoHo, Artemesia in Chicago, W.A.R.M. in Minneapolis, and the Woman's Building in Los Angeles. Specialized magazines such as the *Feminist Art*

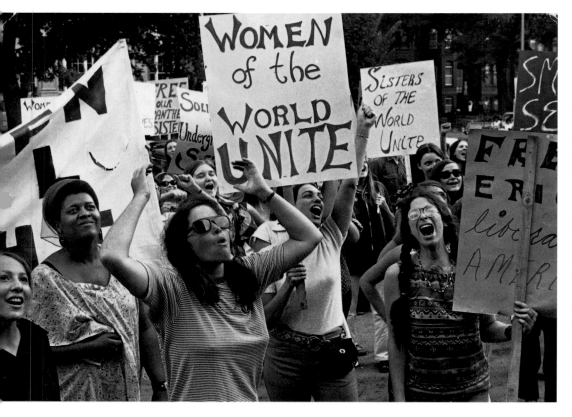

372. *Women's Rights Demonstration*, 1970s

Journal and *Heresies* were founded, as was the Women's Caucus for Art, an activist group within the College Art Association. Schools in California led the way in establishing women's programs, including the Feminist Art Program started by the artists Judy Chicago and Miriam Schapiro at the California Institute of the Arts in 1971. By 1974, over a thousand colleges and universities in America were offering women's studies courses.

There were ad hoc offshoots of the Art Workers Coalition who demonstrated against sexism (and racism) in the art world. In 1970, they picketed the Whitney Museum to increase the number of women included in the Whitney Annual,

which had previously represented only 5 percent of the exhibiting artists.[124] The next year, the number rose to 22 percent. Another group, Women in the Arts, protested the paucity of women represented by commercial dealers in New York in 1971 and the absence of women from important museum exhibitions such as the Corcoran Biennial. A parallel group on the West Coast, the Los Angeles Council of Women Artists, protested against the huge 1970 "Art and Technology" exhibition at the Los Angeles County Museum of Art, which included no women.

FEMINIST LITERATURE

Emerging in a tumultuous era of liberation movements, protest marches, and manifestos, women's literature of the 1960s and 1970s was a consciousness-raising literature. In 1963, Betty Friedan's groundbreaking study *The Feminine Mystique* launched the women's liberation movement by diagnosing the epidemic of despair, "the problem that has no name," among educated American housewives who were "afraid even to ask. . .'Is this all?'" That same year, the young protagonist of Sylvia Plath's harrowing *roman à clef, The Bell Jar,* cast a cold eye upon her future as a suburban housewife, concluding that it "seemed a dreary and wasted life for a girl with fifteen years of straight A's." Extending this dark vision into a new genre of suburban gothic, Joyce Carol Oates traced out the shadows of unresolved passions and drives behind the shining surfaces of suburban life in novels such as *Expensive People* (1968) and *Wonderland* (1971). By 1968, in the first widely publicized demonstration of the nascent movement, protesters at the Miss America Pageant tossed into a "Freedom Trash Can" their copies of *Ladies' Home Journal* and *Vogue*; home economics textbooks and typing manuals; and "instruments of torture" such as bras, girdles, curlers, high-heeled pumps, and makeup.

Many of the era's literary heroines fled marriages and homes in search of freedom and personal fulfillment, a search that often took the form of a sexual odyssey. Erica Jong's scandalous *Fear of Flying* (1973) sends her married heroine Isadora Zelda Wing on a quest for the "zipless fuck"—sex free of all guilt and ulterior motives. And unlike her literary forerunners Anna Karenina and Emma Bovary, Isadora lives to tell about it. Women's right to control—and enjoy—their sexuality was an essential part of liberation, as *Our Bodies, Ourselves* (1971), the revolutionary guide to women's sexuality, urged, even by its very title. Isadora might be seen as a hyperbole of the more typical American woman who, with access to the Pill and, after 1973, the legal right to abortion, found it possible to experience an unprecedented degree of sexual freedom. Molly Bolt, the indomitable lesbian heroine of Rita Mae Brown's *Rubyfruit Jungle* (1973), is equally triumphant as she successfully defends her right to be sexually "polymorphous and perverse" in a coming-of-age novel that leaves the tortured heroines of Radclyffe Hall's *The Well of Loneliness* (1928) far behind.

African American women, too, experienced immense political gains and increased visibility in the 1960s and 1970s. From Fannie Lou Hamer's impassioned speech on behalf of the Mississippi Freedom Democratic Party at the 1964 Democratic National Convention to the election of Shirley Chisholm and Barbara Jordan to the U.S. House of Representatives (in 1968 and 1973, respectively), African American women began to be heard—and counted—as never before. In literature, Toni Morrison and Ntozake Shange sought to account for the life experiences of those on the margins of society who had largely escaped the notice of the predominantly white, middle-class feminist movement. Shange's hit Broadway play *for colored girls who have considered suicide/ when the rainbow is enuf* (1975) gives voice to the experiences of black women, most dramatically, a young girl who had been "closed in silence so long / she doesn't know the sound / of her own voice." And Morrison's early novels *The Bluest Eye* (1970) and

Curators across the nation began examining their choices and criteria, asking, for instance, whether terms like "quality" were objective or patriarchally defined. As art institutions responded to the pressure, modest statistical victories and increased visibility were achieved, but the representation of women in exhibitions and permanent collections soon leveled off at 20–25 percent, where it more or less remains today.

The cumulative effect of feminist activities during the seventies, however, is inestimable. By the end of the decade, women in the arts had their own support system and were beginning to revise standard, male-oriented histories. In addition, they had the confidence to turn what had been a negative— criticism that their work was too "feminine"—into a source of strength and pride. They were also instrumental in establishing new criteria for "quality," which had been based on Western, white male standards, and opening American art up to non-Western, nonwhite, and non-male traditions.

Many of the political issues that surfaced within women's liberation activism were transformed into aesthetic investigations by artists. Role reversals, gender stereotypes, domestic activities, and female sexual imagery were introduced into art as subject matter (figs. 374–77, 397). There were long debates about whether specific "female" attributes could be identified to characterize art by women. Many subscribed to the essentialist view that softness (as already seen in the work of Eva Hesse, for example) and "central core" imagery, which metaphorically relates to female sexual forms, were two of these attributes.

The methods and materials of traditional women's crafts soon became the stuff of high art. Activities such as sewing, quilting, weaving, appliqué, stenciling, silhouetting, and china painting changed the terms of art making. Women's crafts were celebrated in Miriam Schapiro and Judy Chicago's *Womanhouse* project, where all kinds of domestic activities were valorized through works of art created by a number of women artists to fill an abandoned house (fig. 378). Craft and domesticities were later enshrined in Judy Chicago's feminist masterpiece *The Dinner Party*—a large triangular table with thirty-nine ceramic plates decorated with painted labial forms that commemorated great female historical, mythological, and cultural figures (fig. 379).

Sula (1973) depict both the devastating intertwining of racial prejudice and sexual discrimination and the powerful, life-sustaining bonds of sisterhood among African American women.

Some of the aims of African American feminism were unique to it; others it shared with feminism at large. As women emerged from silence and submission, they saw the end of an old order and the beginning of a new one. Surveying the contemporary landscape, Adrienne Rich's 1971 poem "Waking in the Dark" observes that it is "A man's world. But finished." Feminism, seeking to shape a new world, has always of necessity been a utopian movement in thought and practice, and that impulse runs strong in documents such as the National Organization for Women's "Founding Statement of Purpose" (1966) and the "Redstockings Manifesto" (1969); in essays such as Gloria Steinem's "What Would It Be Like If Women Win" (fig. 373); and in many of the feminist science fiction novels of the 1970s. Joanna Russ' *The Female Man* (1975) traces out women's potential through its depiction of four genetically identical women living in parallel worlds. Marge Piercy's *Woman on the Edge of Time* (1976) shuttles between a debased present and a visionary, yet seemingly practical, future based on feminist principles.

Even if its utopian visions still exceeded reality, the women's liberation movement had by the late 1970s acquired a strong sense of how far women had come. Marilyn French's best-selling 1977 novel, *The Women's Room* (after Virginia Woolf's *A Room of One's Own*), captures the sweeping transformation of several women's lives from the 1950s through the early 1970s. Summing up these astonishing changes, it reminds its readers that "the simple truth—that men and women are equal—can undermine a culture more devastatingly than any bomb." Throughout the 1960s and 1970s, the women's liberation movement and women's literature moved together from anxiety to a strong affirmation of feminist consciousness, from despair to a new understanding of what it is to be a woman. —P. G.

The first wave of self-consciously feminist artists played a critical role in the art of the seventies, and their influence continues to resonate today. Many issues that artists are now grappling with were foreshadowed by these women. Art engaged with sexuality, politics, gender roles, sexualized violence, first-person video, autobiography, and performance is directly indebted to the feminist movement's redefinition of acceptable content in art. As the art historian Andreas Huyssen concluded, "It was especially the art, writing, film-making and criticism of women and minority artists with their recuperation of buried and mutilated traditions, their emphasis on exploring forms of gender-and-race-based-subjectivity in aesthetic production and experiences, and their refusal to be limited to standard canonizations, which added a whole new dimension to the critique of high modernism and the emergence of alternative forms of culture."[125]

373. *Gloria Steinem, a Founder and Editor of* Ms. *Magazine,* 1977
UPI/Corbis-Bettmann

374. Mary Kelly
*Post-Partum Document
Prototype*, 1974
Mixed media, 14 x 11 in.
(35.6 x 27.9 cm)
Generali Foundation, Vienna

375. Lynda Benglis
Advertisement in Artforum,
1974
© Lynda Benglis/Licensed
by VAGA, New York, NY

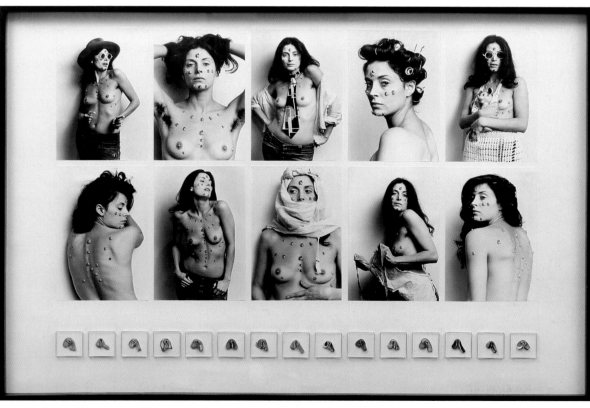

376. Hannah Wilke
*S.O.S. Starification Object
Series*, 1974–82
Mixed media, 40½ x
58 in. (102.9 x 147.3 cm)
Private collection

377. **Nancy Spero**
Codex Artaud XVII, 1972
Type and painted collage
on paper, 45 x 18 in.
(114.3 x 45.7 cm)
Collection of the artist

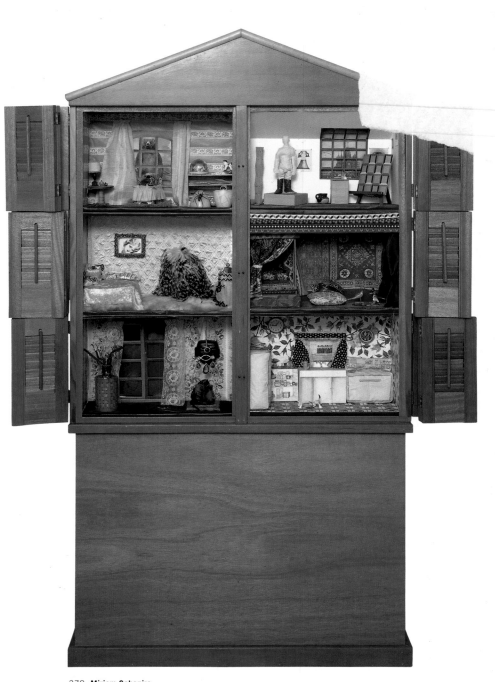

378. **Miriam Schapiro**,
with **Sherry Brody**
The Doll House, from
Womanhouse, 1972
Mixed media, 84 x 40 x
41 in. (213.4 x 101.6 x
104.1 cm)
National Museum of
American Art, Smithsonian
Institution, Washington,
D.C.; Museum purchase
through the Gene Davis
Memorial Fund

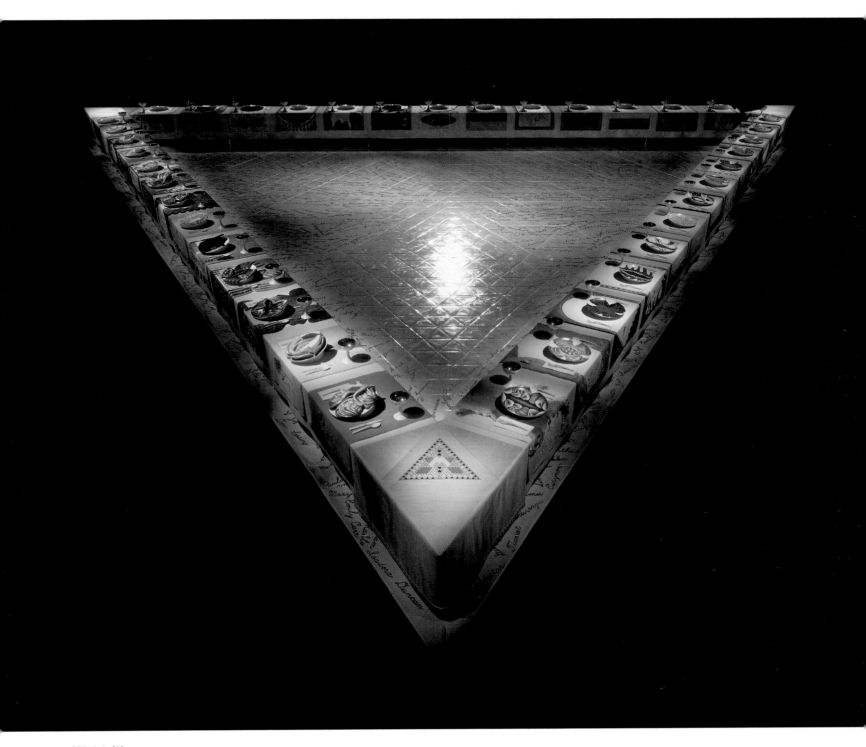

379. **Judy Chicago**
The Dinner Party, 1974–79
Painted porcelain and
needlework, 576 x 576 x
36 in. (1463 x 1463 x
91.4 cm)
Collection of the artist
© 1979 Judy Chicago

PATTERN AND DECORATION

The introduction of craft by women nourished one of the primary art trends of the 1970s, a movement known as P+D, or Pattern and Decoration, which drew directly on various craft traditions and favored painterly, flat, floral, abstract decoration. Miriam Schapiro, among early practitioners of this style, used fabrics, wallpaper, and flower designs that honored the female domestic sphere. Like Minimalism, Pattern painting was based on the repetition of a motif in an all-over composition and often relied on the structure of overlapping grids. But the motifs employed, far from being reductive and geometric, were arabesque in conception.

Pattern painters—both male and female—defied the elitist and puritanical viewpoint epitomized by the critic Clement Greenberg's early admonishment: only when painting "becomes mere decoration does abstract art proceed in a void and really turn into 'dehumanized' art."[126] Rejecting such dogma, Pattern painting, by embracing the decorative and ornamental, opened up art to a host of non-Western and nonmainstream traditions, from Far Eastern to Celtic, Native American to Islamic. Artists such as Ree Morton, Robert Kushner, Kim MacConnel, and Joyce Kozloff challenged male-dominated Western high art with multicultural sources, nonhierarchical imagery, visceral, narrative, and personal content (figs. 380, 381). The old hierarchy dividing art and craft was upset by artists such as Thomas Lanigan-Schmidt, who raided ethnic neighborhoods such as New York's Chinatown for his sculptures of foil, glitter, and brightly colored plastic, or Robert Kushner, who exhibited fabric fashion creations as "paintings" (figs. 382, 383).

The repetition and patterning in folk and outsider art found favor with the Chicago artist Roger Brown, who subjected his figurative imagery to an overall mesmerizing patterning (fig. 384). Chicago had long been a bastion of a regional imagist tradition, going back to the Monster Roster of the 1950s. In the late sixties and early seventies, this tradition was still flowering, albeit in a different guise, and in 1974 came to national attention through the traveling survey exhibition "Made in Chicago." This work, by Ed Paschke, Roger Brown, Jim Nutt, Karl Wirsum, and Gladys Nilsson, among others, drew on sources in primitive, untutored outsider art, street art, and comic books to create a unique, defiantly nonmainstream art. The Chicago Imagists, as they were called, often used shocking color combinations, black humor, and crude, distorted, or sadistic subject matter (figs. 385, 386), making a local contribution to the "cult of the ugly" or "bad painting" that was developing elsewhere in the seventies. The recognition of regional styles and cultures exemplified by these Chicago artists was part of the pluralism of the decade.

Even Frank Stella, known for his Minimalist geometric abstractions in the 1960s, made an abrupt shift in the 1970s to exuberant embellishment. In his Exotic

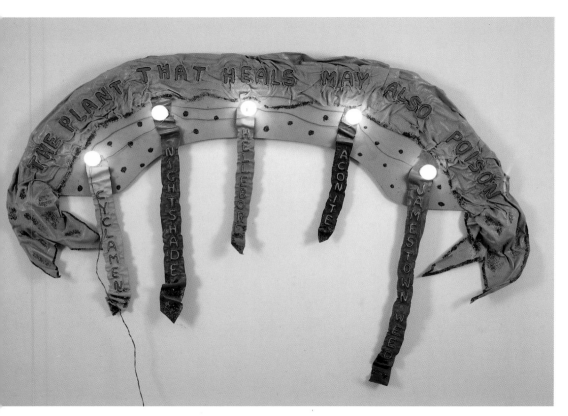

380. **Ree Morton**
The Plant That Heals May Also Poison, 1974
Celastic, glitter, and paint on wood, 46 x 64 x 4 in. (116.8 x 162.6 x 10.2 cm)
Private collection; courtesy Alexander and Bonin, New York

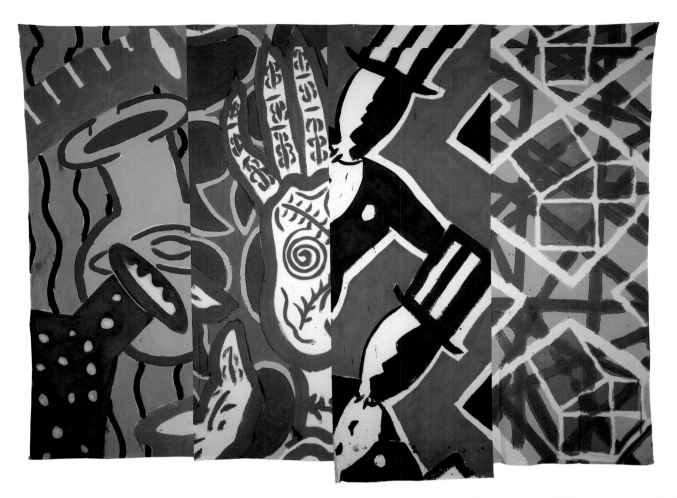

381. **Kim MacConnel**
Formidable, 1981
Synthetic polymer on
cotton, 97¼ x 129¼ in.
(247 x 328.3 cm)
Whitney Museum of
American Art, New York;
Purchase, with funds from
the Louis and Bessie Adler
Foundation, Inc., Seymour
M. Klein, President 82.8

382. **Robert Kushner**
Biarritz, from *The Persian
Line: Part II*, 1976
Acrylic on cotton, synthetic
brocade, and fringe, 74 x
86³⁄₁₆ in. (188 x 219 cm)
Courtesy the artist and DC
Moore Gallery, New York

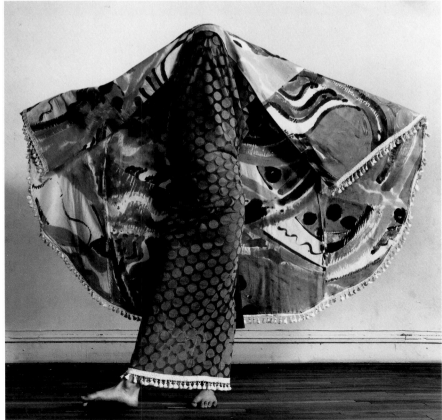

383. **Thomas Lanigan-Schmidt**
Panis Angelicus, 1970–87
Mixed-media installation with monstrance, candlesticks, and altar cloth, 7 x 6 x 3½ ft. (2.1 x 1.8 x 1.1 m)
Groninger Museum, The Netherlands

384. **Roger Brown**
The Entry of Christ into Chicago in 1976, 1976
Oil on canvas, 72 x 120 in. (182.9 x 304.8 cm)
Whitney Museum of American Art, New York; Purchase, with funds from Mr. and Mrs. Edwin A. Bergman and the National Endowment for the Arts, and Joel and Anne Ehrenkranz, by exchange 77.56

385. **Jim Nutt**
Running Wild, 1970
Acrylic on plexiglass and
enamel on wood frame,
46 x 43½ in.
(116.8 x 110.5 cm)
Collection of Lawrence
and Evelyn Aronson; cour-
tesy Phyllis Kind Gallery,
New York

386. **Ed Paschke**
Fumar, 1979
Oil on canvas, 60 x 46 in.
(152.4 x 116.8 cm)
Collection of Ellen and
Richard Sandor

Bird series, inspired by a trip to India, curvilinear cut-metal reliefs are covered with glitter and bright, brushy paint strokes (fig. 387). Jasper Johns turned to patterned "cross-hatch" paintings in the seventies (fig. 388), and Lucas Samaras produced elaborate fabric quilt works hung on the wall like paintings. Although all three artists had previously engaged patterning as an element in their work, the events of the decade encouraged them to give it a new, extravagant focus. Sol LeWitt, who had moved from Minimalism to Conceptualism in the late sixties, turned his attention to large wall drawings that transformed architectural interiors (figs. 389, 390). Based on simple instructions that could be executed by trained assistants, such as "line to point to plane," the wall drawings were visually mesmerizing and often flamboyant and colorful. Pattern painting and Patterning reverberated in related disciplines as well. The architect Robert Venturi proclaimed, "Less is a bore," and advocated an architecture of vernacular exuberance.[127] He regarded the International Style as insensitive and tyrannical, not adequate to the complexity and contradiction of contemporary life.

387. **Frank Stella**
Bonin Night Heron,
1976–77
Mixed media on aluminum,
99 x 125⅜ in.
(251.5 x 318.5 cm)
Albright-Knox Art Gallery,
Buffalo; Gift of Seymour H.
Knox

388. Jasper Johns
Corpse and Mirror, 1974
Oil, encaustic, newsprint,
paper fragments, and
crayon on canvas, 50 x
68⅛ in. (127 x 173 cm)
Private collection
© Jasper Johns/Licensed
by VAGA, New York, NY

389. Sol LeWitt
Cover design for *Music in
Twelve Parts, Parts 1 & 2*,
by Philip Glass, 1974

390. Sol LeWitt
Installation view of
"Sol LeWitt" at The
Museum of Modern Art,
New York, 1978

Center wall:
Wall Drawing #289, 1976
(detail)
Crayon and graphite,
dimensions variable
Whitney Museum of
American Art, New York;
Purchase, with funds from
the Gilman Foundation,
Inc. 78.1.1–4

Left and right walls:
Wall Drawing #308, 1978
Crayon, dimensions
variable
Private collection

PERFORMANCE, BODY ART, AND VIDEO

The explorations of feminist art had a strong effect on developments in performance work, by both female and male artists. A number of performance activities in this period focused on issues of female identity and a woman's relationship to her body. Carolee Schneemann, as a Fluxus artist in the early 1960s, had foreshadowed feminist concerns in works such as *Eye Body* (fig. 391), where serpents crawled over her body in an evocation of a female goddess. *Eye Body* had a natural eroticism that Schneemann described as "giving our bodies back to ourselves."[128] Other proto-feminist, Fluxus performances include Yoko Ono's *Cut Piece* and Shigeko Kubota's *Vagina Painting* (figs. 392, 394). In *Cut Piece*, performed at Carnegie Hall in New York, the audience was invited to come up on stage and cut off Ono's clothing, a strategy designed to question the relationship between subject and object, victim and aggressor. Kubota's performance involved squatting over a piece of paper and painting with a brush fastened to her underwear and dipped in red paint. *Vagina Painting* obviously refers to menstruation, procreation, and creation and redefines Action Painting within the codes of female anatomy. These works established a precedent for later performances with explicit sexual content, such as Schneemann's graphic *Interior Scroll* (fig. 393), in which she pulled a long scrolling text from her vagina and read from it. The text contained a secret letter to the critic Annette Michelson, who had dismissed Schneemann's work. In both action and content, Schneemann was invoking the creation metaphor.[129]

391. **Carolee Schneemann**
Eye Body: 36 Transformative Actions for Camera, 1963
Gelatin silver print, 11 x 14 in. (27.9 x 35.6 cm)
Collection of the artist
Photograph by Erró

During the 1970s, women's performances often became involved with concepts of role-playing, guise and disguise, body and beauty. The Silueta series by Ana Mendieta, a young Cuban-born artist, was a cross between performance and Earth art. In a sequence that suggested violence, fertility, and resurrection, she cut the shape of her figure into the earth, set it on fire, covered it with flowers, and outlined it in fireworks against the night sky—and all the actions were documented through photographs (figs. 395, 396). Other performances Mendieta made in the early seventies included a simulated, bloody rape scene, staged in her apartment (1973), and *Death of a Chicken* (1972), in which she eerily anticipated her own violent demise a decade later. (She fell to her death from her high-rise apartment following an argument with her husband, the sculptor Carl Andre.)

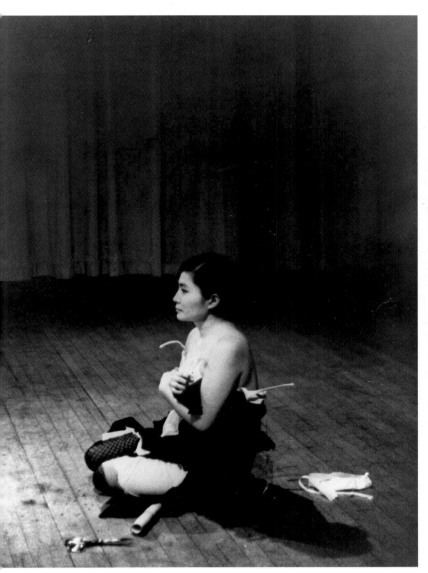

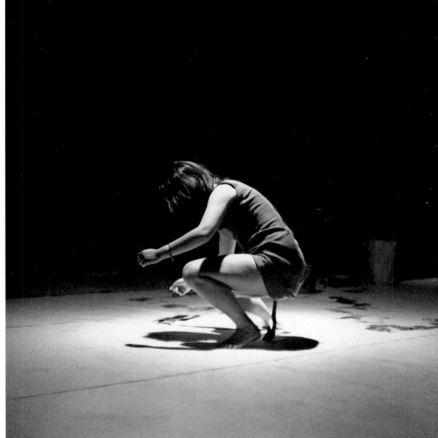

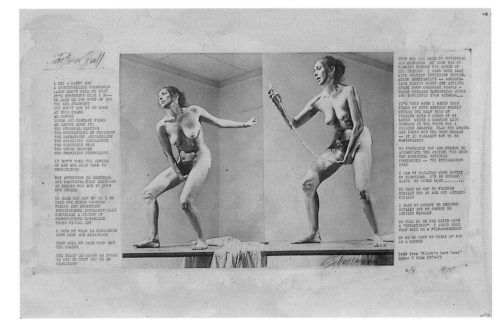

395. **Ana Mendieta**
Untitled, from the *Silueta*
series, 1976
Performance on beach
with red pigment
Private collection

396. **Ana Mendieta**
Anima (Alma/Soul), 1976
Performance with bamboo
armature and fireworks
Private collection

397. **Francesca Woodman**
House 3, Providence,
1975–76
Gelatin silver print, 8 x 10
in. (20.3 x 25.4 cm)
Collection of George and
Betty Woodman

398. **Eleanor Antin**
Carving: A Traditional Sculpture, 1972 (detail)
148 gelatin silver prints and text panel, 28 x 185 in. (71 x 470 cm)
The Art Institute of Chicago; Twentieth-Century Discretionary Fund

399. **Adrian Piper**
Food for the Spirit, 1971 (detail)
Fourteen gelatin silver prints, 20 x 16 in. (50.8 x 40.6 cm) each
Whitney Museum of American Art, New York; Purchase, with funds from the Photography

400. **Adrian Piper**
Catalysis IV, 1970
Street performance, New York
Collection of the artist; courtesy Thomas Erben Gallery, New York

Other artists—Eleanor Antin, Adrian Piper, and Laurie Anderson—probed the physical and psychological boundaries that informed their lives as women and artists. In *Carving: A Traditional Sculpture*, Antin documented a five-week diet and loss of eleven and a half pounds through 148 black-and-white photographs of front, back, and side views of her naked body as it was being transformed into what she called "an aesthetic Greek sculpture" (fig. 398). Laurie Anderson photographed men who accosted her with sexual remarks and other gratuitous comments in *Object, Objection, Objectivity* (1973). Adrian Piper used her body as both an immediate art object and a gendered and ethnically stereotyped art commodity (fig. 399). In the Catalysis series (fig. 400), she presented herself in bizarre guises in public—on a bus with a bath towel stuffed in her mouth, in the Metropolitan Museum with gum on her face, or in the lobby of the Plaza Hotel with Mickey Mouse balloons attached to both ears.

Artists' use of the body to explore identity was increasingly prevalent—particularly in performance and video work, which evolved into full-fledged art forms during this period. Building on the legacy of Happenings and Fluxus performances, and the radical experiments of the Judson Dance Theater, many artists took up performance, often in concert with conceptual activities, feminist activities, or video work. Some of the other important performance events of the time include Vito Acconci's *Seedbed* (fig. 403), where he lay naked, masturbating, under a wooden ramp in New York's Sonnabend Gallery, invisible but audible to the audience. The Los Angeles artist Chris Burden subjected

STRUCTURE AND METAPHOR: POSTMODERN DANCE

In the early 1970s, many choreographers built on the discoveries of the 1960s—the wide-ranging, breakaway first phase of postmodern dance—in a more analytic mode. In March 1975, Michael Kirby, the editor of *The Drama Review*, published a special issue of the journal devoted to postmodern dance, perhaps the first time this label was used in print. He explained, "The choreographer does not apply visual standards to the work. The view is an interior one: movement is not pre-selected for its characteristics but results from certain decisions, goals, plans, schemes, rules, concepts, or problems. Whatever actual movement occurs during the performance is acceptable as long as the limiting and controlling principles are adhered to."

This second phase of postmodern dance, or analytic postmodern dance (which, as one can see from Kirby's description, was allied to Conceptual and Minimalist art), rejected musicality, meaning, characterization, mood, and atmosphere. It used costume, lighting, and objects in functional and anti-illusionistic rather than in expressive ways. Analytic postmodern choreographers created low-key, reductive, factual movements and relaxed movement styles. Their compositional strategies included scores, task movements, verbal commentaries, geometric forms, mathematical systems, and repetition, all meant to distance movement from dramatic narratives and personal expression. They often danced in silence.

Despite the label "postmodern" (used to draw a distinction between this generation and that of historical modern dance), the analytic postmoderns were in fact "modernist," as that term is understood in the visual arts—describing works that reveal the conditions of a medium's materials and making. The postmoderns emphasized movement and choreographic structure as the essential materials of dance; they separated dance from the other arts; they made no reference to external subject matter.

Lucinda Childs' *Calico Mingling* (1973), a walking piece for four dancers who trace out semicircular, circular, and linear forms as they implacably stride forward and backward, is an exemplary work in the analytic postmodern mode. So is Trisha Brown's *Primary Accumulation* (fig. 401), a series of gestures and other movements strung together according to a mathematical system, done lying on the floor. *Einstein on the Beach* (fig. 410), an opera by Robert Wilson, with music by Philip Glass and choreography by Lucinda Childs and Andy deGroat, was an early collaborative venture in which Minimalist work from several disciplines merged to create a new maximalism. Childs and Glass collaborated with the visual artist Sol LeWitt on *Dance* (1979), which sparked a series

401. **Trisha Brown**
Primary Accumulation, 1972
Photograph © 1972 Babette Mangolte, All Rights of Reproduction Reserved

402. **Meredith Monk**
Education of the Girlchild,
1973, photograph by
Beatriz Schiller

of large-scale collaborations among chore-
ographers, composers, and visual artists.
Both *Einstein* and *Dance* foreshadowed
new directions for dance in the 1980s.

Although the improvisational group
Grand Union (1970-76), which grew out
of Yvonne Rainer's work and included
Rainer, Trisha Brown, Steve Paxton, David
Gordon, and Douglas Dunn, was more the-
atrical than the Minimalist dances several
of its individual members made on their own (anything, from rock music to verbal play
to outrageous costumes, was fair game for the group), it nevertheless belongs to the
category of analytic postmodern dance, because it was so often engaged in revealing
conditions of performance. So, too, does Contact Improvisation, a duet form devised by
Steve Paxton (done either in an informal "jam" situation or in a theatrical setting) that
is based on aikido, sports, and social dancing and has spread as a community-based
practice to become an international network.

Analytic postmodern dance dominated the avant-garde dance scene, but another
strand of postmodern dance developed in the 1970s. Related to analytic postmodern
dance in its simplicity and austerity, metaphoric and metaphysical postmodern dance
drew on non-Western forms of dance, martial arts, and meditation and on countercul-
tural interest in communal rituals and spiritual expression. Metaphoric postmodern
dance, like analytic postmodern dance, used techniques of radical juxtaposition, ordi-
nary movements, and stillness and repetition—but often with a more theatrical presen-
tational style. Examples of metaphoric postmodern dance include Meredith Monk's
mythic "operas," such as *Education of the Girlchild* (fig. 402), about a mysterious
community of women, Kenneth King's dances that created metaphors for technological
information systems, and Laura Dean's spinning dances.

All this avant-garde activity took place on the crest of a dance boom in the 1970s
that saw an increase in audiences, funding, and training for all forms of dance. There
were regular—and longer—seasons by major ballet and modern dance companies (both
American and foreign) in New York, which in the 1970s became the dance capital of
the world. And, just as regional theater spread in the 1960s and 1970s, so the dance
boom of the 1970s expanded the regional ballet movement; small cities now often
boasted a ballet company as well as an opera and a symphony orchestra. A vigorous
black dance movement—whose practitioners included Alvin Ailey, Eleo Pomare, Rod
Rodgers, and Arthur Mitchell and the Dance Theater of Harlem—built audiences in
black communities and often explored political and social themes through techniques
that drew on traditional African American dance forms. Television, too, participated in
the dance boom, with regular broadcasting of dance documentaries and experiments in
the new genre of video dance. Both identity politics and the crossbreeding of dance and
mass media helped usher in a new phase of postmodern dance in the 1980s. —S. B.

Top, left and right:

403. **Vito Acconci**
Seedbed, 1972
Performance/installation
at Sonnabend Gallery,
New York
Wood ramp and loud-
speaker, 120 x 720 x
264 in. (304.8 x
1828.8 x 670.6 cm)
Courtesy Barbara
Gladstone Gallery,
New York
Photograph by Kathy
Dillon

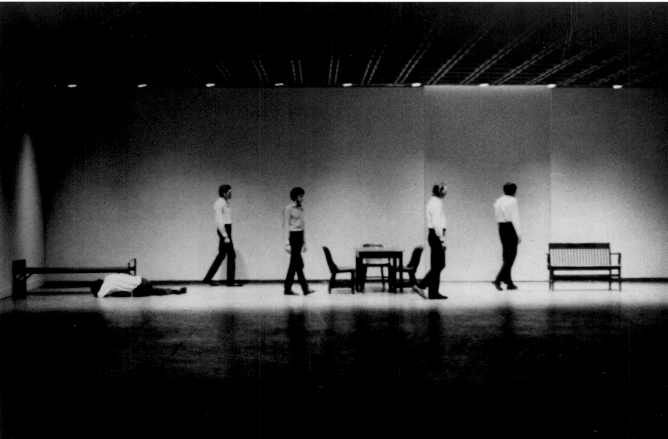

404. **Scott Burton**
Group Behavior Tableau,
1972
Performance at the
Whitney Museum of
American Art, New York

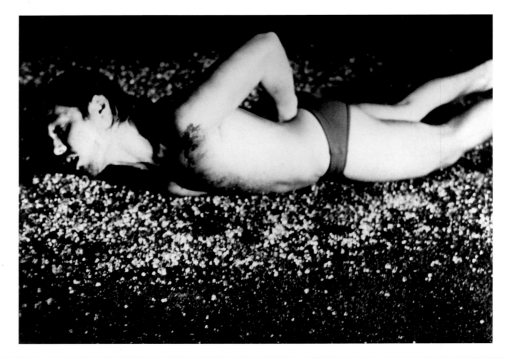

405. **Chris Burden**
Through the Night Softly,
1973
Street performance,
Los Angeles
Collection of the artist

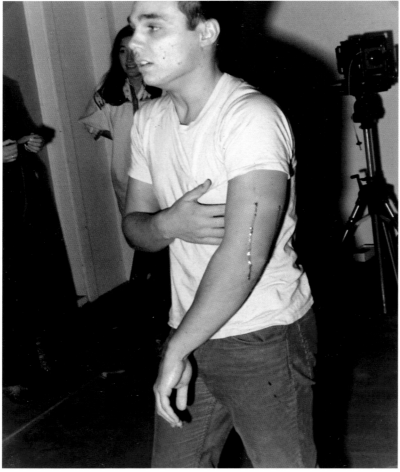

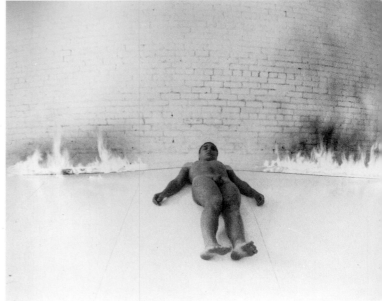

406. **Chris Burden**
Shoot, 1971, from *Chris Burden Deluxe Book: 1971–1973*, 1974
Loose-leaf binder with hand-painted cover containing fifty-three gelatin silver prints and text, 11½ x 11½ x 2 in. (29.2 x 29.2 x 5.1 cm) overall
Whitney Museum of American Art, New York; Purchase, with funds from Joanne Leonhardt Cassullo 92.70a–bbb

407. **Chris Burden**
Icarus, 1973
Performance, Venice, California
Collection of the artist

himself to a number of harrowing trials and tests of endurance and tolerance—such as locking himself in a 2 x 2 x 3-foot locker for five days, crawling through broken glass, or having a friend shoot him in the arm (figs. 405–07). These dangerous situations implicated the viewer as a witness and voyeur. At about the same time, the German artist Joseph Beuys performed *Coyote: I Like America and America Likes Me*, at the René Block Gallery in New York, where he lived with a wild coyote for a week (fig. 408). Performances such as these, played out in galleries before a small audience, were not widely known to the public. But the idea of performance itself was more influential and soon began to affect mainstream art forms, crossing over into film, theater, and opera.

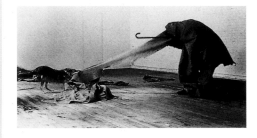

408. **Joseph Beuys**
Coyote: I Like America and America Likes Me, 1974
Performance at the René Block Gallery, New York

PERFORMANCE ART: IN AND OUT OF THE MAINSTREAM

In the early seventies, performance art was the perfect antidote to Conceptual art, with its highly intellectual propositions and rarefied aesthetic of printed text and black-and-white photograph. Artists such as Joan Jonas, Vito Acconci, Scott Burton, and Dennis Oppenheim created performances which dealt directly with experience and perception, in real time and space, bringing to life the somewhat paradoxical concerns of Conceptual art. A few years later, by the mid-seventies, artists such as Adrian Piper, Julia Heyward, Michael Smith, and Laurie Anderson steeped in the Conceptual ethos of their mentors, added several new ingredients—autobiographical material, popular culture, and stylish execution—that would entirely change the direction of performance art. In eloquent multimedia monologues, street performances, and imitation TV soap operas, these artists shifted the focus of performance beyond the realm of art to the everyday. In doing so, they critiqued the impact of media on American life and triggered a discussion that would dominate the art of the eighties.

They also gravitated to New York, with its irresistible downtown art world made famous in the sixties by Andy Warhol's Factory and the Velvet Underground, and in the early seventies by artist-run alternative spaces such as 112 Greene Street, the Kitchen, and Franklin Furnace. The unique draw of downtown Manhattan was the availability of large inexpensive lofts in a compact urban neighborhood where artists, composers, choreographers, and filmmakers lived and worked side by side and generated a collective mood of invention. By the end of the seventies, the area was threaded through with new music venues as well. Crisscrossing the streets late at night, these artists moved easily from the art world to the punk music world of CBGB and the Mudd Club, the Ocean Club, or TR 3, with a sense that they were mixing a heady brew of high art and popular culture. Indeed, media-generation artists of the eighties viewed performance art as a means to shuttle between high and low. Laurie Anderson's historic crossing of the invisible divide, her opus *United States* (fig. 409) and her six-record contract with the industry giant

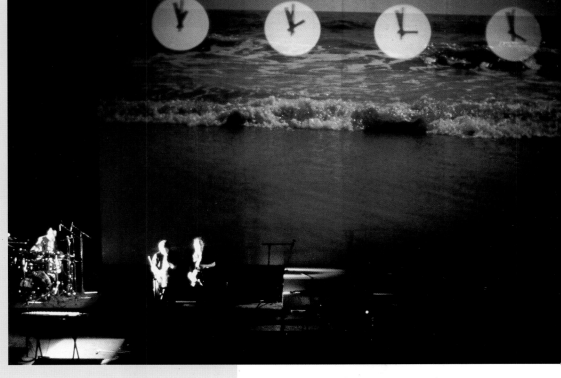

409. **Laurie Anderson**
Let X = X, from *United States*, 1983
Performance at the Brooklyn Academy of Music, New York

Warner Brothers, showed that such a shift was possible. At the Brooklyn Academy of Music (BAM), on the same stage where Robert Wilson (fig. 410) had presented his groundbreaking, large-scale performance extravaganzas *Deafman Glance* (1971) and

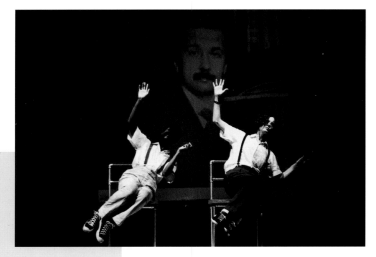

The Life and Times of Joseph Stalin (1973), Anderson's event generated excitement in both audiences and the press, encouraging the organizers of the Next Wave Festival (begun the preceding year at BAM) to pursue large audiences for an ongoing program of innovative international work. The Brooklyn venue set new standards for performance art, while the Next Wave Festival introduced the contradictory notion of a popular avant-garde as a force for the eighties.

Even as BAM encouraged the development of fully realized, highly produced, and large-scale performance work, downtown venues such as P.S. 122, the Knitting Factory, and Exit Art continued to provide a showcase for the more intimate material of artists such as Eric Bogosian, Spalding Gray, Karen Finley, David Cale, Holly Hughes, Laurie Carlos, Alien Comic (fig. 411), Ann Carlson, and Ishmael Houston-Jones. Bogosian's live "portraits" of American men, Gray's autobiographical solos, and Finley's chilling manifestos riveted audiences and established the monologue as a popular genre within performance history. All three artists would be catapulted into the mainstream—Bogosian and Gray into theater and television, Finley into the spotlight of controversy with her unflinching descriptions of abusive behavior toward women. It was Finley's application for an NEA grant that helped unleash the right-wing effort to censor funding for non-profit institutions. Despite mainstream attention to their work, these artists returned frequently to the venues that had supported their earliest pieces, as much for the opportunity to showcase works in progress as for the permissive and supportive atmosphere that gave them license to investigate new directions.

In the media-driven 1980s, performance art took on the professional gloss of mainstream theater and television, with stand-up comics, talk show hosts, and cabaret as models for quickly sketched work that often took place in the bars of New York's Lower East Side—at the Pyramid Club, Limbo Lounge, or the WOW Café. John Jesurun, John Kelly, and Ann Magnuson enjoyed the challenge of holding audience attention in the noisy, informal spaces, while roving art critics reviewed the material as a kind of avant-garde entertainment. By the end of the decade, pulp magazines were referring to performance as the art form of the eighties, and several Hollywood movies even featured performance artists in their cast of characters. In the 1990s, by contrast, many artists reclaimed performance as a mechanism for grassroots activism, and in the hands of Tim Miller or the late David Wojnarowicz, members of ACT UP or Gran Fury, it became the most effective means to publicize political and social issues, from AIDS to homelessness to racial and gender prejudice.

Provocation remains a constant characteristic of performance art. It is a volatile form that artists use to respond to and effect change—whether political, in the broadest sense, or cultural. Despite the few who have made it into the mainstream, performance remains an untamable and unmarketable art form. —R. G.

410. Sheryl Sutton and Lucinda Childs in Einstein on the Beach, by Philip Glass and Robert Wilson, 1976
Photograph © 1976 Babette Mangolte, All Rights of Reproduction Reserved

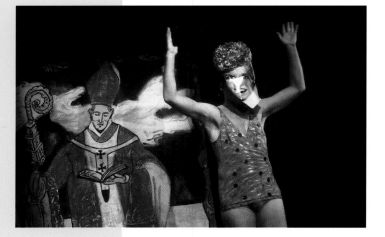

411. **Alien Comic**
Pope Dream, 1988
Performance at P.S. 122, New York

If photography had been put to new use in the service of performance art, it was joined in the seventies by video, which had emerged as a new art form in the late 1960s after Sony introduced its Portapak—a cheap, portable video camera. Nam June Paik, who had investigated the aesthetics of video with his prepared television sets (fig. 156), was among the first to purchase a Portapak. Artists' use of video quickly became as common an activity as drawing and painting, and they employed the technology in diverse forms, from single-channel tapes on monitors to sculptural installations (fig. 414). The art dealer Howard Wise, who had specialized in kinetic art, was the first to hold a video exhibition, entitled "TV as a Creative Medium" (1969). Video also lent itself to diverse ideologies: the decentralized distribution system of cable television and satellite transmission made it possible to create and broadcast alternatives to commercial television for a large audience.

The accessibility of video appealed to a wide range of artists, who incorporated the technology into other art forms. William Wegman, famous for photographs of his Weimaraner, Man Ray (fig. 415), integrated performance and video to produce a new type of entertainment. He began using video in 1969, and his work, starring Man Ray, is best known for its visual puns and deadpan humor (fig. 416). This style of humor had a tradition among West Coast Pop and Conceptual artists, including Ed Ruscha, John Baldessari, and Bruce Nauman (figs. 347, 412, 413). Nauman was an especially important influence because he represented a new kind of artist, one who worked in multiple styles and media. His sculpture, photography, performance, and video art used language and body references, and his increasing mix of violence and the absurd served as a potent stimulus for other artists. During the late sixties and seventies, Nauman explored video, sometimes to document performances, sometimes in conjunction with sculptural installations, and sometimes as independent single-channel works.

412. **Bruce Nauman**
Self Portrait as a Fountain, from the series *Photograph Suite*, 1966
Chromogenic color print, 20⅑₆ x 23¹⁵⁄₁₆ in. (51 x 60.8 cm)
Whitney Museum of American Art, New York; Purchase 70.50.9

413. **Bruce Nauman**
Waxing Hot, from the series *Photographic Suite*, 1966
Chromogenic color print, 20⅑₆ x 20¼ in. (51 x 51.4 cm)
Whitney Museum of American Art, New York; Purchase 70.50.11

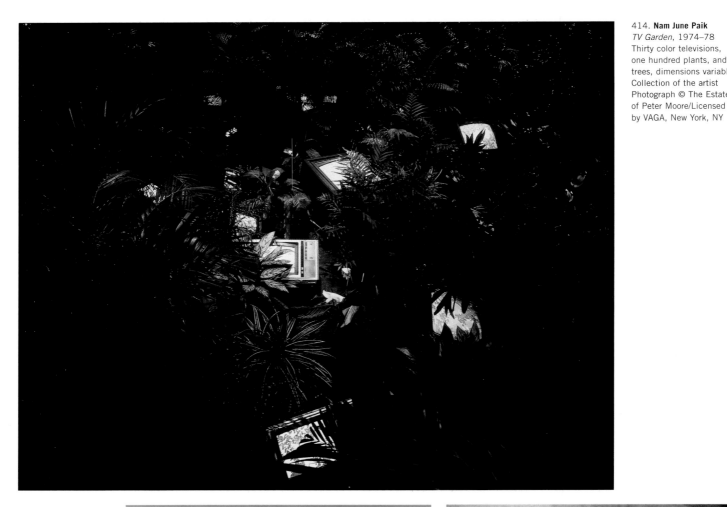

414. **Nam June Paik**
TV Garden, 1974–78
Thirty color televisions,
one hundred plants, and
trees, dimensions variable
Collection of the artist
Photograph © The Estate
of Peter Moore/Licensed
by VAGA, New York, NY

415. **William Wegman**
*Man Ray
Contemplating a Bust
of Man Ray*, 1978
Gelatin silver print,
14 x 11 in. (35.6 x
27.9 cm)
Collection of the artist

416. **William Wegman**
Still from *Reel 4:
Wake Up*, 1973–74
Videotape, black-
and-white, sound;
21 min.
Collection of the artist

VIDEO ART, FILM AND VIDEO INSTALLATION: 1965–1977

Video art was born out of three strands of 1960s American counter-culture: the utopian desire for an expanded perception through new technology, the anti-Vietnam War and civil rights movements, and a rebellion against the institutional authority of mainstream television. From its inception in the mid-sixties, video developed in three directions: psychedelically inflected image processing, politi-cized community activism, and performative art videotapes and installations. The first video image processing of the mid-sixties used audio synthesizers, echoing earlier experiments in electronic music by artists such as La Monte Young, Tony Conrad, and John Cage. Two of the key figures in early video art, Steina Vasulka and Nam June Paik, were both classically trained musicians. When Paik moved to New York from Germany in 1965, he bought one of the first Sony Portapak video recorders and began to collab-orate with the filmmaker Jud Yalkut, who was shooting multimedia expanded cinema events and combining film with video. Together they made one of the first videotapes, *Videotape Study No. 3* (fig. 417). In the same year, Paik began his long collaboration with Charlotte Moorman, a classical cellist and the organizer of the New York Avant-Garde Festival, with whom he made numerous video performances (fig. 160).

In San Francisco, following the electronic experiments of the West Coast abstract filmmaker James Whitney in the early sixties, Bill Hearn, Eric Seigel, and Stephen Beck made the first video synthesizers in 1968–70. These devices enabled abstract images to be created on a TV screen without a camera, and black-and-white camera images to be artificially colorized. Seigel's videotape *Einstein* (1968), in which a photograph of Albert Einstein is psychedelically colorized by means of feedback, is one of the earliest examples of video image processing. Ed Emshwiller's early videotapes also used the early synthesizer techniques. Two major pioneers of video image processing, Steina and Woody Vasulka, made important early experiments, rescanning and manipulating the electronic image in works such as *Calligrams* (1970), whose didacticism evoked the materialist, reflexive inquiry of Structuralist film.

In 1969, Howard Wise presented the first exhibition in America devoted to video art at his gallery in New York; the show included Paik, Paul Ryan, Frank Gillette, Ira Schneider, Earl Reiback, and Aldo Tambellini. A proliferation of video exhibitions fol-lowed, first in alternative spaces and later in museums. After Wise closed his gallery in 1970, he formed the first artists' video distribution organization, Electronic Arts Intermix. Leo Castelli and Ileana Sonnabend followed, creating Castelli-Sonnabend Tapes and Films in 1972, and in 1976 Video Databank was founded in Chicago.

The technological optimism of the late 1960s also led to the founding of a number of collective groups, which sought to develop alternative systems of social relationships through video. Raindance, a collective founded in 1969, proposed radical theories of video as a new communications tool, influenced by Marshall McLuhan's and Buckminster Fuller's writings on technology. Antfarm, established in 1968 in San Francisco, made performances, alternative video events, and videotapes. Videofreex, founded in 1971, created an experimental alternative television center, Lanesville TV. Top Value Television

417. **Jud Yalkut** and **Nam June Paik**
Videotape Study No. 3,
1967–69
Videotape, black-and-white, sound; 4 min.
Electronic Arts Intermix,
New York

418. **Joan Jonas**
Vertical Roll, 1972
Videotape, black-and-white, sound; 20 min.
Electronic Arts Intermix,
New York

(TVTV), a collective that established the alternative video documentary movement, made a number of subversive documentaries, such as *The Lord of the Universe* (1974), a scathing exposé of the teenage guru Maharaj Ji.

From 1967 to the mid-seventies, several television stations recognized the importance of the new creativity in video. WGBH Boston, WNET in New York, and KQED TV in San Francisco created residencies for artists with funds from the Rockefeller Foundation, and in 1969 WGBH broadcast *The Medium Is the Medium*, the first program of artists' video on television. Richard Serra's *Television Delivers People* (1973), produced with Carlotta Schoolman, made a direct attack on the values of commercial television by scrolling revealing statistical information about television consumers down the screen, backed by a Muzak soundtrack.

By 1968, video was playing an important role in the new language of art making, reflecting the interdisciplinary experimentation with different media and artistic forms that characterized the sixties and early seventies. The instant-feedback quality of video aligned it with performance, Process art, and new dance, for which it functioned as both document, mirror, and perceptual tool. Artists such as Vito Acconci, Dennis Oppenheim, Peter Campus (fig. 419), Keith Sonnier, Charlemagne Palestine, and William Wegman on the East Coast, and Bruce Nauman, Terry Fox, John Baldessari, Chris Burden, Howard Fried, Paul McCarthy, Doug Hall, and Lynn Hershman on the West Coast, began a conceptual examination of the physical and psychic self through video. Performative actions, made alone in the studio, sometimes over long periods of time, were recorded by the fixed frame of the video camera, which replaced a live audience. For Acconci, the video camera functioned both as a documentation of his confrontational performances and as a means of setting up a provocative dialogue between himself and the viewer and, by extension, between public and private space.

419. **Peter Campus**
Interface, 1972
Closed-circuit video installation, dimensions variable
Musée national d'art moderne, Centre Georges Pompidou, Paris

Video also became an important medium for a new generation of women artists, for whom its democratic, time-based, art-historical properties offered new possibilities for personal expression. Joan Jonas, Mary Lucier, Martha Rosler, Adrian Piper, Beryl Korot, Shigeko Kubota, Dara Birnbaum, Hermine Freed, Nancy Holt, Eleanor Antin, Lynda Benglis, Hannah Wilke, and Linda Montano, among others, made videotapes and performances at the beginning of the seventies that questioned established perceptions of social, political, and erotic female identity. Jonas' *Vertical Roll* (fig. 418) simultaneously deconstructed the female body and the technology of video by filming sections of her body, both naked and costumed, and abstracting them within a repeatedly shifting horizontal frame. Martha Rosler's *Semiotics of the Kitchen* (1975), by contrast, parodied a cooking demonstration by using the utensils to express rage and

frustration. For male as well as female artists exploring new, radical forms, the time-based medium of video offered the potential for profound transformation, on personal, political, and formal levels, and remained a potent force for artists throughout the seventies.

From the mid-1960s onward, artists had also begun to use large-scale projected film, slide, and, later, video images to transform three-dimensional space into participatory environments. These early environments, which reflected the psychedelic sensibility of the decade, functioned as sensory, communal dream spaces, in which the audience became fully involved. By the end of the 1960s, artists had begun to experiment with other forms, using the newly emerging video technology, whose instant-feedback, real-time qualities enabled human behavior to be observed live. Live feedback became a central component of a new body of video installation work, shown mainly in alternative spaces and artists' studios, whose meaning was intimately connected with performance, Conceptual and Body art, and Minimalism's radical shift of meaning from the art object to the viewer's presence in space.

Frank Gillette and Ira Schneider's *Wipe Cycle* (1969) used several monitors and cameras, in time delay, to mix live shots of the viewer with a series of broadcast and taped television images, suggesting a new, participatory technological and televisual environment. Other conceptual video pieces in this mode include Beryl Korot's *Dachau* (1974), Mary Lucier's *Dawn Burn* (1975), and Nam June Paik's *TV Buddha* (1975). Bruce Nauman pushed video's perceptual inquiry to extremes in works such as the video installation *Live-Taped Video Corridor* (fig. 420). Nauman constructed each piece as a claustrophobic spatial environment, in which the viewer experienced physical restriction or disorientation. The close relation between video installation and performance was also demonstrated in the installation work of Vito Acconci and Dennis Oppenheim. Oppenheim produced a number of important performative films, videotapes, and film installations, including *Gingerbread Man* (1970–71), in which the body became the central subject.

The concept of mirroring was central to these and other psychological investigations of the artist's and viewer's presence in space. During the seventies, Peter Campus made a series of groundbreaking video installations, in which viewers encountered their often distorted reflection, recorded in real time by a hidden video camera. In Dan Graham's *Present Continuous Past(s)* (1974), time-delay video feedback created a fragmentation of the single spatial and temporal perceptual viewpoint. In a climate in which the concept of the autonomous self was breaking down, video installation became a primary site for the renegotiation of the boundaries between public and private space, the studio and the gallery, and between artist, art work, and viewer. —C. I.

420. **Bruce Nauman**
Live-Taped Video Corridor,
1969–70
Video installation, 384 x
144 x 20 in. (975.4 x
365.8 x 50.8 cm)
Solomon R. Guggenheim
Museum, New York

ALTERNATIVE SPACES

The rapid rise of new forms such as video and performance required their own specialized venues. In New York, Global Village and Electronic Arts Intermix arose to serve the needs of independent video makers. The Kitchen Center (which had started out as a group of artists showing videotapes and playing music in the kitchen of the Broadway Central Hotel) was founded in 1971 as an exhibition and performance space for video, performance, and music. Printed Matter and Franklin Furnace were devoted to the production and exhibition of artists' books.

Most of these nonprofit alternative spaces were springing up in the New York art community of SoHo, the old industrial manufacturing neighborhood south of Houston Street populated by rag processors and junk shops. Although in 1970 only a handful of commercial galleries were there, nonprofit spaces opened up to serve various constituencies—among them, as we have seen, 112 Greene Street, specializing in process-oriented sculpture; 98 Greene Street, where an eclectic mix of Conceptual art, poetry, performances, and painting exhibitions were held; and feminist cooperatives such as A.I.R. Gallery.

In 1971, the SoHo area became the first neighborhood in the country to be zoned for artists. Artists in search of cheap space and good light had started to work in lofts there in the late forties and early fifties. But the loft movement caught on in the sixties, when Mayor Robert Wagner implemented an "Artists in Residence" variance for SoHo. Artist-entrepreneurs such as the Fluxus artist George Maciunas bought and developed buildings for their fellow artists. The artists were urban pioneers, reclaiming abandoned factory buildings, revitalizing what had been an industrial slum. Artists around the country followed suit, "gentrifying" decayed and forgotten areas of other urban centers.

Alternative spaces sprang up across the country as well—in Buffalo (Hallwalls), Chicago (Artemisia and N.A.M.E.), Atlanta (Nexus), Seattle (and/or), San Francisco (Museum of Conceptual Art), and Los Angeles (LACE, Los Angeles Contemporary Exhibitions, and the Los Angeles Institute of Contemporary Art). All these venues served the growing number of artists whose work the commercial system could not handle. They soon became an essential part of the farm system for commercial galleries and museums, often giving emerging artists their first shows. Ironically, these "alternatives" were made possible by the government's largesse. By 1977, the National Endowment for the Arts (NEA) had an allocation of $100 million and was funding the operations of many of these venues, as were the New York State Council on the Arts and similar organizations in other states. In fact, the term "alternative space" is credited to the critic and artist Brian O'Doherty, who served as head of the NEA's visual arts division from 1969 to 1976.[130] Government support was crucial during the 1970s, when America was in a recession economy brought on by the Organization of Petroleum Exporting Countries (OPEC) oil embargo. The art market, as a result, was soft. These federal and state grants enabled artists to go on working and experimenting, and kept the alternative exhibition spaces alive.

PAINTING AND SCULPTURE RECONCEIVED

The alternative art forms that flourished in the 1970s posed a challenge to the traditional media of painting and sculpture. Could these media survive the growing popularity of process-oriented work, Conceptual art, performance, video, and installation? The answer, for some painters and sculptors, lay in reconceiving their work in the "impure" terms set forth by the new art. Rejecting the formalist dogma that governed painting and sculpture through Minimalism, they embraced subject matter and psychological content.

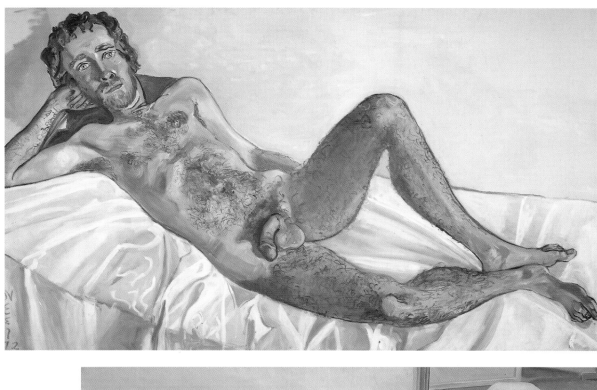

421. **Alice Neel**
John Perrault, 1972
Oil on canvas, 38 x 63½
in. (96.5 x 161.3 cm)
Whitney Museum of
American Art, New York;
Gift of anonymous donors
76.26

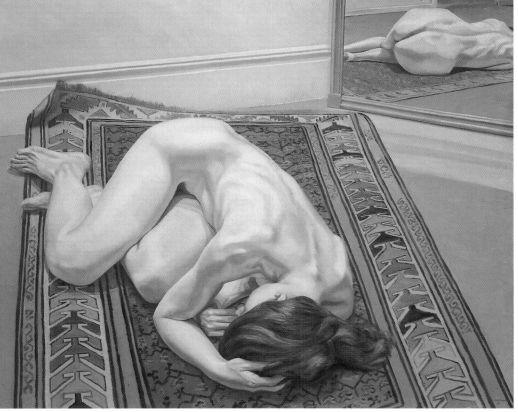

422. **Philip Pearlstein**
*Female Model on Oriental
Rug with Mirror*, 1968
Oil on canvas, 60 x 72 in.
(152.4 x 182.9 cm)
Whitney Museum of
American Art, New York;
50th Anniversary Gift of
Mr. and Mrs. Leonard A.
Lauder 84.69

423. **Cy Twombly**
Untitled, 1969
Oil and crayon on canvas,
78 x 103 in.
(198.1 x 262.6 cm)
Whitney Museum of
American Art, New York;
Purchase, with funds from
Mr. and Mrs. Rudolph B.
Schulhof 69.29

Several older artists, among them Philip Guston, Alice Neel, Philip Pearlstein, and Cy Twombly, offered a way out of the oppressive academy of formalist painting (figs. 421–24). In 1969, Guston's work took a radical new direction. Abandoning abstraction, he introduced mysterious, symbolic figures that became a model for many young painters. These thickly painted canvases are populated by a cartoon-like personal lexicon of symbols, often images of despair—cigarettes, bottles of alcohol, and his schematic head, dominated by a big eye. Alice Neel, who had been at work since the thirties, was valued for her frank and confrontational portraits of strong-willed characters depicted against blank grounds. Both of these artists used rough, somewhat crude and expressionist methods in their emotionally charged works—the paint announced itself as material even in the service of subject matter. Both embraced the subjective and emotional and helped pave the way for the reintroduction of recognizable subject matter in painting. In Philip Pearlstein's figurative paintings, one or two nude models are arranged within a cropped view of a domestic interior. The coolness of the flesh tones, the pose of the figures, which usually excludes the face, and the exaggerated perspectives, combine to give Pearlstein's paintings an unsettling expressive quality despite the hard-edge execution. Cy Twombly's process-oriented abstract paintings, which he had been making since the fifties, were admired by younger artists for their mythological content and literary allusions—often made manifest through titles, palette, and graffiti-like imagery—as well as for their sensual passages of paint and independence from any style or school.

Younger artists such as Neil Jenney, Jonathan Borofsky, Susan Rothenberg, Jennifer Bartlett, Pat Steir, and Elizabeth Murray were also reasserting the viability of painting. Jenney deliberately used "bad" painting techniques—quick brushstrokes

424. **Philip Guston**
Cabal, 1977
Oil on canvas, 68 x 116 in.
(172.7 x 294.6 cm)
Whitney Museum of
American Art, New York;
50th Anniversary Gift of
Mr. and Mrs. Raymond J.
Learsy 81.38

THEM AND US

425. **Neil Jenney**
Them and Us, 1969
Acrylic on canvas, 58½ x
135 x 4 in. (148.6 x
342.9 x 10.2 cm)
The Edward R. Broida
Collection

426. **Nancy Graves**
Camel VI, 1968–69
Wood, steel, burlap,
polyurethane, animal skin,
wax, oil paint, 90 x
144 x 48 in. (228.6 x
365.8 x 121.9 cm)
National Gallery of
Canada, Ottawa;
Purchased 1969
© Nancy Graves
Foundation/Licensed by
VAGA, New York, NY

and cartoony figures—in works that often had direct satirical, political content (fig. 425). Later, in a dramatic reversal, he adopted an ultra-refined, hyperreal technique to present a grim view of the technological ravages of the environment. Jonathan Borofsky made his dreams the subject matter of his drawings, paintings, and sculpture, which were often combined in powerful and densely loaded installations (fig. 428). Susan Rothenberg began a series of monochromatic paintings in which the field was filled with the ghost image of a horse (fig. 429). Jennifer Bartlett similarly let personal and figurative allusions enter into her gridded works, which also explored the many possibilities of mark making (fig. 430). Pat Steir's work shows a Conceptualist tendency to deconstruct the constituent parts of painting—line, color, texture—and then recombine them in a personal iconography (fig. 427). Elizabeth Murray pushed the suggestiveness of abstract forms in her large-scale and brightly colored abstractions to allude to the furniture and domestic props of her life (fig. 431). An exhibition at the Whitney Museum in 1978 defined this revival of figuration as "New Image Painting." All these artists challenged the old division between abstraction and representation and kept painting alive during a period when many considered it an outmoded practice.

427. **Pat Steir**
Line Lima, 1973
Oil and graphite on canvas,
84 x 84 in.
(213.4 x 213.4 cm)
Whitney Museum of
American Art, New York;
Gift of an anonymous
donor 74.44

Just as painting was reconceived, so sculpture was moving in a more allusive and metaphoric direction. Joel Shapiro was one of the first to introduce recognizable imagery in his condensed, geometric solids of this period, using the schematized forms of a house, bridge, ladder, or chair, and then the human figure (fig. 432). The Lilliputian size of these forms was countered by the grand scale of their presence, demonstrating that scale and size are very different concepts. Nancy Graves made lifesize sculptures of camels that suggest something from a natural history museum diorama (fig. 426). In later works, nature manifested itself in cast bronze, highly colored assemblages of leaves, pods, branches, and flowers. Bryan Hunt made sculptures of the Great Wall of China and the Empire State Building (fig. 433) before moving into a more ambiguous, quasi-abstract realm of bronze lakes and waterfalls. Scott Burton, who had staged several performance tableaux where figures interacted with furniture props, turned to sculptures of improbable yet usable furniture, for which he later received public commissions (fig. 404).

The 1970s, a period of fragmentation and soul-searching, produced exhilarating, fertile, laissez-faire growth in the arts. Though few neat, packageable trends emerged, many forms and ideas flourished. "Pluralism" was the catchword used to describe these heterogeneous tendencies, which opened up a host of new possibilities, among them that the idea of a dominant style or even of an artist adhering to a single style might be a thing of the past.

428. **Jonathan Borofsky**
*Running Man at
2,550,116,* 1978
Acrylic on plywood,
89 x 110 in.
(226.1 x 279.4 cm)
The Patsy R. and
Raymond D. Nasher
Collection, Dallas

429. **Susan Rothenberg**
For the Light, 1978–79
Synthetic polymer and
vinyl paint on canvas,
105 x 87 in. (266.7 x
221 cm)
Whitney Museum of
American Art, New York;
Purchase, with funds from
Peggy and Richard
Danziger 79.23

In 1976, America celebrated its two hundredth birthday. The bicentennial was an occasion for renewing patriotic sentiments and looking back with pride at the history and achievements of the nation (though cynics viewed the festivities as a marketing bonanza—the "buy"centennial "sell"ebration). That same year, Jimmy Carter was elected president, following the short administration of Gerald Ford, who had taken office after Richard Nixon's resignation in 1974, and who had pardoned Nixon for his role in the Watergate scandal. Carter, the Democratic governor of Georgia, was a dark-horse candidate, but the country was eager for a new kind of leader— honest, compassionate, homegrown, and untainted by the political machinations that had characterized the Nixon years. Carter understood that Americans had lost confidence in their government, and he tried to heal the nation by identifying with the people and preaching a combination of idealism, common sense, and ethical values.

Under Carter's administration, a nuclear non-proliferation pact, curbing the spread of nuclear weapons, was signed in 1977 by fifteen countries, including the United States and the Soviet Union. The following year, Carter brokered a Middle East peace settlement between Egypt's President Anwar Sadat and Israel's Prime Minister Menachem Begin, and in 1979 he signed the SALT II arms-reduction agreement with Soviet President Leonid Brezhnev. Carter was especially sensitive to environmental issues—he created the Department of Energy, banned the dumping of raw sewage into the ocean, and established controls on strip mining. In view of the ongoing Arab oil embargo, he encouraged energy conservation and led by example, ordering the thermostat turned down in the White House.

In spite of these accomplishments, Carter's presidency was plagued by internal and external crises. Domestically, the oil embargo had contributed to a stagnant economy wracked by high inflation. On the international front, the Shah of Iran, long supported by the United States, was forced to abdicate in early 1979 and militant Islamic fundamentalists took power. In November, they seized the U.S. embassy in Tehran, taking more than sixty hostages. Despite constant efforts at negotiation, Carter was unable to arrange the release of the hostages. In late December, the Soviet Union invaded Afghanistan, unleashing world protests. Save for withdrawal from the 1980 Olympic Summer Games in Moscow, America seemed powerless.

If the administration was ultimately ineffectual, it was because Carter remained a Washington outsider whose lack of political connections in the capital and whose strong moral convictions made it difficult for him to succeed in the insider world of Washington politics. Ultimately, he was unable to build enough support in Congress to get many of his proposals passed.

The arts, however, thrived during Carter's administration, in no small part thanks to Joan Mondale, the vice president's wife, who was a vocal and visible advocate. One noticeable effect was an increased support for art at the community level, as artists themselves sought to forge meaningful connections with their communities and reach broader audiences.

The Mediated World: Art and Photography

In the late 1960s, a young man named Stewart Brand was sitting on his San Francisco rooftop, high on LSD, when he had an epiphany: that a photograph of earth from space would change the way everyone thought about our planet. He started a campaign, complete with buttons reading, "Why haven't we seen a photograph of the whole earth yet?" He sent some of these buttons to the National Aeronautics and Space Administration (NASA), and in 1967 *Lunar Orbiter 5* was outfitted to send back just such images. Brand put one of the black-and-white photographs of earth taken from space on the front and back covers of his *Whole Earth Catalog*, first published in 1968, and the ecology movement was born (fig. 435).

Suddenly, because of the photograph, we had a whole new perspective on our planet—as a small oasis adrift in the universe, fragile and precious, poignantly beautiful but agonizingly lonely.[131]

This is one dramatic example of the power of pictures, of how photography has changed our feelings about ourselves and our place in the world. (It is also an example of how, paradoxically, technology helped give rise to the anti-technology ecology movement.) By the early seventies, we had seen the first photographs of a

human fetus developing in the womb (fig. 434), the footprint of the first human to walk on the moon (fig. 436), and we had watched the Watergate hearings on television. We had the color Polaroid camera, the Instamatic camera, the Portapak video camera, the Intel microprocessor, the CAT scan, and cable television. Technology had expanded the visual world and turned us all into image makers.

In art, photography had long been considered a stepchild to painting and sculpture. But the technological image world that greeted the seventies helped generate enthusiasm and respect for photography as a privileged medium. Moreover, the pluralism of that decade encouraged a revamping of old hierarchies as well as the invention of new art forms. Photography, as we have seen, was playing new roles in art, from serving as a key element of Conceptual art to documenting Earthworks and performance pieces. It would soon move to the center of avant-garde practice and, at the same time, become a vibrant mainstream medium for art making.

434. *West German Family-Planning Film (Helga)*, 1967
UPI/Corbis-Bettmann

435. *Whole Earth Catalog* Menlo Park, California: Portola Institute, 1968

436. *View of Astronaut Footprint in Lunar Soil*, from *The New York Times*, July 21, 1969

"Straight," or traditional, photography was receiving increasing recognition as several specialized photography galleries opened, prices for photographs at auction rose, and art periodicals began to publish serious critical essays on the works of photographers. Another significant development in straight photography during the seventies was the acceptance of color photography, previously derided as impure or too commercial, as a legitimate vehicle for fine art. William Eggleston, Stephen Shore, and Joel Meyerowitz, among others, explored vernacular scenes of roadside America and patterns of random facts in their confident, ambitious color photographs (figs. 437–39). Their interest in the changing American landscape was paralleled by the architect Robert Venturi's study of mall architecture, highway signage, and the Las Vegas strip (fig. 228). Other photographers were looking at changes in the American landscape in a different, more cynical light. Work referred to as New Topographics (after a 1975 exhibition at the George Eastman House in Rochester, New York) comprises deadpan images of a dystopic

437. **Stephen Shore**
Untitled (The Falls Market), 1974
Chromogenic color print,
7¹¹⁄₁₆ x 9¹¹⁄₁₆ in. (19.5 x
24.6 cm)
Whitney Museum of
American Art, New York;
Gift of the artist and
Pace/MacGill Gallery
93.62

438. **William Eggleston**
*Near Minter City and
Glendora, Mississippi
(Woman in Green Dress)*,
1969–70
Dye-transfer print, 8⅞ x
13³⁄₁₆ in. (22.5 x 34.1 cm)
The Museum of Modern
Art, New York; Purchase
© William Eggleston/A+C
Anthology

439. **William Eggleston**
Algiers, Louisiana, c. 1972
Dye-transfer print, 16¹³⁄₁₆ x
11 in. (42.7 x 27.9 cm)
The Museum of Modern
Art, New York; Purchased
as the gift of the John E.
Galvin Charitable Trust on
behalf of the Crouse Family
© William Eggleston/A+C
Anthology

440. **Robert Adams**
*Along Interstate 25,
1968*, 1968
Gelatin silver print, 5⅝ x
5¹³⁄₁₆ in. (14.1 x 14.8 cm)
Whitney Museum of
American Art, New York;
Purchase, with funds from
the Photography
Committee 96.10

441. **Richard Misrach**
Boojum Tree, 1976
Split toned silver print,
14 x 14 in.
(35.6 x 35.6 cm)
Robert Mann Gallery,
New York
© Richard Misrach

Right, top to bottom:

442–45. **Lewis Baltz**
*Element numbers 28, 29,
30*, and *31*, from *Park
City*, 1979
102 gelatin silver prints,
dimensions variable
Whitney Museum of
American Art, New York;
Partial and promised gift
of Michael R. Kaplan
P.14a–xxxx.97

America (figs. 440–45). Robert Adams, Lewis Baltz, Frank Gohlke, Richard Misrach, and the German team of Bernd and Hilla Becher cast a dispassionate eye on factory architecture, grain elevators, industrial parks, construction sites, and landfills, factually documenting the debris, deterioration, and contamination of the environment. The ecological sensibility of their work made conscious reference to nineteenth-century documentary photographs of a pristine American West, as they presented evidence of twentieth-century human intrusions on the environment.

While such manifestations of ecological awareness contributed to the popularity of straight photography in the seventies, the potential of the medium was being stretched in another direction. The appropriation of photographs in Pop and Conceptual art had opened

THE OFFICE PARK

During the 1970s, the American corporate headquarters, which at least since the completion of the Woolworth Building early in the century ideally had stood as an impressive office tower dominating an urban skyline, began to confront the material and conceptual implications of a new, suburban, car-driven society. Having left the city centers in the 1950s, white-collar workers now increasingly demanded to have offices as close to their single-family houses as the nearest freeway exit. Moreover, a post-1960s egalitarian and communal ethos made the manifest and vertical hierarchy of the corporate tower increasingly a thing of the past. A new model evolved instead, related to ideas first pursued by proponents of the German *Bürolandschaft*—a concept of "office landscape" developed in the 1960s—where an informal, horizontally organized office structure was meant to foster teamwork and collaboration. This interior-planning scheme depended on a flexible, open floor plan housed within a simple but unified exterior skin.

Skidmore, Owings & Merrill, Cesar Pelli, Kevin Roche, and many other architects contributed significantly to the refinement of this building type, which was perfectly suited to the Minimalist aesthetic of the era. Buildings such as Roche's 1968 Ford Foundation in New York (fig. 446) were meant to provide the image not only of an egalitarian work force but of a working community, by voiding the traditional center of the structure and providing instead an interior atrium and semiprivate landscape. Pelli's 1975 Pacific Design Center in Los Angeles (fig. 447), composed of large hangars of completely smooth yet brightly colored glass, paved the way for the soon-to-be ubiquitous mirrored office building, with which corporate culture attempted to minimize its bulk by integrating it into the surrounding environment. At the same time, however, the sites of these loftlike buildings with reflective surfaces and interior landscapes began to expand into extensive and perfectly manicured lawns. As these mirrored behemoths twinkled in their "golf course" settings, the office park occupied the landscape like an aristocratic country estate, while leisure and labor took on a new and peculiar relationship. —S. L.

446. **Kevin Roche**
Ford Foundation Building, New York, 1968, photograph by Ezra Stoller

447. **Cesar Pelli**
Pacific Design Center, West Hollywood, California, 1975, photograph by Marvin Rand

up new possibilities for a hybrid use of photography. Many kinds of hybrids proliferated in this decade—from the mural-scale collaged photographs of David Hockney to the hand-worked self-portraits in Lucas Samaras' series of *Autopolaroids*—images taken with a Polaroid camera, then manipulated during the development process to create dreamlike visions. Finally, the large-scale Cibachrome prints by Cindy Sherman, Sarah Charlesworth, or Andres Serrano, which came to prominence in the 1980s, rivaled painting and sculpture in size and in the spectacular saturated-color effects produced by the oil-based Cibachrome printing technique (figs. 454, 457, 551).

Another manifestation of photography's growing reputation was the great popular success of Photorealism—a style of painting, based on photographs, that simulated photography's shiny, cold surfaces. Photorealism appealed to Americans' sense of literalness and took Pop's fascination with the consumer landscape to the level of superrealism. The painters Ralph Goings, Richard Estes, Robert Bechtle, and Robert Cottingham zeroed in on gleaming, reflective surfaces—the chrome and glass of shop windows, storefronts, car fenders, mirrors—to produce a somewhat dislocating, hyperreal landscape (figs. 448, 449). Their paintings communicated the seamless surface of the photograph and the mechanical nature of the camera's eye. Duane Hanson, a sculptor, similarly applied a photographic hyperverisimilitude to his polyester resin and polyvinyl three-dimensional replicas of ordinary people—a maid, a security guard, a tourist couple—who in a gallery setting are sometimes difficult to distinguish from the viewers (fig. 450).

448. **Richard Estes**
The Candy Store, 1969
Oil and synthetic polymer on canvas, 47¾ x 68¾ in. (121.3 x 174.6 cm)
Whitney Museum of American Art, New York; Purchase, with funds from the Friends of the Whitney Museum of American Art 69.21
© Richard Estes/Licensed by VAGA, New York, NY

449. **Robert Bechtle**
'61 Pontiac, 1968–69
Oil on canvas, 59¾ x 84¼ in. (151.8 x 214 cm)
Whitney Museum of American Art, New York; Purchase, with funds from the Richard and Dorothy Rodgers Fund 70.16

Perhaps the most important contribution to photography in the 1970s, and into the 1980s, was made by artists engaged in a critical dialogue about the nature of photographic representation. Many of these artists (who did not even consider themselves photographers) felt that images rather than real experience had come to define the world. As the critic Douglas Crimp wrote in the exhibition catalog for "Pictures," the 1977 landmark exhibition at Artists Space that introduced some artists of this generation, "To an ever greater extent our experience is governed by pictures, pictures in newspapers and magazines, on television and in the cinema. Next to these pictures firsthand experience begins to retreat, to seem more and more trivial. While it once seemed that pictures had the function of interpreting reality, it now seems that they have usurped it."[132]

These artists, raised on television, understood the power of pictures. Yet, as witnesses to the Vietnam War and the Watergate scandal, they also evinced a healthy skepticism about the truth of received images and considered the issue of representation to be a crucial problem. "Representation," wrote the critic Craig Owens, "is not—nor can it be—neutral; it is an act—indeed the founding act—of power in our culture."[133] To artists and theorists alike, the photograph had lost its status as a paradigm of veracity.

This questioning of photographic representation constituted a rite of passage for a whole generation of artists—Barbara Kruger, Sherrie Levine, Cindy Sherman, Richard Prince, Robert Longo, David Salle, Sarah Charlesworth, Allan McCollum, and Laurie Simmons. These artists were media literate, both addicted to and aware of the media's capacity for celebrity making, violence mongering, and sensationalism, its ideological power and seductive materialism. Pictures shaped their visual and critical viewpoints. Some, like the Pop artists before them, were employed by media companies—Barbara Kruger was chief designer for Condé Nast's *Mademoiselle* magazine, and Richard Prince was doing picture research for Time-Life. There they had firsthand exposure to the inner workings and materials of the mass media and soon incorporated photographs and photomechanical procedures into their art to redefine photography no less than art itself.

450. **Duane Hanson**
Woman with Dog, 1977
Cast polyvinyl, poly-chromed in acrylic with cloth and hair, life size
Whitney Museum of American Art, New York; Purchase, with funds from Frances and Sidney Lewis
78.6

As influential as the commercial world was the California Institute of the Arts (CalArts) in Valencia, the training ground for many of these artists. Arguably the nation's most important art school in the seventies, it had been founded in 1961 by Walt Disney as a sort of interdisciplinary beehive that would feed his industry. With the establishment of Judy Chicago and Miriam Schapiro's Feminist Art Program there in 1971 and the subsequent appointment of the Conceptual artists Douglas Huebler, Michael Asher, and John Baldessari to the faculty, CalArts became an avant-garde academy—an alternative art school, like the Nova Scotia College of Art and Design or the Whitney Museum of American Art Independent Study Program. The example of John Baldessari, who headed one of the innovative departments at CalArts, encouraged many students to trade in their paintbrushes for cameras—as he had done in 1967 (figs. 355, 451).

Photographic work of this generation often emphasized "making" a photograph rather than "taking" one, which subverted the conventional desire to capture the perfect composition in a single frame. The artists appropriated photographic imagery as available material for art making and transformed it through collage,

451. **John Baldessari**
Ashputtle, 1982
Eleven gelatin silver
prints, one silver dye
bleach print (Cibachrome),
and text panel, 84 x
72 in. (213.4 x
182.9 cm) overall
Whitney Museum of
American Art, New York;
Purchase, with funds from
the Painting and
Sculpture Committee
83.8a–m

452. **David Salle**
We'll Shake the Bag,
1980
Acrylic on canvas,
48 x 72 in. (121.9 x
182.9 cm)
Collection of Ellen Kern
© David Salle/Licensed by
VAGA, New York, NY

453. **Richard Prince**
*Untitled (3 Women
Looking in One Direction)*,
1980
Three chromogenic color
prints, 40 x 60 in.
(101.6 x 152.4 cm) each
Chase Manhattan Bank,
New York

editing, reordering, and quotation. These include Barbara Kruger's photomontage works, Cindy Sherman's and Laurie Simmons' staged tableaux, and David Salle's paintings that incorporate photographic references (figs. 452, 455–60). In the most extreme cases, Richard Prince and Sherrie Levine rephotographed an image from a magazine advertisement or an art book to make a double, thus extending the Duchampian tradition of the readymade to the public image bank of popular culture (figs. 453, 466, 467). Though the work of these artists took different forms, all were using photography as a given mode of seeing that *creates* reality—including our self-images.

In a serial work from the late 1970s, *April 21, 1978*, Sarah Charlesworth photocopied the front pages of newspapers from around the world to track a single event, the kidnapping of Italian Prime Minister Aldo Moro (fig. 454). She excised the texts so that only the masthead and photographs remained. The resulting sequence of images, as well as their sizes and interrelationships on the page, created new narratives. At first, the altered pages seemed to reveal nonsensical, surrealistic conjunctions of images. In the aggregate, however, they showed how the news is treated in different cultures, constructed to suggest who and what is important, and how astonishingly sparse is the representation of women.

In her *Untitled Film Stills*, Cindy Sherman took active control of her own image as she directed herself performing a series of prototypical film noir characters and codified images of femininity for the camera (figs. 455–57). By using herself as a model to replicate other models, she forces us to consider our conditioning, to deflect our gaze away from the female as the object of (male) desire and toward representation itself. Part performance artist, part photographer, Sherman is both subject and object, image and author. Her women and her work project a vague anxiety readable as a mixture of desire, anticipation, and victimization. Like Sherman, Laurie Simmons also probed prevailing sexual stereotypes. Simmons has used dolls, ventriloquists' dummies, and anthropomorphized objects as surrogates posed in deliberately awkward, blank tableaux (fig. 458). Techniques of children's play lure the viewer into her alienated and unsettling environments, where role-playing and role models can be examined.

Barbara Kruger, in the spirit of the agitprop photomontages made earlier in the century by the Russian Constructivists and German artists in the Weimar Republic, overlaid bold, red blocks with italic type on evocative found and enlarged black-and-

454. **Sarah Charlesworth**
April 21, 1978, 1978
(detail)
Forty-five gelatin silver prints, approximately 24 x 20 in. (53.3 x 50.8 cm) each
The Museum of Contemporary Art, Los Angeles; Gift of Eileen and Peter Norton

455. **Cindy Sherman**
Untitled Film Still #6,
1978
Gelatin silver print,
10 x 8 in.
(25.4 x 20.3 cm)
Collection of Alvin and
Marilyn Rush; courtesy
the artist and Metro
Pictures, New York

456. **Cindy Sherman**
Untitled Film Still #16,
1978
Gelatin silver print,
10 x 8 in.
(25.4 x 20.3 cm)
Private collection; cour-
tesy the artist and Metro
Pictures, New York

457. **Cindy Sherman**
Untitled #93, 1981
Silver dye bleach print
(Cibachrome), 24 x 48 in.
(61 x 121.9 cm)
Collection of the artist;
courtesy the artist and
Metro Pictures, New York

458. **Laurie Simmons**
Walking Camera II (Jimmy the Camera), 1987
Gelatin silver print,
82¹³⁄₁₆ x 47½ in.
(210.3 x 120.7 cm)
Whitney Museum of
American Art, New York;
Purchase, with funds from
the Photography
Committee 94.107

459. **Barbara Kruger**
Untitled (Your Manias Become Science), 1981
Gelatin silver print,
37 x 50 in. (94 x 127 cm)
Collection of Dr. and Mrs.
Peter Broido

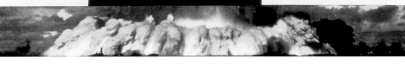

460. **Barbara Kruger**
Untitled (Your Body Is a Battleground), 1989
Photographic silkscreen
on vinyl, 112 x 112 in.
(284.4 x 284.4 cm)
The Broad Art Foundation,
Santa Monica, California

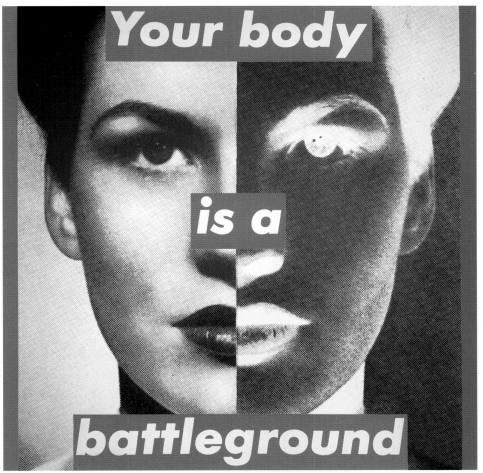

461. Jenny Holzer
Selection from
Inflammatory Essays,
1979–82
Offset paper posters, 17 x
17 in. (43.2 x 43.2 cm)
each

462. Jenny Holzer
Truisms, 1982
Spectacolor signboard,
240 x 480 in. (561.6 x
1219.2 cm)
Public Art Fund, Inc.,
Times Square, New York

463. Jenny Holzer
Installation view of
Laments, 1989, at the Dia
Art Foundation, New York
LED (Light-Emitting
Diode) signs and
sarcophagi, sarcophagi:
24⅜ x 82 x 30 in. (61.9 x
208.3 x 76.2 cm) each;
signs: 128 x 10 x 4½ in.
(325.1 x 25.4 x 11.4 cm)
each

white images. These texts, such as *You Kill Time*, *Your Gaze Hits the Side of My Face*, *Your Manias Become Science*, and *Your Body Is a Battleground* (figs. 459, 460), are often accusatory statements, which invert the masculine voice of media and advertising copy. Kruger addressed women as subjects and spectators, and in her many public projects—books, posters, and billboards—reclaimed media space for her alternative editorial messages. Her work and trademark look has been so effective that it has been widely imitated by the media, proving that influence can go both ways. In recent years, she has been commissioned to design covers for such magazines as *Time* and *Esquire*, and in 1992 *Newsweek* named her one of the top one hundred "cultural elite" in the United States—a group that included no other visual artists.[134]

Jenny Holzer's art is related to Kruger's vernacular signage and public form of address, though it is exclusively text-based. Her *Inflammatory Essays*, *Truisms*, and the *Living Series* consist of pithy pronouncements that intersect the public and the private. They are printed on fly sheets, cast into bronze plaques, printed on decals and T-shirts, or illuminated on LED signs (figs. 461–63).

POSTMODERN ARCHITECTURE: POPULISM AND POWER

Architecture is generally thought to be the most conservative of the arts. Directly linked to and dependent on institutional sources of money, fettered by the regulations and bureaucracy of professionalization and licensure, and expected by society to memorialize and monumentalize civic life, architecture has often been seen as inherently reactive to and protective of historical norms. It is thus ironic that architecture was also the arena in which the first discussions about postmodernism—what it was, whether it was, whether it should be—took place. In fact, the earliest use of the term "postmodern" seems to have been in the title of a 1945 essay by Joseph Hudnut, then dean of Harvard's Graduate School of Design, called "The Post-modern House." Certainly Robert Venturi's work of the late 1960s and 1970s has subsequently been considered fundamental to postmodernism. But it was not until the 1980s that architecture became the overt and central focus of the battle over the definition of postmodernism. Projects such as Michael Graves' Portland Public Services Building in Oregon, Philip Johnson's AT&T headquarters in New York, and Charles Moore's Piazza d'Italia in New Orleans (fig. 464) generated international debate about the return of ornament and symbolism, the use of historical references, and an emphasis on representation and signification.

One of the ironies accompanying these projects is the discursive ambivalence they engendered. On the one hand, the architects themselves represented their work as a populist critique of the glass box, claiming to return historical richness and social meaning to the function of architecture. Their rhetoric of a new architecture for Everyman went hand in hand with the economic and social policies of the Reagan era. Robert A. M. Stern, for instance, developed a popular television show called *Pride of Place*, a rousing romp through the history of American architecture. The series, which aired on PBS, emphasized the democratic ideals expressed by the national tradition, but lingered over loving shots of Newport, Rhode Island, "cottages"—the affectionate name for the summer mansions of families such as the Vanderbilts—as examples of this egalitarian freedom. Michael Graves posed for advertisements selling expensive kitchenware, and every shopping mall in the country began to sport pastel colors and faux-antique columns.

464. **Charles Moore**
Piazza d'Italia, New Orleans, 1975–80
Photograph © Norman McGrath/Esto.

Her statements—among them, "Everyone's work is equally important," "Private property created crime," "Money creates taste," and "Abuse of power comes as no surprise"—raised questions about control, authority, and subjugation and packed a punch in the urban spaces where they were often displayed.

All these artists probe stereotypes of desire and of female objectification by intervening in the process that creates them. Their work is inconceivable without feminism. But women were also leaders in this new generation because they gravitated naturally toward photography. There was, first of all, a long tradition of women working in the medium (Kruger studied with Diane Arbus, and Charlesworth studied with Lisette Model). Women, moreover, were quicker to recognize that the sociocultural definition of gender was not justified by any genetic determinants, but rather was constructed through photographic representation, whether in magazines, newspapers, billboards, or on television and movie screens. To Sherrie Levine, Sarah Charlesworth, Barbara Kruger, Cindy Sherman, and Laurie Simmons, photography itself was therefore the most potent means of deconstructing the gender stereotypes that it had helped create.

But there was another side to this complicity with populism: many of these same buildings triggered a complex discourse that stressed not the symbolic value of representation but its potential duplicitousness and instability. The very eclecticism and pastiche of postmodernism served as evidence of a new form of abstraction, where signs proliferated madly and promiscuously. The abandonment of the modernist box permitted theorists from many disciplines to focus on spatial conditions of unprecedented complexity and to use them to show that the certainties of the Enlightenment were giving way to a new, less teleological attitude of the present.

A unifying, though no less ironic, element of these opposing views of postmodernism is that architecture remained the touchstone of the debate for the culture at large. Indeed, a significant impact of postmodernism in architecture was the transformation of its successful practitioners into celebrities with star status. On television, in magazines, and as retailers and trendsetters, architects came to mingle with other "personalities"—personalities also invented by the media and by a popular desire for intimacy with public figures and a whiff of their power and success. This strange combination of nostalgia, fantasy, exploration, and money came together in the transformation of the Disney company from a simple producer of cartoons to a postmodern and corporate version of the Medici family of the Renaissance (fig. 465). As Graves, Stern, Frank Gehry, and a whole host of international architects were hired to give thematic substance to hotels, restaurants, and ever-proliferating theme parks, a new form of postmodern patronage was born. In the process, architecture assumed a cultural significance it had not enjoyed for decades, but lost more critical respect than it could perhaps afford. —S. L.

465. **Michael Graves**
*Team Disney Building,
Burbank, California,*
1986–91
Disney characters ©
Disney Enterprises, Inc.
Corbis/Robert Holmes

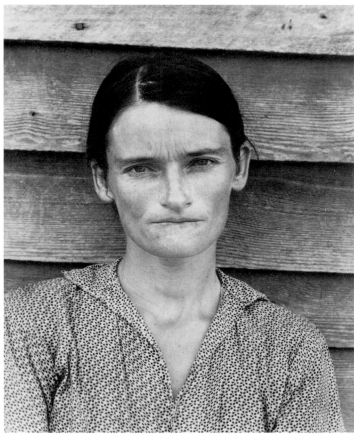

466. **Richard Prince**
Spiritual America, 1983
Chromogenic color print,
23½ x 15⅞ in.
(59.7 x 40.3 cm)
Whitney Museum of
American Art, New York;
Gift of an anonymous
donor 91.86.2

467. **Sherrie Levine**
*Barcham Green Portfolio
No. 5 (Walker Evans)*,
1986
Photogravure and
aquatint, 19 x 14¹⁵⁄₁₆ in.
(48.3 x 37.9 cm)
Whitney Museum of
American Art, New York;
Purchase, with funds from
the Print Committee
90.42

Not only can the reframing of found images show how representation shapes our perception of gender, but it again raises questions about uniqueness, authorship, and originality—just as the mechanical, reproductive imagery of Pop art had earlier challenged the role of the artist in traditional painting and sculpture. To some artists of the late 1970s and early 1980s, originality was nothing more than a socially constructed fiction of mastery, control, and empowerment. This fiction is made patently manifest in the "rephotography" of Richard Prince and Sherrie Levine, for instance, where found photographs from magazine spreads or illustrations of art objects are rephotographed with little alteration and signed as originals. By bringing the image into an art context, its social codes and peculiar unreality—what Richard Prince refers to as "social science fiction"—also become apparent.[135] Acting as an editor, Prince chose photographs of sunsets, biker chicks, hot rods, and female entertainers to rephotograph. He then made subtle alterations to produce strange or special hallucinatory effects, ranging from softened clarity in enlarged images to loving details in cropped photos (fig. 466). Though at first it seemed that his minimal intervention involved no thought or effort, the images were actually carefully chosen for form and content, and their transformation was significant.

Likewise, Sherrie Levine chose reproductions of works of art by earlier male masters of European modernism—Egon Schiele, Aleksandr Rodchenko, Kazimir Malevich, Fernand Léger, El Lissitzky, Piet Mondrian, and Joan Miró—as well as the classic American photographers Walker Evans and Edward Weston (fig. 467). Sometimes she rephotographed their works, and sometimes she faithfully copied them as intimate watercolors and drawings on the same scale as the reproductions from which they were taken. Though interpreted as a subversive commentary on originality, authorship, and ownership, the process enabled Levine to make those works hers. Ultimately, both Prince and Levine show that the personal and the social are necessarily intertwined and that they replace the heroic artist-subject with an unstable, ambiguous, and anti-heroic presence.

THE CRITICAL LEGACY OF POSTSTRUCTURALISM

The rise of distinctively postmodernist practices required a reconceptualization of the terms in which art was received and discussed. A new form of art history and criticism evolved, one that reflected the body of European critical and theoretical work known as poststructuralism. Poststructuralism developed in the intellectual and political climate of post-1968 France, especially in the writings of Roland Barthes, Jean Baudrillard, Jacques Derrida, Michel Foucault, and Jacques Lacan. They challenged the classical humanist division of knowledge into discrete fields such as art history, literature, and philosophy, arguing instead for a fluid, hybrid terrain called the human sciences. Although their writings fall into no single discipline—Lacan's work, for example, merges psychoanalysis and linguistics and is pertinent to literary criticism—all examine the participation of systems of representation in broad social and historical processes.

These works—including Barthes' *Critical Essays*, Foucault's *The Order of Things* and *Discipline and Punish*, and Derrida's *Of Grammatology*—were translated into English during the 1970s and disseminated to an American audience. By the late 1970s, poststructuralist approaches had entered the framework of American universities. Art history, traditionally considered an autonomous discipline, had been transformed sufficiently by the mid-1980s for the noted historian Norman Bryson to remark on the tendency in the "New Art History" to seek out relations with other fields and to adapt critical methods from them. Such crossovers also reflected an interest on the part of the new generation of artists and writers in the postwar media image world. New journals appearing on both sides of the Atlantic (*October* and *Representations* in the United States; *Screen*, *Block*, and *Word and Image* in England) published writing informed by poststructuralist concepts alongside English translations of Continental texts.

Poststructuralism has no single definition; as an ensemble of approaches, it should be distinguished from deconstruction, the specific analytical method that Derrida developed to dismantle the foundations of Western philosophy and literature. Nevertheless, all of poststructuralism shares a "deconstructive" aim of exposing representations as historical formations that not only occupy social space but also exercise power. The work of Foucault and Baudrillard, in particular, provides influential accounts of the ways in which dominant social orders use coded representations to consolidate and perpetuate their political power. In visual arts practices of the 1980s, representations were increasingly seen not as re-presentations of an existing reality but as reality's constitutive agent. The poststructuralist view that what we know as reality is produced through representations reflects the extent to which images and symbols intervene in our world, shaping attitudes and social norms.

Criticism in the 1980s took aim at the received ideas of modernism, at its institutions—studio, gallery, museum—and its art. Opposing the view of the art work as a bounded object produced by a creative subject, critics contested the notions of authorship, originality, "enduring meaning," and "eternal value." Emblematic of these concerns are Rosalind Krauss' influential collection of essays *The Originality of the Avant-Garde and Other Modernist Myths* (1985) and Douglas Crimp's *On the Museum's Ruins* (1993). As Walter Benjamin had predicted in the 1930s, photography played a role in

Manifestations such as rephotography and the examination of images as social constructs rather than as veristic views of reality presented a new group of critics with an opportunity to define a postmodernist art. Postmodernism, like modernism before it, does not concern a particular style or movement, but is rather a shift in attitude about what the value of art is, how it should be defined, what it should strive for, and what it can signify. To modernists, art was validated as the expression of individual creativity, and its disciplines—especially painting and sculpture—were supposed to be truthful to the essential properties of each medium. These were the underlying principles of twentieth-century modernism, including Clement Greenberg's formalist criticism and modernist art from Abstract Expressionism through Minimalism. But even Minimalism, as we have seen, questioned the idea of authorship, as sculptors used prefabricated industrial materials, or had their designs executed by others. Moreover, from the fifties on, new forms of art were introduced—Pop, Postminimalism, Conceptual, and performance, among others—that disintegrated the old boundaries between media and introduced "impure," nontraditional materials into art.

this critical project, its multiple, machine-made means serving to dislodge aesthetic assumptions of creative expression and artistic singularity. What Crimp termed "the photographic activity of postmodernism" was addressed in criticism by Krauss, Hal Foster, Craig Owens, and Abigail Solomon-Godeau, among others.

Yet, as Owens commented in 1983, it was a "specifically feminist consciousness" that placed "the politics of representation. . .on the agenda of contemporary art." Critics and artists alike argued that sexuality is a social construction, resulting from the widespread circulation of signs. Again, imported theory had a priming role, especially the work of the French feminists Hélène Cixous and Luce Irigaray; the French Marxist philosopher Louis Althusser; and the British-based film theorists Laura Mulvey and Stephen Heath, whose work was published in *Screen*. However, at the core were the psychoanalytic writings of Lacan. As early as 1958, he summarized the radical powers newly attributed to images, observing that "images and symbols *for* the woman cannot be isolated from images and symbols *of* the woman. . . .It is representation, the representation of feminine sexuality. . .which conditions how it comes into play." —K. L.

With the modernist criteria challenged, two kinds of postmodernism arose. The first was a popular, retrograde form found in much new architecture and the emerging Neo-Expressionist painting. This work used a pastiche of historical styles and decorative elements to declare art's independence from the modernist concept of stylistic unity. But the more profound form of postmodernism, as seen in the photographic work of Cindy Sherman, Sherrie Levine, Richard Prince, and their colleagues, deconstructed and reconstructed the very nature of representation.

A new generation of critics framed this postmodernism in terms derived from European philosophy and literary theories that had evolved into a general concept known as poststructuralism. Poststructuralism perceived all forms of art, visual or verbal, as a set of social signs or cultural codes. This theoretical proposition became the framework for an intellectually rigorous art criticism that focused—as the artists were doing—on the political and sexual nature of representation and on the systems of power that shaped it.

Although this critical theory eventually became rigid and self-limiting, failing to take into account the visual pleasures and psychological content that enriched the art, it did succeed in giving photography a privileged position in the postmodernist project. Artists and theorists both understood that the supposed truthfulness and naturalism of photography made it the principal agent of ideology.

Street Culture: Art and Community

While some artists were using media images to critique the media itself, others were employing media techniques to situate their messages in a public context. Taking to the streets, they created billboards, fly posters, graffiti, and other public signage. This engagement with "public address" intersected with a broader artistic movement toward grassroots community activism and a renewed interest in street life.

Much of this community-oriented art came out of New York City. The multiethnic street culture of the Lower East Side (which included the East Village), the South Bronx, or Times Square had great appeal to a new generation of artists, many of whom, having been priced out of SoHo, were living in these neighborhoods. Their reclamation of abandoned or tenement spaces was reminiscent of the loft movement in SoHo a decade earlier. And they, too, inadvertently created a dilemma for themselves: their very presence in these neighborhoods hastened the process of gentrification—and the consequent loss of the energetic cultural diversity that had nourished them.[136]

By the 1970s, the Lower East Side was an impoverished area, heavily infiltrated by junkies and drug pushers; it was also home to punk rockers, Hell's Angels, prostitutes, and many immigrant groups. Artists and musicians were drawn to a neighborhood that had become a twenty-four-hour carnival. Out of this heady street culture came a second wave of activist alternative groups, including the artist collectives Collaborative Projects (Colab) and Group Material on the Lower East Side, and Fashion Moda in the Bronx. These new groups—whose members insisted that they were not alternatives to anything—favored a nonchalant mix of art and popular culture. With their inclusive and democratic vision, these artists revolutionized curatorial practice and provided a new, less dogmatic model for the expression of social activism.

Colab was one of several artist collectives that emerged at the end of the 1970s, partly in response to the growing institutionalization of older alternative spaces, and partly because younger artists wanted to form their own groups. The activities of Colab were always provocative and embraced the community. Located in a storefront space called ABC No Rio (a name taken from a faded street sign), Colab specialized in dense hangings in atypical spaces (fig. 468). Founded initially as a way to funnel public grant money to individual artists, the group soon concentrated on generating publicly sited art projects that dealt with the social concerns of the artists and the community. Sometimes Colab illegally commandeered abandoned structures. In 1979, for instance, it took over an empty city-owned building on Delancey Street as a venue for the "Real Estate Show," which attacked New York's housing policies.[137] The group's activities extended to many media: *X Magazine*, which pioneered punk graphics, was a Colab publication, and several members of Colab started the New Cinema, a center for the emerging No Wave Super-8 film movement.

In 1980, Colab occupied a former massage parlor near Times Square and turned it into a temporary art venue. The "Times Square Show" was one of the first

468. Installation view of "Animals Living in Cities" at ABC No Rio, New York, 1980
Photograph © Andrea Callard 1980

469. **Michael Oblowitz**
King Blank, 1983
16 mm film, black-and-
white, sound; 73 min.
Courtesy Rosemary
Hochschild

NO WAVE CINEMA

Between 1978 and 1987, No Wave Cinema was a small, though ultimately influential, film movement that operated out of New York's East Village and owed its existence to a technological innovation. In the late 1970s, Kodak introduced and mass-marketed a new small-gauge film: Super-8 mm sound film. At $6.50 per three-minute roll, Super-8 afforded many artists, musicians, and performers the opportunity to explore the medium of filmmaking without the budgetary constraints of the more expensive 16 mm and 35 mm formats. Since most practitioners of Super-8 filmmaking were not formally trained in the craft, they developed their own shooting and editing language—frequently influenced by B movies of the 1950s. Of equal importance, however, was the high-contrast black-and-white or acidic color of the film, which gave No Wave Cinema its striking appearance. Thus the combination of experimental filmmaking techniques and a new film stock produced an innovative cinema aesthetic.

Super-8 mm sound film used a magnetic sound strip on the edge of the film stock to record sound—much like audiocassette tapes—which distinguished it from previous 8 mm films. The recorded sound tracks often included dialogue improvised by the actors or music produced by bands of the period, such as the Contortions, D.N.A., Mars, John Lurie and the Lounge Lizards, and Lydia Lunch's Teenage Jesus and the Jerks. Retaining the aggressive aural style of the punk movement, these bands employed a combination of scraping guitars, jazzlike improvisation, and accelerated vocals, showing no allegiance to any one particular musical style or "wave." They thus became known as No Wave bands. The films known as No Wave Cinema recorded their performances against settings of New York buildings and bleak interiors. Thematically, No Wave films were equally cutting edge, incorporating social issues pertinent to the East Village underground: rebellion against authority and against conservative sexual politics. By embracing these visual and aural aesthetics, challenging themes, and often frank and graphic portrayals, No Wave Cinema became a vanguard movement.

Many of the filmmakers identified with it were also founders or members of the artist collective Colab. One of Colab's first projects was the New Cinema, which in 1978 began to regularly exhibit media works in a former Polish social club on East 8th Street. The New Cinema screened works by its founders Becky Johnston, Eric Mitchell, and James Nares, as well as those by Vivienne Dick and John Lurie. The screenings at the New Cinema were also distinguished by their presentation format: the films were transferred from Super-8 film to videotape and then projected with an Advent video projector. The New Cinema's bold repudiation of the accepted distinction between film and video—the latter long viewed by film advocates as inferior—marked an important step in the equalization of the two moving-image technologies.

470. **Richard Kern**
Fingered, 1986 (featuring
Lydia Lunch)
Super-8 mm film-to-video-
tape transfer, black-and-
white, sound; 25 min.
© Richard Kern

events of the eighties to define a new street sensibility (figs. 471, 472). The show was really a month-long party, exhibition, and performance event that was jam-packed with raw and raucous art, installations, and film projections.[138] There was work by over a hundred emerging artists, including many who would later win individual renown—Keith Haring, Kiki Smith, Becky Howland, Christy Rupp, John Ahearn, Jean-Michel Basquiat, Tom Otterness, Nan Goldin, and Jenny Holzer. Their work was socially conscious and took on sexual and political themes, but was also often playful. Most of the art had a handmade or homemade look, and the artists expressed an antipathy to the market by selling their pieces inexpensively. The "Times Square Show" also featured graffiti art, S&M erotica, punk art, political manifestos, documentary photography, and Conceptual installations—most of it responding to the character and content of Times Square. Despite—or because of—its street origins, this art had broad appeal, and the show received extensive press coverage and was well attended.

During Colab's much publicized landmark exhibition, the "Times Square Show" (1980), Beth and Scott B organized a revolutionary film, video, and slide component that presented early works by important filmmakers such as Charlie Ahearn, The B's, Nan Goldin, Jim Jarmusch, James Nares, Michael Oblowitz, and Gordon Stevenson. In many cases, it was the first time their films had been screened in public. Until the "Times Square Show," the films had been seen only in relatively private environments—nightclubs such as Max's Kansas City, lofts, or alternative spaces such as the OP Screening Room. In these uncensored venues, the filmmakers freely rejected the usual constraints on language, graphic sexuality, and aestheticized violence enforced in the majority of established film houses. No Wave films typically feature realistic presentations of sex workers and the sex industry and the undercover double-dealings of spies and law enforcement officials. And because women played a prominent role in No Wave Cinema, strong female characters were frequently featured. Important works of the movement include Beth and Scott B's *G-Man* (1978), Kathryn Bigelow's *Set-Up* (1978), Amos Poe's *The Foreigner* (1978), Abel Ferrara's *Ms. 45* (1980), Franco Marinai's *Blue Pleasure* (1981), Michael Oblowitz's *King Blank* (fig. 469), Lizzie Borden's *Working Girls* (1986), and Richard Kern's *Fingered* (fig. 470), featuring Lydia Lunch. Through its graphic portrayal of things only hinted at in mainstream cinema and its bold new visual aesthetic, No Wave Cinema became a cutting-edge influence. Ultimately, these filmmakers and their styles made the transition from short productions to feature-length works for mainstream theatrical presentation and television, later imitated in music videos and commercial Hollywood films such as Quentin Tarantino's *Reservoir Dogs* (1992) and Oliver Stone's *Natural Born Killers* (1994). —M. Y.

Fashion Moda was founded in 1978 in the South Bronx by the transplanted Austrian artist Stefan Eins, who had run a small alternative space in SoHo and wanted to work in what was then considered the worst slum in America. Fashion Moda was visionary in its ambition to celebrate the convergence of different cultures (African American, Asian, Hispanic, Caribbean) in the ethnically diverse neighborhood of the South Bronx—in all of its signage and publicity material, the name Fashion Moda was printed in English and then repeated in Chinese, Russian, and Spanish versions. Community members were directly engaged in the exhibitions, both as subjects for portraits and as contributing artists. For instance, John Ahearn and Rigoberto Torres met at Fashion Moda in 1979 and began collaborating on head and body casts of neighborhood residents. Eins was the first to recognize the brilliance of graffiti art and introduced many of the most talented "writers" to the art world and the public.

Group Material, the most rigorous of the three groups, eschewed Colab's messy, street-inspired style in favor of a more incisive Conceptual structure. This activist collective, founded in 1979, included Doug Ashford, Julie Ault, Tim Rollins, Felix Gonzalez-Torres, and Karen Ramspacher. In 1981, they opened a storefront gallery on East 13th Street to experiment within a framework of broader social activism, mounting a series of shows that tackled such issues as alienation, gender, Americana, and U.S. intervention in Central American politics. One of the most popular shows was called "People's Choice," in which the group asked citizens who lived on the street to bring in objects they considered beautiful. Among the things exhibited were personal mementos, religious icons, folk art, original works of art, and reproductions.[139] By 1982, Group Material had decided to give up the gallery

471. Installation view of the "Times Square Show," New York, 1980
Photograph © Andrea Callard 1980

472. Installation view of the "Times Square Show," New York, 1980
Photograph © Andrea Callard 1980

473. **Tom Otterness**
The Boating Party, from the series *The New World*, 1982–91
Glass fiber–reinforced concrete, 24⅜ x 103¼ x 16 in. (62.9 x 262.3 x 40.6 cm)
Whitney Museum of American Art, New York; Gift of Carolyn and Brooke Alexander and Kiki Smith in honor of Tom Armstrong 91.53
© Tom Otterness/Licensed by VAGA, New York, NY

and channel its energies into public areas, doing projects on billboards around 14th Street and purchasing ad space for art works on the New York subways and bus lines. Perhaps the most notable exhibition associated with Group Material, however, was the "AIDS Timeline," which the group organized in 1989 (fig. 474). The "AIDS Timeline," shown in different venues across the country, was designed as a chronology that traced the history of the AIDS crisis in America and placed it in a social and political context. Facts, statistics, documentary photographs, and works of art revealed how government inaction and media apathy compounded the crisis and how affected communities worked to diminish it.

474. Group Material
AIDS Timeline, 1989–91
Mixed-media installation,
dimensions variable
Courtesy Group Material

Tim Rollins, independently of Group Material, began to operate a workshop with a group of high school students from the South Bronx called K.O.S. (Kids of Survival). Under his guidance, the students produced ambitious collaborative paintings in response to texts they had read (fig. 475). These texts, such as Franz Kafka's *Amerika* and George Orwell's *Animal Farm*, were selected for their anti-authoritarian stances—for their implicit criticism of institutional power structures. Pages of the texts formed the surface of the work, overlaid with imagery inspired by the stories.

On the West Coast, another collaborative group was investigating exploitation, poverty, and urban blight in the border dynamics between Mexico and the United States. The Border Art Workshop—Taller de Arte Fronterizo—founded in 1984, consisted of a revolving group of artists working collaboratively with migrant communities and schools along the U.S.-Mexican border between San Diego and Tijuana. The Workshop was devoted to promoting the cultural diversity of the binational area and explored issues such as immigration, human rights, censorship, AIDS, and abortion as they affected the regional population. In 1986, the Workshop set up an office at Capp Street Project in San Francisco. This office functioned in reality as an art project, a site where residents of the United States, Canada, and Mexico could communicate with each other through fax machines, an 800 telephone line, and the mail.

475. Tim Rollins + K.O.S.
Amerika—For Thoreau,
1987–88
Watercolor, charcoal, and
bister on book pages on
linen, 60 x 175 in.
(152 x 445 cm)
Collection of Mr. and Mrs.
Richard A. Rapaport

Many of the New York artists from Colab, Fashion Moda, and Group Material also interacted socially and professionally with the No Wave movement in film and the New Wave movement in music that had been flourishing on the Lower East Side since the early seventies in places such as CBGB, the former Hell's Angels hangout turned punk rock club (fig. 478).[140] Struggling musicians—the Ramones (fig. 479), Patti Smith, the Talking Heads, and Television—got their starts at CBGB, pioneering a new punk sound that called for "Death to Disco,"

TALKING LOUD AND SAYING NOTHING: FUNK AND PUNK

In the 1970s, two strands of music that had remained in the background in the 1960s began to dominate popular music—funk and punk. They were inspired by two remarkable musicians, James Brown and Lou Reed. Brown began his career in the mid-1950s as a rhythm and blues bandleader with hits such as "Please, Please, Please." By the 1960s, he was one of the biggest stars in America, helping to fuel the soul music explosion, along with Otis Redding, Marvin Gaye, Sly Stone, Curtis Mayfield, and Aretha Franklin. But his most powerful legacy was funk. Simply put, in the hands of James Brown (fig. 476), funk emphasized the bass and drum track rather than the more traditional guitar, keyboards, and voice. This change of emphasis was revolutionary. Over the next three decades, putting complex polyrhythms before melody became the most notable feature of virtually every form of music except guitar-based rock 'n' roll.

Brown's most important protégé was another bandleader, George Clinton, who led various groups under the rubric Parliament Funk. By the mid-1970s, as they proclaimed in a notable song, America had become "One Nation Under a Groove." At the end of the decade, young urban DJs began sampling Brown, P-Funk, and their peers, bringing the beats even more to the foreground to create an entirely new culture called hip-hop. ("Sampling" is the term used to indicate when new tracks are literally built upon manipulated versions of earlier recordings; the more traditional method involves covering or replaying existing songs.)

Another sixties legend, Lou Reed and his band, the Velvet Underground, shaped the future of rock by mixing simple melodies with abstract instrumentation and decadent points of view. They released four albums between 1967 and 1970, all of which were commercial failures. However, thirty years later their work continues to be as influential as that of any other band of their time. The Velvet Underground gained renown in the sixties through its association with Andy Warhol. It was the house band at the Factory and headlined "The Exploding Plastic Inevitable" tour that paralleled the psychedelic light shows on the West Coast presided over by the Grateful Dead. These were multimedia presentations, including music, lights, and crowd participation, analogous to the performance art movement, and they spurred the growth of hippie culture a few years later.

Lou Reed's legacy first became apparent in the early 1970s with a burst of raw underground rock energy that ranged from Iggy and the Stooges, the Modern Lovers,

the dominant pop music of the period. Members of the punk, or "blank," generation were nihilistic and shocked the public with their unabashed anger, manifest in S&M attire, outrageous body piercings, and spiky hairstyles. Many visual artists sympathized with their defiant attitude and predilection for in-your-face expression.

Some photographers, among them Nan Goldin, Peter Hujar, Mark Morrisroe, and Robert Mapplethorpe, chronicled this scene through their frank, discomforting pictures. Mapplethorpe lived with Patti Smith in the early seventies and photographed her frequently (fig. 480). At mid-decade, he became a staff photographer for Andy Warhol's

476. *James Brown*, n.d. Photograph © James A. Steinfeldt/Shooting Star

477. *New York Dolls in a Santa Monica, California, Bathroom*, 1974, photograph by Bob Gruen

Interview magazine and also started producing highly graphic depictions of the gay S&M underworld in which he participated (figs. 481, 482). Inspired by classical art, Mapplethorpe applied a traditional, refined, and elegant aesthetic to brutal and shocking subject matter.

Nan Goldin, slightly younger than Mapplethorpe, captured the colorful, squalid Lower East Side demimonde of poets, musicians, and artists and the psychological intensity of their drug addiction, sexual experimentation, gender transformation, and AIDS-related illness. Her multimedia slide work *The Ballad of Sexual Dependency*, begun in 1976 and continued through 1992, includes a wide range of figures from this world, among them her friends and lovers. In its brutally honest, but tender, portrayal of this

and the New York Dolls (fig. 477) to David Bowie and Roxy Music. By the mid-seventies, Reed's transformation of rock into a potent combination of primitive guitar-based noise and a world-weary point of view had become omnipresent with the birth of punk music, first in New York and then in London.

At that time, pop music had become largely moribund. So-called progressive rock elevated technique over expression to the extent that the airwaves were flooded with almost as much mediocre music as they had been in the early 1960s. And a maligned genre of dance music called disco dominated mass culture. Punk began as a dark underground rebellion against these mainstream influences.

Led by Patti Smith (fig. 480), an energetic poet with the heart of a rocker, punk was born in a grungy bar on New York's Lower East Side called CBGB. Bands such as the Ramones (fig. 479), Television, Blondie, and the Talking Heads began to develop an intelligent new version of rock music based as much on French nineteenth-century Symbolist poets Arthur Rimbaud and Paul Verlaine as on rockers like Reed and Jim Morrison. However, punk did not win mass acclaim until almost two decades later, with the growth of so-called alternative rock, led by bands such as R.E.M., Nirvana, and Pearl Jam.

During the mid-seventies, Britain was a tinderbox of hopeless youth let down by the unfulfilled promise of the sixties and by depressed economic conditions. Inspired by the raw power of the independent sounds emerging from New York, the Sex Pistols, the Clash, and other bands started a second British invasion. They added a bit more style and verve to rock and helped transform it from staid middle age into something that appears to be able to renew itself over and over again. —J. C.

478. *Joey Ramone and David Johansen at the Entrance to CBGB, New York*, c. 1977, photograph by Bob Gruen

479. *The Ramones Performing at CBGB, New York*, 1977, photograph by Ebet Roberts

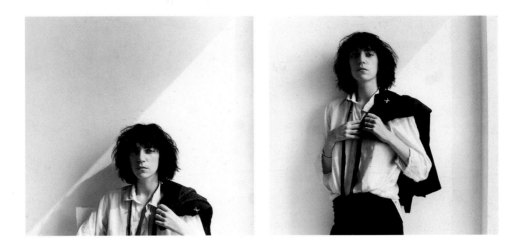

480. **Robert Mapplethorpe**
Patti Smith—Horses,
1975
Two gelatin silver prints,
20 x 16 in. (50.8 x
40.6 cm) each
© The Estate of Robert
Mapplethorpe

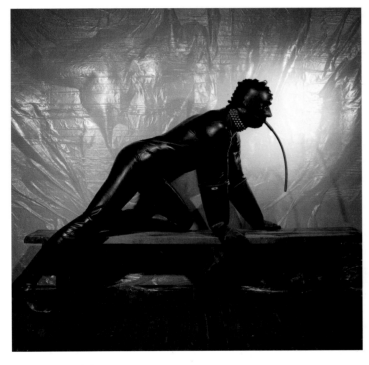

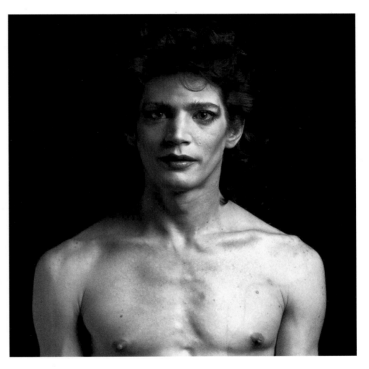

481. **Robert Mapplethorpe**
Joe, NYC, 1978
Gelatin silver print, 20 x
16 in. (50.8 x 40.6 cm)
© The Estate of Robert
Mapplethorpe

482. **Robert Mapplethorpe**
Self-Portrait, 1980
Gelatin silver print, 20 x
16 in. (50.8 x 40.6 cm)
Collection of Howard and
Suzanne Feldman
© The Estate of Robert
Mapplethorpe

483–88. **Nan Goldin**
The Ballad of Sexual Dependency, 1976–92 (detail)
690 slides with audiotape, computer disk, and titles, dimensions variable

Left to right, top to bottom:

Gilles and Cootscho Embracing, 1992
Cookie with Me After 7, 1986
Cookie at Tin Pan Alley, 1983
French Chris on the Convertible, 1979
Brian on the Phone, 1981

David Wojnarowicz at Home, 1990
Whitney Museum of American Art, New York; Purchase, with funds from the Mrs. Percy Uris Bequest, the Painting and Sculpture Committee, and the Photography Committee 92.127a–b

community, the *Ballad* remains one of the most potent and poignant documents of the era (figs. 483–88). The expressionist, diaristic, and confessional approach of both Goldin and Mapplethorpe increasingly resonated throughout photography as the eighties progressed (figs. 489–91).

The New Wave bohemian world was largely nocturnal and cultish. As the critic Edit deAk said, "We are the ultra/meta/post/anti/para/sub/urban-aughts."[141] Late-night club life became an important catalyst in a community that included artists, writers, musicians, performers, and filmmakers. Clubs like Limbo Lounge, Club 57, Pyramid Club, 8BC, the Mudd Club, and Irving Plaza (figs. 494–96) were forums for new art, music, fashion, and underground film and video by artists such as Lawrence Weiner, Michael Oblowitz, Dara Birnbaum, and Chris Burden. Jean-Michel Basquiat's band played at the Mudd Club and CBGB. In fact, many other artists—Robert Longo, Richard Prince, David Wojnarowicz, for example—were in bands, for "garage" bands flourished in art schools of the period. Club 57, in the basement of the Holy Cross Polish National Church on St. Mark's Place, featured theme nights that took a satirical look at nostalgic or popular subjects—Bongo Beat Night, Rockabilly Truckers, Las Vegas Lounge, 007, Monster Movie Club, Love-In, and Ammo (fig. 495). This club, whose playful parody and humor embraced John Waters' offbeat cult films and the B-52's upbeat dance music, launched several careers, notably those of artists Keith Haring and Kenny Scharf and the comedienne Ann Magnuson, who was soon destined for Hollywood (fig. 496). The spectacle of club life encouraged an entrepreneurial spirit that included the mounting of exhibitions and promotion of careers; ultimately, some acts were taken to a mainstream audience.

489. **Mark Morrisroe**
Untitled (Self-Portrait Standing in the Shower), 1981
Silver dye bleach print (Cibachrome), 20 x 16 in. (50.8 x 40.6 cm)
Whitney Museum of American Art, New York; Purchase, with funds from the Photography Committee 94.83

490. **Peter Hujar**
Dead Dog, Newark, 1985
Gelatin silver print, 14½ x 14½ in. (36.8 x 36.8 cm)
The Estate of Peter Hujar; courtesy James Danziger Gallery, New York

491. Larry Clark
Untitled, from the portfolio
Tulsa, 1972
Gelatin silver print,
8⁷⁄₁₆ x 5¾ in. (21.4 x 14.6 cm)
Whitney Museum of American
Art, New York; Purchase, with
funds from the Photography
Committee 92.111.3

492. David Wojnarowicz
Seven Miles a Second, 1987
Mixed media on paper, 44 x
34 in. (111.7 x 86.4 cm)
Courtesy Estate of David
Wojnarowicz and P.P.O.W.,
New York

493. Dara Birnbaum
*Technology/Transformation:
Wonder Woman*, 1978–79
Videotape, color, sound;
5½ min.
Electronic Arts Intermix,
New York

494. *Wendy Wild at Irving Plaza, New York*, 1981, photograph by Andé Whyland

495. *"Ammo" at Club 57, New York*, 1981, photograph by Andé Whyland

496. *Ann Magnuson as "Lena Haagen-Dazsovich" at Club 57, New York*, 1981, photograph by Andé Whyland

DECLARATION OF INDEPENDENTS: ANOTHER DOOR TO CINEMA

While Hollywood refined the process of creating blockbusters by committee, independent filmmakers—typically women, minorities, disgruntled actors, or a combination thereof—made movies on a shoestring about those ignored by majority culture.

497. *The Brother from Another Planet*, 1984, directed by John Sayles

Ida Lupino, the English-born thespian who specialized in American dames, is the godmother of independent filmmakers. Marginalized women were her beat. *Not Wanted* (1949) deals with unwed motherhood, *The Outrage* (1950) with rape, and *Never Fear* (1950) with a ballerina who discovers she has polio. Best was *Hard, Fast, and Beautiful* (1951), about a tennis star whose mother lives vicariously through her achievements.

If in Hollywood the redeemed hero was king, then in Sam Fuller's films, the irredeemable ruled. Consider *China Gate* (1957), where soldiers of fortune attack a Communist outpost for mercenary rather than ideological reasons; or *Underworld U.S.A.* (1961), where an innocent man becomes a rodent in order to kill the mob's king rat; or *Shock Corridor* (1963), where a crusading journalist feigns mental illness in order to investigate an insane asylum and then himself descends into madness.

Hollywood experience taught the actor John Cassavetes that studio movies were sanitized to protect the audience from raw emotion and characters. As a director, he encouraged performers to improvise, using a handheld camera to simulate authentic situations and emotions. In *Shadows* (1960), he explored an interracial romance, in *Husbands* (1970) male menopause, and in *A Woman Under the Influence* (1974) the impact of a wife's mental breakdown on her hard-hat husband.

498. Richard Edson, Eszter Balint, and John Lurie in *Stranger Than Paradise*, 1984, directed by Jim Jarmusch
The Samuel Goldwyn Company

The politically committed novelist John Sayles turned to films with *The Return of the Secaucus Seven* (1980), where he comically confronted lost idealism. In *Matewan* (1987), he mourned the slaughter of unionizers. He explored the crisis of urban America with humor in *The Brother from Another Planet* (fig. 497) and with drama in *City of Hope* (1991).

In the shadows of Hollywood back lots, Charles Burnett made movies about African American life. Films such as *Killer of Sheep* (1977), which looks at life in a ghetto, and *To Sleep with Anger* (1990), about a trickster who deceives an inner-city family, are parables of black experience. Up in San Francisco's Chinatown, the filmmaker Wayne

Artist collectives, though they began in a noncommercial spirit, eventually developed their own special brand of commercialism that dovetailed with the enterprising club scene in the overcharged East Village world. The first commercial gallery to open in the neighborhood in the eighties was Fun Gallery, run by the underground film star Patti Astor. As its name suggests, the atmosphere of the gallery captured the euphoria and exuberance of a new generation of artists. Astor promoted a street sensibility—graffiti, in particular—and sensed the sales potential of this hitherto down-and-out illegal art form. She featured flamboyant, wild-style graffiti artists such as Futura 2000, Daze, Fab 5 Freddy (Fred Brathwaite), Dondi White, Keith Haring, and Jean-Michel Basquiat, all of whom had started out working underground in the subway long before some of them became art world names (figs. 500–06).

Graffiti was linked to hip-hop, break dancing, and rap, all captured in the Colab artist Charlie Ahearn's 1982 film *Wild Style*, in which Astor starred. Some of the graffiti "writers" transferred their "tags," or name brands, onto canvas, while others evolved a

Wang made his breakthrough *Chan Is Missing* (1982), a comic caper that lampooned Asian American stereotypes. Wang's subsequent work includes the studio-produced *The Joy Luck Club* (1993), a tapestry of Chinese American lives adapted from the novel by Amy Tan. With his deadpan characters in deadbeat settings, the director Jim Jarmusch made films that find the humor in people, usually foreigners, who are plucked down in places not mentioned in tourist guides—most notably, *Stranger Than Paradise* (fig. 498), *Mystery Train* (1989), and *Night on Earth* (1991).

While preparing his directorial debut, *Ordinary People*, actor Robert Redford organized workshops at his Sundance ranch in Utah in 1979. Out of these grew the Sundance Institute, which gives fledgling filmmakers, screenwriters, and composers an opportunity to develop projects; so did the affiliated Sundance Film Festival, an annual confab showcasing the work of American independents that defined the emerging generational sensibility in movies such as *sex, lies, and videotape* (1989, Steven Soderbergh), *Slacker* (1991, Richard Linklater), *El Mariachi* (1992, Roberto Rodriguez), and *Clerks* (1994, Kevin Smith).

Allison Anders, the Lupino of the nineties, explored the myriad ways in which gender becomes destiny. In *Gas, Food, Lodging* (1992), about a single mom and her two daughters, mom's anger toward runaway dad plays out in her daughters' attitudes toward men. Set in the Los Angeles Chicano barrio, *Mi Vida Loca* (1994) shows the tribal rites of gang girls. *Grace of My Heart* (1996), which chronicles the pop music scene in the 1950s and 1960s, focuses on an aspiring female singer who instead succeeds as a songwriter. It is a parable of independent filmmaking: if the front door is closed, find a way in through the basement. —C. R.

499. **Ida Applebroog**
Shake, from *Dyspepsia Works*, 1980
Ink and Rhoplex on vellum, 48 x 48 in. (121.9 x 121.9 cm)
Private collection

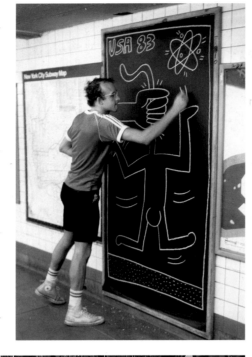

500. *Keith Haring in New York City Subway*, c. 1980–83
© The Estate of Keith Haring

501. **Keith Haring**
Subway Drawing, 51st Street, c. 1980–83
© The Estate of Keith Haring

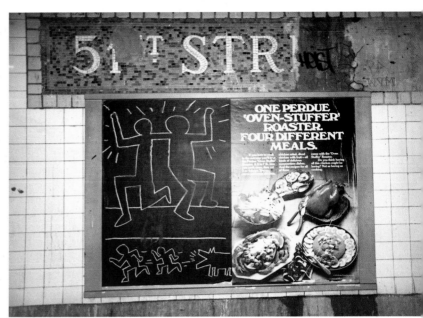

502. **Kenny Scharf**
Black-light Installation at the Whitney Biennial, 1985 (detail)

503. **Jean-Michel Basquiat**
Untitled, 1983
Oil stick and ink on paper, 19½ x 15½ in. (49.5 x 39.4 cm) irregular
Whitney Museum of American Art, New York; Purchase, with funds from Mrs. William A. Marsteller, The Norman and Rosita Winston Foundation, Inc. and the Drawing Committee 91.16

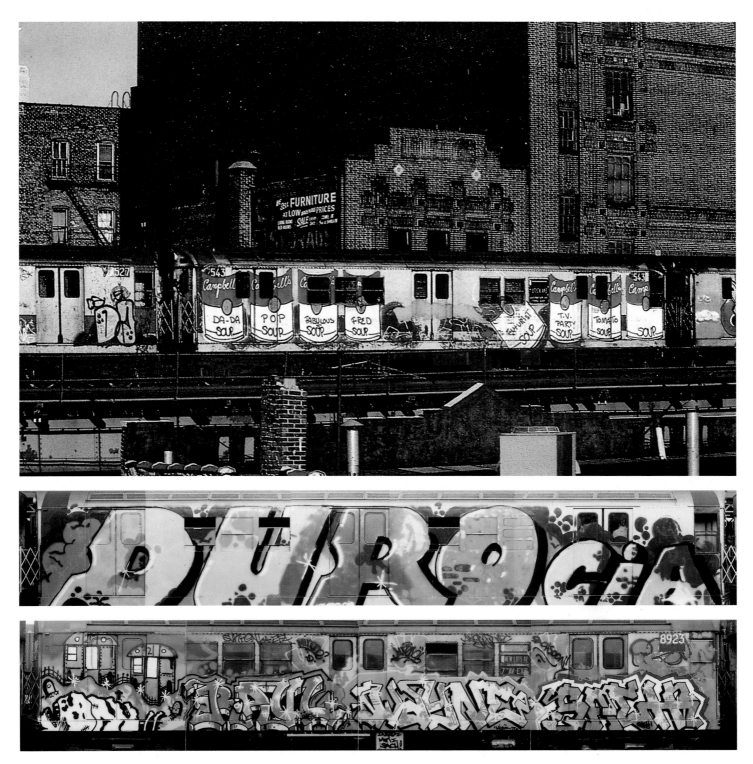

504. **Fab 5 Freddy**
Campbell's Soup Cans,
South Bronx, New York,
1980
Subway graffiti
Photograph by Martha
Cooper

505. **Duro CIA**
Duro CIA, 1980
Subway graffiti
Photograph by Henry
Chalfant

506. **Raul, Wayne, Sach**
Raul, Wayne, Sach, 1982
Subway graffiti
Photograph by Henry
Chalfant

hybrid pictorial language that combined graffiti with Pop, Surrealism, and other high-art styles. Keith Haring used universally legible signs in his simple cartoon-style line drawings, which could be executed quickly on empty advertising placards on the subway platform or on large tarp canvases in the studio. His images ranged from playful barking dogs and cavorting figures to the radiant child (his signature image) and apocalyptic explosions, as well as safe sex and anti-drug messages. Kenny Scharf likewise used a psychedelic cartoon style and Day-Glo palette to execute space-age images on canvas and customize everyday appliances. Jean-Michel Basquiat, who would soon rise to fame and stardom, became a casualty of the age when he died of a drug overdose at age twenty-eight in 1988. Basquiat's street tag was "Samo" with a crown over it. In his canvases, he created a blend of the sophisticated and the primitive rendered in de Kooning-style brushwork that merged images drawn from African culture and American popular culture with scratched-out words and phrases that formed a unique African American poetry (fig. 507).

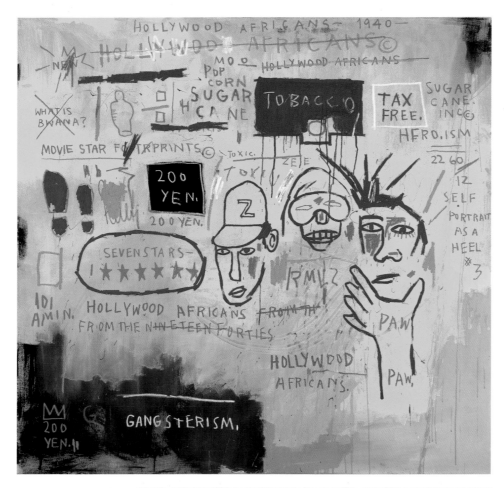

507. **Jean-Michel Basquiat**
Hollywood Africans, 1983
Synthetic polymer and mixed media on canvas, 84 x 84 in. (213.4 x 213.4 cm)
Whitney Museum of American Art, New York; Gift of Douglas S. Cramer 84.23

508. Installation view of the "Famous Show" at the Gracie Mansion Gallery, New York, 1982

Soon other commercial galleries started to open in the East Village. Most of them were owned and operated by artists, and they encompassed a broad aesthetic range—from Civilian Warfare, which featured expressionism and a contemporary junk aesthetic, to Gracie Mansion, who started out by showing intimately scaled art in her bathroom (fig. 508), to Nature Morte, International with Monument, and the Pat Hearn Gallery, all of which favored cool, Neo-Conceptual work. It wasn't long before museums and uptown galleries started to do "East Village Scene" shows and the neighborhood became an exotic location for museum tours and Sunday outings. By 1984, there were almost seventy storefront galleries on the Lower East Side, which together formed an entire "alternative" commercial art community.

Market Power

The 1980s ushered in a growing conservative sentiment in the nation's social and political life. Many Americans had become increasingly disillusioned by the perceived inability of the Carter administration to lead the nation, revitalize the economy, or articulate a compelling vision for the future. In 1980, half the electorate failed to go to the polls, reflecting a general alienation from politics and government. But those who did vote elected Ronald Reagan, a Republican, in a landslide victory (fig. 509). With Reagan's election, however, came the right wing's ascent to power, and for community activists and protest artists, it was a crushing blow. In contrast to Carter, Reagan presented a new and clear conservative vision of America's future—one based on decentralized government, a return to "traditional" values, and an aggressive foreign policy, all of which perfectly suited the New Right, as it came to be called.

A former Hollywood actor, Reagan had campaigned under the slogan "Make America Proud Again," and his administration constantly invoked patriotism, faith in God, and freedom from government interference. As the decade progressed, these credos became weapons for the New Right in its war against liberal politics. Reagan's two-term tenure spurred the growth of right wing, single-issue groups, who had had enough of the radicalism and liberalism of the sixties and seventies, which they held responsible for the sexual revolution, Vietnam war protests, and the breakdown of the nuclear family. They galvanized their forces to defeat the Equal Rights Amendment in 1982 and wage strident campaigns against homosexuality and abortion.

509. *President Ronald Reagan and First Lady Nancy Reagan at the White House*, 1980s

Reagan wasted no time in shrinking the federal government, cutting taxes, and dismantling many of the social programs of the previous two decades. For the unskilled, the unemployed, or those dependent on government assistance, it was a bleak period. But Reagan's policies were good for American business. The tax cuts, combined with substantial increases in military spending, helped promote one of the largest economic expansions and stock market booms the country had ever seen. Those at the upper economic levels of society spent lavishly and enjoyed a high standard of living.

The booming economy had a trickle-down effect on the art world, which also prospered. With the rise of the New Right and the market boom came a resurgence of traditional forms of art: painting and sculpture that could be collected. The spectacular ascent of the young painter Julian Schnabel is emblematic of the mood that was sweeping the country. Schnabel, who had come from Brooklyn via Brownsville, Texas, burst upon the art scene in 1980 like a "bull in the china shop," said *Newsweek*—an allusion both to his aggressive self-confidence and the broken plates he painted on.[142] He soon teamed up with the young art dealer Mary Boone, whose unbridled ambition and energy matched Schnabel's boldness and brazen self-promotion. The two persuaded Leo Castelli to get on board, and so the venerable dealer took on his first new artist in over a decade. The prices for Schnabel's work quickly escalated.

Schnabel's paintings on broken crockery caused a sensation when they were shown (fig. 510). They made many critics apoplectic but reinforced the belief that painting could be lifted out of its supposed doldrums, even if through a combination of daring and arrogance. The fractured, dimensional surface of the works, which had precedents in 1970s Pattern painting, literally broke the flatness of the

picture plane. Freely mixing figurative and abstract idioms, Schnabel went on to paint on velvet, linoleum, and theater backdrops, creating lush, decorative painting on an operatic scale and full of historical allusions. Schnabel invoked grand themes through his titles and made portraits of or dedicated works to a host of cultural, religious, and historical figures—among them Saint Ignatius Loyola, Saint Francis, Pope Pius IX, Malcolm Lowry, Antonin Artaud, and Maria Callas; to this pantheon, he also added family and friends.

510. **Julian Schnabel**
The Patients and the Doctors, 1978
Oil, plates, and glue on wood, 96 x 108 x 12 in. (244 x 274 x 30.5 cm)
Private collection

Schnabel's intense, large-scale works spoke for a renewed belief in the power and possibility of painting. In this sense, they recalled the expansive confidence and heroics of Abstract Expressionism. Another brand of nostalgia also pervades Schnabel's art: with its pastiche of historical quotations from earlier masterworks and literary texts (any subject or image was fair game) and mix of high and low culture (fig. 511), it presented a postmodernist affection for appropriating older styles, as in the Chippendale-style top that caps Philip Johnson's 1984 AT&T Building in New York.

In the late seventies, Schnabel's bold and dramatic style was also stimulated by his recognition of certain postwar European artists. Sigmar Polke, Anselm Kiefer, Jannis Kounellis, and Joseph Beuys, who had been at work since the sixties, were practically unknown in America at the time, having been overshadowed by the American avant-garde. They were all process-oriented and used unconventional materials (straw, tar, fat, felt, and minerals) in daring and expressive painting and sculpture. Some, like Polke, had pioneered the incompatible conjunctions of styles and superimpositions of images as a standard operating procedure, breaking with the imperative of stylistic consistency. Other Americans besides Schnabel started taking note of this important European art, prompted by, among other things, the memorable Beuys retrospective at the Guggenheim Museum in 1979.

In fact, the 1980s witnessed an influx of art from Europe, as Americans discovered that vanguard art was no longer an exclusively American affair. European imports had begun in the 1960s, with the Nouveaux Réalistes, for example, mostly to complement American developments. But this art was never understood in its own context. In the eighties, however, exhibitions and sales of Arte Povera works, those by Beuys, and younger Neo-Expressionist German painters and British sculptors, along with work by the new Italian painters known as Transavanguardia, brought European art to the forefront of American consciousness for the first time since World War II.

This new internationalism was signaled by a number of exhibitions in the early eighties that also focused on the revival of painting: "A New Spirit of Painting" at the Royal Academy of Arts, London (1981); "Zeitgeist" at the Martin-Gropius-Bau, Berlin (1982); and "The New Art" at the Tate Gallery, London (1983). These were just some of the shows that spotlighted young painters such as Schnabel, along with several of his American peers, among them David Salle, Eric Fischl, Susan Rothenberg, Jean-Michel Basquiat, and Robert Longo—alongside the European painters Sigmar Polke, Georg Baselitz, Francesco Clemente, Anselm Kiefer, Markus Lüpertz, Jörg Immendorff, Gerhard Richter, and A. R. Penck. The work of this group was often characterized as Neo-Expressionist, though like all appellations, the label never adequately described the art or the artists' intentions. Nevertheless, these artists did have certain characteristics in common: they embraced expression and sentiment to create an art of excess, one that was emotionally and physically charged.

511. **Julian Schnabel**
Exile, 1980
Oil and antlers on wood,
90 x 120 in. (228.6 x 304.8 cm)
Collection of Mrs. Barbara Schwartz

Eric Fischl almost single-handedly infused life into narrative figuration with his genre paintings that revealed the psychosexual underside of the suburban American soul (figs. 514, 515). Susan Rothenberg, who had introduced figurative imagery in the 1970s in her horse paintings (fig. 429), continued in the next decade to explore abstract gesture and mark making around allusive figurative content. She was soon annexed to the Neo-Expressionist movement—and remained one of its few women. Robert Longo presented a rock 'n' roll, cinematic vision of corporate culture through images of ambivalent and alienated desires in his Men in the Cities series (fig. 513). In these monumental, larger-than-life works on paper, conceived by Longo but executed by a commercial illustrator, men and women dressed for success strike poses that alternately suggest pleasure or pain. Leon Golub weighed in with the strongest paintings of his career. His Mercenary series—paintings featuring men committing acts of brutality and aggression against other men—won him international recognition for the first time (fig. 512).

David Salle, a thoughtful provocateur, created paintings with a new kind of space inspired by film montage (figs. 516, 517). For many observers, these works, with their disjunctive spaces, stylistic variety, and unexpected combinations of imagery, came to epitomize postmodern painting. Salle pilfered fragments of images from numerous sources, from art and design to pornography, and then combined and layered them in moody, introverted paintings. The vibration of quotations and styles produced a visual buzz, even though the expression was emotionally neutral. Rather than presenting an image of reality, he was presenting the equivocal reality of images.

Some questioned Salle's right to use these scavenged images. The cartoonists Mike Cockrill and Judge Hughes brought suit against Salle for copyright infringement

512. **Leon Golub**
White Squad I, 1982
Synthetic polymer on
canvas, 120 x 184 in.
(304.8 x 467.4 cm)
Whitney Museum of
American Art, New York;
Gift of The Eli Broad
Family Foundation and
purchase, with funds from
the Painting and
Sculpture Committee
94.67

513. **Robert Longo**
Untitled, 1981
Charcoal, graphite,
silkscreen, ink, and tem-
pera on paper, 60 x 96 in.
(152.4 x 243.8 cm)
Collection of B.Z./Michael
Schwartz

514. **Eric Fischl**
Sleepwalker, 1979
Oil on canvas, 72 x 108 in.
(182.9 x 274.3 cm)
Private collection

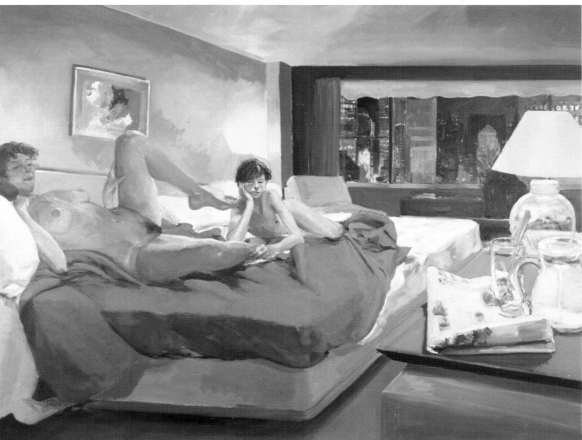

515. **Eric Fischl**
Birthday Boy, 1983
Oil on canvas, 84 x 108 in.
(213.3 x 274.3 cm)
Collection of Achille and
Ida Maramotti

516. **David Salle**
What is the Reason for Your Visit to Germany, 1984
Acrylic and oil on canvas with lead on wood,
96 x 191½ in.
(243.8 x 486.4 cm)
Ludwig Forum für Internationale Kunst, Germany
© David Salle/Licensed by VAGA, New York, NY

517. **David Salle**
B.A.M.F.V., 1983
Oil on canvas and satin with cement elements,
101 x 145 in.
(256.5 x 368.3 cm)
Collection of Barbara Schwartz
© David Salle/Licensed by VAGA, New York, NY

for using one of their drawings of Lee Harvey Oswald in the painting *What Is the Reason for Your Visit to Germany?* (fig. 516). The suit was ultimately settled out of court, but the issue of copyright came to the fore in the eighties, as appropriation became a central art strategy. In their use of "borrowed" images, Salle, Richard Prince, and Jeff Koons, among others, tested the legal bounds of ownership, public domain, and "fair use."

Other artists subjected found or cannibalized imagery to a greater degree of transformation. Jasper Johns, who had long employed quotation in his works, began to incorporate painted images of his own earlier pictures as well as works by Barnett Newman, photographs of his dealer Leo Castelli, and more cryptic details from masterworks such as Matthias Grünewald's sixteenth-century

Isenheim Altarpiece (fig. 518). Andy Warhol continued his practice of using found images, but during the eighties made abstract works from silkscreens of camouflage patterns and Rorschach blots (fig. 519).

Ross Bleckner explored seductive optical effects in sensual painted versions of degraded Op art (fig. 520), a short-lived movement of the sixties based on the optical effects of color and pattern conjunctions. Bleckner's 1981 exhibition of optical abstractions proved influential on younger artists, including Philip Taaffe and Peter Halley. Bleckner also simultaneously created very moody, romantic pictures that were memorials to friends lost to AIDS (fig. 521). Like the German artist Gerhard Richter, he maintained two contradictory painting styles. Taaffe mixed invented forms with forms borrowed from Ellsworth Kelly, the Op artist Bridget Riley, and Myron Stout in exquisitely seductive, collaged canvases (fig. 522). Lari Pittman used decals, stencils, and signs in his distinctive amalgamations, pushing the limits of "good" taste—while redeeming debased, vulgar, and discredited images (fig. 527).

The idea that one could construct an abstract painting from found images, as Salle, Bleckner, Taaffe, and Pittman did, preoccupied many painters during the 1980s. Carroll Dunham gleaned images from the wood grain of his plywood supports, while Terry Winters started out with scientific diagrams, architectural models, and organic forms (figs. 528, 529). Christopher Wool used commercially available stencils and wallpaper rollers in his all-over abstract patterned works (fig. 532). The collective belief of these artists in the continued viability of abstract painting was bolstered by the fresh work being produced by older artists, from the ecstatic curvilinear traceries of Willem de Kooning and Brice Marden (figs. 524, 526) to the pattern appropriations of Andy Warhol. Sculptors, too, explored new forms of abstraction using found images or objects. Martin Puryear's and Robert Therrien's sensual, Minimalist sculptures, which frequently allude to landscapes as well as to furniture, tools, and other man-made objects (fig. 530), John Newman's sci-fi hybrids of natural and machine forms, and Mel Kendrick's carved wood totems all attest to a renewed vitalism in eighties sculpture.

518. **Jasper Johns**
Racing Thoughts, 1983
Encaustic and collage on
canvas, 48 x 75⅛ in.
(121.9 x 190.8 cm)
Whitney Museum of
American Art, New York;
Purchase, with funds from
the Burroughs Wellcome
Purchase Fund; Leo
Castelli; the Wilfred P. and
Rose J. Cohen Purchase
Fund; the Julia B. Engel
Purchase Fund; the
Equitable Life Assurance
Society of the United
States Purchase Fund;
The Sondra and Charles
Gilman, Jr. Foundation,
Inc.; S. Sidney Kahn;
The Lauder Foundation,
Leonard and Evelyn
Lauder Fund; The Sara
Roby Foundation; and the
Painting and Sculpture
Committee 84.6
© Jasper Johns/Licensed
by VAGA, New York, NY

521. **Ross Bleckner**
The Gate, 1985
Oil on linen, 48 x 40 in.
(121.9 x 101.6 cm)
Collection of B.Z./Michael
Schwartz

519. **Andy Warhol**
Rorschach, 1984
Synthetic polymer paint on
canvas, 120 x 96 in.
(304.8 x 243.8 cm)
Estate of Andy Warhol

520. **Ross Bleckner**
The Arrangement of Things,
1982 and 1985
Oil on canvas, 96 x 162 in.
(243.8 x 411.5 cm)
Museum of Fine Arts,
Boston; M. Theresa B.
Hopkins Fund

522. **Philip Taaffe**
Passionale Per Circulum Anni, 1993–94
Mixed media on canvas,
137¼ x 116 in.
(348.6 x 294.6 cm)
Whitney Museum of
American Art, New York;
Purchase, with funds
from the Painting and
Sculpture Committee and
the Ruth and Seymour M.
Klein Foundation, with
additional funding from
Sandra and Gerald
Fineberg, and Linda and
Harry Macklowe 94.68

523. **Peter Halley**
*Two Cells with Circulating
Conduit*, 1985
Day-Glo acrylic, acrylic,
and Roll-A-Tex on canvas,
63 x 109 in.
(160 x 276.9 cm)
Collection of Michael H.
Schwartz

524. **Willem de Kooning**
Untitled VII, 1983
Oil on canvas, 80 x 70 in.
(203.2 x 177.8 cm)
Whitney Museum of
American Art, New York;
Partial and promised gift of
Robert W. Wilson P.4.84

525. **Richard Diebenkorn**
Ocean Park #125, 1980
Oil on canvas, 100 x
81 in. (254 x 205.7 cm)
Whitney Museum of
American Art, New York;
Purchase, with funds from
the Charles Simon
Purchase Fund, the
Painting and Sculpture
Committee, and anony-
mous donors, by exchange
80.36

526. **Brice Marden**
4 (Bone), 1987–88
Oil on linen, 84 x 60 in.
(213.3 x 152.4 cm)
Collection of Helen
Marden

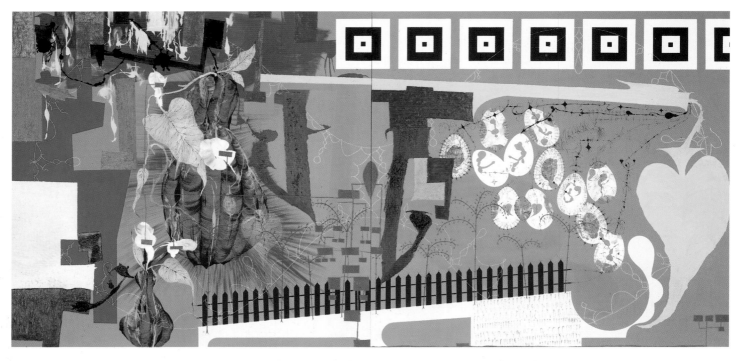

527. **Lari Pittman**
An American Place, 1986
Oil and acrylic on panel,
80 x 164 in.
(203.2 x 416.6 cm)
The Museum of
Contemporary Art, Los
Angeles; The El Paso
Natural Gas Company
Fund for California Art

528. **Carroll Dunham**
Pine Gap, 1985–86
Mixed media on wood
veneer, 77 x 41 in.
(195.6 x 104.1 cm)
Whitney Museum of
American Art, New York;
Purchase, with funds from
The Mnuchin Foundation
86.36

529. **Terry Winters**
Good Government, 1984
Oil on linen, 101¼ x
137¼ in. (257.2 x
348.6 cm)
Whitney Museum of
American Art, New York;
Purchase, with funds from
The Mnuchin Foundation
and the Painting and
Sculpture Committee
85.15

530. **Martin Puryear**
Mus, 1984
Wood and wire mesh,
44 in. (111.8 cm) length,
26 in. (66 cm) diameter
Collection of Marguerite
and Robert K. Hoffman

531. **Allan McCollum**
Installation detail of
Plaster Surrogates,
1982–83, at the Marion
Goodman Gallery, New
York, 1983

532. **Christopher Wool**
Untitled, 1990
Alkyd enamel on
aluminum, 108 x 72 in.
(274.3 x 182.9 cm)
Whitney Museum of
American Art, New York;
Purchase, with funds
from the Painting and
Sculpture Committee
91.2

533. Jeff Koons
One Ball Total Equilibrium Tank, from *Spalding Dr. J. Silver Series*, 1985
Glass, steel, sodium chloride reagent, distilled water, and basketball,
64¼ x 30¾ x 13¼ in.
(164.5 x 78.1 x 33.7 cm)
Dakis Joannou Collection, Athens

534. Jeff Koons
Rabbit, 1986
Stainless steel, 41 x 19 x 12 in. (104.1 x 48.2 x 30.5 cm)
The Eli and Edythe L. Broad Collection

Other artists made abstract objects that functioned as cultural signs. Peter Halley's simple geometric vocabulary of squares and rectangles stands for cells and conduits and suggests an architecture of circuitry for a new technological world (fig. 523). Allan McCollum's *Surrogates*, begun in 1981, were handmade Hydrocal objects made to look like small Minimalist paintings—black fields, surrounded by white mats, bordered by black frames (fig. 531). Though made by hand, they recalled mass-produced objects, and McCollum in fact turned them out by the hundreds, typically installing these *Surrogates* in big groupings of twenty to forty units. This abstraction about art as commodity had its roots in Pop and Conceptual art and is not far removed from Richard Artschwager's earlier simulations of abstract paintings, where synthetic Formica wood grain stands for a picture of wood (fig. 296).

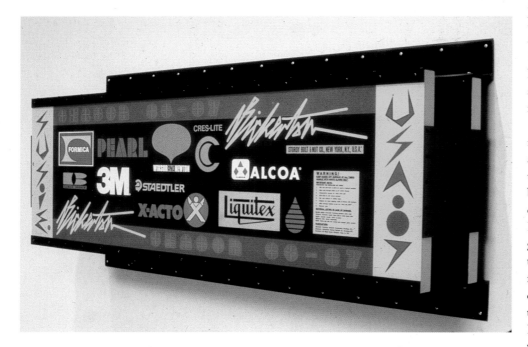

535. **Ashley Bickerton**
Le Art (Composition with Logos, #2), 1987
Mixed media, 34½ x 72 x 15 in. (87.6 x 182.3 x 38.1 cm)
Private collection; courtesy Sonnabend Gallery, New York

The quiet morbidity and surreal nature of these objects was taken to a hyperreal level by Jeff Koons, who used actual consumer goods as symbolic surrogates for the idea of art as commodity and the self as product. His vacuum cleaner encased in plexiglass, basketballs floating in fish tanks, or a stainless steel bunny cast from an inflatable toy are pristine objects, with the life squeezed out of them (figs. 533, 534). Koons, like the Pop artists, took consumer goods and transformed them through alterations in scale and material. By making them dysfunctional, he turned them into metaphoric artifacts. His brilliant series of sculptures engaged a wide range of consumer habits—from liquor consumption and pornography to sports and entertainment. The self-conscious awareness of the art object as commodity can also be seen in Ashley Bickerton's *Le Art*—a crafted, machinelike form covered in logos like a customized race car; the inclusion of the artist's signature in two highly visible places suggests a surrogate self-portrait (fig. 535).

These were the years when art became a big business. In 1980, a new price level was reached for the work of a living artist when Jasper Johns' *Three Flags* was sold to the Whitney Museum for $1 million. The financial stakes were suddenly raised, and artists began to take an active interest in the marketing of their works. No longer did artists think, as many had in the seventies, that selling was somehow equated with selling out. In fact, artists in the eighties often had waiting lists for work not yet made. Everyone was profiting from a booming economy. Dealers and collectors controlled market value. Critics were hired to write essays for catalogs underwritten by galleries; art advisers took the uninitiated by the hand and showed them what to buy and what works were likely to appreciate (taking a cut of the purchase price in the process); and curators and critics went free-lance, organizing shows for whomever would foot the bill.

A new generation of collectors also emerged, one that identified with the bold moves of the new artists. Charles Saatchi, Eli Broad, and Douglas Cramer established their own private museums to house their collections. Meanwhile, public

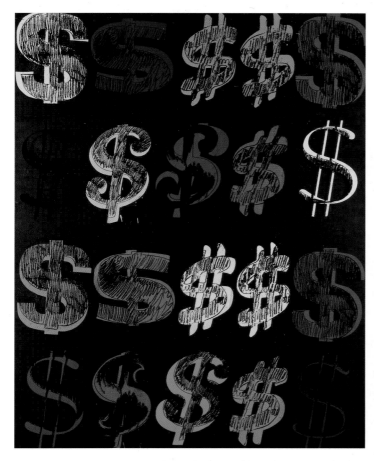

536. **Andy Warhol**
Dollar Signs, 1981
Synthetic polymer paint
and silkscreen ink on can-
vas, 90 x 70 in. (228.6 x
177.8 cm)

538. *Keith Haring, Andy
Warhol, and Jean-Michel
Basquiat at the Whitney
Biennial*, 1985, photo-
graph by Paula Court

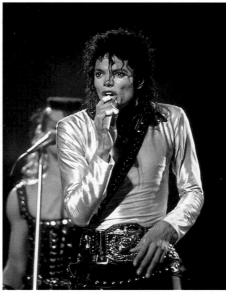

537. *Michael Jackson,
"Bad" Tour*, 1989

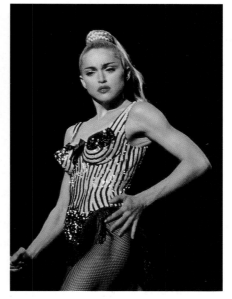

539. *Madonna, "Blonde
Ambition" Tour*, 1990

museums were expanding at a frantic pace, with new buildings and wings for contemporary art breaking ground across the country. Art was not only fashionable and profitable, it was also considered a tangible commodity, and many banks started accepting art as collateral against loans. Art was fetching staggering prices; the bidding at auctions was frenzied and intoxicating. By the end of the decade, de Kooning's *Interchange* (1955) broke another record for a living artist, selling at auction to a private collector for $20.7 million in 1989.

The "big boys"—the Neo-Expressionist painters—got the most ink during the 1980s and soon became "art stars." They interacted with other celebrities and business tycoons, moving effortlessly between the world of art and the world of power, commerce, and fame. This Hollywoodization of the art world had been initiated by Andy Warhol, whose entrepreneurship and star-making abilities now enchanted a new generation of self-made stars. The monarch of the scene, Warhol fraternized with the younger artists, including Haring, Basquiat (with whom he collaborated), and Schnabel, to whom he was a role model and father figure (fig. 538).

THE NEW HOLLYWOOD: RISKY BUSINESS

In 1980, Ronald Reagan was elected president and *The Empire Strikes Back* (Irvin Kershner), the triumph of an authoritarian evil force over altruistic do-gooders, was the year's top-grossing film. The two events inaugurated an era of corporate and cultural raiders.

The following year witnessed the launch of the television show *Entertainment Tonight*, which promoted the logic that if a film made a lot of money, it must be good. Soon afterward came MTV, which purveyed videos of popular songs. MTV's lightning-paced edits, eroticized imagery, and fractured narratives influenced films such as *Flashdance* (1983, Adrian Lyne) and *Top Gun* (1986, Tony Scott).

In a nation long polarized by Vietnam, Watergate, and what to do about double-digit inflation, political and social consensus was elusive. The only thing most Hollywood films of the eighties could agree on was that, in the words of the Michael Douglas character in *Wall Street* (1987, Oliver Stone), "greed is good."

Movies about money made money. *Risky Business* (1983, Paul Brickman) introduced Tom Cruise as a teenage entrepreneur who makes a pile as a pimp. *Wall Street* profiled the rise and fall of a snaky moneyman (Michael Douglas) who preaches the gospel of greed and finds a young disciple (Charlie Sheen). Whereas seventies movies were about the corruption of youth by elders, in eighties movies youth could hardly wait to sell out. *The Big Chill* (1983, Lawrence Kasdan) celebrated the reunion of 1960s idealists turned 1980s capitalists.

540. Henry Thomas in *E.T.: The Extra-Terrestrial*, directed by Steven Spielberg, 1982 Universal Pictures

Two action-adventure series, the Indiana Jones and Rambo cycles, introduced invincible heroes, embodied by, respectively, a bullwhip-cracking Harrison Ford and an Uzi-toting Sylvester Stallone, who arrived as if immunized from the self-doubt of the preceding decade. Although the Indiana Jones movies that began with *Raiders of the Lost Ark* (1981, Steven Spielberg, produced by George Lucas) are set on the eve of World War II and the Rambo pictures that began with *First Blood* (1982, Ted Kotcheff) are set after Vietnam, both purveyed the spectacle of war for a nation fighting the last battles of the Cold War.

Next to these fantasy heroes were reality heroines. There was Sissy Spacek as the country canary Loretta Lynn in *Coal Miner's Daughter* (1980, Michael Apted), Jessica Lange as Patsy Cline in *Sweet Dreams* (1985, Karel Reisz), Sigourney Weaver as the primatologist Dian Fossey in *Gorillas in the Mist* (1988, Michael Apted), and Meryl Streep as the nuclear whistle-blower Karen Silkwood in *Silkwood* (1983, Mike Nichols) and as the storyteller Isak Dinesen in *Out of Africa* (1985, Sydney Pollack). Weaver in *Aliens* (1986, James Cameron) and Linda Hamilton in *The Terminator* (1984, James

541. **Nam June Paik**
Fin de Siècle II, 1989
201 television sets and
four laser discs, 480 x
168 x 60 in. (1219.2 x
426.7 x 152.5 cm) overall
Whitney Museum of
American Art, New York;
Gift of Laila and Thurston
Twigg-Smith 93.139

Money spelled success for much of the "greed decade." It was the era of block-buster movies (*Jaws* had initiated the trend in 1975, but later action adventure movies such as *Raiders of the Lost Ark* [1981] took the phenomenon to a new high), and blockbuster art shows, beginning with "Treasures of Tutankhamen" at the Metropolitan Museum of Art in 1978. Drawing more than a million visitors, the exhibition was a portent of things to come and established new expectations for the gate. "What is loved is a hit. What is a hit is loved," said the writer George Trow.[143]

Michael Jackson's album *Thriller* topped the charts in 1983, and "Material Girl" Madonna emerged as a major pop star in 1984. The mistress of manufactured images for the camera, she created shifting personas to reflect ever-changing desires (fig. 539). Given the growing love affair between the entertainment industry and the art world, it comes as no surprise that several painters of the eighties, including Salle, Schnabel, and Longo, went on to direct Hollywood movies in the nineties.

Cameron)—both produced by Gale Anne Hurd—flexed their muscles in primal films about a woman fighting to rescue her surrogate or biological child. At the same time, the Terminator himself, a cyborg killer portrayed by Arnold Schwarzenegger, embodied the era's obsession with machismo, muscles, and machines.

The antidote to these high-testosterone and high-estrogen affairs was a trio of gender-bending comedies in which women pose as men to enjoy male prerogatives and vice versa. The fun of *Tootsie* (1982, Sydney Pollack), *Victor/Victoria* (1982, Blake Edwards), and *Yentl* (1983, Barbra Streisand) was in watching Dustin Hoffman, Julie Andrews, and Streisand explore how the other gender lived.

The defining film of the decade, *E.T.: The Extra-Terrestrial* (fig. 540), was virtually alone in suggesting that something besides money and success could fill the emotional void. Spielberg's inspirational movie about suburban kids adrift after the divorce of their parents has a wizened creature from another planet unify a broken family, involving its members in something larger than themselves. The film, which capitalized on marketing strategies such as product placement and merchandise tie-ins, was a spectacular commercial success and pop-cultural phenomenon. Many studios, misidentifying *E.T.*'s market as primarily young and male, started cranking out movies targeted at young boys. Only *E.T.*, however, whose audience was actually quite diverse, had widespread appeal.

Before the 1960s, movies were marketed to the broadest possible audience. By the 1980s, it was the rare film—for example, *The Untouchables* (1987, Brian De Palma), a romanticized account of how the federal agent Eliot Ness (Kevin Costner) cleaned up mobsters such as Al Capone (Robert De Niro) in Prohibition-era Chicago—that had wide appeal. Studio marketing departments had perfected the divide-and-conquer art of narrowcasting a movie to a target group. A film such as *The Color Purple* (1985, Steven Spielberg), tracing forty years in the life of a Southern black woman (Whoopi Goldberg), was pitched to African Americans. Comedies such as *Fast Times at Ridgemont High* (1982, Amy Heckerling), *Desperately Seeking Susan* (1985, Susan Seidelman), which featured the pop singer Madonna, and the John Hughes cycle starring Molly Ringwald—*Sixteen Candles*, *The Breakfast Club*, and *Pretty in Pink*—all zeroed in on the teenage market. *Platoon* (1986, Oliver Stone), a grunt's-eye view of Vietnam, was pitched to young and middle-aged males. In slicing up the audience, marketers reinforced the divisions in the American pie.

In 1989, George Bush was inaugurated president and *Batman* (Tim Burton), about the conflicted triumph of a plutocrat vigilante do-gooder (Michael Keaton) over the forces of anti-establishment evil (Jack Nicholson), was the year's top-grossing film. So blurred were distinctions between good and evil that it was increasingly hard to tell the heroes from the villains. —C. R.

The Culture Wars

The economic prosperity of the Reagan years gave the Republicans broad support among the electorate. When Reagan's term ended in 1988, George Bush, his vice president, was elected president in a landslide victory, in which the Republicans swept forty states. But the boom economy did not last. The first signs of weakness had appeared already toward the end of Reagan's second term. On October 19, 1987 ("Black Monday"), the stock market took a nosedive, dropping 22.6 percent in a single day. Although the market eventually recovered, a warning had been raised about the soundness of the American economy. Within three years, rising interest rates, which made it more expensive to borrow money, began to cripple domestic production and led to the collapse of the real estate market. A general decline in consumer spending, combined with the high interest rates, drove the economy into recession. Within a short time, many things that had come to signify the excesses of American life tumbled with the market: down went extravagant lifestyles, overextended savings and loan institutions, and real estate empires. By the end of the decade, the art market collapsed as well. The 1980s closed with a bad case of burnout and a need to reassess values.

Not everyone, moreover, had enjoyed the privileges of wealth, comfort, and fame during the eighties. Among those who struggled with poverty, homelessness, AIDS, and racism, quiet despair and pent-up resentments turned into rage. The AIDS epidemic, which was identified and named in 1982, most graphically represents the other side of the 1980s.

The art world was ravaged by the AIDS epidemic. Scores of art professionals and artists—including Scott Burton, Keith Haring, and David Wojnarowicz—perished. During most of the Reagan years, right-wing groups blamed AIDS on immoral sexual behavior or drug addiction, and the government was slow to initiate research, treatment, and education programs. Gay activist groups such as ACT UP and Gran Fury raised increasingly strong voices of protest. The art world, united for the first time, helped raise millions of dollars for AIDS research (Art Against Aids), provided artists estate planning (Visual Aids), and produced art in direct response to the crisis. The art of David Wojnarowicz, who died in 1992, was

542. **Robert Mapplethorpe**
Self-Portrait, 1988
Gelatin silver print, 24 x
20 in. (61 x 50.8 cm)
The Chase Manhattan
Bank, New York
© The Estate of Robert
Mapplethorpe

Sometimes I come to hate people because they can't see where I am. I've gone empty, completely empty and all they see is the visual form; my arms and legs, my face, my height and posture, the sounds that come from my throat. But I'm fucking empty. The person I was just one year ago no longer exists; drifts spinning slowly into the ether somewhere way back there. I'm a xerox of my former self. I can't abstract my own dying any longer. I am a stranger to others and to myself and I refuse to pretend that I am familiar or that I have history attached to my heels. I am glass, clear empty glass. I see the world spinning behind and through me. I see the complex ramine erratic effects of gesture made by constant population. I look familiar but I am a complete stranger being mistaken for my former selves. I am a stranger and I am moving. I am moving on two legs soon to be on all fours. I am no longer animal, vegetable, or mineral. I am no longer made of circuits or disks. I am no longer coded and deciphered. I am all emptiness and futility. I am an empty stranger, a carbon copy of my form. I can no longer find what I'm looking for outside of myself. It doesn't exist out there. Maybe it's only in here, inside my head. But my head is glass and my eyes have stopped being cameras, the tape has run out and nobody's words can touch me. No gesture can touch me. I've been dropped into all this from another world and I can't speak your language any longer. See the signs I try to make with my hands and fingers, see the vague movements of my lips among the shadows. It's all blank with a hectic civilization. I am in dark times and only the dim disappearing without a notice. I feel I am glass. Tell me all is well and tell me I am a glass human. I am a glass human disappearing in rain. I am standing among all of you waving my invisible arms and hands. I am shouting my invisible words. I am getting so weary. I am growing tired. I am waving to you from here. I am crawling and looking for the aperture of complete and final emptiness. I am vibrating in isolation among you. I am screaming but it comes out like pieces of clear ice. I am signalling that the volume of all this is too high. I am waving. I am waving my hands. I am disappearing. I am disappearing but not fast enough.

545. David Wojnarowicz
Subspecies Helms Senatorius, 1990
Silver dye bleach print (Cibachrome), 12¼ x 19 in. (31.1 x 48.3 cm)
Courtesy Estate of David Wojnarowicz and P.P.O.W., New York

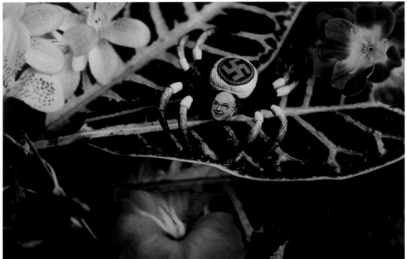

543. David Wojnarowicz
Untitled, 1992
Gelatin silver print with screen print, 38¼ x 25⅞ in. (97.2 x 65.7 cm)
Whitney Museum of American Art, New York; Purchase, with funds from the Sondra and Charles Gilman, Jr. Foundation, the Robert Mapplethorpe Foundation, Inc., and the Richard and Dorothy Rodgers Fund 92.74

544. Gran Fury
Kissing Doesn't Kill: Greed and Indifference Do, 1989
Silkscreen on three panels, 30 x 144 in. (76.2 x 365.8 cm)
Art Against AIDS/On the Road (a project of AmFAR) and Creative Time, Inc., New York

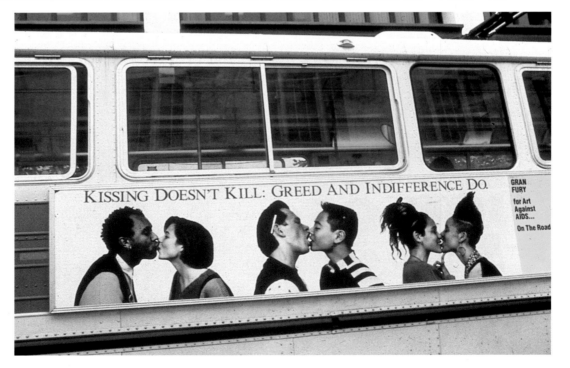

ART ABOUT AIDS

Beginning in the early 1980s, AIDS assaulted the American art world with shocking savagery. Many talented artists were cut off in their prime—or before they had reached it—among them Scott Burton, Arnold Fern, the General Idea members Felix Partz and Jorge Zontal, Felix Gonzalez-Torres, Tony Greene, Keith Haring, Peter Hujar, Adrian Kellard, Robert Mapplethorpe, Nicolas Moufarrege, Rod Rhodes, Hugh Steers, Paul Thek, and David Wojnarowicz. Not surprisingly, many of the most effective and compelling art works of the late eighties and early nineties engage the specter of AIDS—in sorrow, rage, and remembrance.

Art about AIDS arose in vehement response to images of people with AIDS featured on the nightly news and in the morning papers. During the first few years of the epidemic—AIDS was discovered in 1981—the media held a monopoly on representations of AIDS and offered only images of emaciated AIDS "victims" and "disease carriers." The earliest artistic responses to this sort of photojournalism appeared in the work of photographers who tried to create a more balanced picture of people living with, rather than only dying from, AIDS. The best known of these efforts was that of the portraitist Nicholas Nixon, whose serial images of courage and despair in the face of death were shown in 1988 at The Museum of Modern Art in New York.

The first exhibited paintings about AIDS were Ross Bleckner's numerical renderings of the total of HIV-related fatalities. He followed this 1985 show of grim statistics on canvas with seductively beautiful and melancholic images of dimmed lights and funerary urns. Bleckner's mournful images were complemented by the work of dozens of widely shown artists who explored the entire gamut of emotional responses to AIDS. Among the best-known works

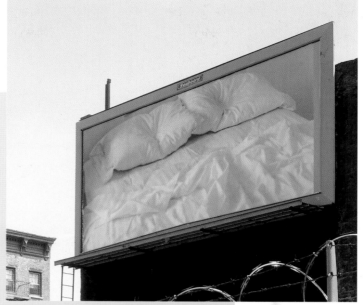

546. **Felix Gonzalez-Torres**
Untitled, 1991
Billboard in New York City, dimensions variable
The Werner and Elaine Dannheisser Collection, on long-term loan to The Museum of Modern Art, New York

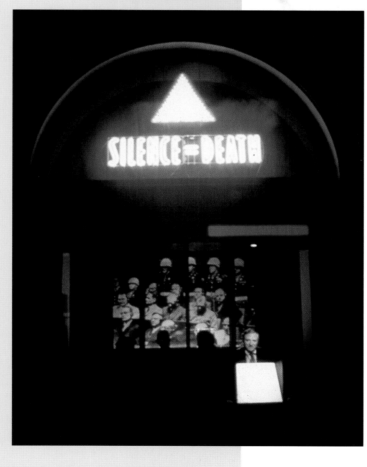

547. **ACT UP (Gran Fury)**
Neon Sign (Silence = Death), 1987
Neon tubes, 48 x 79 in. (121.9 x 200.7 cm)
New Museum of Contemporary Art; Purchase through William Olander Fund

among the strongest of these statements (fig. 543). In image- and text-packed, politically charged paintings and brooding photomontages, he empathized with powerlessness and vulnerability and expressed the antagonism between the organic and the mechanical, man and nature (fig. 492). He frankly depicted and wrote about gay sex, and his anger at being marginalized—or worse, demonized by institutionalized homophobia (fig. 545).

To neoconservatives, the AIDS crisis was a threat to the moral fabric of the nation just as Communism had once been. When the wall dividing the eastern and western sectors of Berlin—and, symbolically, East and West Germany—came down in 1989, it was the beginning of the end of the Cold War and the Communist peril. As America confronted mounting economic problems and social unrest, the reactionary right looked for a new scapegoat—and found it in progressive culture. Within this realm, any art that offended the standards of the moral majority was deemed "pornographic" or "obscene." Pornography and obscenity replaced Communism as the new bogeyman. The era of sexual McCarthyism, which culminated a decade later in President William Clinton's impeachment trials, had begun.

In 1989, a series of vicious attacks was launched against artists, cultural institutions, and the National Endowment for the Arts (NEA), intensifying into a heated public and political debate. Throughout the media, culture was assaulted with a force many never imagined possible. It was shocking and sobering to recognize that basic First Amendment rights to free expression were in fact fragile and required continual defense and vigilance.

are Felix Gonzalez-Torres' conceptual texts and billboards (fig. 546), Keith Haring's ebulliently drawn safer-sex messages, Duane Michals' poetic serial photographs of handsome men enveloped in flowers, Nan Goldin's intimate photo documents of friends stricken with HIV, David Wojnarowicz's painted diatribes against the political system, and Masami Teraoka's images of condom-wielding geishas in the style of Japanese Ukiyo-e prints, to name just a few.

Some of the most influential AIDS art was public art produced by collectives and rarely seen in galleries and museums. Remarkably, the iconic images or symbols of the AIDS epidemic are not made-for-TV movies, photojournalistic pictures, or schmaltzy pop songs, but the NAMES Project Quilt, a community art work, and two logo-emblem images, Silence = Death (fig. 547) and the Red Ribbon (fig. 548), which were conceived by, respectively, the Silence = Death collective (some of whose members became the core of the Gran Fury collective), and the Artists' Caucus of Visual AIDS, the New York organization that in 1989 originated Day Without Art, the annual day of mourning and action in response to the AIDS crisis.

Gran Fury originally operated as the propaganda arm of the activist group ACT UP, exhibiting its work both in the streets and in galleries. The group gave visual form to the shocking statistics emanating daily from the federal Centers for Disease Control with graphic street works that married the methods of art, advertising, and education. One print offered the alarming news that one in sixty-one babies born in New York is HIV–positive and another wittily cajoled men to "Use Condoms or Beat It." The group's famous Benetton ad–inspired image of three interracial, homosexual, and heterosexual couples kissing above the caption "Kissing Doesn't Kill: Greed and Indifference Do" prompted one Chicago alderman to call the print ad "an incitement to homosexuality" when it was exhibited on the sides of buses in that city (fig. 544). Like everything touched by HIV, the art it spawned has been frequently controversial and often politicized. —R. A.

548. **Visual AIDS**
The Red Ribbon, 1991

Warning signs of a conservative cultural backlash had appeared in 1980, when Reagan attempted to abolish the NEA or at least drastically slash its budget. But the public attitude toward government-funded art began to change with the highly publicized controversy that raged around Richard Serra's *Tilted Arc,* a permanent, site-specific sculpture commissioned in 1979 by the General Services Administration (GSA) for 26 Federal Plaza in Lower Manhattan (fig. 549). Though the work was selected by an NEA-appointed panel of experts and exhaustively reviewed by the GSA for two years before its installation in 1981, *Tilted Arc* aroused hostilities immediately after it went up. Many of the federal employees working in and around the building felt that Serra's work—a massive, curving, tilted plane of Cor-ten steel bisecting the outdoor plaza—was ugly, threatening, and mean-spirited, a rusting eyesore that obstructed freedom of movement and open views. They called the 12-foot-high and 120-foot-long arc an "iron curtain" and a "steel wall." Most of the art community, however, praised and passionately defended *Tilted Arc* on aesthetic

549. **Richard Serra**
Tilted Arc, 1981 (no longer exists)
Cor-ten steel, 144 x 1440 x 2½ in. (365.8 x 3657.6 x 6.4 cm)
Installed in Federal Plaza, New York

grounds, pointing out that challenging work often needs time before its artistic language can be appreciated and understood by a broader public.

Unwilling to try and close the gap between the art community and the public, and afraid to be the target of public acrimony, the GSA began to consider "relocating" the work. In 1985, after much petitioning and testimony on both sides in public hearings—presided over by the GSA and therefore hardly impartial—*Tilted Arc*

was ordered removed. Serra argued that because *Tilted Arc* was commissioned as a permanent, site-specific work, its removal would be tantamount to destruction. Divorced from its intended context, the sculpture would lose all integrity as a work of art.

Public opinion and the GSA won out. But the decision to remove *Tilted Arc* set a dangerous precedent for government censorship of art and challenged the legitimacy of the art community's professional standing. It also posed larger questions: How should public money be spent on works of art and who should decide what is best for the "public"—specialists (i.e., art professionals), popular opinion, or government authorities?

There was even some public outcry against Maya Lin's *Vietnam Veterans Memorial* (fig. 550), now the most frequently visited place in Washington, D.C. Influenced by Earthworks and

550. **Maya Lin**
Vietnam Veterans Memorial, Washington, D.C., 1980–82
Granite, 450 ft.
(137.2 m) length

Serra's confrontational site-specific sculptures, *Tilted Arc* in particular, Lin cut a wedge shape into the ground and buttressed it with polished black granite walls. You descend down the wedge to its low point, then up the other side, all the while reading the names of the dead soldiers inscribed on the walls. One of the most powerful public sculptures in America, the memorial is an enveloping tombstone and wailing wall that allows for private mourning in a public space. When it was installed, however, some Vietnam veterans groups objected to the abstraction of its conception. Why, they wondered, could there not be a representation of the heroism of the soldiers? Their lobbying efforts were successful, and a figurative tableau by Frederick Hart now stands in proximity to Lin's work.

The protesting veterans were accustomed to war memorials that showed brave, bronze-cast soldiers. Their objection to Lin's work, therefore, was less about its subject than its nonrepresentational form. *Tilted Arc*, in the meantime, was being denounced not for its abstract conception but for interfering in a public space. Both types of protest—against style and against function—were now joined by an outcry against content, this time from the extreme right. In the spring of 1989, just as *Tilted Arc* was being dismantled, the Reverend Donald Wildmon, an evangelical minister from Mississippi and head of the American Family Association (AFA), had a fateful encounter with a photograph. Wildmon had been noted for his attacks against films, such as *The Last Temptation of Christ*, and television, calling for sponsors of certain objectionable programs to withdraw their funding or face boycotts. In an Awards for the Visual Arts (AVA) exhibition catalog, supported by a grant

from the NEA and the Equitable Life Assurance Society, Wildmon came across *Piss Christ*, a photograph by the Puerto Rican-born artist Andres Serrano that depicted a crucifix submerged in urine (fig. 551). Wildmon saw red, and the witch-hunt was on against Serrano, the NEA, and other "blasphemous" artists and their supporters. "Degenerate," he called them, the very term used by the Nazis in their purge of progressive culture in Germany. Wildmon organized a massive

551. **Andres Serrano**
Piss Christ, 1987
Silver dye bleach print (Cibachrome), silicone, plexiglass, and wood frame, 60 x 40 in. (152.4 x 101.6 cm)
Collection of the artist

letter-writing campaign against Equitable, and after receiving several thousand complaints from policyholders, the company withdrew its decade-long sponsorship of the AVA program. Wildmon also alerted several friends in Congress, notably Senator Jesse Helms, a Republican from North Carolina.

At about the same time, a young African American artist, Dread Scott, came under fire for an installation at the School of The Art Institute of Chicago that forced visitors to walk on the American flag as they entered the work. The State of Illinois cut support to the school, and President George Bush tried, unsuccessfully, to pass a constitutional amendment making flag desecration a federal offense.

The groundswell of hostility to culture was nowhere more evident than in the controversy that surrounded the now notorious exhibition "Robert Mapplethorpe: The Perfect Moment." The show of Mapplethorpe's technically classic but frankly erotic, homosexually oriented photographs (fig. 552) had been organized by the Institute of Contemporary Art at the University of Pennsylvania, Philadelphia, where it opened in December 1988; it then traveled to the Museum of Contemporary Art in Chicago. The next scheduled stop was The Corcoran Gallery of Art in Washington, D.C. But just a few days before the opening, the gallery's director, Christina Orr-Cahall, responding to the mood in Washington, decided to cancel the exhibition. The political firestorm ignited by her action culminated the following year in a showdown in Cincinnati, where museum director Dennis Barrie was indicted for hosting the Mapplethorpe exhibition at the Contemporary Arts Center. Mapplethorpe's work was used by Wildmon, Helms, Senator Alfonse D'Amato of New York, and others to illustrate their charges that decay and depravity permeated culture and that the NEA, in funding such "immoral trash," was flagrantly disregarding public decency.[144] A Wildmon AFA press release on Mapplethorpe offered the following denunciation: "The exhibit of photographs by Mapplethorpe, a homosexual who died of AIDS earlier this year, contains homoerotic photos that are nothing less than taxpayer-funded homosexual pornography."[145]

Wildmon's further attack on Mapplethorpe as a child molester, child pornographer, and sexual deviant was a fabrication that played on the public's fears about homosexuality and the spread of AIDS. A full-fledged sex panic was under way, allowing demagogues to exploit entrenched anxieties about change, difference, and the explicitly sexual.[146] And the panic was part of a larger right-wing attempt to regulate public expression of identity, deny freedom of choice, and diminish challenges to religious and governmental authority. Not surprisingly, it was gay, lesbian, black, and Hispanic artists who became the primary targets in this crusade against culture (fig. 544). The neoconservative position, which blamed the artists for not conforming to majority standards, was perhaps best summarized by Irving Kristol in a *Wall Street Journal* editorial: "What the 'arts community' is engaged in is a politics of radical nihilism. . . . What they do, in fact, is powerfully shaped by certain radical ideological currents; radical feminism, homosexual and lesbian self-celebration and black racism are among them."[147]

552. **Robert Mapplethorpe**
Man in Polyester Suit,
1980
Gelatin silver print, 40 x
30 in. (101.6 x 76.2 cm)
© The Estate of Robert
Mapplethorpe

In July 1989, one month after the Mapplethorpe show was canceled at the Corcoran, Jesse Helms took advantage of a sparsely attended Senate session to sneak through an amendment prohibiting the use of public funds (that is, NEA funds) for works that include "depictions of sadomasochism, homoeroticism, the sexual exploitation of children, or individuals engaged in sex acts and which, when taken as a whole, do not have serious literary, artistic, political, or scientific value." All 1990 NEA grant recipients were then required to sign this anti-obscenity pledge. In July 1990, John Frohnmayer, the head of the NEA, vetoed four grants by the lesbian, gay, and feminist performance artists Karen Finley, Holly Hughes, Tim Miller, and John Fleck for being "too political." The artists filed suit when their appeal was rejected in August. Three years later they settled the suit, winning reinstatement of the grants as well as damages for invasion of privacy and challenging the constitutionality of the "decency" pledge requirement of the NEA's 1990 guidelines.

These controversies weakened the NEA and threatened its credibility and existence. Many critics, like Kristol, argued that the agency should be abolished altogether. Others favored slashing the budget and imposing stricter content limitations on grants or restructuring the NEA and the peer panel review system. Still others wondered whether avant-garde art—which has traditionally assaulted mainstream values—should be funded by a government agency at all.

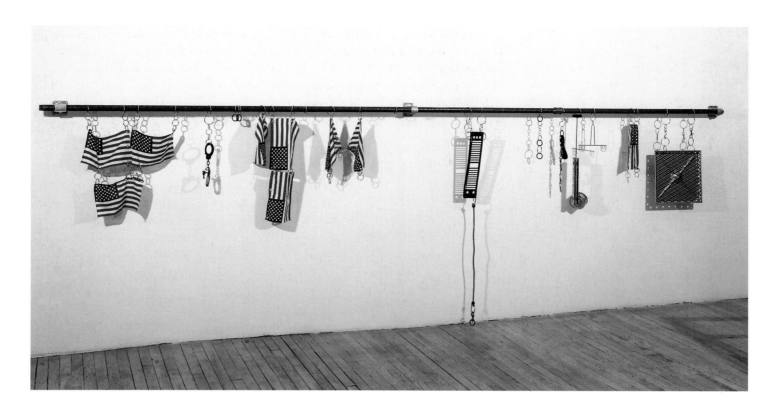

553. **Cady Noland**
The Big Shift, 1989
Pole, fittings, loops, flags,
handcuffs, miscellaneous
metal, bungee cord, key-
holder strap, bug sprayer,
and grill, 57 x 172 x 5 in.
(144.8 x 436.9 x 12.7 cm)
Collection of Jeffrey Deitch

In the fall of 1990, Congress reauthorized the NEA for a three-year term instead of the usual five-year term, but with no restrictions. It was decided that obscenity be determined by the courts and that any grantee convicted of obscenity be required to return the grant money. The NEA is still in existence, but its 1990 budget of $175 million has been cut in half and fellowships to individual artists were eliminated in 1995.

By 1990, vanguard artists found themselves not only embattled by reactionary forces but deprived of support from collectors and museums. The big money from corporate and private patrons that had funded exhibitions and brought prices to a near outrageous level was not available. Perhaps as a backlash against such excesses, many supporters of the arts turned to other causes. Art was no longer fashionable, and many galleries closed, while others retrenched, favoring safe artists with proven track records.

In retrospect, however, these crises served to raise important issues: Who decides what is art? What constitutes censorship? Throughout history, definitions of indecency and obscenity have shifted with the prevailing winds. In 1882, Walt Whitman's *Leaves of Grass* was banned in Boston; Theodore Dreiser's *An American Tragedy* was declared obscene by a Massachusetts court in 1930; and U.S. courts banned the sale of James Joyce's *Ulysses* until 1933. Two further questions emerged from the turbulence of the eighties: Is "quality" a relative, socially determined word—like "obscenity"? And, finally, how can the gap between art and the public's understanding of it be bridged? As a new global economy began to emerge in the nineties, new audiences for art had a vital interest in these questions.

Approaching
the Millennium
1990–2000

On the eve of the 1990s, dramatic political changes around the globe promised a "new world order." In 1989, thousands of pro-democracy demonstrators occupied Beijing's Tiananmen Square. Though violently suppressed by the Chinese government, this expression of dissent could not be completely silenced, and Beijing began to soften its hard-line rule. In the West, the collapse of the Berlin Wall heralded the end of Soviet domination in Central and Eastern Europe as well as the reunification of Germany. Within a short time, the Soviet Union itself was breaking up into independent, non-Communist states. At the start of the decade, the right-wing dictator Augusto Pinochet stepped down as president of Chile, while the South African parliament abrogated the country's racist apartheid laws. In the Middle East, Palestinians and Israelis were sitting together at the peace table.

The sense of optimism that greeted these auspicious events was not always fulfilled. The end of the Cold War, for example, created a vacuum of authority that unleashed long-repressed nationalist sentiments. Indeed, all over the world ethnic groups began to assert themselves in a drive for self-determination that has come to be identified with the 1990s. Throughout the nations in the former Communist bloc, such groups claimed the right to self-rule and self-expression—even when their populations were spread across established political borders. Serbs, Croats, Albanians, and smaller minorities in Yugoslavia had lived together, as Christians and Muslims, until liberation from the Communist yoke set off deadly internecine violence. Elsewhere, conflicts among different ethnic, religious, and political groups raged unabated in the post-Cold War era. Ethnic hostility erupted into genocide in Rwanda, endangering the stability of several Central African nations. Separatist and independence movements roiled India, Sri Lanka, Indonesia, and Ethiopia. Later in the decade, fragile peace accords reached in Israel and Northern Ireland threatened to unravel amid continuing factional strife.

In the United States, the idea of difference—racial, ethnic, sexual, and political—underwent a more positive evolution. It was a key element in the campaign and early administration of Bill Clinton, elected president in 1992 (and reelected in 1996). A liberal Democrat and baby boomer, Clinton rode to victory on a centrist platform of fiscal conservatism tempered with a progressive social agenda—health care reform, abortion rights, gun control, and inclusive policies toward people of color, women, gays and lesbians, and other groups that had been effectively disenfranchised during twelve years of Republican leadership. Clinton appointed more women and minorities to his cabinet than any previous president. He also met with gay and lesbian leaders in the White House and, early in his presidency, advocated an end to the ban on homosexuals in the military. Like his hero John F. Kennedy, Clinton understood the power of television, using nationally televised "town meetings" to debate issues such as the need to improve race relations in an effort to heal the discord among America's multicultural constituencies. And there was need for such debates. Despite the progressivism of the administration's policies, racial strife still lurked within American culture, sometimes emerging with appalling violence.

Clinton's call for national unity had wide appeal, and his administration eventually enjoyed a high approval rating. Much of Clinton's popularity, however, derived not from his social agenda but from the unprecedented economic upturn over which he presided. From 1992 to the end of the decade, the U.S. economy flourished, fueled in part by the lowest interest rates in a generation and the explosion of high-technology industries. Not surprisingly, the Clinton administration was also a strong advocate for the use of the Internet and other technological innovations in both education and business. The administration promoted an "Information Superhighway," linking individuals, communities, countries, and cultures,

which would revolutionize education and trade. His forecast proved accurate: in 1993, the Internet linked 5 million people worldwide; at the end of the decade, about 100 million people were active online.

The Internet is but one part of a phenomenon known as globalization, which has produced a new, worldwide business and entertainment culture through the ubiquity and immediacy of modern telecommunications systems. Another part is represented by the international trade agreements that have been formulated in the 1990s—the North American Free Trade Agreement (NAFTA) between the United States and Mexico, the ongoing negotiations for the General Agreement on Tariffs and Trade (GATT), which involves countries around the world, and the Maastricht Treaty, signed by many European nations. These treaties, by reducing tariffs and other trade barriers and opening national borders, forged commercial and cultural links across the globe. Through such agreements and the proliferation of technology, diverse communities have been consolidating into a broad "global village" of trading and cultural partners. This new globalism naturally promoted the idea of cultural homogeneity. But such homogeneity also threatened a loss of individuality, of the characteristics that distinguish people, ethnic groups, and even nations. The desire to maintain and even assert these distinctions in an increasingly uniform world led people to search for new ways to be different, new ways to reinvent local and native traditions.

This sensitivity to difference within a global consciousness has had a dramatic effect on art and the mapping of its boundaries. We have started to look for innovation in art made outside the cultural "mainstream," whether in the diverse communities of America or in other areas of the world. Indeed, the definition of the word "mainstream" has undergone a radical revision, in part as a result of shifting demographics. Twenty years ago, for example, the population of Los Angeles was 70 percent Anglo; today it is just 40 percent Anglo. The increasingly articulate voices of different ethnic groups, nationally and globally, has moved the issue of personal identity to the forefront of political as well as aesthetic concerns. Identity

AMERICANIZATION: THE EXPORT OF AMERICAN CULTURE

Wherever you live in the world, whoever you may be, once the lights dim in a movie theater, or the screen lights up on your TV or PC, you become part of the American century. Many of the catchwords and concepts of twentieth-century political and cultural life have a peculiarly American provenance: the global market as the touchstone of capitalist "free" enterprise in the West; democratic capitalism as the rubric of the West's crusade against Communist or Socialist "empires of evil"; or, more recently, the catchword of global theorists, the "Coca-Cola-ization" of the world—which suggests that from a curvaceous bottle emerges the genie of the American dream—youth, entertainment, cool technologies, and hot financial markets.

The global spread of "America" as *the* quintessential cultural icon of the twentieth century, or as the "style" of *living* in the present (on-screen or on-line) and looking the part (jeans, Nikes, sweats), is about the triumph of an "image." The spread of Americanism as a cultural style comes from the capacity of American popular culture to translate its values, lifestyle, and products—its ideology—into consumable and reproducible images that can either be imitated or reinvented across the world, wherever Western-style "free" and "privatized" markets exist.

In the American century, then, a lifestyle can become an ideology in a way no other dominant "world" culture made possible for its subjects—to be an "anglicized" colonized person, for instance, was emphatically *not* to be British. If this century has been called the American century, it is not merely because of the feudal grip of Hollywood or Silicon Valley on the rest of the world, or even because Michael Jordan and Bill Gates bestride the world like colossi. What is distinctive about American cultural industries and icons is their ability to give "American" images a global relevance, an innate sense (however inappropriate) of belonging in various national and cultural locations.

Americanization, for instance, is not simply the creation of a global "youth" culture because MTV services "one quarter of the world's television households in 85 territories . . . tailored to the life-style and sensibilities of 12–34 year olds" (MTV Global fact sheet). The imaginative power of Americanization lies in persuading other cultures and nations to experience and commodify their own sense of modernity or postmodernity in an American style. That style, as a cultural commodity, is no longer the all-American "apple pie à la mode" of the fifties. The contemporary consumption of Americanized global culture is much more on the "take-out" model, where what is consumed may be "ethnic" but the style of consumption is still a version of the good ol' American drive-in. Global company logos illustrate this shift rather well. MTV's philosophy is "think globally, act locally," while the Ford Motor Company motto is "To be a multinational group, it is necessary to be national everywhere." What this means is that "Americanization" is less evident in the cultural "product" and more concerned with the process and the program. Americanization is now the "global" connectivity between national cultures that can reach their own peoples only through a cultural agency that is at once visible and invisible. What is "American" is neither simply the local nor the global but the economic and cultural linkage between the two. For instance, 85 percent of MTV Mandarin consists of music videos from China, while 75 percent of MTV India

politics and the debates around multiculturalism and race in fact constitute one of the most important developments of the early nineties. Events such as the beating of Rodney King by officers of the Los Angeles Police Department, famously captured on videotape, which led to rioting in Los Angeles when the officers were acquitted, or the trial of O. J. Simpson, the former football star accused of murdering his white ex-wife, Nicole Brown Simpson, became lightning rods for race issues in America.

In the arts, multiculturalism was evident in groundbreaking exhibitions such as "The Decade Show: Frameworks of Identity in the 1980s" at the New Museum of Contemporary Art, New York (1990), which highlighted artists of color who had been working throughout the eighties in relative obscurity. The 1993 Biennial at the Whitney Museum of American Art similarly featured "other" voices—of African Americans, Native Americans, and Asian Americans, as well as gays and lesbians. One of the most memorable contributions to the show was supplied by Los Angeles artist Daniel Martinez, who made buttons reading "I can't imagine ever wanting to be white" that were distributed at the museum entrance. The "Black Male" exhibition, also at the Whitney (1994), examined changing representations of black masculinity in America through art and film. These and other exhibitions, among them "Magiciens de la terre" (1989) at the Centre Georges Pompidou, Paris, which emphasized non-Western art and traditions in a fortress of Western culture, prompted a revaluation of what had previously been considered lesser places and cultures. Biennials in Johannesburg, Istanbul, Kwangju, and São Paulo caught the world's attention in the 1990s, as the demarcation line between margin and center blurred and shifted. The cultural relativity of terms such as "beauty" and "quality" was exposed, as it had been in the seventies by feminists and black activists.

Cultural diversity has awakened our understanding that the dominant aesthetic discourse has been Western, bourgeois, and male. The African American contribution to the nation's life and culture, for example, has long been undervalued. It is now foregrounded by the work and perspective of black

consists of Hindi music videos. Yet, says MTV Global, "each channel adheres to the overall style, programming philosophy and integrity of the MTV trademark while promoting local cultural tastes and musical talent." In this process, national cultures, once considered sovereign, are now downgraded to "local" tastes and talents.

Is Americanization nothing more than cultural imperialism dressed in the drag of digital technology, its tentacles twitching to the new rhythms of rockumentaries? To answer this question, we must look beyond the depredations of the icons and acronyms of Americanization—AOL, CNN, MTV, McDonald's, and Mickey Mouse. What then becomes apparent are two important aspects of the function of Americanization in contemporary conditions.

First, Americanization is frequently the "name" given to the anxious process of flux and confusion that accompanies moments when societies are in transformation and nations in transition. With the meltdown of the Soviet Union, and the emergence of genocidal nationalisms the world over, the very integrity of the nation-state as a political entity is in jeopardy as never before. It is little wonder, then, that in the midst of this historical trauma, the triumphalism frequently associated with the survival of the "American system" should be seen by many as a corporate takeover of other national cultures.

Second, the massive technological revolution that ends this century much as it began creates a deeper anxiety about who we are as a "people." Computer imaging, digitalization, cloning—these technological advances produce a deep fear that we will be turned from culture-respecting "individuals" to leisure-ravaging masses. Americanization is, then, the expression of an anxiety attributed to the standardization of taste and what Stefan Zweig called the "monotonization of the world" created by the global production of mass culture. At the end of the century, as nations lose some of their cultural sovereignty, and the supreme autonomy of the individual is wrested away by the power of intelligent machines, Americanization becomes the most salient sign of our precarious future.

The final irony of the American century may well be that what America has to teach the global world, at the dawn of the twenty-first century, is the lesson it has been struggling to learn, as a nation, throughout the present one. Despite the dispiriting statistics on race, poverty, crime, and the "culture wars" that bedevil America, there is scarcely another country more obsessed with the rights of minorities and the recognition of cultural diversity. Like all obsessions, American pluralism is prone to failure, defensiveness, overreaction, and fatigue. But it is nonetheless a magnificent obsession. It has infused the American century with a spirit of freedom and equality embodied in civil rights, women's rights, the needs of and obligations toward AIDS communities, the freedom of cultural and artistic expression, the care of the environment, and much else. If worldly ambition can fly on the wings of such a spirit of Americanization—with all its false starts and lost paths—then we may yet see a more equitable movement between one way of life and another, between oneself and the Other. —H. K. B.

Americans who have changed the mainstream—among them the sports hero Michael Jordan; pop music star Michael Jackson; film directors Spike Lee, John Singleton, and Julie Dash; author Toni Morrison; poet Maya Angelou; military leader General Colin Powell; Harvard professors of African American studies Henry Louis Gates, Jr., and Cornel West; talk show host Oprah Winfrey; and documentary filmmaker Henry Hampton. By defying clichés that limited the role of blacks in America, they have altered long-standing racial stereotypes.

A generation of visual artists have emerged in the nineties who also engage and challenge these stereotypes. Understanding that we all identify with the images through which the dominant culture represents us, they claim those representations in order to disclaim them—a process that forces a change in the viewer's consciousness. Kara Walker, for instance, imagines herself as a nineteenth-century slave girl in allegorical silhouette cycloramas (fig. 556). A police lineup is the subject of Gary Simmons' work, and the candidates for inspection are symbolized by a row of gold-plated basketball sneakers (fig. 557). In another work by Simmons, the

A NEW AVANT-GARDE IN ARCHITECTURE

In 1988, The Museum of Modern Art in New York held an exhibition entitled "Deconstructivist Architecture," which attempted to present as a consolidated entity an international group of architects, among them Zaha Hadid, Rem Koolhaas, Peter Eisenman, Daniel Libeskind, and Bernard Tschumi. The premise of the show was twofold: first, that this group of architects was engaged in a critical practice deploying strategies associated with the historical avant-gardes, especially Russian Constructivism; second, that this redeployment was informed by the tactics of theorists such as Jacques Derrida. While there was much controversy over whether deconstructivism was simply another style in the postmodern smorgasbord of styles or a categorically different form of practice—and perhaps even more debate over whether someone like Frank Gehry read philosophy at all—deconstructivism did register an architectural sea change (fig. 554). It helped invent a new and hybrid form of architect—part critic, part theorist, part professional—who pursued a fundamentally interdisciplinary practice that paralleled the emergence of new types of transmedia art forms. Moreover, many of the most prominent architects involved were European-born but located at least part of the time in the United States: the Dutch Koolhaas was at the Institute for Architecture and Urban Studies in New York when he wrote his influential *Delirious New York* in 1978 (fig. 555); Libeskind, born in Poland, taught for many years at the Cranbrook Academy of Art in Michigan; and Tschumi, trained at the École des Beaux-Arts in Paris, ultimately became dean of Columbia University's Graduate School of Architecture in New York.

This influx of people and ideas did a great deal to dismantle the sentimental patriotism of American postmodernism. Perhaps most important, the architects' appeal to theoretical rigor opened architecture to the critical voices of feminism, AIDS activism, postcolonialism, and other transformative intellectual and political developments. By the time the first major buildings of these architects were completed—Koolhaas' Kunsthalle in Rotterdam (1992), Tschumi's *Parc de la Villette* in Paris (1998), and Libeskind's Jewish Museum in Berlin (1998)— their earlier theoretical work had already contributed to a particularly American effort to establish a critical, even avant-garde, architectural practice for the late twentieth century. —S. L.

554. *Deconstructivist Architecture*, by Philip Johnson and Mark Wigley New York: The Museum of Modern Art, 1988

555. *Delirious New York: A Retroactive Manifesto for Manhattan*, by Rem Koolhaas, cover illustration by Madelon Vriesendorp New York: Oxford University Press, 1978

556. **Kara Walker**
*The End of Uncle Tom and
the Grand Allegorical Tableau
of Eva in Heaven*, 1995
(detail)
Cut paper, 10 x 40 ft.
(3 x 12.1 m) overall
Collection of Jeffrey Deitch

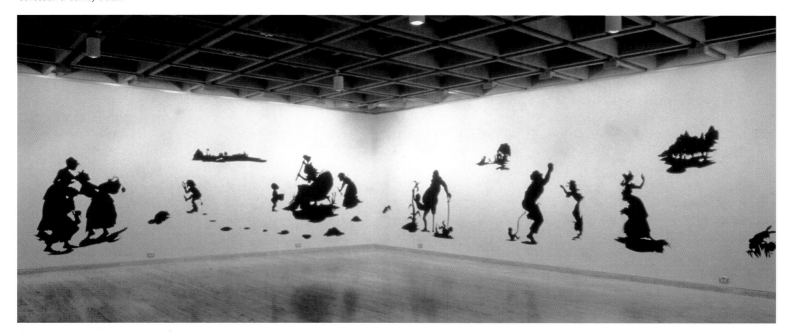

557. **Gary Simmons**
Lineup, 1993
Synthetic polymer on wood
with gold-plated basketball
shoes, 114 x 240½ x
18 in. (289.6 x 610.9 x
45.7 cm) overall
Whitney Museum of
American Art, New York;
Purchase, with funds from
the Brown Foundation, Inc.
93.65a–p

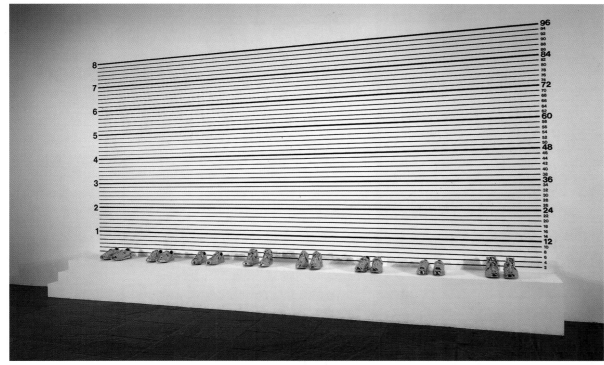

eyes from a black cartoon figure populate a chalkboard mural. Glenn Ligon commemorates texts by great African American authors, among them Langston Hughes, James Baldwin, and Zora Neale Hurston ("I do not always feel colored") in his black-on-white or black-on-black stenciled paintings (fig. 559). Kerry James Marshall celebrates black jazz musicians in *Souvenir IV* (fig. 561), from an ambitious cycle of narrative history paintings that represent his experience of black cultural history and civil rights ferment in the fifties and sixties. The Cherokee artist Jimmie Durham fashioned a self-portrait that resembles a hanging, hide-like "red skin," covered with statements such as "Indian penises are usually large and colorful," which interrogate stereotypes of Native Americans and provide a new perspective on the concept of national identity (fig. 558).

Beginning in the late 1980s, Lorna Simpson used photographs of an anonymous black woman seen in back view. In *2 Tracks* (fig. 560), panels containing a single black braid flank the central image of a woman with short-cropped hair. Under the braids are signs that read "back" and "track," making obvious allusion to social struggle and personal growth. Carrie Mae Weems' early photographs confront a variety of extreme racial stereotypes. A later work, *Untitled (Man Reading Newspaper)*, presents a pictorial narrative about love, power, control, and equality between a black man and woman that also reflects broader social situations (fig. 563).

The story—and storytelling—represent one of the most potent sites of cultural identity and have experienced a comeback in the 1990s in narratives in art and literature. In addition to Weems, Walker, and Marshall, Zoe Leonard has mined the power of storytelling. Her photo archive for *The Watermelon Woman*, a 1996 film by Cheryl Dunye, brings the story of the fictional African American actress Fae Richards to life (fig. 564). Dunye created the character partly to explore her own racial and sexual identity; and Leonard constructed an "authentic" historical archive of eighty-two different images "documenting" Richards' life for the film.

Two of the most important artists for this new generation were David Hammons and Adrian Piper, who in the 1970s had already taken a Conceptual approach to race issues (figs. 368, 399, 400). Two decades later, both Hammons and Piper were finally acclaimed for their earlier work, and they continued to expand their conceptions through the more theatrical forms of video and installation. The work of Hammons, who in the 1970s made assemblage sculptures using spades and chains as racial metaphors, grew into large sculptural installations such as the one made in 1992, where nappy hair from a barbershop floor is applied to wire and stones, the effect resembling an abstraction of dreadlocks (fig. 562). Among Piper's works from this period is *Black Box/White Box* (1992) , which from the outside appears to be two large Minimalist cubes. Upon entering these boxes, however, the viewer finds a charged installation on race, including a loop of the videotaped beating of Rodney King by Los Angeles police.

Cultural diversity in the arts has been a positive consequence of the ascendancy of different ethnic groups in the nineties. In this era of global cosmopolitanism,

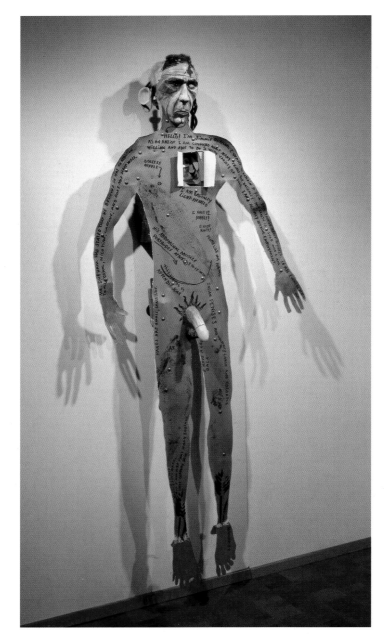

558. **Jimmie Durham**
Self-Portrait, 1986
Canvas, wood, paint, metal, synthetic hair, fur, feathers, shell, and thread, 78 x 30 x 9 in. (198.1 x 76.2 x 22.9 cm)
Whitney Museum of American Art, New York; Purchase, with funds from the Contemporary Painting and Sculpture Committee 95.118

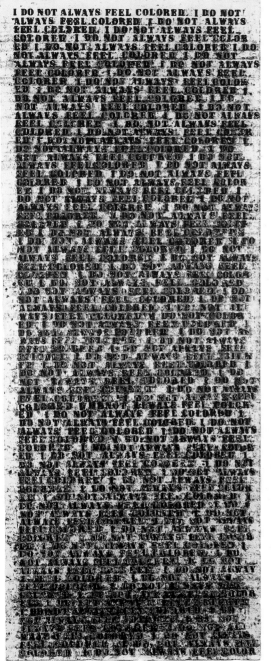

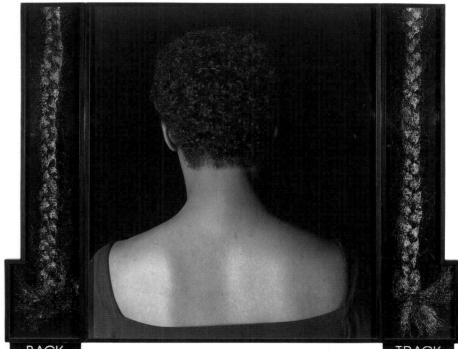

BACK TRACK

559. Glenn Ligon
Untitled (I Do Not Always Feel Colored), 1990
Oil stick and gesso on wood panel, 80 x 30⅟₁₆ x 1½ in. (203.2 x 76.4 x 3.8 cm)
Whitney Museum of American Art, New York; Promised gift of The Bohen Foundation in honor of Tom Armstrong
P.2.91

560. Lorna Simpson
2 Tracks, 1990
Three gelatin silver prints with two plastic plaques, 48⅞ x 62³⁄₁₆ x 1¹¹⁄₁₆ in. (124.1 x 158.9 x 4.3 cm) overall
Whitney Museum of American Art, New York; Gift of Raymond J. Learsy and Gabriella De Ferrari
91.59.4a–e

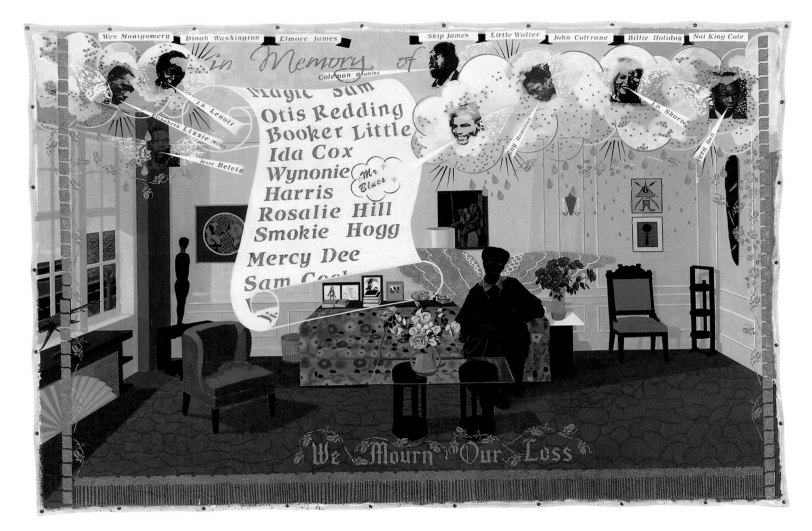

561. **Kerry James Marshall**
Souvenir IV, 1998
Synthetic polymer and
glitter on paper on canvas
with grommets, 107½ x
157½ in. (273.1 x
400.1 cm)
Whitney Museum of
American Art, New York;
Purchase, with funds from
the Painting and
Sculpture Committee
98.56

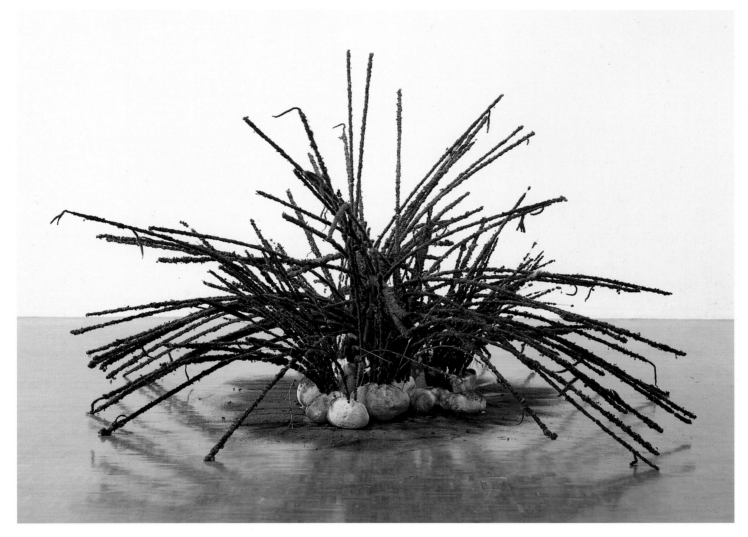

562. **David Hammons**
Untitled, 1992
Copper, wire, hair, stone,
fabric, and thread, 60 in.
(152.4 cm) height
Whitney Museum of
American Art, New York;
Purchase, with funds from
the Mrs. Percy Uris
Bequest and the Painting
and Sculpture Committee
92.128a–u

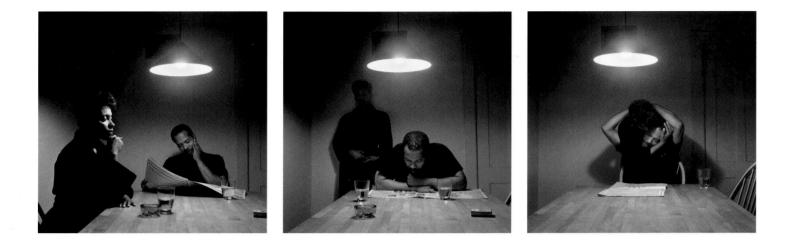

563. Carrie Mae Weems
Untitled (Man Reading Newspaper), from *Kitchen Table Series*, 1990
Three gelatin silver prints, 27 x 27 in. (68.6 x 68.6 cm) each
Collection of Eileen and Peter Norton

564. Zoe Leonard
The Fae Richards Photo Archive, 1993–96
Seventy-eight gelatin silver prints and four chromogenic color prints created for Cheryl Dunye's film *The Watermelon Woman* (1996), dimensions variable
Whitney Museum of American Art, New York; Purchase, with funds from the Contemporary Painting and Sculpture Committee and the Photography Committee 97.51a–dddd

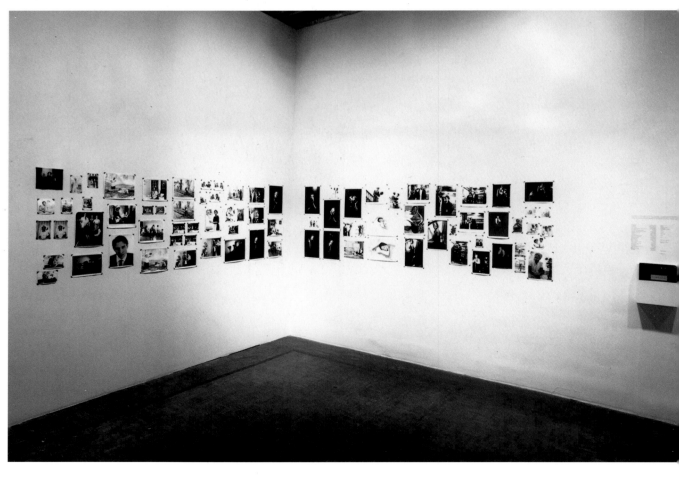

In the nineties, Europeans indeed seemed more interested in art coming out of Los Angeles than in that from anywhere else in America. To Americans, still plagued by a lingering sense of cultural inferiority, the recognition and approval of Europeans went a long way. The idiosyncratic work of the California artist Mike Kelley, for instance, baffled audiences in New York at first, but when the Germans showed enthusiasm for his assemblages of rag dolls and stuffed animals, New York quickly got on board.

The Museum of Contemporary Art in Los Angeles was particularly important in promoting the new art of the area, as the wide-scale success of the 1992 exhibition "Helter Skelter: L.A. Art in the 1990s" testifies. The title of the exhibition refers to the brutal slaying of film director Roman Polanski's pregnant wife, Sharon

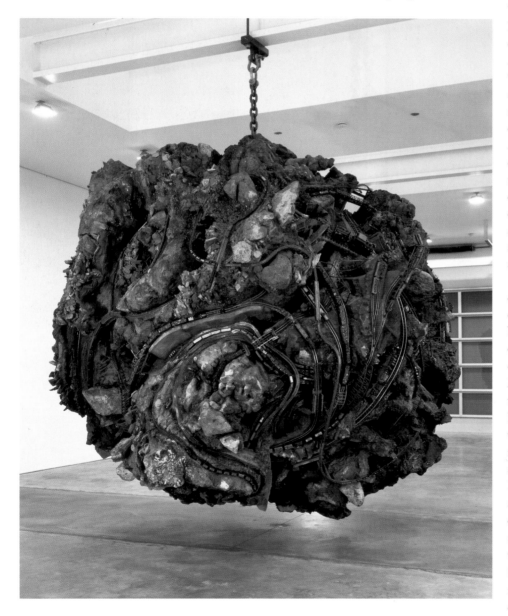

570. **Chris Burden**
Medusa's Head, 1990
Internal electronic motor and drive mechanism with model railroad trains and tracks, 16 ft. (4.9 m) height, 5 tons (5080.3 kg) weight
Collection of the artist

Tate, along with four others, by cult leader Charles Manson and his followers in affluent Beverly Hills in 1969. After the bloodbath, Manson scrawled "Helter Skelter" (the title of a Beatles song) on the walls. The allusion to the infamous murders was intended to emphasize an important aspect of Los Angeles art—that it often reveals the dark side of sunny, lotus-land hedonism. "Helter Skelter" was a defining exhibition that brought together many of Los Angeles' top artists of the eighties and early nineties in a museum setting, and it generated tremendous attendance and national press coverage.

The works in "Helter Skelter" conjured up the grisly Manson murders and other violent, macabre, and bitterly comic images of cultists, the empty wasteland of turmoil (as also depicted in the 1982 film fantasy *Blade Runner*), and what Joan Didion called the "weather of catastrophe, of apocalypse."[149] It also acknowledged the spectacle of consumer culture, shopping malls, hype, tourists, crazy architecture, and theme parks that constitutes the Los Angeles landscape. The art presented shared very little with that of earlier "finish fetish" or "light and space" artists or those absorbed with the painterly qualities of light. "Helter Skelter" presented the white male nightmare—haunting images of adolescence and its dysfunctional relationships with the adult world, and images of dispossession, alienation, antisocial behavior, vulnerability, and aggression. Many of the artists drew on underground comics, rock 'n' roll, and pulp literature as sources for their sardonic and grotesque brand of Pop. Their works were "in your face"—raw, visceral, unrelenting, and obsessive in their anxiety.

571. **Paul McCarthy**
Hot Dog, 1975
Performance, Pasadena,
California

572. **Paul McCarthy**
Bossy Burger, 1991
Performance/installation
at the Rosamund Felsen
Gallery, Los Angeles

573. **Mike Kelley**
*More Love Hours Than
Can Ever Be Repaid* and
The Wages of Sin, 1987
Stuffed fabric toys and
afghans on canvas with
dried corn; wax candles on
wood and metal base, two
parts: *More Love Hours
Than Can Ever Be Repaid*,
90 x 119¼ x 5 in. (228.6
x 302.9 x 12.7 cm);
The Wages of Sin, 52 x
23¾ x 23¾ in. (132.1 x
60.3 x 60.3 cm)
Whitney Museum of
American Art, New York;
Purchase, with funds from
the Painting and
Sculpture Committee
89.13a–e

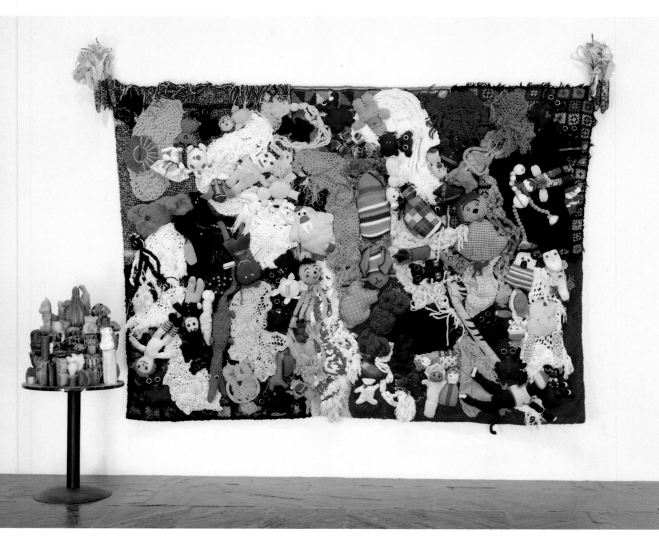

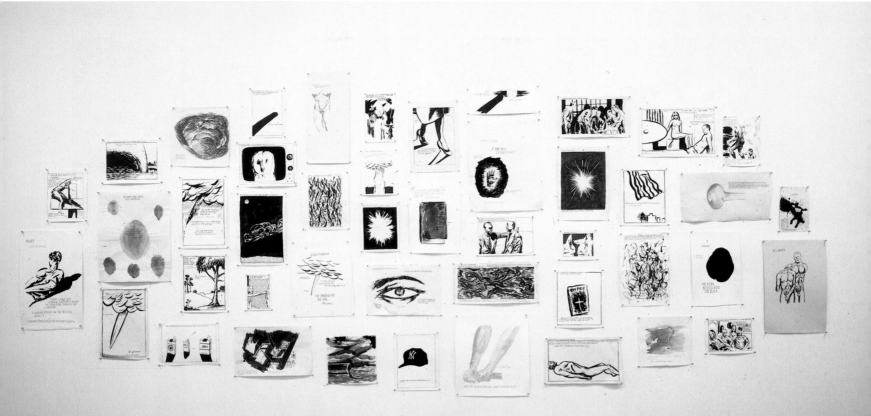

574. **Raymond Pettibon**
Installation view at David
Zwirner Gallery, New York,
1995

575. **Raymond Pettibon**
No Title (Draw It As),
1990
Pen and ink on paper,
11½ x 8 in.
(29.3 x 20.3 cm)
Private collection

The element of anxiety and danger was always present in Chris Burden's work, but now it was embodied in densely compacted hanging spheres of metal and toy train tracks, which look like horrific post-apocalyptic detritus (fig. 570). Paul McCarthy, who in the seventies began staging grotesque and visceral performances (fig. 571), in the nineties made disturbing objects that involve mechanical performing figures in stage-set tableaux (fig. 572). Raymond Pettibon's eccentric drawings merge personal observations, literary history, and pop culture in a range of emotions, from the agitated to the lethargic (figs. 574, 575). Cast-off, rejected rag dolls found at flea markets are stitched together by Mike Kelley in works such as *More Love Hours Than Can Ever Be Repaid*, a disturbing reminder of child abuse or other painful childhood memories (fig. 573). In another work, *Lumpenprole*, the dolls are concealed under an afghan, their shapes creating a topography of repressed memories (fig. 576).

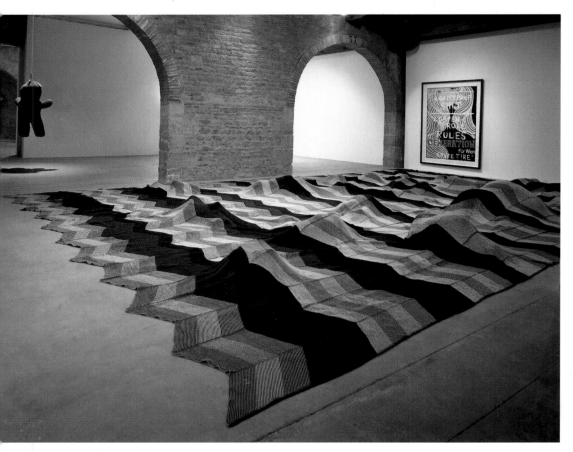

576. **Mike Kelley**
Installation view of "Mike Kelley" at the Musée d'Art Contemporain, Bordeaux, France, 1992
Foreground: *Lumpenprole*, 1991; background: *Ageistprop*, 1991

Although the work of Los Angeles artists can be interpreted in a regional context, the work of other artists across America also took a dark turn in the early nineties. Several exhibitions— "Dislocations" at The Museum of Modern Art, New York (1991), "Distemper: Dissonant Themes in the Art of the 1990s" at the Hirshhorn Museum and Sculpture Garden, Washington, D.C. (1996), and the international traveling show "Post Human" (1992–93)—have charted a growing sense of alienation, doom, and dystopia that may express the anxiety of a society awaiting the millennium. We have witnessed bizarre cultists committing mass suicide, terrorists blowing up airplanes and government buildings, the continuing AIDS plague, police brutality captured on videotape, and the moral breakdown of our most trusted and admired heroes. These strange events and the media's fixation and incessant replay of lurid disasters, criminal violence, and confessional spectacle has intensified our sense of wariness and fallibility.

In art, this unease has found palpable expression in the word-based paintings of Christopher Wool (fig. 532), the moody, scavenged-sign installations of Jack Pierson (fig. 577), and the abject images of Paul McCarthy, Mike Kelley, and Sue Williams (fig. 578). Indeed, an art of extreme vulnerability and fragility is one of the principal characteristics of the nineties, as is also seen in the work of Felix Gonzalez-Torres, Jim Hodges, Richard Prince, and Robert Gober.

Gober's work has long alluded to loving, dying, and waste, as well as to domestic dysfunction. Even his use of dismembered body parts, such as a single trousered leg protruding from the wall (fig. 580), is both tender and discomforting. The sinks he began to make as early as 1985 are nonfunctional domestic objects, lacking hardware and pipes and presented in repeated sequences or in stacked pairs in the serial form of Minimalism (fig. 579). But they are handmade and have a decidely human

577. Jack Pierson
Desire, Despair, 1996
Metal, plastic, plexiglass,
and wood, 117½ x 56¼ in.
(298.5 x 142.9 cm)
Whitney Museum of
American Art, New York;
Purchase, with funds from
the Painting and Sculpture
Committee 97.102.2a–l

578. Sue Williams
Large Blue Gold and Itchy,
1996
Oil and synthetic polymer
on canvas, 96 x 108 in.
(243.8 x 274.3 cm)
Whitney Museum of
American Art, New York;
Purchase, with funds from
the Contemporary Painting
and Sculpture Committee
97.55

579. **Robert Gober**
The Ascending Sink, 1985
Plaster, wood, wire lath,
steel, and semigloss
enamel paint, two pieces
stacked, 30 x 33 x 27 in.
(76.2 x 83.8 x 68.6 cm)
each
Private collection

580. **Robert Gober**
*Untitled (Leg with
Candle)*, 1991
Wax, cloth, wood, leather,
and human hair, 13½ x
7 x 37½ in. (34.3 x
17.8 x 95.5 cm)
Whitney Museum of
American Art, New York;
Purchase, with funds from
Robert W. Wilson 92.6

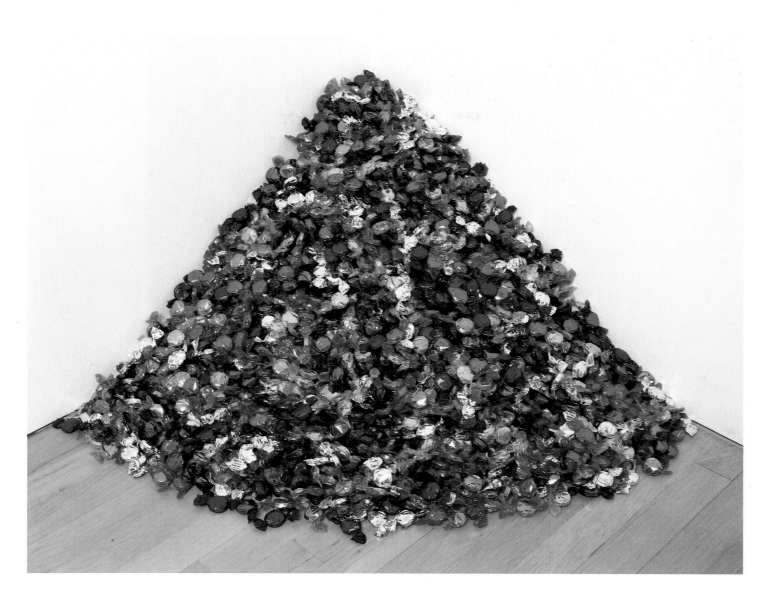

581. **Felix Gonzalez-Torres**
Untitled (Portrait of Ross in L.A.), 1991
Continuously replenished supply of multicolored candies individually wrapped in cellophane, dimensions variable
Private collection; courtesy Andrea Rosen Gallery, New York

presence. Gober's work of this period, which reintroduced intimacy and directness through the handcrafted object, was a touchstone for artists in the nineties.

Felix Gonzalez-Torres, like Gober, emerged in the eighties, and his work is the antithesis of the overblown, hyperbolic statements dominant at that time. Gonzalez-Torres, who died of AIDS in 1996, produced art in a variety of media that confronted real and projected loss. Following his partner's death, he made a photographic billboard project depicting their empty bed (fig. 546). He is best known for his ephemeral works, such as endlessly replenishable piles of candy (fig. 581) or stacks of printed paper meant to be taken away by the audience, or the more permanent and elegant strings of illuminated light bulbs (fig. 582). Although Gonzalez-Torres' art consciously references the scatter art and Postminimal forms of the late sixties, he endowed it with a personal conceptual content (the amount of candy "spilled" might be equal to his partner's weight, for instance), mixed with the activist's sense of generosity and democracy (he was a member of Group Material for years).

Just as Pop art provided a model for many artists in the eighties, artists in the nineties looked back to seventies art—to its scatter, ephemerality, and heterogeneity. In both decades, no dominant style prevailed, no major movements were named, only a few art "stars" emerged, and no clear ideology held sway. Again, as in the

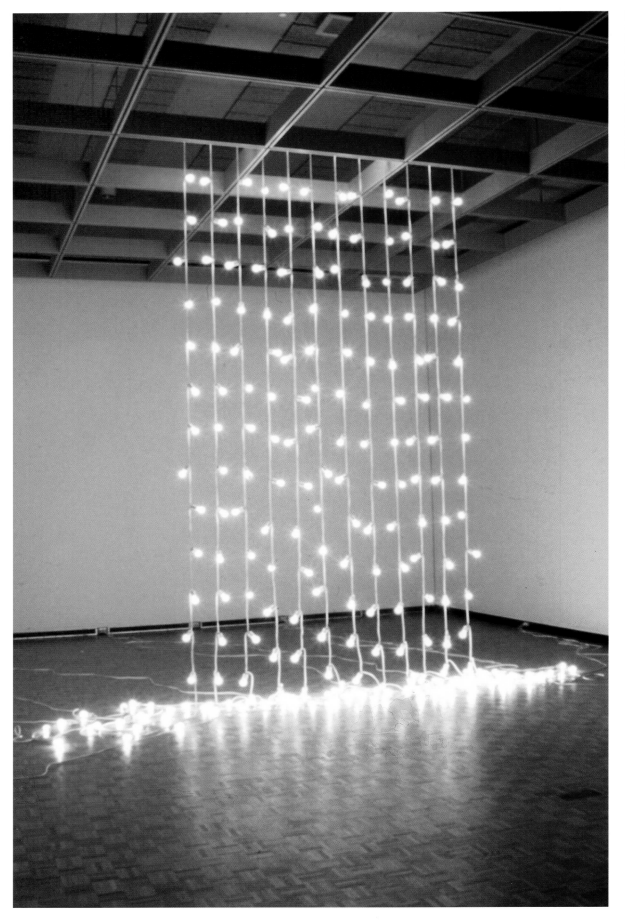

582. **Felix Gonzalez-Torres**
Untitled (North), 1993
Twenty-two light bulbs,
twelve strings, extension
cords, twelve parts, 270 in.
(685.8 cm) length, with
240 in. (609.6 cm) extra
cord each
Marieluise Hessel
Collection on permanent
loan to the Center for
Curatorial Studies, Bard
College, Annandale-on-
Hudson, New York

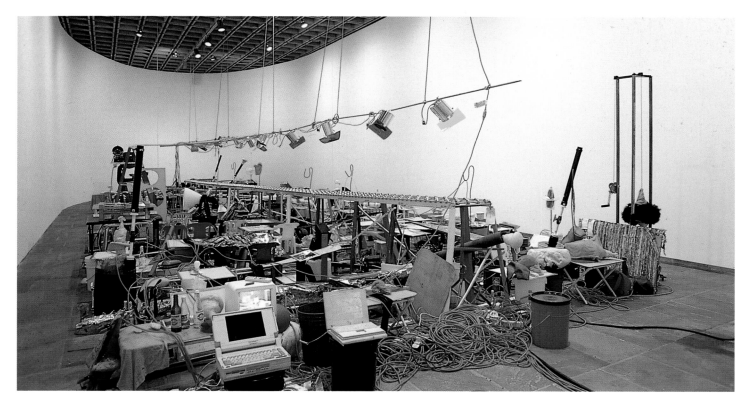

583. Jason Rhoades
Uno Momento/the theatre in my dick/a look to the physical/ephemeral, 1996
Mixed-media installation, approximately 25 x 70 ft. (7.6 x 21.3 m)
Hauser & Wirth, Zurich

584. Jim Hodges
On We Go, 1996
Silver-plated chain with pins, 57 x 48 x 22 in. (144.8 x 121.9 x 55.9 cm)
Collection of Eileen and Peter Norton

seventies, artists turned to ephemeral installations, film, performance, and photography. Their works employed modest materials and revealed an intimate touch and emotional life in a visually unheroic language. The materials in Jim Hodges' sculpture range from thin silver chains that form delicate spiderwebs (fig. 584) to synthetic flowers stitched together as sumptuous curtains. In Hodges' art, as in that of other young artists, beauty is precarious and humble attention is paid to craft. In stark contrast are the vast assemblage environments of Jason Rhoades, where objects are distributed across a large field in a seemingly random fashion (fig. 583). The arrangement, however, is actually a carefully considered structure that reveals the artist's interest in the typically male culture of tools, fix-it-yourself magazines, and home improvement projects.

A number of artists who had been at work for years came to prominence in the nineties. Among those we have already encountered are David Hammons, Mike Kelley, and Robert Gober, as well as Louise Bourgeois, Lari Pittman, and Kiki Smith. Their aesthetic, which had defied the hyperbolic spectacle of so much eighties art, became critical in defining that of the nineties. Bourgeois' career enjoyed something of a renaissance as she produced some of her strongest work in her eighties, proving that age has nothing to do with generative power. Her loom-

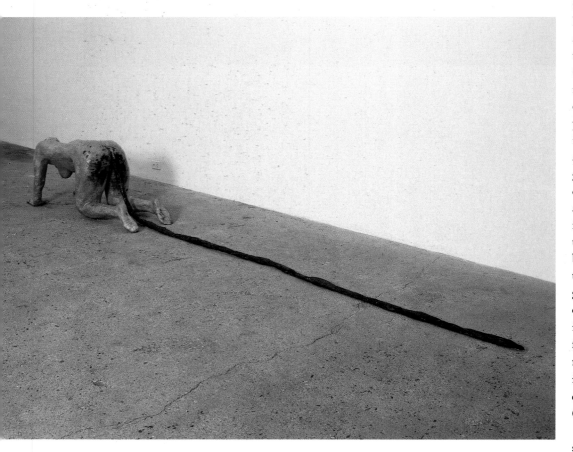

585. **Kiki Smith**
Tale, 1992
Wax, pigment, and papier-
mâché, 23 x 160 x 23 in.
(58.4 x 406.4 x 58.4 cm)
Collection of
Jeffrey Deitch

ing cast bronze spiders, "cells" or cage-like environments, and her wonderful assemblages of clothes saved over a lifetime provoked and enchanted audiences (fig. 586). Lari Pittman's work of the nineties draws on a range of ethnic traditions, high and low culture, and gay politics, inventing a unique style that is garishly beautiful, humble and bold, and that makes use of both modest language and epic scale. Kiki Smith started out as a member of Colab, making lowly and offbeat objects out of plaster, paper, fabric, and glass that usually referred to some part of the human anatomy, to body function, or to our relationship to the environment. In the nineties, her growing material inventiveness and lyricism were matched by an increasingly intense subject matter. Using life-size figures, Smith's work became bolder, more visceral, and more provocative in its graphic depictions of death, decomposition, waste, and regeneration (fig. 585).

Women have made some of the strongest contributions to art in the nineties. From Jennifer Pastor's elaborately researched and meticulously executed sculptural tableaux to Toba Khedoori's delicate monumental renderings of architectural structures to Shahzia Sikander's contemporary updatings of traditional Indian miniature painting and Kara Walker's powerful wall-scale silhouette cutouts, it is clear that women are expanding our visual vocabulary, often continuing to draw on and update craft traditions (fig. 556). Other significant contributions by women include Catherine Opie's and Sharon Lockhart's color photographs and Ann Hamilton's

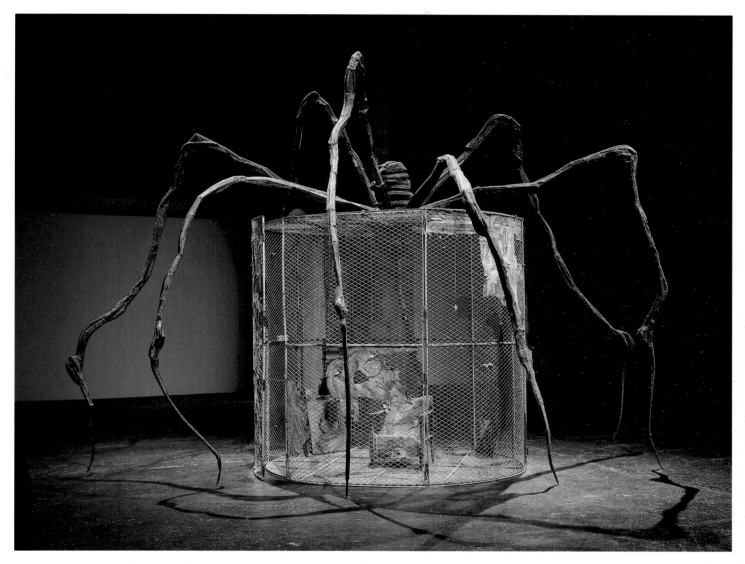

586. **Louise Bourgeois**
Spider, 1997
Steel and mixed media,
175 x 262 x 204 in.
(444.5 x 665.5 x
518.2 cm)
Courtesy Cheim & Read,
New York
© Louise Bourgeois/
Licensed by VAGA,
New York, NY

587. **Ann Hamilton**
Mantle, 1996
Performance with shortwave
radio, table, and sixty
thousand flowers at Miami
Art Museum, Florida

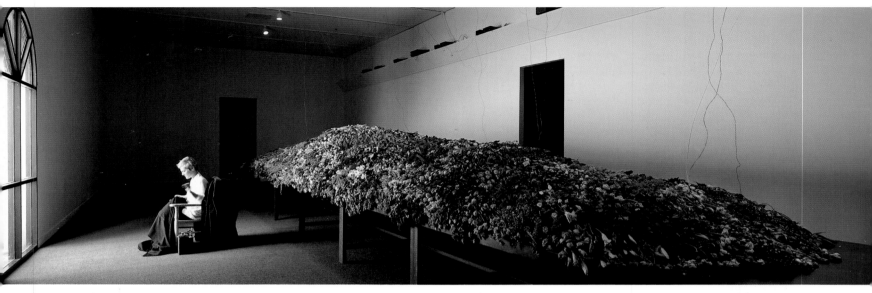

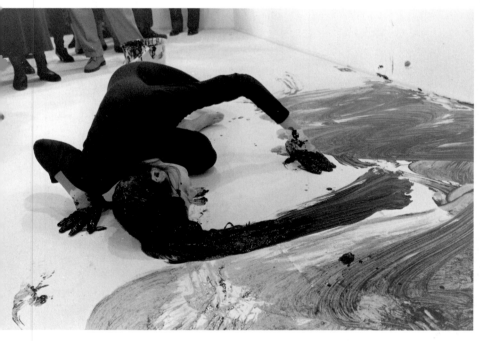

588. **Janine Antoni**
Loving Care, 1992 (detail)
Performance with hair dye
at Anthony d'Offay Gallery,
London
Courtesy of the artist
and Luhring Augustine,
New York

589. **Catherine Opie**
Self-Portrait, 1993
Chromogenic color print, 39⅝
x 29⁹⁄₁₆ in. (100.6 x 76 cm)
Whitney Museum of
American Art, New York;
Purchase, with funds from
the Photography Committee
94.64

and Janine Antoni's tactile, performance-oriented sculptures and installations (figs. 588, 589), all of which convey a combination of toughness, delicate beauty, and sensuality.

The resurgence of the handmade and craft-related procedures in much nineties art is, in part, a reaction to the encroachment of technology on modern life and the distancing of human relations through the mediation of machines. New technologies such as video conferencing, online trading, cellular phones, virtual reality, and cybersex have diminished the need for personal contact. This has, in turn, allowed relationships to become infused with imagination and fantasy. One can project fantasies on the Internet, for instance, and even create imaginary surrogates of a different sex or age. Such merging of reality and fiction through new technologies has blurred the boundaries between the two. Today, we are more likely to wonder whether or not a photograph represents an actual reality, particularly since the computer can create seamless, lifelike scenes constructed (or enhanced) from real and/or fabricated imagery.

The construction of fictional realities has extended to the human form. People alter their appearance, sexuality, and identity—physically through bodybuilding, sex-change operations, plastic surgery; conceptually, through spin doctors. Michael Jackson and Ivana Trump have transformed their personas through plastic surgery. Face-lifts, breast implants, and liposuction are commonplace in our youth-obsessed, wrinkle-free world. The plastic, the artificial, and the non-natural reign. The sense that biology is no longer destiny has raised new moral issues. With the dawn of genetic engineering, biotechnology, and cloning, there is every indication that we may be moving into a "post-human" phase of evolution.

These new notions of the body and the self have stimulated a major revival and reinvention of figurative art, but now with a Conceptual orientation, from Paul McCarthy's mechanical figures (fig. 572) to Cindy Sherman's recent photographs, which construct hybrid figures from body parts, props, and prostheses (fig. 590), and to Robert Gober's installations of figures and body parts—pierced, dismembered, and submerged into the floor as components of strange tableaux (fig. 591).

Two important artists who gained attention in the 1990s for their figurative works are Charles Ray and Matthew Barney. Ray, who during the 1980s made idiosyncratic abstract sculpture where things were not what they seemed, turned to figurative work at the beginning of the nineties (figs. 594, 595). Continuing to mine the strange in the familiar, he has made self-portraits that look like stiff, store mannequins or family ensembles that subtly distort scale to suggest dysfunction. With their human forms and mechanical appearance, Ray's works are strange hybrids that combine public and private, presence and absence. Matthew Barney's early performances, in which he scaled the wall of the gallery, took the art world by storm (fig. 592). In later works, he subjects himself to numerous

590. **Cindy Sherman**
Untitled (Mannequin), 1992
Silver dye bleach print (Ilfochrome), 68¹⁄₁₆ x 45⅛ in. (172.9 x 114.6 cm)
Whitney Museum of American Art, New York; Purchase, with funds from the Wilfred P. and Rose J. Cohen Purchase Fund and the Photography Committee 92.76

591. **Robert Gober**
Installation view of
Untitled, 1995–97, at The
Geffen Contemporary, The
Museum of Contemporary
Art, Los Angeles, 1997
Emanuel Hoffmann
Foundation, Basel

592. **Matthew Barney**
Blind Perineum, 1991
Videotape, color, silent;
87 min.
Barbara Gladstone Gallery,
New York
© 1991 Matthew Barney

593. **Matthew Barney**
Drawing Restraint 7, 1993
Videotape, color, silent;
13 min.; steel, plastic, and
fluorescent light fixtures in
room, 120 x 180 x 264 in.
(304.8 x 457.2 x 670.6 cm)
Whitney Museum of
American Art, New York;
Purchase, with funds from
the Painting and Sculpture
Committee 93.33
© 1993 Matthew Barney

594. **Charles Ray**
Puzzle Bottle, 1995
Glass, painted wood, and
cork, 13⅜ x 3¾ x 3¾ in.
(34 x 9.5 x 9.5 cm)
Whitney Museum of
American Art, New York;
Purchase, with funds from
the Contemporary Painting
and Sculpture Committee
and Barbara and Eugene
Schwartz 95.85a–b

595. **Charles Ray**
Fall '91, 1992
Mannequin and mixed
media, 96 x 36 x 26 in.
(243.8 x 91.4 x 66 cm)
The Broad Art Foundation,
Santa Monica, California

596. *Afrika Bambaataa,* n.d.

THE BEAT GOES ON: HIP-HOP RULES

Toward the end of the century, the turntable overtook the guitar as the symbol of popular music and a global DJ culture was born. The idea that music is something to be played *with* more than actually played began with the combination of advanced recording technology (multitracking, electronic manipulation of sound) and the experimental use of the recorded medium—from John Cage's music collages to James Brown's and John Coltrane's extended rhythmic and melodic repetitions. Over the past thirty years, pop music has been transformed from a medium played and recorded to one of overtly manipulated preexisting elements.

This musical revolution, however, did not reach critical mass until the late 1970s, with the birth of hip-hop and its most popular offshoot, rap. In its most basic form, rap originated with MCs rhyming over beats laid down by DJs who spun and scratched vinyl records on two turntables linked by a switcher. The practice started in Jamaica during the 1960s, when traveling music promoters set up in public to play instrumental "dub" versions of reggae records and to talk, or "toast," over them. The most remarkable local producer was Lee "Scratch" Perry, who was responsible for Bob Marley and the Wailers' earliest and best tracks. Perry, along with other pioneers such as King Tubby and Augustus Pablo, had branched out on his own by the mid-seventies, inventing the exaggerated use of reverb and obviously mixed and manipulated rhythms that came to be known as dub. It ushered in a fundamental change in the way records are made and enjoyed.

597. *Public Enemy,* 1990

The influence of sound systems began to expand as Jamaican immigrants flooded into Brooklyn, New York, where local DJs began adapting the idea to funk. Grandmaster Flash and Afrika Bambaataa (fig. 596) were the first of such DJs to gain popularity outside their own community. In their work, one can hear all the nascent elements of hip-hop, rap, and DJ culture: quirky repetitive beats overlaid with offbeat sound effects and

tough personal raps about sexual prowess
or social conditions. By the 1980s, virtu-
ally every urban release was based upon
a riff sampled from James Brown or the
classic guitar figure and beat from Chic's
disco hit "Good Times."

Bambaataa emerged from Flash's
shadow by making the most unusual
mixes, notably "Looking for the Perfect
Beat," which combined rap with music
sampled from the groundbreaking German
electronic group Kraftwerk. But the most
significant music was often made by DJs
live in clubs or on the radio. It was not
until the eighties, when the New York
University students Russell Simmons and
Rick Rubin combined rap and rock, that
the genre broke out of its local community
to take on the world. Their label, Def Jam,

598. *David Byrne*, 1997

helped spawn a global hip-hop culture—legions of artists who continue to create limber
rhyming poetry syncopated to complex beats cut up and reconstructed by expert DJs.
The three most influential groups in the eighties were Public Enemy, who matched
political diatribes with aggressively dense sonic collages (fig. 597); De La Soul, who
along with the producer Prince Paul broadened the range and tone of samples to
include mainstream pop and offbeat cultural detritus; and N.W.A., who pioneered the
West Coast style called gangsta rap, which mixed laid-back seventies funk with contro-
versial lyrics dealing with misogyny and violent crime.

During the eighties, another form of synthesis blossomed in the rock world. Led by
David Byrne and producer Brian Eno, the Talking Heads constructed records from layers
of Afro-pop, Latin rhythms, and punk flourishes. This continued the omnivorous tradi-
tion of rock and acknowledged that some of the most important music in the 1970s
and 1980s was made outside the United States and Britain, notably in West Africa and
Brazil by artists such as Salif Keita, Fela Kuti, Gilberto Gil, and Caetano Veloso.

Along with other so-called New Wave artists such as Devo, and pop maestros like
Michael Jackson and Madonna, Byrne also pioneered the medium of music videos,
short films that reflected pop music's ongoing preoccupation with visual iconography
(fig. 598). The rapid rise of MTV, a twenty-four-hour cable channel devoted to such
videos, ensured that this form of synthetic pleasure would continue to fuel the engines
of youth culture around the world. —J. C.

599. Tom Cruise and
Cuba Gooding, Jr., in
Jerry Maguire, directed
by Cameron Crowe, 1996
Columbia Tri-Star Pictures

HOLLYWOOD: OF CANNIBALS AND KINGS

"The trouble with movies as a business is that they're an art; the trouble with movies as an art is that they're a business," quipped Charlton Heston, paraphrasing the ancient Hollywood paradox. During the last decade of the century that witnessed the birth of film as both business and art, filmmakers increasingly juggled the contradictory roles of businessman and artist.

Thus Steven Spielberg, who directed an immodest number of the most successful movies ever made, divided his output between profit and honor. For profit, he made the dinosaur theme park thrill rides *Jurassic Park* (1993) and its 1997 sequel, *The Lost World*. For honor, he made the serious dramas *Schindler's List* (1993), about the Nazi war profiteer who saves the lives of Jews working for him; *Amistad* (1997), about the 1839 slave mutiny; and *Saving Private Ryan* (1998), a World War II combat film about the glory and folly of losing lives to save lives. Spielberg's serious films were the most explicit products of the "culture of empathy" inaugurated with President Bill Clinton in 1992.

Similarly, the director Jonathan Demme, who scored a phenomenal success with the psycho-thriller *The Silence of the Lambs* (1991), starring Jodie Foster as the FBI trainee recruited to debrief the psychotic cannibal Hannibal Lecter (Anthony Hopkins), seemed determined to invest his talents in more empathic projects, such as *Philadelphia* (1993), about a homophobic black attorney (Denzel Washington) who defends an AIDS-stricken lawyer (Tom Hanks) fired from his firm and comes to recognize homophobia as a form of racism; and *Beloved* (1998), starring Oprah Winfrey and Danny Glover, from the Toni Morrison novel about traumatized former slaves after Emancipation.

600. Denzel Washington
and Angela Bassett in
Malcolm X, directed by
Spike Lee, 1992
Warner Brothers

Under the political watch of President George Bush, Communist regimes from Berlin to Moscow fell, as did the Berlin Wall. This had the immediate effect of robbing American films of the perennial bad guy, the Communist madman. The confusion about whether Communists were friends or enemies gave considerable dramatic tension to such films as *The Hunt for Red October* (1990, John McTiernan) and *Crimson Tide* (1995, Tony Scott).

The demise of America's historic enemy also prompted many Americans to look for the enemy within. The actor-director Kevin Costner's *Dances with Wolves* (1990) is the saga of a Civil War soldier who abhorred U.S. treatment of Native Americans and joined a Lakota Sioux tribe. Robert Redford's *Quiz Show* (1994), with Ralph Fiennes and John Turturro as the winner and loser of a rigged 1950s game show, explored how television sponsors exploited an unsuspecting public. *Jerry Maguire* (fig. 599) featured Tom Cruise as an amoral sports agent who learns from a football player (Cuba Gooding, Jr.) about values of the nonmonetary kind.

Like *Jerry Maguire*, *White Men Can't Jump* (1992, Ron Shelton), starring Woody Harrelson and Wesley Snipes as basketball hustlers, suggested that the one level playing field for black and white Americans was—the playing field. Only Denzel Washington seems to have found other arenas. Perhaps the first African American to

transformations—from man to woman to mythological creature—with clothing and makeup and specifically crafted, special-effects prostheses (fig. 593). He has also elaborated his mythological narratives in an epic cycle of film works entitled *Cremaster*.

The confusion of the real and the imaginary qualifies almost every cultural art form of the decade. The "mockumentary," for instance, is a new form of film that looks like a documentary, but intentionally mixes fact and fiction. In his film *JFK*

play the everyman in Hollywood movies where race wasn't the subject, he starred as a journalist in *The Pelican Brief* (1993, Alan J. Pakula), a navy lieutenant in *Crimson Tide*, and an army officer in *Courage Under Fire* (1996, Edward Zwick)—in addition to his roles as a black Civil War soldier in *Glory* (1989, Edward Zwick) and as the eponymous political activist in *Malcolm X* (fig. 600).

Led by the prolific and prodigiously talented Spike Lee, who made the searing drama of racism *Do the Right Thing* (1989), the epic biography *Malcolm X*, and the Million Man March drama *Get on the Bus* (1996), African American filmmakers during the 1990s were able to break into Hollywood. John Singleton's *Boyz N the Hood* (1991) and Allen and Albert Hughes' *Menace II Society* (1993) were bleak dispatches from the war zone of South Central Los Angeles, films that led the critic Armond White to observe that "black kids see their teenage years in terms of survival, while white kids see theirs in terms of fun."

The exception to White's thesis may be *Clueless* (1995, Amy Heckerling), an update of Jane Austen's Emma as a Beverly Hills High sophomore, which boasted rich kids black and white. Heckerling was one of many women filmmakers to make their marks with romantic comedies. Others included Penny Marshall with *Big* (1988), starring Hanks as the boy in a man's body caught between his desire to be big and to remain a kid, and Nora Ephron with *Sleepless in Seattle* (1993).

Like an uncommon number of nineties hits, *Sleepless* starred Tom Hanks, the decade's most beloved common man, as the widower renewed by love. Hanks brought the human factor to films, whether as the AIDS-afflicted lawyer in *Philadelphia*, the coach in *A League of Their Own* (1992, Penny Marshall), the slow-witted witness to history in *Forrest Gump* (1994, Robert Zemeckis), the astronaut Jim Lovell in *Apollo 13* (1995, Ron Howard), or the squadron leader in *Saving Private Ryan*.

Among actresses, only Jodie Foster enjoyed a career as varied. As the spooked fed in *Silence of the Lambs*, the mother of a prodigy in *Little Man Tate* (1991), which she also directed, the cardsharp in *Maverick* (1994, Richard Donner), and the scientist who receives a message from extraterrestrials in *Contact* (1997, Robert Zemeckis), Foster made women the intellectual subject rather than the sexual object of films.

As military arsenals were downsized after the Cold War, a domestic war erupted over violence on screen. The two most controversial films were *Thelma and Louise* (1991, Ridley Scott) and *Pulp Fiction* (1994, Quentin Tarantino). The former starred Geena Davis as a runaway wife and Susan Sarandon as her pal who use a handgun in self-defense and, as fugitives, go on a shooting spree. *Pulp Fiction*, a stylized affair influenced by film noir, starred John Travolta and Samuel L. Jackson as hitmen-philosophers with a glib attitude toward killers and killing. Both films inflamed the national debate about screen violence, and both were very, very popular.

But the biggest debate at century's end is internal. In response to spectacles such as the very real-seeming velociraptors in *Jurassic Park* or the title character appearing in historic newsreel footage in *Forrest Gump*, the burning question is whether film technology is threatening to overwhelm film narrative. Not only is film an art and a business, it is also a storytelling and technological vehicle. —C. R.

(1991), director Oliver Stone used black-and-white film segments to suggest found footage. The film, which weaves together found documentary footage, constructed documentary footage, and constructed fiction about the assassination of President Kennedy, focuses on a moment when many Americans began to question the official government account. In *The Truman Show* (1998), the protagonist is the unwitting star of a television series: every aspect of his life is staged, controlled, and invaded by the camera without his knowledge. When he finally discovers what is going on, he is not allowed to escape. The question "is it real?" is ever present today as virtual experiences such as travel and sex through the Internet, or the simulacra of Las Vegas, have become commonplace. In a total reversal of standards, anything that looks real must now be doubted, while anything announcing its artificiality is more trustworthy.

The rise of the artificial has been accelerated by digital technology, which has provided new imaging techniques that also expand the visual imagination. Artists can use the computer as a tool to visualize and study fractal formations, to freeze and retrieve frames from television and movies, as a visual encyclopedia, and as a means to manipulate images. They are also using the computer for archiving and storing images and as a preparatory tool. Terry Winters, for example, employs computer-generated forms as a basis for the linear networks of lines that give his new paintings an electronic buzz (fig. 601). Mathew Ritchie has evolved an elaborate creation myth in his paintings that is in part inspired by computer games and animation—and he has a website that serves as a corollary to the paintings.

601. **Terry Winters**
Parallel Rendering 2,
1996
Oil on linen, 96 x 120 in.
(243.8 x 304.8 cm)
Tate Gallery, London

602. **Gary Hill**
*Inasmuch As It Is Always
Already Taking Place,*
1990
16-channel video/sound
installation at The
Museum of Modern Art,
New York

FILM AND VIDEO INSTALLATION IN THE 1980S AND 1990S

By the beginning of the eighties, performative, perceptual video installations had been replaced by theatrical environments, often shown in museums, in which the video monitor operated as a narrative element. As video editing grew more sophisticated and technology more widespread, two perennial subjects in American art—landscape and the urban environment—became major themes, in a range of videotapes and installations by Bill Viola, Doug Hall, Mary Lucier, Rita Myers, Juan Downey, Frank Gillette, Dara Birnbaum, Shigeko Kubota, Woody and Steina Vasulka, Susan Hiller, Nam June Paik, and Bruce and Norman Yonemoto. Woody and Steina Vasulka, pioneers of early video art, created a number of installations, including Steina's *The West* (1983), a study of the New Mexican desert. Mary Lucier's *Ohio at Giverny* (fig. 604) evoked childhood memory through a luminous depiction of the French and American countryside, while Bill Viola's installations—such as *Room for St. John of the Cross* (1983)—framed the relationship between man, nature, and the physical landscape within an existential spirituality.

Many of these artists continued to make video installations through the 1980s and 1990s. In a period that saw the fall of the Berlin Wall and Communism in Europe, Dara Birnbaum's installations such as *Tiananmen Square* (1990–91) reflected a concern with the deep social and political changes taking place. Bruce Nauman's angst-ridden pieces, including *Clown Torture* (fig. 605), expressed strong feelings of alienation, disorientation, anxiety, and violence. The role technology played in this alienation had been underlined in Nam June Paik's ironic installations *Moon Is the Oldest TV* (1965–76), in which technology replaces nature. Tony Oursler's projective installations of the early nineties made visible technology's intrusiveness on a psychic level.

Video projection had been used by artists such as Nauman, Viola, and Peter Campus since the 1970s (fig. 419). Projection released the video image from the constriction of the television monitor and, in the work of Gary Hill, Oursler, and Viola, from any frame at all. Bill Lundberg, Robert Whitman, and Tony Conrad had projected film onto objects in the 1960s. Now the frameless image returned. In Hill's *Tall Ships*, sixteen black-and-white, ghostlike projections of people move interactively, according to the viewer's movements, in the darkness of a long corridor.

The widespread use of video projection in the 1990s led to a new, cinematic

604. **Mary Lucier**
Ohio at Giverny, 1983
(detail)
Seven monitors, dimensions variable, with two laser-discs, color, sound;
18½ min.
Whitney Museum of American Art, New York; Purchase, with funds from the Louis and Bessie Adler Foundation, Inc., Seymour M. Klein, President and Mrs. Rudolph B. Schulhof
83.35a–j

For some artists, digital technologies have become a primary medium. Artists' websites have proliferated, as have works made specifically for the Web, which incorporate text, images, and quick-time sequences. Through the Internet, artists can distribute their work to millions of viewers at very little cost. Cyberspace has become a new public venue for artists to work in.

Artists making video installations, such as Gary Hill and Bill Viola (figs. 602, 603), have used digital technology to enhance their presentations or to create inter- active works. Advanced digital resolu- tion in the nineties has taken the video medium into a more sensual, sculptural, and experiential realm. Other techno- logical advances permit a level of retinal stimulation and sensationalism that has supplanted the low-key, relatively drab video art of the past. New video works such as Hill's *Tall Ships* and Viola's *Tree of Knowledge* create zones or environ- ments where the viewer can enter and interact with a magnified landscape of faces, body fragments, and other images. The extension of video into a physically interactive dimension—as in Diana Thater's rich, chromatic projections or

aesthetic, in which the languages of video and film began to merge. Diana Thater made a number of site-specific installations using different planes of projected video imagery that examined nature within the language of Hollywood film and Conceptual art (fig. 606). Artists working in other media—for example, Janine Antoni and Ann Hamilton in sculpture and performance (figs. 587, 588)—also began to make video installations.

Film asserted itself as a major medium and influence throughout the 1990s. Matthew Barney made the *Cremaster* series, a group of highly baroque films designed to be shown exclusively in movie theaters, and the imagery in his installations referenced forties Hollywood film. The narratives in Lorna Simpson's sumptuous black-and-white video projections evoked the stylized dramas of Hollywood film noir. By contrast, Liisa Roberts' installations used film as sculpture, inserting the plane of the projected film image into the gallery space in order to question our perceptions of time and memory. Just as the Internet had begun to break down the concept of art in physical space, film, the oldest time-based medium of all, used the moving image to reassert concrete spatial form. —C. I.

605. **Bruce Nauman**
Clown Torture: Dark and Stormy Night with Laughter, 1987
Video installation, color, sound, continuous loop; dimensions variable
Collection of Barbara Balkin Cottle and Robert Cottle

606. Diana Thater
The Bad Infinite, 1993
Three color laserdiscs, three laserdisc players, one sync box, three video projectors, and film gels, dimensions variable
Whitney Museum of American Art, New York; Purchase, with funds from The Robert B. and Emilie W. Betts Foundation 95.84a–j

607. Tony Oursler
Getaway #2, 1994
Mattress, cloth, video projector, laserdisc player, and laserdisc, 16 x 117½ x 86 in. (40.6 x 298.5 x 218.4 cm) overall
Whitney Museum of American Art, New York; Purchase, with funds from the Contemporary Painting and Sculpture Committee 95.22a–h

Tony Oursler's hybrid talking heads (figs. 606–08)—has made the medium more challenging to artists and more engaging to viewers. Video has in fact finally been accepted as a serious art form. It is not only collected with growing enthusiasm but has been stealing the spotlight from other art forms at large international art exhibitions. Video has also become a familiar language thanks to the global pervasiveness of MTV, with its fast-cutting videos set to music—videos often made by independent video artists as a means of supporting themselves.

The expansive, diverse art of the past decade is still too close to be called history or to be viewed with sufficient perspective. As in earlier periods, it encompasses multiple and contradictory tendencies, and we can only speculate about what future generations will find of lasting consequence. One thing is clear, however, even up close: we are shedding the old chauvinistic attitudes that gave rise to the term "The American Century" and are recognizing the multiplicity of cultures that is, and probably always has been, America's greatest strength. Over the past five decades, a profound shift has occurred in our approach to both history and cultural practice. Revisionist art history and the influence of cultural studies have overturned many once cherished assumptions—about the purpose and development of the avant-garde, about the hierarchies upon which the foundations of modern art history have been built, and about fixed styles and national boundaries. Artists now consider almost anything a fit subject or material for art making, while a heterogeneous array of perspectives has enriched the ways we look at art. Despite these changes—and because of them—two old questions still have currency: What is art? And what is American?

608. **Tony Oursler**
Mother's Boy, 1996
Sony CPJ 200 projector,
VCR, videotape, and
acrylic on fiberglass,
18 in. (45.7 cm) diameter
Collection of Tom Peters

Notes

1. Henry Louis Gates, Jr., "New Negroes, Migration, and Cultural Exchange," in *Jacob Lawrence: The Migration Series*, exh. cat. (Washington, D.C.: The Phillips Collection, 1993), pp. 17–21.

2. Dore Ashton, *The New York School: A Cultural Reckoning* (New York: Viking Press, 1972), p. 61.

3. Clement Greenberg, "'American-Type' Painting," *Partisan Review* (1955), reprinted in Greenberg, *Art and Culture: Critical Essays* (Boston: Beacon Press, 1961), p. 228.

4. Edward Alden Jewell, "End-of-the-Season Melange," *The New York Times*, June 6, 1943, sec. 2, p. 9, quoted in Irving Sandler, *The Triumph of American Painting: A History of Abstract Expressionism* (New York: Praeger Publishers, 1970), p. 33.

5. See Romy Golan, "On the Passage of a Few Persons Through a Rather Brief Period of Time," in Stephanie Barron with Sabine Eckmann, *Exiles and Emigrés: The Flight of European Artists from Hitler*, exh. cat. (Los Angeles: Los Angeles County Museum of Art, 1997), pp. 128–46.

6. Willem de Kooning, quoted in Robert Goodnough, ed., *Modern Artists in America* (New York: Wittenborn, Schulz, 1951), p. 225. The term "abstract expressionism" was first used in relation to New York artists in 1946 by *The New Yorker* critic Robert Coates.

7. Barnett Newman, quoted in Thomas Hess, *Barnett Newman*, exh. cat. (New York: The Museum of Modern Art, 1971), pp. 37–39.

8. Mark Rothko, "The Statement," *The Tiger's Eye* (October 1949), p. 114; Clyfford Still, quoted in Dorothy C. Miller, *Fifteen Americans*, exh. cat. (New York: The Museum of Modern Art, 1952), pp. 21–22.

9. Jackson Pollock, quoted by Lee Krasner in Barbara Rose, "A Conversation with Lee Krasner" (c. 1972), p. 10, quoted in Ellen Landau, "Lee Krasner: A study of Her Early Career, 1926–1949," Ph.D. diss. (Newark: University of Delaware, 1981), p. 210. Krasner recalled introducing Pollock to Hofmann, who asked, "Do you paint from nature?" Pollock replied, "I *am* nature."

10. Clement Greenberg, "'American-Type' Painting," pp. 218–19.

11. Mark Rothko, excerpt from "A Symposium on How to Combine Architecture, Painting, and Sculpture," *Interiors*, 110 (May 1951), p. 104.

12. Jackson Pollock, "My Painting," *Possibilities*, 1 (Winter 1947–48), p. 79.

13. Harold Rosenberg, "The American Action Painters," *Art News*, 51 (December 1952), pp. 22–23.

14. Clement Greenberg, "'American-Type' Painting," p. 228.

15. Ibid., p. 211.

16. Jackson Pollock, "My Painting," p. 79.

17. Elaine de Kooning, quoted in Irving Sandler, *The Triumph of American Painting*, p. 249.

18. David Smith, quoted in the typescript of The Museum of Modern Art's 1952 panel, "The New Sculpture: A Symposium," p. 7.

19. Theodore Roszak, quoted ibid.

20. Robert Rosenblum, "The Abstract Sublime," *Art News*, 59 (February 1961), pp. 38–41, 56–58; Lawrence Alloway, "The American Sublime," *The Living Arts*, 2 (1963), pp. 11–22, reprinted in Alloway, *Topics in American Art Since 1945* (New York: W. W. Norton, 1975), pp. 31–41.

21. Kirk Varnedoe, "Abstract Expressionism," in William Rubin, ed., *Primitivism in 20th Century Art: Affinity of the Tribal and the Modern*, vol. 2, exh. cat. (New York: The Museum of Modern Art, 1984), p. 653.

22. Sidra Stich, *Made in the USA* (Berkeley and Los Angeles: University of California Press, 1987), pp. 237, 245.

23. The "Irascibles" protested the exclusion of Abstract Expressionism from the exhibition "American Painting Today–1950," organized by The Metropolitan Museum of Art. "Open Letter to Roland L. Redmond, President, The Metropolitan Museum of Art" (May 20, 1950), in *Art News*, 49 (Summer 1950), pp. 226–27, reprinted in Clifford Ross, *Abstract Expressionism: Creators and Critics* (New York: Harry N. Abrams, 1990), pp. 226–27.

24. Dorothy Seiberling, "Jackson Pollock: Is He the Greatest Living Painter in the United States?" *Life*, August 8, 1949, pp. 42–45.

25. Norman Mailer, quoted in John Montgomery, *The Fifties* (London: Allen and Unwin, 1965), title page.

26. "American Identity/American Art," *Constructing American Identity*, exh. cat. (New York: Whitney Museum of American Art, 1991), p. 11.

27. Jane De Hart Mathews, "Art and Politics in Cold War America," *American Historical Review*, 81 (October 1976), p. 772.

28. Ibid., p. 774.

29. For the right-wing attack on modern art in the 1950s, see William Hauptman, "The Suppression of Art in the McCarthy Decade," *Artforum*, 12 (October 1973), pp. 48–52.

30. Alfred H. Barr, Jr., "Is Modern Art Communistic?," *The New York Times Magazine*, December 14, 1952, p. 30.

31. For Senator George Dondero, see Hauptman, "The Suppression of Art in the McCarthy Decade."

32. Ibid., p. 50.

33. Jane De Hart Mathews, "Art and Politics in Cold War America," pp. 772–73.

34. For a discussion of the link between Cold War politics and the successful promulgation of American Abstract Expressionism, see Serge Guilbaut, *How New York Stole the Idea of Modern Art: Abstract Expressionism, Freedom, and the Cold War* (Chicago and London: University of Chicago Press, 1983); Eva Cockcroft, "Abstract Expressionism, Weapon of the Cold War," *Artforum*, 12 (June 1974), pp. 39–41; Max Kozloff, "American Painting During the Cold War," in *Twenty-five Years of American Painting, 1948–1973*, exh. cat. (Des Moines: Des Moines Art Center, 1973).

35. David and Cecile Shapiro, "Abstract Expressionism: The Politics of Apolitical Painting," in Jack Salzman, ed., *Prospects*, no. 3 (1977), pp. 175–214.

36. Eva Cockcroft, "Abstract Expressionism, Weapon of the Cold War," pp. 39–41.

37. André Chastel, *Le Monde*, January 17, 1959, quoted in Ross, *Abstract Expressionism: Creators and Critics*, pp. 287–88.

38. Eric Newton, "As the British View Our Art," *The New York Times*, January 15, 1956, sec. 2, p. 14, quoted in Hayden Herrera, *American Art Goes to Europe* (unpublished manuscript).

39. Clyfford Still, "Open Letter to an Art Critic," *Artforum*, 2 (December 1963), reprinted in Ross, *Abstract Expressionism: Creators and Critics*, pp. 199–200.

40. Clement Greenberg, "'American-Type' Painting," p. 209.

41. Irving Sandler, "The Community of the New York School," *The New York School: The Painters and Sculptors of the Fifties* (New York: Harper & Row, 1978), pp. 29–48. For a discussion of second-generation Abstract Expressionist artists of color and women, see Ann E. Gibson, *Abstract Expressionism: Other Politics* (New Haven: London, 1997).

42. Simone de Beauvoir, *The Second Sex*, trans. H. M. Parshley (1953; rev. ed. New York: Random House, 1990).

43. For the California School of Fine Arts, see Susan Landauer, *The San Francisco School of Abstract Expressionism*, exh. cat. (Laguna Beach, California: Laguna Art Museum, 1996).

44. Clement Greenberg, "Towards a Newer Laocoön," *Partisan Review*, 7 (July–August 1940), p. 305: "Emphasize the medium and its difficulties, and at once the purely plastic, the proper values of visual art come to the fore."

45. Harold Rosenberg, *The Anxious Object* (1966; rev. ed. Chicago: University of Chicago Press, 1982), p. 77.

46. Ad Reinhardt, "Twelve Rules for a New Academy" (1953), in *Art News*, 56 (May 1957), pp. 37–38, 56.

47. For Clement Greenberg's discussion of the essential and inherent qualities of flatness and two-dimensionality in painting, see his essay "Modernist Painting," *Art and Literature* (Spring 1965), reprinted in John O'Brian, ed., *Clement Greenberg: The Collected Essays and Criticism*, vol. 4 (Chicago: University of Chicago Press, 1993), pp. 85–93.

48. Allan Kaprow, "The Legacy of Jackson Pollock," *Art News*, 57 (October 1958), p. 56.

49. Howard R. Moody, "Reflections on the Beat Generation," *Religion in Life*, 28 (Summer 1959), p. 427.

50. Allen Ginsberg, "Howl," *Howl and Other Poems* (San Francisco: City Lights Books, 1956), p. 9.

51. Jack Kerouac, foreword to Robert Frank, *The Americans* (New York: Grove Press, 1959; reprt. Zurich: Scalo, 1997), p. 6.

52. Allen Ginsberg, "Improvised Poetics," interview, November 26, 1968, published in Donald Allen, ed., *Composed on the Tongue* (Bolinas, California: Grey Fox Press, 1980), p. 43.

53. Jane Livingston, *New York School Photographs, 1936–1963* (New York: Stewart, Tabori & Chang, 1992), pp. 259, 274.

54. Ibid., p. 260.

55. Edward Steichen, introduction to *The Family of Man*, exh. cat. (New York: The Museum of Modern Art, 1955).

56. Robert Rauschenberg, quoted in Calvin Tomkins, *Off the Wall: Robert Rauschenberg and the Art World of Our Time* (New York: Penguin Books, 1980), p. 87.

57. Robert Rauschenberg, "Untitled Statement," in Dorothy C. Miller, ed., *Sixteen Americans*, exh. cat. (New York: The Museum of Modern Art, 1959), p. 58.

58. John Cage, "On Robert Rauschenberg, Artist and His Work," *Metro*, no. 2 (May 1961), pp. 36–51.

59. Ibid., p. 103.

60. Barbara Haskell, *Blam! The Explosion of Pop, Minimalism, and Performance, 1958–1964*, exh. cat. (New York: Whitney Museum of American Art, 1984), p. 31.

61. For a history of Black Mountain College, see Martin Duberman, *Black Mountain: An Exploration in Community* (New York: E. P. Dutton, 1972).

62. Ibid., pp. 350–58, for eyewitness accounts of this performance by Cage at Black Mountain College.

63. For Duchamp in America and Neo-Dada activity in the 1950s, see Susan Hapgood, *Neo-Dada: Redefining Art, 1958–62*, exh. cat. (New York: American Federation of the Arts, 1994); Bonnie Clearwater, ed., *West Coast Duchamp* (Miami Beach, Florida: Grassfield Press, 1991).

64. Robert Rosenblum, "Jasper Johns," *Arts Magazine*, 32 (January 1958), pp. 54–55.

65. Thomas Crow, *The Rise of the Sixties* (New York: Harry N. Abrams, 1996), pp. 15–16.

66. Claes Oldenburg, "Brief Description of the Show" (1960), reprinted in Germano Celant, *Claes Oldenburg: An Anthology*, exh. cat. (New York: Solomon R. Guggenheim Museum; and Washington, D.C., National Gallery of Art, 1995), p. 50.

67. Claes Oldenburg, "Untitled Statement" (1961), reprinted ibid., p. 96.

68. Allan Kaprow, "The Legacy of Jackson Pollock," *Art News*, 57 (1958), p. 57.

69. For more information on actions, performances, and activities, see Paul Schimmel, *Out of Actions: Between Performance and the Object, 1949–1979*, exh. cat. (Los Angeles: The Museum of Contemporary Art, 1998).

70. "Trend to the 'Anti-Art,'" *Newsweek*, March 31, 1958, pp. 94, 96.

71. George Maciunas, *Fluxus Manifesto* (1963), reprinted in *In the Spirit of Fluxus*, exh. cat. (Minneapolis: Walker Art Center, 1993), p. 24.

72. For the use of strategies based on "motivation analysis" to guide advertising campaigns in the 1950s, see Vance Packard, *The Hidden Persuaders* (New York: D. McKay Co., 1957) pp. 3–11.

73. Leo Steinberg, "Other Criteria," in *Other Criteria: Confrontations with Twentieth-Century Art* (New York: Oxford University Press, 1972), pp. 82–91.

74. Andy Warhol, quoted in "Pop Art—Cult of the Commonplace," *Time*, May 3, 1963, p. 72.

75. Harold Rosenberg, "The Game of Illusion: Pop and Gag," *The Anxious Object* (Chicago: University of Chicago Press, 1964), p. 63.

76. Calvin Tomkins, *Off the Wall: Robert Rauschenberg and the Art World of Our Time* (New York: Penguin Books, 1980), p. 185.

77. Herbert Read, "The Disintegration of Form in Modern Art," *Studio International*, 169 (April 1965), pp. 151, 153–54.

78. Ibid.

79. "Symposium on Pop Art" was organized by Peter Selz at The Museum of Modern Art in 1962. The panel comprised Henry Geldzahler, Stanley Kunitz, Hilton Kramer, Leo Steinberg, and Dore Ashton, with Selz as moderator; transcript published in *Arts*, 37 (April 1963), pp. 36–44.

80. Ibid., p. 52.

81. John Canaday, "Pop Art Sells On and On—Why?" *The New York Times Magazine*, May 31, 1964, p. 52.

82. Jasper Johns, quoted in G. R. Swenson, "What Is Pop Art? Interviews with Eight Painters," part 2, *Art News*, 62 (February 1964), p. 66.

83. Otto Hahn, untitled statement, in *Leo Castelli: Ten Years*, exh. cat. (New York: Leo Castelli Gallery, 1967).

84. *The Philosophy of Andy Warhol: From A to B and Back Again* (New York: Harcourt Brace Jovanovich, 1975), p. 92.

85. Richard F. Shepard, "To What Lengths Can Art Go?" *The New York Times*, May 13, 1965, p. 1; and "Art: Pop," *Time*, May 28, 1965, p. 80.

86. Allan Kaprow, "Should the Artist Become a Man of the World?" *Art News*, 63 (October 1964), p. 37.

87. Robert Motherwell, quoted in Barbara Rose and Irving Sandler, "Sensibility of the Sixties," *Art in America*, 55 (January–February 1967), p. 47.

88. Frank Stella, quoted in Bruce Glaser, "Questions to Stella and Judd," *Art News*, 65 (September 1966), pp. 58–59.

89. Andy Warhol, quoted in Robert Hughes, "The Rise of Andy Warhol," *The New York Review of Books*, February 18, 1982, p. 7.

90. John Cage, *Silence: Lectures and Writings by John Cage* (Middletown, Connecticut: 1966), p. 93.

91. Andy Warhol, quoted in Barbara Rose, "ABC Art," *Art in America*, 53 (October–November 1965), p. 69.

92. "The Artists Say: Dan Flavin," *Art Voices*, 4 (Summer 1965), p. 72.

93. Donald Judd, "Specific Objects" (1965), reprinted in *Donald Judd: Complete Writings, 1959–1975* (New York: New York University Press, 1975), pp. 181–89.

94. Clement Greenberg, "Recentness of Sculpture," *American Sculpture of the Sixties*, exh. cat. (Los Angeles: Los Angeles County Museum of Art, 1967), p. 25.

95. Maurice Berger, *Labyrinths: Robert Morris, Minimalism, and the 1960s* (New York: Harper and Row Publishers, 1989).

96. Lawrence Alloway, "Serial Forms," *American Sculpture of the Sixties*, p. 15.

97. Anna C. Chave, "Minimalism and the Rhetoric of Power," *Arts Magazine*, 64 (January 1990), pp. 44–63.

98. Gregory Battcock, "The Art of the Real: The Development of a Style, 1948–68," *Arts*, 42 (June 1968), p. 44.

99. See Robert Pincus-Witten, "Postminimalism: An Argentine Glance," *The New Sculpture, 1965–75: Between Geometry and Gesture*, exh. cat. (New York: Whitney Museum of American Art, 1990).

100. Lucy Lippard, "Eccentric Abstraction," *Art International*, 10 (November 1966), revised essay reprinted in Lippard, *Changing: Essays in Art Criticism* (New York: E. P. Dutton, 1971), p. 98.

101. Robert Morris, "Anti-Form," *Artforum*, 6 (April 1968), pp. 33–35.

102. Donald Judd, "Specific Objects," p. 187.

103. Max Kozloff, "9 in a Warehouse: An 'Attack on the Status of the Object,'" *Artforum*, 7 (February 1969), pp. 38–42.

104. Robert Pincus-Witten, "Postminimalism: An Argentine Glance," p. 25.

105. Richard Serra, quoted in Rosalind E. Krauss, *Passages in Modern Sculpture* (New York: Viking Press, 1977), p. 276.

106. See Rosalind E. Krauss, *Passages in Modern Sculpture* (New York: The Viking Press, 1977), chap. 6, pp. 201–42.

107. Michael Fried, "Art and Objecthood," *Artforum*, 5 (Summer 1967), pp. 12–23.

108. Tony Smith, quoted in Samuel Wagstaff, Jr., "Talking with Tony Smith," *Artforum*, 5 (December 1966), p. 19.

109. Robert Smithson, "The Monuments of Passaic," *Artforum*, 6 (December 1967), pp. 48–51.

110. Robert Smithson, "Entropy and the New Monuments," *Artforum*, 4 (June 1966), pp. 26–31.

111. Walter de Maria, "The Lightning Field: Some Facts, Notes, Data, Information, Statistics and Statements," *Artforum*, 18 (April 1980), p. 58.

112. Joseph Kosuth, "Art After Philosophy" (1969), in Gabriele Guercio, ed., *Art After Philosophy and After: Collected Writings, 1966–1990* (Cambridge, Massachusetts: MIT Press, 1991), p. 20.

113. Sol LeWitt, "Paragraphs on Conceptual Art," *Artforum*, 5 (Summer 1967), pp. 79–83.

114. Joseph Kosuth, "Art as Idea as Idea," in *Information*, exh. cat. (New York: The Museum of Modern Art, 1970), p. 69.

115. Seth Siegelaub, quoted in Charles Harrison, "On Exhibitions and the World at Large: A Conversation with Seth Siegelaub," *Studio International*, 178 (December 1969), reprinted in Gregory Battcock, *Idea Art: A Critical Anthology* (New York: E. P. Dutton, 1973), pp. 165–73.

116. Douglas Huebler, quoted in *January 5–31, 1969*, exh. cat. (New York: Seth Siegelaub, 1969), n.p.

117. See Jack Burnham, *Software*, exh. cat. (New York: The Jewish Museum, 1970).

118. Lucy Lippard and John Chandler, "The Dematerialization of Art," in Lippard, *Changing*, p. 255.

119. Robert Hughes, "The Decline and Fall of the Avant-Garde," *Time*, December 18, 1972, pp. 111–12.

120. Jon Hendricks and Jean Toche, *GAAG, the Guerrilla Art Action Group, 1969–1976: A Selection* (New York: Printed Matter, 1978).

121. A statement from these artists—John Dowell, Sam Gilliam, Daniel Johnson, Joe Overstreet, Melvin Edwards, Richard Hunt, and William T. Williams—was published in the "Politics" section in *Artforum*, 9 (May 1971), p. 12.

122. Victor Sorell, "Articulate Signs of Resistance and Affirmation in Chicano Public Art," in *Chicano Art: Resistance and Affirmation, 1965–1985*, exh. cat. (Los Angeles: Wight Art Gallery, University of California, Los Angeles, 1990), pp. 148–51.

123. Linda Nochlin, "Why Have There Been No Great Women Artists?," *Art News*, 69 (January 1971), pp. 22–39.

124. Grace Glueck, "Women Artists Demonstrate at Whitney," *The New York Times*, December 23, 1970, reprinted in *Cultural Economies: Histories from the Alternative Arts Movement, NYC* (New York: The Drawing Center), p. 23.

125. Andreas Huyssen, "Mapping the Postmodern," in *After the Great Divide: Modernism, Mass Culture, Postmodernism* (Bloomington: Indiana University Press, 1986), p. 185.

126. Clement Greenberg, "On the Role of Nature in Modernist Painting" (1949), reprinted in Greenberg, *Art and Culture*, p. 174.

127. Robert Venturi, *Complexity and Contradiction in Architecture* (1966; 2nd ed. New York: The Museum of Modern Art, 1977), p. 17.

128. Carolee Schneemann, quoted in Lucy R. Lippard, *Overlay: Contemporary Art and the Art of Prehistory* (New York: Pantheon Books, 1983), p. 67.

129. Dan Cameron, *Carolee Schneemann: Up To and Including Her Limits*, exh. cat. (New York: The New Museum of Contemporary Art, 1996), pp. 27–28.

130. Phil Patton, "Other Voices, Other Rooms: The Rise of the Alternative Space," *Art in America*, 65 (July-August 1977), pp. 80–89.

131. Vickie Goldberg, *The Power of Photography: How Photographs Changed Our Lives* (New York: Abbeville Press, 1991).

132. Douglas Crimp, *Pictures*, exh. cat. (New York: Artists Space; Committee for the Visual Arts, 1977), p. 3.

133. Craig Owens, quoted in Barbara Kruger and Sarah Charlesworth, "Glossalia," *Bomb*, 5 (Spring 1983), p. 61.

134. Jonathan Alter, "The Cultural Elite: The Newsweek 100," *Newsweek*, October 5, 1992, p. 37.

135. Richard Prince, quoted in Kristine McKenna, "On Photography: Looking for Truth Between the Lies," *Los Angeles Times*, May 19, 1985, p. 91.

136. Irving Sandler, "Tenth Street Then and Now," in Janet Kardon, *The East Village Scene*, exh. cat. (Philadelphia: Institute of Contemporary Art, University of Pennsylvania, 1984), pp. 10–19; Craig Owens, "East Village '84: Commentary, The Problem with Puerilism," *Art in America*, 72 (Summer 1984), pp. 162–63.

137. Lehmann Weichselbaum, "The Real Estate Show," *East Village Eye* (January 1980), reprinted in Alan Moore and Marc Miller, eds., *ABC No Rio Dinero: The Story of a Lower East Side Art Gallery* (New York: ABC No Rio with Collaborative Projects, 1985), pp. 52–53.

138. Jeffrey Deitch, "Report from Times Square," *Art in America*, 68 (September 1980), pp. 58–63.

139. Elizabeth Hess, "The People's Choice," *The Village Voice* (1981), reprinted in Moore and Miller, eds., *ABC No Rio Dinero*, p. 24.

140. For a detailed history of CBGB-OMFUG, see Roman Kozak, *This Ain't No Disco: The Story of CBGB* (Boston: Faber and Faber, 1988).

141. Edit deAk, "Urban Kisses/Slum Hisses" (1981), reprinted in Moore and Miller, eds., *ABC No Rio Dinero*, pp. 34–35.

142. Mark Stevens, "Bull in the China Shop," *Newsweek*, May 11, 1981, p. 79.

143. George W. S. Trow, *Within the Context of No Context* (Boston: Little, Brown and Company, 1981), p. 27.

144. Jesse Helms, quoted in Cathleen McGuigan, "Arts Grants Under Fire," *Newsweek*, August 7, 1989, p. 23.

145. Quoted in Richard Bolton, "The Cultural Contradictions of Conservatism," *New Art Examiner*, 17 (June 1990), p. 26.

146. Carol Vance has introduced the sex panic theory, most notably in "Reagan's Revenge: Restructuring the NEA," *Art in America*, 78 (November 1990), pp. 49–55.

147. Irving Kristol, "It's Obscene But Is It Art?" *The Wall Street Journal*, August 7, 1990, p. A8.

148. Lari Pittman, quoted in *Sunshine & Noir: Art in L.A. 1960–1997*, exh. cat. (Humlebaek, Denmark: Louisiana Museum of Modern Art, 1997), p. 202.

149. Joan Didion, *Slouching Towards Bethlehem* (New York: Dell Publishing, 1968), p. 65, quoted in Norman M. Klein, "Inside the Consumer-Built City: Sixty Years of Apocalyptic Imagery," in *Helter Skelter: L.A. Art in the 1990s*, exh. cat. (Los Angeles: The Museum of Contemporary Art, 1992), p. 27.

Selected Bibliography

General
Surveys: Art, History, and Culture

Albright, Thomas. *Art in the San Francisco Bay Area, 1945–1980: An Illustrated History* (exhibition catalog). Berkeley: University of California Press, 1985.

Armstrong, Tom, et al. *200 Years of American Sculpture* (exhibition catalog). New York: Whitney Museum of American Art, 1976.

Arnason, H. H. *History of Modern Art: Painting, Sculpture, Architecture, Photography*. 3rd ed. (revised and updated by Daniel Wheeler). New York: Harry N. Abrams, 1986.

Ashton, Dore. *American Art Since 1945*. New York: Oxford University Press, 1982.

Bearden, Romare, and Harry Henderson. *A History of African-American Artists: From 1792 to the Present*. New York: Pantheon Books, 1993.

Bois, Yve-Alain, and Rosalind E. Krauss. *Formless: A User's Guide* (exhibition catalog). Paris: Centre Georges Pompidou, 1996.

Brougher, Kerry, et al. *Hall of Mirrors: Art and Film Since 1945* (exhibition catalog). Los Angeles: The Museum of Contemporary Art, Los Angeles, 1996.

Brown, Milton W., et al. *American Art: Painting, Sculpture, Architecture, Decorative Arts, Photography* (1979). Reprt. Englewood Cliffs, New Jersey: Prentice-Hall; New York: Harry N. Abrams, 1988.

Burnham, Jack. *Beyond Modern Sculpture: The Effects of Science and Technology on the Sculpture of This Century* (1968). Reprt. New York: George Braziller, 1982.

Crane, Diana. *The Transformation of the Avant-Garde: The New York Art World, 1940–1985*. Chicago: University of Chicago Press, 1987.

Fineberg, Jonathan. *Art Since 1940: Strategies of Being*. New York: Harry N. Abrams, 1995.

Forty Years of California Assemblage (exhibition catalog). Los Angeles: Wight Art Gallery, University of California, Los Angeles, 1989.

Frascina, Francis, et al., *Modernism in Dispute: Art Since the Forties*. New Haven: Yale University Press in association with The Open University, 1993.

Geldzahler, Henry. *New York Painting and Sculpture: 1940–1970* (exhibition catalog). New York: The Metropolitan Museum of Art, 1969.

Hughes, Robert. *American Visions: The Epic History of Art in America*. New York: Alfred A. Knopf, 1997.

Hunter, Sam, ed. *An American Renaissance: Painting and Sculpture Since 1940* (exhibition catalog). Fort Lauderdale, Florida: Museum of Art, 1986.

Joachimides, Christos M., and Norman Rosenthal, eds. *American Art in the 20th Century: Painting and Sculpture, 1913–1993* (exhibition catalog). Berlin: Martin-Gropius-Bau; London: Royal Academy of Arts and the Saatchi Gallery, 1993.

Krauss, Rosalind E. *Passages in Modern Sculpture*. New York: Viking Press, 1977.

Leja, Michael. *Reframing Abstract Expressionism: Subjectivity and Painting in the 1940s*. New Haven: Yale University Press, 1993.

Lucie-Smith, Edward. *American Art Now*. New York: William Morrow and Company, 1985.

Patton, Sharon F. *African American Art*. New York: Oxford University Press, 1998.

Plagens, Peter. *Sunshine Muse: Contemporary Art on the West Coast*. New York and Washington, D.C.: Praeger Publishers, 1974.

Powell, Richard J. *Black Art and Culture in the 20th Century*. New York: Thames and Hudson, 1997.

Rose, Barbara. *American Art Since 1900* (1967). Rev. ed. New York and Washington, D.C.: Praeger Publishers, 1975.

Rosenthal, Mark. *Abstraction in the Twentieth Century: Total Risk, Freedom, Discipline* (exhibition catalog). New York: Solomon R. Guggenheim Museum, 1996.

Senie, Harriet F. *Contemporary Public Sculpture: Tradition, Transformation, and Controversy*. New York: Oxford University Press, 1992.

Smith, Richard Candida. *Utopia and Dissent: Art, Poetry, and Politics in California*. Berkeley: University of California Press, 1995.

Warren, Lynne, et al. *Art in Chicago, 1945–1995* (exhibition catalog). Chicago: Museum of Contemporary Art, 1996.

Wheeler, Daniel. *Art Since Mid-Century: 1945 to the Present*. New York: Vendome Press, 1991.

Criticism and Theory

Ashton, Dore. *Out of the Whirlwind: Three Decades of Arts Commentary*. Ann Arbor, Michigan: UMI Research Press, 1987.

Berger, Maurice, ed. *Modern Art and Society: An Anthology of Social and Multicultural Readings*. New York: Icon Editions/HarperCollins Publishers, 1994.

Bois, Yve-Alain. *Painting as Model* (1990). Reprt. Cambridge, Massachusetts: October/MIT Press, 1995.

Bryson, Norman, ed. *Calligram: Essays in New Art History from France*. New York: Cambridge University Press, 1988.

Buettner, Stewart. *American Art Theory: 1945–1970*. Ann Arbor, Michigan: UMI Research Press, 1981.

Burgin, Victor. *The End of Art Theory: Criticism and Postmodernity*. Atlantic Highlands, New Jersey: Humanities Press International, 1986.

Calas, Nicolas. *Transfigurations: Art Critical Essays on the Modern Period*. Ann Arbor, Michigan: UMI Research Press, 1985.

Crimp, Douglas. *On the Museum's Ruins*. Photographs by Louise Lawler. Cambridge, Massachusetts: MIT Press, 1993.

Crow, Thomas. *Modern Art in the Common Culture*. New Haven: Yale University Press, 1996.

Danto, Arthur C. *Beyond the Brillo Box: The Visual Arts in Post-Historical Perspective*. New York: Farrar, Straus & Giroux, 1992.

———. *The Transfiguration of the Commonplace: A Philosophy of Art.* Cambridge, Massachusetts: Harvard University Press, 1981.

Davis, Douglas. *Artculture: Essays on the Post-Modern.* Introduction by Irving Sandler. New York: Icon Editions/Harper & Row, 1977.

de Duve, Thierry. *Clement Greenberg Between the Lines.* Translated by Brian Holmes. Paris: Éditions Dis Voir, 1996.

———. *Kant after Duchamp.* Cambridge, Massachusetts: October/MIT Press, 1996.

Ferguson, Russell, et al., eds. *Discourses: Conversations in Postmodern Art and Culture.* Photographic sketchbook by John Baldessari. New York: The New Museum of Contemporary Art; Cambridge, Massachusetts: MIT Press, 1990.

Ferguson, Russell, et al., eds. *Out There: Marginalization and Contemporary Cultures.* New York: The New Museum of Contemporary Art; Cambridge, Massachusetts: MIT Press, 1990.

Foster, Hal, ed. *The Anti-Aesthetic: Essays on Postmodern Culture.* Seattle: Bay Press, 1983.

———. *Recodings: Art, Spectacle, Cultural Politics.* Port Townsend, Washington: Bay Press, 1985.

———. *The Return of the Real: The Avant-Garde at the End of the Century.* Cambridge, Massachusetts: October/MIT Press, 1996.

Frascina, Francis, and Jonathan Harris, eds. *Art in Modern Culture: An Anthology of Critical Texts.* New York: Icon Editions/HarperCollins Publishers, 1992.

Fusco, Coco. *English Is Broken Here: Notes on Cultural Fusion in the Americas.* New York: New Press, 1995.

Gablik, Suzi. *Has Modernism Failed?* New York: Thames and Hudson, 1984.

Gilbert-Rolfe, Jeremy. *Beyond Piety: Critical Essays on the Visual Arts, 1986–1993.* New York: Cambridge University Press, 1995.

———. *Immanence and Contradiction: Recent Essays on the Artistic Device.* New York: Out of London Press, 1985.

Greenberg, Clement. *Art and Culture: Critical Essays.* Boston: Beacon Press, 1961.

Harrison, Charles, and Paul Wood, eds. *Art in Theory, 1900–1990: An Anthology of Changing Ideas.* Cambridge, England: Blackwell Publishers, 1993.

hooks, bell. *Art on My Mind: Visual Politics.* New York: New Press, 1995.

Jones, Caroline A. *Machine in the Studio: Constructing the Postwar American Artist.* Chicago: University of Chicago Press, 1996.

Kozloff, Max. *The Privileged Eye: Essays on Photography.* Albuquerque: University of New Mexico Press, 1987.

Kramer, Hilton. *The Revenge of the Philistines: Art and Culture, 1972–1984.* New York: Free Press, 1985.

Krauss, Rosalind E. *The Originality of the Avant-Garde and Other Modernist Myths* (1985). Reprt. Cambridge, Massachusetts: MIT Press, 1994.

Lacy, Suzanne, ed. *Mapping the Terrain: New Genre Public Art.* Seattle: Bay Press, 1995.

Lippard, Lucy R. *Changing: Essays in Art Criticism.* New York: E. P. Dutton, 1971.

———. *Mixed Blessings: New Art in a Multicultural America.* New York: Pantheon Books, 1990.

———. *Overlay: Contemporary Art and the Art of Prehistory.* New York: Pantheon Books, 1983.

Masheck, Joseph. *Modernities: Art-Matters in the Present.* University Park: Pennsylvania State University Press, 1993.

McEvilley, Thomas. *Art and Discontent: Theory at the Millennium.* Kingston, New York: Documentext/McPherson & Company, 1991.

———. *Art and Otherness: Crisis in Cultural Identity.* Kingston, New York: Documentext/McPherson & Company, 1992.

McLuhan, Marshall, and Quentin Fiore. *The Medium Is the Massage: An Inventory of Effects.* New York: Random House, 1967.

O'Brian, John, ed. *Clement Greenberg: The Collected Essays and Criticism.* Vol. 1, *Perceptions and Judgments, 1939–1944.* Vol. 2, *Arrogant Purpose, 1945–1949.* Vol. 3, *Affirmations and Refusals, 1950–1956.* Vol. 4, *Modernism with a Vengeance, 1957–1969.* Chicago: University of Chicago Press, 1986, 1993.

O'Doherty, Brian. *Inside the White Cube: The Ideology of the Gallery Space.* Introduction by Thomas McEvilley. Santa Monica and San Francisco: Lapis Press, 1986.

O'Hara, Frank. *Art Chronicles, 1954–1966.* New York: Venture/George Braziller, 1975.

Owens, Craig. *Beyond Recognition: Representation, Power, and Culture.* Berkeley: University of California Press, 1992.

Rosenberg, Harold. *The Anxious Object: Art Today and Its Audience.* New York: Horizon Press, 1964.

———. *The De-Definition of Art: Action Art to Pop to Earthworks.* New York: Horizon Press, 1972.

———. *Discovering the Present: Three Decades in Art, Culture, and Politics.* Chicago: University of Chicago Press, 1973.

———. *The Tradition of the New.* New York: Horizon Press, 1959.

Sontag, Susan. *Against Interpretation and Other Essays* (1966). Reprt. New York: Octagon/Farrar, Straus & Giroux, 1978.

Staniszewski, Mary Anne. *Believing Is Seeing: Creating the Culture of Art.* New York: Penguin Books, 1995.

Steinberg, Leo. *Other Criteria: Confrontations with Twentieth-Century Art.* New York: Oxford University Press, 1972.

Tomkins, Calvin. *The Bride and the Bachelors: Five Masters of the Avant-Garde* (1965). Rev. ed. New York: Penguin Books, 1976.

Varnedoe, Kirk, and Adam Gopnik, eds. *Modern Art and Popular Culture: Readings in High and Low.* New York: The Museum of Modern Art and Harry N. Abrams, 1990.

Wallis, Brian, ed. *Art after Modernism: Rethinking Representation.* Foreword by Marcia Tucker. New York: The New Museum of Contemporary Art; Boston: David R. Godine, 1984.

Wolfe, Tom. *The Painted Word.* New York: Farrar, Straus & Giroux, 1975.

Artists' Writings

Chicago, Judy. *Through the Flower: My Struggle as a Woman Artist.* Introduction by Anaïs Nin. Garden City, New York: Doubleday & Company, 1975.

Chipp, Herschel B. *Theories of Modern Art: A Source Book by Artists and Critics.* Contributions by Peter Selz and Joshua C. Taylor. Berkeley: University of California Press, 1968.

Cummings, Paul, ed. *Artists in Their Own Words.* New York: St. Martin's Press, 1979.

Golub, Leon. *Do Paintings Bite? Selected Texts, 1948–1996.* Ostfildern, Germany: Cantz Verlag, 1997.

Graham, Dan. *Video-Architecture-Television: Writings on Video and Video Works, 1970–1978.* Halifax, Nova Scotia: The Press of the Novia Scotia College of Art and Design; New York: New York University Press, 1979.

Halley, Peter. *Collected Essays, 1981–1987.* Zurich: Bruno Bischofberger Gallery, 1988.

Johnson, Ellen H., ed. *American Artists on Art: From 1940 to 1980.* New York: Icon Editions/Harper & Row, 1982.

Judd, Donald. *Complete Writings, 1959–1975.* Halifax, Nova Scotia: The Press of the Novia Scotia College of Art and Design; New York: New York University Press, 1975.

———. *Complete Writings, 1975–1986.* Eindhoven, The Netherlands: Van Abbemuseum, 1987.

Kaprow, Allan. *Essays on the Blurring of Art and Life.* Berkeley: University of California Press, 1993.

Kelly, Mary. *Imaging Desire.* Cambridge, Massachusetts: MIT Press, 1996.

Morris, Robert. "Anti Form." *Artforum,* 6 (April 1968), pp. 33–35.

———. "Notes on Sculpture." *Artforum,* 4 (February 1966), pp. 42–44.

———. "Notes on Sculpture, Part 2." *Artforum,* 5 (October 1966), pp. 20–23.

———. "Notes on Sculpture, Part 3: Notes on Nonsequiturs." *Artforum,* 5 (June 1967), pp. 24–29.

———. "Notes on Sculpture, Part 4: Beyond Objects." *Artforum,* 7 (April 1969), pp. 50–54.

Motherwell, Robert. *The Collected Writings of Robert Motherwell.* New York: Oxford University Press, 1992.

Newman, Barnett. *Barnett Newman: Selected Writings and Interviews.* Edited by John P. O'Neill. New York: Alfred A. Knopf, 1990.

Piper, Adrian. *Out of Order, Out of Sight.* Vol. 1, *Selected Writings in Meta-Art, 1968–1992.* Vol. 2, *Selected Writings in Art Criticism, 1967–1992.* Cambridge, Massachusetts: MIT Press, 1996.

Porter, Fairfield. *Art in Its Own Terms: Selected Criticism, 1935–1975.* Edited and with an introduction by Rackstraw Downes. New York: Taplinger, 1979.

Reinhardt, Ad. *Art-as-Art: The Selected Writings of Ad Reinhardt* (1975). Edited and with an introduction by Barbara Rose. Berkeley: University of California Press, 1991.

Schor, Mira. *Wet: On Painting, Feminism, and Art Culture.* Durham, North Carolina: Duke University Press, 1997.

Smithson, Robert. *Robert Smithson: The Collected Writings.* Edited by Jack Flam. Berkeley: University of California Press, 1996.

Stiles, Kristine, and Peter Selz, eds. *Theories and Documents of Contemporary Art: A Sourcebook of Artists' Writings.* Berkeley: University of California Press, 1996.

Wallis, Brian, ed. *Blasted Allegories: An Anthology of Writings by Contemporary Artists.* Foreword by Marcia Tucker. New York: The New Museum of Contemporary Art; Cambridge, Massachusetts: MIT Press, 1987.

Warhol, Andy. *The Philosophy of Andy Warhol: From A to B and Back Again.* New York: Harcourt Brace Jovanovich, 1975.

Witzling, Mara R., ed. *Voicing Today's Visions: Writings by Contemporary Women Artists.* New York: Universe, 1994.

America Takes Command, 1950–1960

Anfam, David. *Abstract Expressionism.* New York: Thames and Hudson, 1990.

Ashton, Dore. *The New York School: A Cultural Reckoning.* New York: Viking Press, 1973.

Auping, Michael, et al. *Abstract Expressionism: The Critical Developments* (exhibition catalog). Buffalo: Albright-Knox Art Gallery, 1987.

The Fifties: Aspects of Painting in New York (exhibition catalog). Washington, D.C.: Hirshhorn Museum and Sculpture Garden, Smithsonian Institution, 1980.

Frascina, Francis, ed. *Pollock and After: The Critical Debate.* New York: Icon Editions/Harper & Row, 1985.

Gibson, Ann Eden. *Abstract Expressionism: Other Politics.* New Haven: Yale University Press, 1997.

Guilbaut, Serge. *How New York Stole the Idea of Modern Art: Abstract Expressionism, Freedom, and the Cold War.* Translated by Arthur Goldhammer. Chicago: University of Chicago Press, 1983.

Jones, Caroline A. *Bay Area Figurative Art, 1950–1965* (exhibition catalog). San Francisco: San Francisco Museum of Modern Art, 1990.

Kingsley, April. *The Turning Point: The Abstract Expressionists and the Transformation of American Art.* New York: Simon and Schuster, 1992.

Landauer, Susan. *The San Francisco School of Abstract Expressionism* (exhibition catalog). Introduction by Dore Ashton. Laguna Beach, California: Laguna Art Museum, 1996.

Phillips, Lisa. *The Third Dimension: Sculpture of the New York School* (exhibition catalog). New York: Whitney Museum of American Art, 1984.

Polcari, Stephen. *Abstract Expressionism and the Modern Experience.* New York: Cambridge University Press, 1991.

Ross, Clifford, ed. *Abstract Expressionism: Creators and Critics.* New York: Harry N. Abrams, 1990.

Sandler, Irving. *The New York School: The Painters and Sculptors of the Fifties.* New York: Icon Editions/Harper & Row, 1978.

———. *The Triumph of American Painting: A History of Abstract Expressionism.* New York and Washington, D.C.: Praeger Publishers, 1970.

Schimmel, Paul, et al. *Action/Precision: The New Direction in New York, 1955–60* (exhibition catalog). Newport Beach, California: Newport Harbor Art Museum, 1984.

———. *The Figurative Fifties: New York Figurative Expressionism* (exhibition catalog). Newport Beach, California: Newport Harbor Art Museum, 1988.

Selz, Peter. *New Images of Man* (exhibition catalog). New York: The Museum of Modern Art, 1959.

Shapiro, David, and Cecile Shapiro, eds. *Abstract Expressionism: A Critical Record* (1990). Reprt. New York: Cambridge University Press, 1995.

Tuchman, Maurice, ed. *The New York School: Abstract Expressionism in the 1940s and 1950s.* Greenwich, Connecticut: New York Graphic Society, 1971.

Redefining the American Dream, 1950–1960

Armstrong, Elizabeth, et al. *In the Spirit of Fluxus* (exhibition catalog). Minneapolis: Walker Art Center, 1993.

Kaprow, Allan. *Assemblage, Environments, and Happenings.* New York: Harry N. Abrams, 1966.

Kirby, Michael. *Happenings: An Illustrated Anthology.* New York: E. P. Dutton & Co., 1966.

Kostelanetz, Richard. *The Theatre of Mixed Means: An Introduction to Happenings, Kinetic Environments, and Other Mixed-Means Presentations.* New York: RK Editions, 1980.

Phillips, Lisa. *Beat Culture and the New America, 1950–1965* (exhibition catalog). New York: Whitney Museum of American Art, 1995.

Rosset, Barney, ed. *Evergreen Review Reader, 1957–1966.* New York: Blue Moon Books and Arcade Publishing, 1994.

Schimmel, Paul, et al. *Out of Actions: Between Performance and the Object, 1949–1979* (exhibition catalog). Los Angeles: The Museum of Contemporary Art, 1998.

Seitz, William C. *The Art of Assemblage* (exhibition catalog). New York: The Museum of Modern Art, 1961.

Solnit, Rebecca. *Secret Exhibition: Six California Artists of the Cold War Era.* San Francisco: City Lights Books, 1990.

Stich, Sidra. *Made in U.S.A.: An Americanization in Modern Art, the '50s and '60s* (exhibition catalog). Berkeley: University Art Museum, University of California, Berkeley, 1987.

New Frontiers, 1960–1967

Alloway, Lawrence. *American Pop Art* (exhibition catalog). New York: Whitney Museum of American Art, 1974.

———. *Systemic Painting* (exhibition catalog). New York: Solomon R. Guggenheim Museum, 1966.

Ayres, Anne, et al. *L.A. Pop in the Sixties* (exhibition catalog). Newport Beach, California: Newport Harbor Art Museum, 1989.

Battcock, Gregory, ed. *Minimal Art: A Critical Anthology.* Reprt. Berkeley: University of California Press, 1995.

Colpitt, Frances. *Minimal Art: The Critical Perspective.* Ann Arbor, Michigan: UMI Research Press, 1990.

Crow, Thomas. *The Rise of the Sixties: American and European Art in the Era of Dissent.* New York: Perspectives/Harry N. Abrams, 1996.

Haskell, Barbara. *Blam! The Explosion of Pop, Minimalism, and Performance, 1958–1964* (exhibition catalog). New York: Whitney Museum of American Art, 1984.

Lippard, Lucy R. *Pop Art.* Contributions by Lawrence Alloway, Nancy Marmer, and Nicolas Calas. New York and Washington, D.C.: Frederick A. Praeger, 1966.

Livingstone, Marco. *Pop Art: A Continuing History.* New York: Harry N. Abrams, 1990.

Madoff, Steven Henry. *Pop Art: A Critical History.* Berkeley: University of California Press, 1997.

Mahsun, Carol Anne, ed. *Pop Art: The Critical Dialogue.* Ann Arbor, Michigan: UMI Research Press, 1989.

McShine, Kynaston. *Primary Structures: Younger American and British Sculptors* (exhibition catalog). New York: The Jewish Museum, 1966.

Russell, John, and Suzi Gablik, eds. *Pop Art Redefined.* London: Thames and Hudson, 1969.

Sandler, Irving. *American Art of the 1960s.* New York: Icon Editions/Harper & Row, 1988.

Schimmel, Paul, and Donna De Salvo. *Hand-Painted Pop: American Art in Transition, 1955–62* (exhibition catalog). Los Angeles: The Museum of Contemporary Art, Los Angeles, 1992.

Seitz, William C. *Art in the Age of Aquarius, 1955–1970.* Washington, D.C.: Smithsonian Institution Press, 1992.

Tuchman, Maurice. *American Sculpture of the Sixties* (exhibition catalog). Los Angeles: Los Angeles County Museum of Art, 1967.

———. *Art in Los Angeles: Seventeen Artists in the Sixties* (exhibition catalog). Los Angeles: Los Angeles County Museum of Art, 1981.

Warhol, Andy, and Pat Hackett. *POPism: The Warhol '60s*. New York: Harcourt Brace Jovanovich, 1980.

Whiting, Cecile. *A Taste for Pop: Pop Art, Gender, and Consumer Culture*. New York: Cambridge University Press, 1997.

America at the Crossroads, 1964–1976

Armstrong, Richard, and Richard Marshall, eds. *The New Sculpture, 1965–1975: Between Geometry and Gesture* (exhibition catalog). New York: Whitney Museum of American Art, 1990.

Ault, Julie, ed. *Cultural Economies: Histories from the Alternative Arts Movement, NYC* (exhibition catalog). New York: The Drawing Center, 1996.

Battcock, Gregory, ed. *Idea Art: A Critical Anthology*. New York: E. P. Dutton, 1973.

———, ed. *The New Art: A Critical Anthology* (1966). Reprt. New York: E. P. Dutton, 1973.

Beardsley, John. *Probing the Earth: Contemporary Land Projects* (exhibition catalog). Washington, D.C.: Hirshhorn Museum and Sculpture Garden, Smithsonian Institution, 1977.

Broude, Norma, and Mary D. Garrard, eds. *The Power of Feminist Art: The American Movement of the 1970s, History and Impact*. New York: Harry N. Abrams, 1994.

Goldstein, Ann, and Anne Rorimer. *Reconsidering the Object of Art, 1965–1975* (exhibition catalog). Los Angeles: The Museum of Contemporary Art, 1995.

Griswold del Castillo, Richard, Teresa McKenna, and Yvonne Yarbro-Bejarano, eds. *Chicano Art: Resistance and Affirmation, 1965-1985* (exhibition catalog). Los Angeles: Wight Art Gallery, University of California, Los Angeles, 1990.

Hess, Thomas B., and Elizabeth C. Baker, eds. *Art and Sexual Politics: Women's Liberation, Women Artists, and Art History* (1973). Reprt. New York: Collier Books, 1975.

Jones, Amelia, ed. *Sexual Politics: Judy Chicago's "Dinner Party" in Feminist Art History* (exhibition catalog). Los Angeles: UCLA at the Armand Hammer Museum of Art and Cultural Center, 1996.

Kardon, Janet. *The Decorative Impulse* (exhibition catalog). Philadelphia: Institute of Contemporary Art, University of Pennsylvania, 1979.

Lippard, Lucy R. *From the Center: Feminist Essays on Women's Art*. New York: E. P. Dutton, 1976.

———. *Get the Message? A Decade of Art for Social Change*. New York: E. P. Dutton, 1984.

———. *The Pink Glass Swan: Selected Essays on Feminist Art*. New York: New Press, 1995.

———, ed. *Six Years: The Dematerialization of the Art Object from 1966 to 1972* (1973). Berkeley: University of California Press, 1997.

Lucie-Smith, Edward. *Art in the Seventies*. Ithaca, New York: Cornell University Press, 1980.

Marshall, Richard. *New Image Painting* (exhibition catalog). New York: Whitney Museum of American Art, 1978.

Masheck, Joseph. *Historical Present: Essays of the 1970s*. Ann Arbor, Michigan: UMI Research Press, 1984.

McShine, Kynaston, ed. *Information* (exhibition catalog). New York: The Museum of Modern Art, 1970.

Meyer, Ursula. *Conceptual Art*. New York: E. P. Dutton, 1972.

Monte, James, and Marcia Tucker. *Anti-Illusion: Procedures/Materials*. New York: Whitney Museum of American Art, 1969.

Morgan, Robert C. *Art into Ideas: Essays on Conceptual Art*. New York: Cambridge University Press, 1996.

Nochlin, Linda. *Women, Art, and Power and Other Essays*. New York: Icon Editions/Harper & Row, 1988.

Pincus-Witten, Robert. *Postminimalism*. New York: Out of London Press, 1977.

———. *Postminimalism into Maximalism: American Art, 1966–1986*. Ann Arbor, Michigan: UMI Research Press, 1987.

Pollock, Griselda. *Vision and Difference: Femininity, Feminism, and Histories of Art*. New York: Routledge, 1988.

Raven, Arlene, Cassandra L. Langer, and Joanna Frueh, eds. *Feminist Art Criticism: An Anthology*. Ann Arbor, Michigan: UMI Research Press, 1988.

Robins, Corinne. *The Pluralist Era: American Art, 1968–1981*. New York: Icon Editions/Harper & Row, 1984.

Rose, Bernice. *Drawing Now* (exhibition catalog). New York: The Museum of Modern Art, 1976.

Sonfist, Alan, ed. *Art in the Land: A Critical Anthology of Environmental Art*. New York: E. P. Dutton, 1983.

Szeeman, Harald. *Live in Your Head: When Attitudes Become Form. Works, Concepts, Processes, Situations, Information* (exhibition catalog). London: The Institute of Contemporary Arts, 1969.

Tiberghien, Gilles A. *Land Art*. Translated by Caroline Green. New York: Princeton Architectural Press, 1995.

Wilding, Faith. *By Our Own Hands: The Women Artist's Movement, Southern California, 1970–1976*. Santa Monica, California: Double X, 1977.

Restoration and Reaction, 1976–1990

Atkins, Robert, and Thomas W. Sokolowski. *From Media to Metaphor: Art about AIDS* (exhibition catalog). New York: Independent Curators, 1991.

Belli, Gabriella, and Jerry Saltz. *American Art of the '80s* (exhibition catalog). Trento and Rovereto: Museo d'Arte Moderna e Contemporanea, 1991.

Bois, Yve-Alain, et al. *Endgame: Reference and Simulation in Recent Painting and Sculpture* (exhibition catalog). Boston: The Institute of Contemporary Art, 1986.

Carrier, David. *The Aesthete in the City: The Philosophy and Practice of American Abstract Painting in the 1980s*. University Park: Pennsylvania State University Press, 1994.

Crimp, Douglas. *Pictures: An Exhibition of the Work of Troy Brauntuch, Jack Goldstein, Sherrie Levine, Robert Longo, Philip Smith* (exhibition catalog). New York: Artists Space, 1977.

The Decade Show: Frameworks of Identity in the 1980s (exhibition catalog). New York: Museum of Contemporary Hispanic Art/The New Museum of Contemporary Art/The Studio Museum in Harlem, 1990.

Felshin, Nina, ed. *But Is It Art? The Spirit of Art as Activism*. Seattle: Bay Press, 1995.

Fox, Howard N. *Avant-Garde in the Eighties* (exhibition catalog). Los Angeles: Los Angeles County Museum of Art, 1987.

Frank, Peter, and Michael McKenzie. *New, Used, and Improved: Art for the '80s*. New York: Abbeville Press, 1987.

Ghez, Susanne, ed. *CalArts: Skeptical Belief(s)* (exhibition catalog). Chicago: The Renaissance Society at the University of Chicago; Newport Beach, California: Newport Harbor Art Museum, 1988.

Goldstein, Ann, and Mary Jane Jacob. *A Forest of Signs: Art in the Crisis of Representation* (exhibition catalog). Los Angeles: The Museum of Contemporary Art, 1989.

Halbreich, Kathy. *Culture and Commentary: An Eighties Perspective* (exhibition catalog). Washington, D.C.: Hirshhorn Museum and Sculpture Garden, Smithsonian Institution, 1990.

Heartney, Eleanor. *Critical Condition: American Culture at the Crossroads*. New York: Cambridge University Press, 1997.

Heiferman, Marvin, and Lisa Phillips, with John G. Hanhardt. *Image World: Art and Media Culture* (exhibition catalog). New York: Whitney Museum of American Art, 1989.

Joachimides, Christos M., and Norman Rosenthal, eds. *Zeitgeist: Internationale Kunstausstellung Berlin 1982* (exhibition catalog). Berlin: Martin-Gropius-Bau, 1982.

Joachimides, Christos M., Norman Rosenthal, and Nicholas Serota, eds. *A New Spirit in Painting* (exhibition catalog). London: Royal Academy of Arts, 1981.

Kardon, Janet. *The East Village Scene* (exhibition catalog). Philadelphia: Institute of Contemporary Art, University of Pennsylvania, 1984.

Levin, Kim. *Beyond Modernism: Essays on Art from the '70s and '80s*. New York: Icon Editions/Harper & Row, 1988.

Linker, Kate, et al. *Difference: On Representation and Sexuality* (exhibition catalog). New York: The New Museum of Contemporary Art, 1985.

Lucie-Smith, Edward. *Art in the Eighties*. New York: Phaidon/Universe, 1990.

McShine, Kynaston. *An International Survey of Recent Painting and Sculpture* (exhibition catalog). New York: The Museum of Modern Art, 1984.

Moore, Alan, and Marc Miller, eds. *ABC No Rio Dinero: The Story of a Lower East Side Art Gallery*. Foreword by Lucy R. Lippard. New York: ABC No Rio with Collaborative Projects, 1985.

Saltz, Jerry. *Beyond Boundaries: New York's New Art*. Essays by Roberta Smith and Peter Halley. New York: Alfred van der Marck Editions, 1986.

Schjeldahl, Peter. *The Hydrogen Jukebox: Selected Writings of Peter Schjeldahl, 1978–1990*. Introduction by Robert Storr. Berkeley: University of California Press, 1991.

Siegel, Jeanne, ed. *Art Talk: The Early '80s*. New York: DaCapo Press, 1988.

———, ed. *Artwords 2: Discourse on the Early '80s*. Ann Arbor, Michigan: UMI Research Press, 1988.

Taylor, Paul. *After Andy: SoHo in the Eighties*. Portraits by Timothy Greenfield-Sanders. Introduction by Allan Schwartzman. Melbourne: Schwartz City, 1995.

———, ed. *Post-Pop Art*. Cambridge, Massachusetts: MIT Press, 1989.

Tomkins, Calvin. *Post- to Neo-: The Art World of the 1980s*. New York: Henry Holt and Company, 1988.

Approaching the Millennium, 1990–2000

Benezra, Neal, and Olga M. Viso. *Distemper: Dissonant Themes in the Art of the 1990s* (exhibition catalog). Washington, D.C.: Hirshhorn Museum and Sculpture Garden, Smithsonian Institution, 1996.

Clearwater, Bonnie, ed. *Defining the Nineties: Consensus-Making in New York, Miami, and Los Angeles*. North Miami: Museum of Contemporary Art, 1996.

Curiger, Bice. *Birth of the Cool* (exhibition catalog). Zurich: Kunsthaus Zürich; Hamburg: Deichtorhallen Hamburg, 1996.

Deitch, Jeffrey. *Post Human* (exhibition catalog). Pully/Lausanne, Switzerland: FAE Musée d'Art Contemporain; et al.

Golden, Thelma. *Black Male: Representations of Masculinity in Contemporary American Art* (exhibition catalog). New York: Whitney Museum of American Art, 1994.

Grynsztejn, Madeleine. *About Place: Recent Art of the Americas* (exhibition catalog). Essay by David Hickey. Chicago: The Art Institute of Chicago, 1995.

Schimmel, Paul. *Helter Skelter: L.A. Art in the 1990s* (exhibition catalog). Los Angeles: The Temporary Contemporary of The Museum of Contemporary Art, 1992.

Storr, Robert. *Dislocations* (exhibition catalog). New York: The Museum of Modern Art, 1991.

Sussman, Elisabeth, et al. *1993 Biennial Exhibition* (exhibition catalog). New York: Whitney Museum of American Art, 1993.

Wallace, Michele. *Black Popular Culture: A Project*. Dia Center for the Arts Discussions in Contemporary Culture, no. 8. Seattle: Bay Press, 1992.

Zelevansky, Lynn. *Sense and Sensibility: Women Artists and Minimalism in the Nineties*. New York: The Museum of Modern Art, 1994.

Performing Arts: Dance, Theater, and Music

Anderson, Jack. *Art without Boundaries*. Iowa City: University of Iowa Press, 1997.

Auslander, Philip. *American Experimental Theater: A Critical Introduction*. New York: University Arts Resources, 1993.

———. *From Acting to Performance: Essays in Modernism and Postmodernism*. New York: Routledge, 1997.

Banes, Sally. *Dancing Women: Female Bodies on Stage*. New York: Routledge, 1998.

———. *Democracy's Body: Judson Dance Theater, 1962–1964*. Ann Arbor, Michigan: UMI Research Press, 1983.

———. *Greenwich Village 1963: Avant-Garde Performance and the Effervescent Body*. Durham, North Carolina: Duke University Press, 1993.

———. *Writing Dancing in the Age of Postmodernism*. Hanover, New Hampshire: Wesleyan University Press/University Press of New England, 1994.

Battcock, Gregory, and Robert Nickas, eds. *The Art of Performance: A Critical Anthology*. New York: E. P. Dutton, 1984.

Bennington College Judson Project. *Judson Dance Theater, 1962–1966*. Bennington, Vermont: Bennington College, 1981.

Biner, Pierre. *The Living Theatre*. New York: Horizon Press, 1972.

Carr, C. *On Edge: Performance at the End of the Twentieth Century*. Hanover, New Hampshire: University Press of New England, 1993.

Chinoy, Helen Krich, and Linda Walsh Jenkins, eds. *Women in American Theatre: Careers, Images, Movements*. New York: Crown, 1981.

Cohen, Selma Jeanne, ed. *International Encyclopedia of Dance*. New York: Oxford University Press, 1998.

Cooke, Mervyn. *The Chronicle of Jazz*. New York: Abbeville Press, 1998.

Goldberg, RoseLee. *Live Art Since 1960*. New York: Harry N. Abrams, 1998.

Henry, Tricia. *Break All Rules! Punk Rock and the Making of a Style*. Ann Arbor, Michigan: UMI Research Press, 1989.

Little, Stuart W. *Off-Broadway: The Prophetic Theater*. New York: Coward, McCann and Geoghegan, 1972.

Livet, Anne, ed. *Contemporary Dance: An Anthology of Lectures, Interviews, and Essays with Many of the Most Important Contemporary American Choreographers, Scholars, and Critics*. New York: Abbeville Press in association with The Fort Worth Art Museum, 1978.

Morrissey, Lee, ed. *The Kitchen Turns Twenty: A Retrospective Anthology*. New York: The Kitchen Center for Video, Music, Dance, Performance, Film, and Literature, 1992.

Outside the Frame: Performance and the Object. A Survey History of Performance Art in the USA Since 1950 (exhibition catalog). Cleveland: Cleveland Center for Contemporary Art, 1994.

Perkins, William Eric, ed. *Droppin' Science: Critical Essays on Rap Music and Hip Hop Culture*. Philadelphia: Temple University Press, 1996.

Roudane, Matthew C. *American Drama Since 1960: A Critical History*. New York: Twayne, 1996.

Sayre, Henry M. *The Object of Performance: The American Avant-Garde Since 1970*. Chicago: University of Chicago Press, 1989.

Schwarz, K. Robert. *Minimalists: 20th-Century Composers*. London: Phaidon Press, 1996.

Shank, Theodore. *American Alternative Theater*. New York: Grove, 1982.

Siegel, Marcia B. *The Tail of the Dragon: New Dance, 1976–1982*. Durham, North Carolina: Duke University Press, 1991.

Photography

Blessing, Jennifer. *Rrose Is a Rrose Is a Rrose: Gender Performance in Photography* (exhibition catalog). New York: Solomon R. Guggenheim Museum, 1997.

Coke, Van Deren, ed. *One Hundred Years of Photographic History: Essays in Honor of Beaumont Newhall*. Albuquerque: University of New Mexico Press, 1975.

Davis, Keith F. *An American Century of Photography: From Dry-Plate to Digital. The Hallmark Photographic Collection*. Foreword by Donald J. Hall. Kansas City, Missouri: Hallmark Cards, Inc., in association with Harry N. Abrams, 1995.

Greenough, Sarah, et al. *On the Art of Fixing a Shadow: One Hundred and Fifty Years of Photography* (exhibition catalog). Washington, D.C.: National Gallery of Art; Chicago: The Art Institute of Chicago, 1989.

Grundberg, Andy. *Crisis of the Real: Writings on Photography, 1974–1989*. New York: Aperture, 1990.

Grundberg, Andy, and Kathleen McCarthy Gauss. *Photography and Art: Interactions Since 1946* (exhibition catalog). Fort Lauderdale, Florida: Museum of Art; Los Angeles: Los Angeles County Museum of Art, 1987.

Hall-Duncan, Nancy. *The History of Fashion Photography* (exhibition catalog). Rochester, New York: International Museum of Photography, George Eastman House, 1977.

Livingston, Jane. *The New York School Photographs, 1936–1963*. New York: Stewart, Tabori & Chang, 1992.

Newhall, Beaumont. *The History of Photography from 1839 to the Present Day*. Rev. ed. New York: The Museum of Modern Art, 1982.

Petruck, Peninah R., ed. *The Camera Viewed: Writings on Twentieth-Century Photography.* Vol. 2, *Photography after World War II.* New York: E. P. Dutton, 1979.

Smith, Joshua P., and Merry A. Foresta. *The Photography of Invention: American Pictures of the 1980s* (exhibition catalog). Washington, D.C.: National Museum of American Art, Smithsonian Institution, 1989.

Solomon-Godeau, Abigail. *Photography at the Dock: Essays on Photographic History, Institutions, and Practices.* Foreword by Linda Nochlin. Media & Society, no. 4. Minneapolis: University of Minnesota Press, 1991.

Sontag, Susan. *On Photography.* New York: Farrar, Straus & Giroux, 1977.

Squiers, Carol, ed. *The Critical Image: Essays on Contemporary Photography.* Seattle: Bay Press, 1990.

Steichen, Edward. *The Family of Man* (exhibition catalog). Prologue by Carl Sandburg. New York: The Museum of Modern Art, 1955.

Szarkowski, John. *Photography Until Now* (exhibition catalog). New York: The Museum of Modern Art, 1989.

Turner, Peter, ed. *American Images: Photography 1945–1980* (exhibition catalog). London: Barbican Art Gallery, 1985.

Willis, Deborah, ed. *Picturing Us: African American Identity in Photography.* New York: New Press, 1994.

Film, Video, and Sound

The American New Wave, 1958–1967 (exhibition catalog). Minneapolis: Walker Art Center; Buffalo: Media Study/Buffalo, 1982.

Battcock, Gregory, ed. *New Artists Video: A Critical Anthology.* New York: E. P. Dutton, 1978.

Cook, David A. *A History of Narrative Film* (1981). 2nd ed. New York: W. W. Norton & Company, 1990.

Delehanty, Suzanne. *Video Art* (exhibition catalog). Philadelphia: Institute of Contemporary Art, University of Pennsylvania, 1975.

Frampton, Hollis. *Circles of Confusion: Film, Photography, Video. Texts, 1968–1980.* Foreword by Annette Michelson. Rochester, New York: Visual Studies Workshop Press, 1983.

Hall, Doug, and Sally Jo Fifer, eds. *Illuminating Video: An Essential Guide to Video Art.* New York: Aperture in association with the Bay Area Video Coalition, 1990.

Hanhardt, John G., ed. *Video Culture: A Critical Investigation.* Layton, Utah: Peregrine Smith Books in association with Visual Studies Workshop Press, 1986.

A History of the American Avant-Garde Cinema (exhibition catalog). New York: The American Federation of Arts, 1976.

James, David E. *Allegories of Cinema: American Film in the Sixties.* Princeton: Princeton University Press, 1989.

Korot, Beryl, and Ira Schneider, eds. *Video Art: An Anthology.* New York: Harcourt Brace Jovanovich, 1976.

Lander, Dan, and Micah Lexier, eds. *Sound by Artists.* Toronto: Art Metropole; Banff, Canada: Walter Phillips Gallery, 1990.

MacDonald, Scott. *A Critical Cinema: Interviews with Independent Filmmakers.* Berkeley: University of California Press, 1988.

Sitney, P. Adams. *The Avant-Garde Film.* Anthology Film Archives Series, no. 3. New York: New York University Press, 1978.

———. *Visionary Film: The American Avant-Garde.* 2nd ed. New York: Oxford University Press, 1979.

Architecture and Design

Banham, Reyner. *Los Angeles: The Architecture of Four Ecologies.* New York: Harper & Row, 1971.

Betsky, Aaron, ed. *Icons: Magnets of Meaning* (exhibition catalog). San Francisco: San Francisco Museum of Modern Art, 1997.

De Long, David, Helen Searing, and Robert A. M. Stern, *American Architecture: Innovation and Tradition.* New York: Rizzoli, 1986.

Diamonstein, Barbaralee. *American Architecture Now* (1980). Foreword by Paul Goldberger. New York: Rizzoli, 1985.

Dilr, Elizabeth, and Ricardo Scofidio. *Flesh: Architectural Probes.* Essay by Georges Teyssot. New York: Princeton Architectural Press, 1994.

Dreyfuss, Henry. *Designing for People.* New York: Simon and Schuster, 1955.

Eisenman, Peter, et al. *Five Architects: Eisenman, Graves, Gwathmey, Hejduk, Meier.* New York: Oxford University Press, 1975.

Hayden, Dolores. *The Grand Domestic Revolution: A History of Feminist Designs for American Homes, Neighborhoods, and Cities.* Cambridge, Massachusetts: MIT Press, 1981.

Hitchcock, Henry-Russell, and Arthur Drexler, eds. *Built in USA: Post-War Architecture.* New York: The Museum of Modern Art in association with Thames and Hudson, 1952.

Jacobs, Jane. *The Death and Life of Great American Cities.* New York: Random House, 1961.

Jencks, Charles. *The Language of Post-Modern Architecture.* 6th ed. New York: Rizzoli, 1991.

Johnson, Philip, and Mark Wigley. *Deconstructivist Architecture* (exhibition catalog). New York: The Museum of Modern Art, 1988.

Kirkham, Pat. *Charles and Ray Eames: Designers of the Twentieth Century.* Cambridge, Massachusetts: MIT Press, 1995.

Koolhaas, Rem. *Delirious New York: A Retroactive Manifesto for Manhattan.* New York: Monacelli Press, 1994.

McCoy, Esther. *Case Study Houses, 1945–1962.* 2nd ed. Los Angeles: Hennessey & Ingalls, 1977.

Mertins, Detlef, ed. *The Presence of Mies.* New York: Princeton Architectural Press, 1994.

Neutra, Richard Joseph. *Survival through Design.* New York: Oxford University Press, 1954.

Ockman, Joan, ed., in collaboration with Edward Eigen. *Architecture Culture, 1943–1968: A Documentary Anthology.* New York: Columbia University Graduate School of Architecture, Planning, and Preservation and Rizzoli, 1993.

Scully, Vincent. *American Architecture and Urbanism.* Rev. ed. New York: Henry Holt and Company, 1988.

———. *Modern Architecture: The Architecture of Democracy* (1961). Rev. ed. New York: George Braziller, 1975.

Smith, Elizabeth A. T., et al. *Blueprints for Modern Living: History and Legacy of the Case Study Houses* (exhibition catalog). Los Angeles: The Museum of Contemporary Art, 1989.

Soja, Edward W. *Postmodern Geographies: The Reassertion of Space in Critical Social Theory.* New York: Verso, 1989.

Stern, Robert A. M. *New Directions in American Architecture* (1969). Rev. ed. New York: George Braziller, 1977.

Torre, Susana, ed. *Women in American Architecture: A Historic and Contemporary Perspective* (exhibition catalog). New York: The Architectural League of New York, 1977.

Tschumi, Bernard. *Event-Cities: Praxis.* Cambridge, Massachusetts: MIT Press, 1994.

Upton, Dell. *Architecture in the United States.* New York: Oxford University Press, 1998.

Venturi, Robert. *Complexity and Contradiction in Architecture.* Introduction by Vincent Scully. 2nd ed. New York: The Museum of Modern Art in association with the Graham Foundation for Advanced Studies in the Fine Arts, 1966.

Venturi, Robert, Denise Scott Brown, and Steven Izenour. *Learning from Las Vegas: The Forgotten Symbolism of Architectural Form* (1972). Rev. ed. Cambridge, Massachusetts: MIT Press, 1977.

Whitaker, Craig. *Architecture and the American Dream.* New York: Clarkson N. Potter, 1996.

Wiseman, Carter. *Shaping a Nation: Twentieth-Century American Architecture and Its Makers.* New York: W. W. Norton & Company, 1998.

Literature

Hellmann, John. *Fables of Fact: The New Journalism as New Fiction.* Urbana: University of Illinois Press, 1981.

Howard, Richard. *Alone with America: Essays on the Art of Poetry in the United States since 1950.* New York: Atheneum, 1969.

Kerrane, Kevin, and Ben Yagoda, eds. *The Art of Fact: A Historical Anthology of Literary Journalism.* New York: Scribner, 1997.

Mailer, Norman. *The Armies of the Night: History as a Novel, the Novel as History.* New York: New American Library, 1968.

Wolfe, Tom, and E. W. Johnson, eds. *The New Journalism.* New York: Harper & Row, 1973.

Notes on Contributors

Robert Atkins is a New York-based art historian and research fellow at the Studio for Creative Inquiry, Carnegie Mellon University. He is the author of *ArtSpoke: A Guide to Modern Ideas, Movements, and Buzzwords, 1848–1944* (1993), and *ArtSpeak: A Guide to Contemporary Ideas, Movements, and Buzzwords, 1945 to the Present* (1997, rev. ed.).
In 1991 he co-curated "From Media to Metaphor: Art About AIDS," the first major traveling group exhibition about AIDS.

Philip Auslander is associate professor in the School of Literature, Communication, and Culture at Georgia Institute of Technology. He is the author of *The New York School Poets as Playwrights: O'Hara, Ashbery, Koch, Schuyler, and the Visual Arts* (1989); *Presence and Resistance: Postmodernism and Cultural Politics in Contemporary American Performance* (1992); *From Acting to Performance: Essays in Modernism and Postmodernism* (1997); and *Liveness: Performance in a Mediatized Culture* (1999).

Sally Banes is the Marian Hannah Winter Professor of Theater History and Dance Studies at the University of Wisconsin-Madison. She has written extensively on dance, performance, and theater. Her books include *Democracy's Body: Judson Dance Theater, 1962–1964* (1993, reprt.); *Greenwich Village 1963: Avant-Garde Performance and the Effervescent Body* (1993); *Dancing Women: Female Bodies on Stage* (1998); and *Subversive Expectations: Performance Art and Paratheater in New York, 1976–1985* (1998).

Maurice Berger is senior fellow of the Vera List Center for Art & Politics, New School for Social Research. He is the author of numerous books and essays, including *White Lies: Race and the Myths of Whiteness* (1999); *How Art Becomes History* (1992); and *Labyrinths: Robert Morris, Minimalism, and the 1960s* (1989). He is also the editor of *The Crisis of Criticism* (1998).

Homi K. Bhabha is the Chester D. Tripp Professor in the Humanities at the University of Chicago and Visiting Professor in the Humanities at University College, London. He has delivered several honorary lectures and has recently been awarded a fellowship from Wissenschaftskolleg zu Berlin. Bhaba is the author of *The Location of Culture* (1994) and editor of the essay collection *Nation and Narration* (1990). He is currently at work on *A Measure of Dwelling*, a theory of vernacular cosmopolitanism.

John Carlin is the co-founder and president of Funny Garbage, a new media design and production company. He is also the founder and president of The Red Hot Organization, a not-for-profit production company that raises money and awareness for the fight against AIDS through such recording projects as "Stolen Moments" and "Red Hot + Rio." Also a curator, Carlin co-organized "The Comic Art Show" at the Whitney Museum of American Art, Downtown Branch, in 1983.

Tom Finkelpearl worked as a curator at P.S.1 Contemporary Art Center from 1981 to 1990. He was director of the Percent for Art in New York City program from 1990 to 1996, and executive director of the Skowhegan School of Painting and Sculpture program from 1996 to 1999. In 1999 he returned to P.S.1 as program director. His book on public art is in press.

Hilene Flanzbaum is associate professor of twentieth-century American literature and director of creative writing at Butler University. She was general editor of and a contributor to *The Americanization of the Holocaust* (1999) and managing editor of *Jewish-American Literature: A Norton Anthology* (1999).

Paula Geyh is assistant professor of English at Southern Illinois University. She has published numerous articles on postmodern literature, twentieth-century American literature, and literary theory in newspapers and scholarly publications. She was a co-editor of *Postmodern American Fiction: A Norton Anthology* (1997).

RoseLee Goldberg is adjunct professor in the Department of Art at New York University. She was formerly a curator at The Kitchen Center for Video, Music, Dance, Performance, Film, and Literature in New York City. She is the author of *Performance: Live Art since 1960* (1998), a history of performance art over the past four decades, and *Performance Art: From Futurism to the Present* (1988, rev. ed.). She is a frequent contributor to *Artforum* and is currently working on a monograph on Laurie Anderson.

Jeremy Green is assistant professor of English at the University of Colorado, Boulder, where he teaches courses in modern, contemporary, and postmodern American literature. He is currently working on a book, *The Fiction of Don DeLillo: Postmodernism and the American Imaginary*.

Chrissie Iles is curator of film and video at the Whitney Museum of American Art. She curated the film and video component for *The American Century: Art & Culture 1950-2000*, and is now working on a major survey exhibition of video and film installation in America from 1965 to 1975 for the Whitney Museum. She was previously head of exhibitions at the Museum of Modern Art, Oxford, in England. She has lectured widely and published many texts on film and video installation and on the history of performance.

Sylvia Lavin is chair of the Department of Architecture and Urban Design at UCLA. She has received numerous honors and fellowships, including the Getty Center for the History of Art and the Humanities Fellowship (1989–90). She writes extensively on modern and contemporary architecture in journals, magazines, and catalogs. She is the author of *Quatrèmere de Quincy and the Invention of a Modern Language of Architecture* (1992).

Andrew Levy is Edna Cooper Chair in English at Butler University, where he teaches American literature. He is currently working on a book, *American Revolutions*, and he is the author of *The Culture and Commerce of the Short Story* (1993). He co-edited *Postmodern American Fiction: A Norton Anthology* (1997) and *Creating Fiction* (1994).

Kate Linker is a New York-based critic who teaches postmodern theory and practice in the MFA Photography and Related Media program at the School of Visual Arts. Her articles and essays have been published in numerous international magazines and exhibition catalogs, and she is the author of the books *Love for Sale: The Words and Pictures of Barbara Kruger* (1990) and *Vito Acconci* (1994).

Carrie Rickey, film critic of *The Philadelphia Inquirer*, has written about art and film for such publications as *Artforum*, *Art in America*, *American Film*, and *The New York Times*. Her essays are collected in various anthologies, among them *The Rolling Stone Illustrated History of Rock and Roll* (1992, rev. ed.); *Produced and Abandoned* (1990); and *The Triumph of Feminist Art* (1993).

Eugenie Tsai is senior curator at the Whitney Museum of American Art, where she is currently organizing a Robert Smithson retrospective. Previously she curated "Lee Mingwei: Way Stations" (1998); "Gazing Back: Shigeko Kubota and Mary Lucier" (1995); and, for the Whitney Museum at Philip Morris, one-artist exhibitions of the work of Ik-Jung Kang, Byron Kim, Christian Marclay, Shirin Neshat, Carrie Mae Weems, and Lynne Yamamoto. She is the author of the Choice Award-winning book, *Robert Smithson Unearthed* (1991).

Steven Watson is a cultural historian of the group dynamics of the twentieth-century American avant-garde. He has written about the first American avant-garde—the Harlem Renaissance—and about the Beat Generation. His most recent book is *Prepare for Saints: Gertrude Stein, Virgil Thomson, and the Mainstreaming of American Modernism* (1999), and he is currently working on a book about Andy Warhol's Factory.

Matthew Yokobosky is an exhibition designer and curator specializing in film, video installation, and performance. At the Whitney Museum of American Art, he designed "Joseph Stella" (1994) and "The 1995 Biennial Exhibition" (1995) and curated "No Wave Cinema, '78–'87" (1996), which toured internationally. He was the design consultant and film and video curator for *The American Century: Art & Culture 1900-1950*. Currently, he is the exhibition designer of the Brooklyn Museum of Art.

Acknowledgments

A book of this scope requires the contributions of many people. Over the past two years, I have received valuable advice and suggestions from the following friends and colleagues who served as advisers for the exhibition: Maurice Berger, Homi K. Bhabha, Anna Chave, Francis Colpitt, Tom Crow, Stuart Ewen, Leon Falk, Coco Fusco, Joseph Giovaninni, RoseLee Goldberg, Thyrza Goodeve, David Joselit, Michael Kammen, Liz Kotz, Sylvia Lavin, Michael Leja, Greil Marcus, Robert Pincus-Witten, Ralph Rugoff, Allan Schwartzman, Robert Sklar, Rebecca Solnit, Carol Squiers, Mary Anne Staniszewski, Kristine Stiles, Henry Urbach, and Brian Wallis. Some of these advisers also wrote essays for this book, as did other scholars and critics. I am grateful to them all for their contributions, which have immeasurably enriched the volume.

This book would not have been possible without the Publications and New Media Department at the Whitney Museum and Jim Mairs of W. W. Norton. Katy Homans applied her prodigious talent to the design of the volume, while Maurice Berger and Alexandra Shelley gave incisive comments and editorial advice on the manuscript. A generous gift from Susan and Edwin Malloy enabled the publication to proceed. Although everyone mentioned was critical to the book, I am most indebted to Susan Harris, associate curator for *The American Century* project, who coordinated the volume. She has devoted nearly a full year to it with grace, dedication, and perseverance. Ongoing research, documentary material, and back-breaking clerical support were provided by Alpesh Patel, Hyon Su Kwon, Shana Rosengart, Jean Shin, and Adrienne Gagnon. Their conscientious devotion to this project has been remarkable. Some of the people that deserve special mention for their exceptional assistance in obtaining images and research materials are the staffs of Cheim & Reid, the Paula Cooper Gallery, Metro Pictures, Robert Miller Gallery, John Weber Gallery, the Addison Gallery of American Art, and the San Francisco Museum of Modern Art; Emily Abernathy, Jane Austrian, Miles Bellamy, Red Burns, Mary Corey, Laura Cottingham, Virginia Dwan, Janis Ekdahl, Thomas Erben, Nina Felshin, Tom Finkelpearl, Peter Freeman, Diana Gongora, Judith Green, Sara Greenough, Anna Halprin, Pat Hearn, Rob Hooper, Glenn Horowitz, Lillian Kiesler, Barbara Moore, Richard Oram, Ed Rider, Rick Rossin, Emily Russell, Susanna Singer, Tom Staley, Sloane Tanen, David Vaughn, and Joan Washburn.

At the Whitney Museum, a curatorial team was instrumental in developing the exhibition—furnishing ideas, research, and refining structural details that in turn helped define this publication. The team included former curators Adam D. Weinberg, Elisabeth Sussman, and Thelma Golden, and present curators Eugenie Tsai and Chrissie Iles. *The American Century* has truly been a collective endeavor at the Museum, with all the departments straining hard to realize this ambitious project—which includes not only the publication and exhibition but a website and public programs. In addition to the team of in-house curators and committee of advisers, Susan Harris and Karl Willers, also an associate curator for *The American Century* project, helped to research and select objects and then, with intelligence and discernment, saw the exhibition through after my departure from the Whitney Museum. Chrissie Iles, Maurice Berger, and Stephen Vitiello contributed their considerable expertise by curating specific sections of the exhibition. For the design of the exhibition, a talented team was brought in: Christian Hubert, architect, and his associate Jill Leckner met every expectation in their insightful design for a complex project with an overwhelming number of works; Nigel Smith worked with the curators and designers to create an imaginative and complementary graphic design conception. Kathyrn Potts oversaw the public programs, and Melissa Phillips took charge of the website. Willard Holmes, chief operating officer at the Museum, provided steady leadership through many transitions.

The collaboration with Intel has been unprecedented and rewarding, enabling the Museum to conceive and realize an exhibition on this scale. I am grateful to Andrew S. Grove, chairman of Intel, for his vision, and to his staff—Dana Houghton, Kevin Teixeira, Ralph Bond, Vince Thomas, and Ciaran Doyle—for their interest, enthusiasm, curiosity, and commitment to bringing *The American Century* to new audiences through the Internet—and bringing us into the twenty-first century.

Finally, for their support and faith in the importance of this project, I would like to thank the Whitney Board of Trustees, in particular Leonard A. Lauder, chairman; David A. Ross, former director of the Whitney Museum, who initiated the project; and Maxwell L. Anderson, director, who guided it through to completion. —L. P.

246 © Estate of Donald Judd/ Licensed by VAGA, New York, NY; photograph Ellen Page Wilson, courtesy PaceWildenstein, New York. 247 © Estate of Donald Judd/Licensed by VAGA, New York, NY; photograph © Todd Eberle. 248 © Estate of Donald Judd/Licensed by VAGA, New York, NY; photograph Lee Stalsworth. 249 © Estate of David Smith/Licensed by VAGA, New York, NY; photograph © Dan Budnik/Woodfin Camp & Associates. All Rights Reserved. 250 Jerry L. Thompson. 251 Photograph The Jewish Museum, New York/Art Resource, New York. Art work by Robert Morris © 1999 Robert Morris/Artists Rights Society (ARS), New York; art work by Donald Judd © Estate of Donald Judd/ Licensed by VAGA, New York, NY. 252 © 1999 Estate of Tony Smith/Artists Rights Society (ARS), New York; photograph Geoffrey Clements. 253 © 1999 Estate of Tony Smith/Artists Rights Society (ARS), New York; photograph courtesy The Corcoran Gallery of Art, School of Art Archives. 254/255/256 Anthology Film Archives, New York. 257 Photograph © The Estate of Peter Moore/Licensed by VAGA, New York, NY; photograph Barbara Moore. 258/259/260 Photograph © The Estate of Peter Moore/Licensed by VAGA, New York, NY. 261 © 1999 Robert Morris/Artists Rights Society (ARS), New York. Art work by Sol LeWitt © 1999 Sol LeWitt/Artists Rights Society (ARS), New York; photograph Bill Jacobson. 262 Photograph © The Estate of Peter Moore/Licensed by VAGA, New York, NY; courtesy Solomon R. Guggenheim Foundation, New York. Performance © 1999 Robert Morris/Artists Rights Society (ARS), New York. 263 Photograph © The Estate of Peter Moore/Licensed by VAGA, New York, NY. Performance © 1999 Robert Morris/Artists Rights Society (ARS), New York. 264 Jerry L. Thompson. 265 Courtesy PaceWildenstein, New York. 266 Bill Jacobson. 267 © 1999 Brice Marden/Artists Rights Society (ARS), New York; photograph Ben Blackwell. 268 Steven Sloman. 269 Courtesy Pace-Wildenstein, New York. 270 Geoffrey Clements. 271 © 1999 Barnett Newman Foundation/ Artists Rights Society (ARS), New York; photograph Paul Macapia. 272 Jerry L. Thompson. 273 © 1999 Robert Irwin/Artists Rights Society (ARS), New York; photograph Geoffrey Clements. 274 L.A. Louver Gallery, Venice, California.

America at the Crossroads, 1964–1976
275 UPI/Corbis-Bettmann. 276 Photograph © Ron Bennett/UPI/Corbis-Bettmann. 277 UPI/Corbis-Bettmann. 278 John Filo. 279 UPI/Corbis-Bettmann. 280 © Marc Riboud/Magnum Photos, Inc. 281/282 UPI/Corbis-Bettmann. 283/284 Photofest. 285 The Kobal Collection. 286 © Bonnie Freer/Photo Researchers, Inc., New York. 287 © 1999 Robert Morris/Artists Rights Society (ARS), New York; photograph Rudolph Burckhardt. 288 © Fotex/R. Drechsler/Shooting Star. 289 Photofest. 290 © Joel Axelrad/Michael Ochs Archives, Venice, California. 291 The Everett Collection. 292 © Louise Bourgeois/ Licensed by VAGA, New York, NY; courtesy Cheim & Read, New York. 293 © Estate of H. C. Westermann/Licensed by VAGA, New York, NY. 294 Jerry L. Thompson. 295 Sheldan C. Collins. 296 © 1999 Richard Artschwager/ Artists Rights Society (ARS), New York; photograph Steven Sloman. 297 © The Estate of Eva Hesse; courtesy Robert Miller Gallery, New York. 298 © Louise Bourgeois/ Licensed by VAGA, New York, NY; photograph © 1999 The Museum of Modern Art, New York. 299 Jerry L. Thompson. 300 Bill Baron; courtesy the artist. 301 Jerry L. Thompson. 302 Courtesy Barbara Gladstone Gallery, New York; photograph Larry Lamé. 303 Art work by Bruce Nauman: © 1999 Bruce Nauman/Artists Rights Society (ARS), New York; photograph Harry Shunk. 304 © 1999 Bruce Nauman/ Artists Rights Society (ARS), New York; photograph courtesy Leo Castelli Gallery, New York. 305/306 © 1999 Richard Serra/Artists Rights Society (ARS), New York; photograph Peter Moore. 307 © 1999 Richard Serra/Artists Rights Society (ARS), New York; photograph Shunk-Kender. 308 Ralph Lieberman. 309 Copyright © 1969 by Kurt Vonnegut, Jr. Used by permission of Delacorte Press, a division of Random House, Inc. Jacket design by Paul Bacon. 310 Copyright © 1973 by Thomas Pynchon. Used by permission of Viking Penguin, a division of Penguin Putnam Inc. Jacket design by Marc Getter. 311 © 1999 Richard Serra/Artists Rights Society (ARS), New York; photograph Peter Moore. 312 © 1999 Richard Serra/Artists Rights Society (ARS), New York; photograph Geoffrey Clements. 313 © 1999 Richard Serra/Artists Rights Society (ARS), New York. 314 Geoffrey Clements. 315 © 1999 Bruce Nauman/Artists Rights Society (ARS), New York; photograph Geoffrey Clements. 316 © Lynda Benglis/Licensed by VAGA, New York, NY. 317 © Estate of Robert Smithson/Licensed by VAGA, New York, NY; photograph Fred Scruton. Courtesy John Weber Gallery, New York. 318 © 1999 Robert

Morris/Artists Rights Society (ARS), New York; photograph Geoffrey Clements. 319 Jerry L. Thompson. 320 © The Estate of Eva Hesse. 321 © The Estate of Eva Hesse; photograph © 1998 The Detroit Institute of Arts. 321 © The Estate of Eva Hesse; photograph courtesy Robert Miller Gallery, New York. 322 © The Estate of Eva Hesse; photograph Geoffrey Clements. 323 Copyright © 1968 and copyright renewed © 1996 by Tom Wolfe. Reprinted by permission of Farrar, Straus & Giroux, Inc; photograph Sheldan C. Collins. Jacket design by Milton Glaser. 324 Copyright © 1968 by Norman Mailer. Used by permission of Dutton Signet, a division of Penguin Putnam Inc. Jacket by Paul Bacon Studio. 325 Geoffrey Clements. 326 Jerry L. Thompson. 327 © Estate of Robert Smithson/Licensed by VAGA, New York, NY. 328 © Estate of Robert Smithson/Licensed by VAGA, New York, NY; photograph Geoffrey Clements. 329 Courtesy Skidmore, Owings & Merrill LLP. 330 Courtesy Barbara Gladstone. 331 © 1999 Robert Morris/Artists Rights Society (ARS), New York; photograph Walter Russell. © Solomon R. Guggenheim Foundation, New York/Robert Morris Archives. 332 Courtesy the artist. 333 John Cliett. All Reproduction Rights Reserved. © Dia Center for the Arts. 334/335/336/337 Courtesy the artist. 338 © Estate of Robert Smithson/Licensed by VAGA, New York, NY; photograph © Gianfranco Gorgoni. 339 John Cliett; courtesy Dia Center for the Arts, New York. 340 © Christo 1969; photograph Harry Shunk. 341 Sheldan C. Collins. 342/343 Courtesy Holly Solomon Gallery, New York. 344 Courtesy Eisenman Architects. 345 © Tim Street-Porter/ Esto. All Rights Reserved. 346 Courtesy Frank O. Gehry & Associates. 347 © 1999 Bruce Nauman/Artists Rights Society (ARS), New York; courtesy Sperone Westwater, New York. 348 © 1999 Lawrence Weiner/ Artists Rights Society (ARS), New York. 349 © 1999 Joseph Kosuth/ Artists Rights Society (ARS), New York; photograph Geoffrey Clements. 350 © 1999 Joseph Kosuth/Artists Rights Society (ARS), New York. 351 Courtesy the artist. 352 Courtesy Marian Goodman Gallery, New York. 354 Geoffrey Clements. 355 Douglas M. Parker Studio, Los Angeles; courtesy Margo Leavin Gallery, Los Angeles. 356 Geoffrey Clements. 357 © 1999 Hans Haacke/Artists Rights Society (ARS), New York/VG Bild-Kunst, Bonn; courtesy the artist. 358 © 1999 Estate of Douglas Huebler/Artists Rights Society (ARS), New York; courtesy Darcy Huebler/Estate of Douglas Huebler. 359 Geoffrey Clements. 360 Clem Fiori; courtesy the Wooster Group. 361 © 1998 David Burnett/Contact Press Images. 362 Fred S. Prouser/Liaison Agency, Inc. 363 © 1972 Paramount Pictures Corporation. All Rights Reserved. 364 S.S. Archives/Shooting Star International. © All Rights Reserved. 365 The Kobal Collection. 366 David Reynolds; courtesy Jack Tilton Gallery, New York. 367 Photograph © Ka Kwong Hui; courtesy Jon Hendricks. Copyprint by Oren Slor, 1995. 368 Copyright © 1998 Museum Associates, Los Angeles County Museum of Art. All Rights Reserved. 369 © Betye Saar; courtesy Michael Rosenfeld Gallery, New York. 370 Courtesy Phyllis Kind Gallery, New York. 371 Linda Eber; courtesy SPARC. 372 © Don Carl Steffen; courtesy Rapho/Photo Researchers, Inc. 373 UPI/Corbis-Bettmann. 374 Kelly Barrie. 375 Christopher Burke; courtesy Cheim & Read, New York. 376 D. James Dee; courtesy Ronald Feldman Fine Arts, New York. 377 David Reynolds; courtesy Jack Tilton Gallery and P.P.O.W., New York. 378 © Miriam Schapiro; photograph D. James Dee. Courtesy Steinbaum Krauss Gallery, New York. 379 © 1979 Judy Chicago; photograph © Donald Woodman. 380 Orcutt & van der Putten; courtesy Alexander and Bonin, New York. 381 Geoffrey Clements. 382 Harry Shunk; courtesy the artist and DC Moore Gallery, New York. 383 John Stoel. 384 Geoffrey Clements. 385 Courtesy Phyllis Kind Gallery, New York. 386 Courtesy the artist. 387 © 1999 Frank Stella/Artists Rights Society (ARS), New York. 388 © Jasper Johns/Licensed by VAGA, New York, NY. © 1999 Christie's Images, Ltd. 389 © 1999 Sol LeWitt/Artists Rights Society (ARS), New York. © 1974 Virgin Music (Publishers) Ltd. Photograph Geoffrey Clements. 390 © 1999 Sol LeWitt/Artists Rights Society (ARS), New York; courtesy Susanna Singer. 391 Erró; courtesy the artist. 392 Minoru Niizuma; courtesy LenOno Photo Archive, New York. 393 Anthony McCall; courtesy the artist. 394 George Macunias. 395/396 © The Estate of Ana Mendieta; courtesy Galerie Lelong, New York. 397 Courtesy George and Betty Woodman. 398 Courtesy the artist. 399 Geoffrey Clements. 400 Courtesy Thomas Erben Gallery, New York. 401 Photograph © 1972, Babette Mangolte. All Rights of Reproduction Reserved; courtesy Trisha Brown Company. 402 © 1993 Beatriz Schiller. 403 Kathy Dillon; courtesy Barbara Gladstone. 404 Michael Kirby; courtesy the Estate of Scott Burton. 405 Charles Hill; courtesy the artist. 406 Alfred Lutjeans. 407 Barbara Burden; courtesy the artist. 408 © 1999 Artists Rights Society (ARS), New York/VG Bild-Kunst, Bonn; photograph

Ute Klophaus. 409 Perry Hoberman. 410 Copyright © 1976, 1995, Babette Mangolte. All Rights of Reproduction Reserved. 411 Paula Court. 412 © 1999 Bruce Nauman/Artists Rights Society (ARS), New York. 413 © 1999 Bruce Nauman/Artists Rights Society (ARS), New York. 414 Photograph © The Estate of Peter Moore/ Licensed by VAGA, New York, NY. 415 Courtesy the artist. 416 Courtesy the artist. 417/418 Courtesy Electronic Arts Intermix, New York. 419 Photothèque des collections du Mnam/Cci. 420 © 1999 Bruce Nauman/Artists Rights Society (ARS), New York; photograph © Giorgio Colombo, Milan. 421 Geoffrey Clements. 422 Robert E. Mates. 423 Sheldan C. Collins. 424 Courtesy McKee Gallery, New York. 425 Photograph © 1986 Douglas M. Parker, Los Angeles. 426 © Nancy Graves Foundation/Licensed by VAGA, New York, NY. 427 Robert E. Mates. 428 Courtesy Paula Cooper Gallery, New York. 429 © 1999 Susan Rothenberg/Artists Rights Society (ARS), New York; photograph Charles W. Crist. 430 © Jennifer Bartlett; courtesy Robert Miller Gallery, New York. 431 Steven Sloman. 432 Squidds & Nunns. 433 © 1999 Bryan Hunt/Artists Rights Society (ARS), New York; photograph Jerry L. Thompson.

Restoration and Reaction, 1976–1990
434 UPI/Corbis-Bettmann. 435 Used by permission of Whole Earth Magazine, San Rafael, California. 436 Courtesy NASA. 437 Geoffrey Clements. 438/439 © William Eggleston/A + C Anthology; transparency © 1999 The Museum of Modern Art, New York. 440 Geoffrey Clements. 441 © 1976 Richard Misrach; courtesy Robert Mann Gallery, New York. 442/443/444/445 Geoffrey Clements. 446 © Ezra Stoller/Esto. All Rights Reserved. 447 Marvin Rand; courtesy Cesar Pelli & Associates, Inc. 448/449 Geoffrey Clements. 450 Jerry L. Thompson. 451 Sheldan C. Collins. 452 © David Salle/Licensed by VAGA, New York, NY; courtesy Gagosian Gallery, New York. 453 Courtesy Chase Manhattan Bank. 454 Courtesy the artist. 455/456/457 Courtesy the artist and Metro Pictures, New York. 458 Geoffrey Clements. 459 Courtesy Mary Boone Gallery, New York. 460 © Zindman/Fremont; courtesy Mary Boone Gallery, New York. 461 © Jenny Holzer; photograph Jenny Holzer. 462 © Jenny Holzer; photograph Lisa Kahane. 463 © Jenny Holzer; courtesy Jenny Holzer. 464 © Norman McGrath/Esto. All Rights Reserved. 465 Corbis/Robert Holmes; used by permission of Disney Enterprises, Inc. 466 Geoffrey Clements. 467 © Walker Evans Archives/The Metropolitan Museum of Art, New York; photograph Geoffrey Clements. 468 © 1980 Andrea Callard. 469 Courtesy Rosemary Hochschild. 470 Photograph © Richard Kern. 471/472 © 1980 Andrea Callard. 473/474 Geoffrey Clements. 475 Courtesy Mary Boone Gallery, New York. 476 James A. Steinfeldt/Shooting Star. 477/478 Bob Gruen. 479 © 1977 Ebet Roberts. 480 © 1975 The Estate of Robert Mapplethorpe. 481 © 1978 The Estate of Robert Mapplethorpe. 482 © 1980 The Estate of Robert Mapplethorpe. 483/484/485/486/487/488 All photographs © Nan Goldin; courtesy Matthew Marks Gallery, New York. 489 Geoffrey Clements. 490 © The Estate of Peter Hujar; photograph © 1999 D. James Dee. 491 Geoffrey Clements. 492 Courtesy The Estate of David Wojnarowicz and P.P.O.W., New York. 493 Courtesy Electronic Arts Intermix, New York. 494/495/496 © Andé Whyland. 497/498 The Everett Collection. 499 Courtesy Ronald Feldman Fine Arts, New York; photograph Jennifer Kotter. 500 © The Estate of Keith Haring; photograph Chantal Regnault. 501 © The Estate of Keith Haring; photograph Klaus Wittman. 502 © 1999 Kenny Scharf/Artists Rights Society (ARS), New York; photograph Geoffrey Clements. 503 © 1999 Artists Rights Society (ARS), New York/ADAGP, Paris (Jean-Michel Basquiat); photograph Geoffrey Clements. 504 Martha Cooper, from Subway Art, by Martha Cooper and Henry Chalfant (London: Thames and Hudson Ltd., 1984). 505/506 Henry Chalfant, from Subway Art, by Martha Cooper and Henry Chalfant (London: Thames and Hudson Ltd., 1984). 507 © 1999 Artists Rights Society (ARS), New York/ADAGP, Paris (Jean-Michel Basquiat); photograph Bill Jacobson Studio. 508 Timothy Greathouse; courtesy Gracie Mansion. 509 Archive Photos. 510/511 Courtesy the artist. 512 Courtesy Leon Golub. 513 Courtesy the artist and Metro Pictures, New York; photograph Lisa Kahane. 514 Courtesy Mary Boone Gallery, New York. 516 © David Salle/Licensed by VAGA, New York, NY; courtesy Ludwig Forum für Internationale Kunst, Aachen, Germany. 517 © David Salle/ Licensed by VAGA, New York, NY; courtesy Gagosian Gallery, New York. 518 Geoffrey Clements. 519 © 1999 Andy Warhol Foundation for the Visual Arts/Artists Rights Society (ARS), New York; photograph Art Resource, New York. 520 Transparency © 1998 Museum of Fine Arts, Boston. All Rights Reserved. 521 Courtesy Mary Boone Gallery, New York. 522 Courtesy Gagosian Gallery, New York. 523 © Fred Scruton; courtesy the artist. 524/525

Geoffrey Clements. **526** © 1999 Brice Marden/Artists Rights Society (ARS), New York; courtesy Matthew Marks Gallery, New York. **527** Squidds & Nunns. **528** Graphics System. **529** Bill Jacobson Studio, New York. **530** Courtesy Robert K. Hoffman. **531** Courtesy the artist. **532** Geoffrey Clements. **533/534** © Jeff Koons; photograph Douglas M. Parker Studio. **535** Courtesy Sonnabend Gallery, New York. **536** © 1999 Andy Warhol Foundation for the Visual Arts/Artists Rights Society (ARS), New York; photograph Art Resource, New York. **537** The Everett Collection. **538** Paula Court. **539** The Everett Collection. **540** The Kobal Collection. **541** David Allison. **542** © 1988 The Estate of Robert Mapplethorpe. **543** Geoffrey Clements. **544** Courtesy Creative Time, Inc., New York. **545** Courtesy The Estate of David Wojnarowicz and P.P.O.W., New York. **546** Photograph Peter Muscato; courtesy Andrea Rosen Gallery, New York. **547** Courtesy The New Museum of Contemporary Art, New York. **548** Courtesy Visual AIDS Artists Caucus. **549** © 1999 Richard Serra/Artists Rights Society (ARS), New York; photograph Anne Chauvet. **550** © 1988 Lawrence Migdale/Photo Researchers. **551** Courtesy Paula Cooper Gallery, New York. **552** © 1980 The Estate of Robert Mapplethorpe. **553** Courtesy the artist.

Approaching the Millennium, 1990–2000
554 © 1988 The Museum of Modern Art, New York; photograph Geoffrey Clements. **555** © 1978 Rem Koolhaas; photograph Geoffrey Clements. **557** Sandak, Inc. **558** Graphics System. **559/560** Geoffrey Clements. **561** Courtesy Jack Shainman Gallery, New York. **562** Geoffrey Clements. **563** Courtesy the artist and P.P.O.W., New York. **564** Geoffrey Clements. **565** © 1994 Beatriz Schiller. **566** © Tom Brazil. **567** Courtesy Morphosis. **568** Courtesy Diller + Scofidio. **569** © Jeff Goldberg/Esto. **570** Gagosian Gallery, New York; courtesy the artist. **571** Luhring Augustine, New York. **572** Courtesy Patrick Painter, Inc., Santa Monica, California. **573** Geoffrey Clements. **574/575** Courtesy Regen Projects, Los Angeles. **576** F. Delpech; courtesy the artist. **577/578** Geoffrey Clements. **579** D. James Dee; courtesy the artist and Paula Cooper Gallery, New York. **580** Geoffrey Clements. **581** Peter Muscato; courtesy Andrea Rosen Gallery, New York. **584** © Joshua White; courtesy CRG. **585** Courtesy PaceWildenstein, New York. **586** © Louise Bourgeois/Licensed by VAGA, New York, NY. Courtesy Cheim & Read, New York; photograph Frederic Delpech. **587** Courtesy Sean Kelly Gallery, New York. **588** Courtesy the artist and Luhring Augustine, New York. **589/590** Geoffrey Clements. **591** Photograph Russell Kaye; courtesy the artist. **592** Videography P. Strietmann; photograph Larry Lamé. Courtesy Barbara Gladstone. **593** © 1993 Matthew Barney/Videography Peter Strietmann. Courtesy Barbara Gladstone, New York. **594** Sandak, Inc. **595** Courtesy Regen Projects, Los Angeles. **596** Photofest. **597** Tom Burton/The Everett Collection. **598** Phyllis Galembo. **599/600** The Kobal Collection. **601** Courtesy the artist. **602** Courtesy Donald Young Gallery, Chicago. **603** © 1997 Bill Viola; photograph Kira Perov. **604** David Allison. **605** © 1999 Bruce Nauman/Artists Rights Society (ARS), New York; courtesy Donald Young Gallery, Chicago. **606** David Allison. **607** Geoffrey Clements. **608** © Douglas M. Parker Studio.

Foreword © 1999 Pollock-Krasner Foundation/Artists Rights Society (ARS), New York; photograph Steven Sloman

Index

Page numbers in *italics* refer to pages with illustrations.